PERILOUS CHASTITY

PERILOUS CHASTITY

Women and Illness in Pre-Enlightenment Art and Medicine

Laurinda S. Dixon

CORNELL UNIVERSITY PRESS Ithaca and London

First published 1995 by Cornell University Press.

Printed in the United States of America
Colorplates printed in Hong Kong

♾ The paper in this book meets the minimum requirements of the American National Standard for Information Sciences—Permanence of Paper for Printed Library Materials, ANSI Z39.48-1984.

Library of Congress Cataloging-in-Publication Data

Dixon, Laurinda S.
 Perilous chastity : women and illness in pre-Enlightenment art and medicine / Laurinda S. Dixon.
 p. cm.
 Includes bibliographical references and index.
 ISBN 0-8014-3026-7 (cloth). — ISBN 0-8014-8215-1 (pbk.)
 1. Medicine and art—Netherlands. 2. Women in art—Netherlands. 3. Women—Diseases—Netherlands. 4. Genre painting, Dutch. 5. Genre painting—17th century—Netherlands. 6. Feminist art criticism. I. Title.
 N8223.D59 1995
 760'.0449618—dc20 94-34911

To the memory of Elizabeth Gilmore Holt, teacher and friend

CONTENTS

COLORPLATES

ILLUSTRATIONS

ACKNOWLEDGMENTS

This book owes a considerable debt to many individuals and institutions who have given of their time and resources. First and foremost, I thank my friend and colleague Wayne Franits for his unstinting generosity. The final form of the book owes much to his many contributions at every phase of its development. I also express my gratitude to Monica H. Green for her generosity in clarifying my understanding of the early history of hysteria. I thank the Woodrow Wilson Foundation for granting me a year's residence at their center in Washington, D.C., where much of the initial research was conducted. The acquisition of photographs and permissions was supported by a generous grant from the office of the Vice President for Research and Computing at Syracuse University.

I am also grateful for the assistance of staff members at many libraries and museums. Particular recognition is due the National Library of Medicine (Bethesda), the National Gallery of Art (Washington, D.C.), the Library of Congress, the Wellcome Institute for the History of Medicine (London), the Bodleian Library (Oxford), the British Library, the Leiden University Library, the Witt Library of the Courtauld Institute of Art (London), the New York Public Library, the Health Sciences Library of SUNY-Syracuse, and the Syracuse University Libraries, especially the interlibrary loan department and photo center.

Many friends and colleagues from diverse disciplines and professions lent their expertise. I wish especially to acknowledge Kahren Arbitman, Robert Baldwin, Karen DeCrow, Gloria Fiero, Walter Gibson, Ann Sutherland Harris, Elizabeth Johns, Alison Kettering, Kris Koozin, Walter Liedke, Ruth Meyer, Kirsten Mills, Inez Viole O'Neill, Bernadine Z. Paulschock, Johanna Prins, Herman Roodenberg, William Schupbach, Robert Seidenberg, Larry Silver, Ann Simonson, and Gabriel P. Weisberg. I also thank Maureen Quigley for graciously and carefully reading proofs and my very capable editors, Amanda Heller and, at Cornell University Press, Carol Betsch and Bernhard Kendler, for their unwavering support and enthusiasm. For unflinching support and valuable insights at every stage, I give tender thanks to my husband, Chuck Klaus. Finally, I must also include my feline companions, Percy and Alma, who always knew just when to sit on my manuscript.

L. S. D.

PERILOUS CHASTITY

INTRODUCTION

Seventeenth-century Dutch paintings of ailing women, with titles such as *The Doctor's Visit* or *The Lovesick Maiden*, are numerous and, with some variations, remarkably similar. All of them focus on a woman—usually young, pretty, and well dressed—propped up in a chair or languishing in bed (colorpl. 1, fig. 1). In some she has just swooned and lies senseless, the object of frantic efforts to revive her on the part of her maid, her mother, her physician, or all three. Always she is pale and listless; often she stares vacantly with sunken, shadowed eyes or sits in the classic head-on-hand pose of the melancholic. She is usually bundled under several layers of coverlets or is wearing a fur-trimmed jacket colored bright green or blue, or, most often, a warm shade of peach or rose. Her chemise and corset are often unlaced, affording a glimpse of ripe bosom and creamy flesh. Despite her state of dishabille, numerous blankets, fur jackets, charcoal burners, and bed warmers are placed about her, suggesting that she is suffering from a chill and must be kept warm.

Some objects in these paintings are the typical accouterments of a seventeenth-century sickroom: bleeding basins, bottles of medicine, urine flasks, and tall straw containers used to carry urine samples to a doctor's office. Other objects, however, are less obviously medical in purpose, at least in the modern sense. Often the walls of the sickroom are hung with erotic paintings, or a cupid

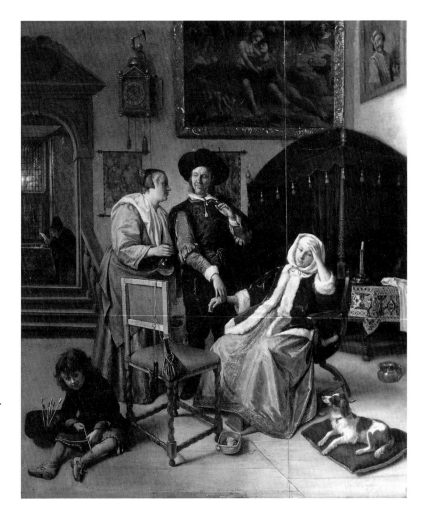

Fig. 1 Jan Steen,
The Doctor's Visit, ca.
1663. Wellington
Museum, Apsley
House, London.
Photo: V & A
Picture Library,
London.

cavorts atop a doorpost—objects traditionally interpreted as allusions to the maiden's lack of a lover or to the delicate condition of pregnancy. Sometimes, however, the walls are decorated with pastoral landscapes, or even with a painting of centaurs and stampeding horses. Occasionally music is being played for the sick woman, and sometimes groups of young people laugh, sing, and joke in her presence. Frequently a dish of sliced lemons is placed near her medicine bottles on a table at the side of her bed. In paintings by the Leiden artist Jan Steen, a charcoal burner appears on the sickroom floor, with one end of a ribbon placed in its smoldering coals. Usually the woman is attended by her doctor, who takes her pulse or gazes intently at a sample of urine held up to the light. These women are clearly weakened by sickness, and the people who surround them often express genuine concern. Occa-

sionally, however, a note of mocking satire intrudes into the sick-room: the physician appears dotty or even ridiculous, or old crones and teasing boys leer suggestively at the poor invalid or outward at the viewer. Are there other messages, not immediately apparent to the modern eye, beneath the surfaces of these paintings?

The connection between art and medicine has not been widely recognized by art historians, very few of whom have explored the history of science as a tool for interpreting images. Even so, modern scholars are increasingly aware that the study of early medicine falls within the province of historians more often than within that of scientists. In this book I reconstruct the medical context surrounding the "lovesick maiden" and "doctor's visit" paintings that form an important subgenre in the works of artists connected primarily, though not exclusively, with the city of Leiden. As is true of all genre paintings, the underlying meanings and associations are deeply rooted in the everyday concerns and practices of seventeenth-century culture—concerns and practices that are alien to our own. Although we can never recreate completely and accurately a way of life that existed centuries ago, we can retrieve much by viewing a work of art in the context of the popular wisdom of its time. The task is complicated by the fact that common associations between art and science which would have been obvious to a seventeenth-century audience are, in many cases, lost to us completely, for, though science underwent dramatic changes during this time, medical knowledge was still largely based on traditions that were two thousand years old. My intention is to show how the art of this period revealed, justified, and perpetuated an ancient medical belief in the innate instability of the female sex, thereby reinforcing traditional notions concerning women's societal roles and intellectual capabilities.

The image of the fragile, passive, housebound woman has always been a reflection more of male wish fulfillment than of female reality. It was supported by scientific dogma that had become absorbed over the ages into the cultural inheritance of the seventeenth century. The key images illustrating this book date from the early modern period, but the concept of woman as inherently weak and unstable was as ancient and universal as the science of medicine itself. In order to understand how and why physicians and artists characterized women in this way, we must drastically revise our modern perception of medicine to include philosophies

not accepted today as scientific. Readers must temporarily sus-
pend all their notions of what constitutes proper medical practice
and imagine themselves critically ill and dependent on the skills of
a seventeenth-century doctor. This is especially difficult for mod-
ern medical professionals, who sometimes react with shock and
denial when confronted with the practices and beliefs of their pre-
Enlightenment forebears. The images in this book must be ap-
proached from the understanding that both art and medicine in the
seventeenth century combined themes which to us seem but dis-
tantly related—science, mechanics, music, Greek philosophy, as-
trology, even humor. Early artists and physicians, unfamiliar with
the specialization characteristic of modern science, experienced
these domains within a seamless cultural context.

The question of sources is an important one. Current art-
historical methodology favors the study of Dutch vernacular lit-
erary texts and emblems as sources for seventeenth-century genre
paintings. This approach assumes that Dutch painters and their
patrons would not have had access to books written in other lan-
guages or, if they had, would not have been likely to use them. Al-
though evidence drawn from vernacular literature is extremely
valuable in the interpretation of many Dutch portraits and genre
themes, it has thus far not proved especially fruitful when applied
to the lovesick maiden pictures. Readers looking for footnote ref-
erences to Dutch medical texts in support of this book's assertions
will therefore be disappointed. Indeed, it was generally believed
throughout the seventeenth century that the older a text, the closer
it came to true wisdom. Most of the sources quoted here refer to
revered names in the history of medicine, figures whose writings
and commentaries formed the basis for medical theory and prac-
tice up until the eighteenth century. These primary sources were
originally written in Greek or Latin and were translated into var-
ious vernacular languages throughout the centuries. Scholarly sci-
entific works written in Dutch were relatively rare, for all Euro-
pean physicians, regardless of nationality, read, wrote, conversed,
and published in Latin, the language of the schools and universi-
ties. This practice assured authors of wide dissemination of their
work and an international reading audience.[1] Knowledge of Latin
was not limited to the educated elite, however, and was more

1. The international concerns of Dutch art patrons are well documented in Alison
McNeil Kettering, *The Dutch Arcadia: Pastoral Art and Its Audience in the Golden Age* (1983).
For discussion of the international connections of Dutch scientists, see Chapter 1.

common among the middle class than we might assume today. Schoolboys played Latin games, and the ancient tongue was considered a necessary tool for the proper cultivation of vernacular languages. Even the quaint proverbs, often cited as examples of provincial Dutch wit, originally stemmed from the clever sayings of the ancient Romans.[2] Seventeenth-century painters thought of themselves as upwardly mobile intellectuals, inheritors of the Aristotelian-Neoplatonic persona of the artist-as-genius evoked in Albrecht Dürer's immensely influential engraving *Melencolia I*.[3] We may never know if a particular painter used a Latin text as a source. It is certain, however, that artists, like seventeenth-century intellectuals more generally, had abiding respect for ancient authors. I do not mean to slight the power of visual influences and traditions in the making of art; nonetheless, artists were more than mere copiers and purveyors of stock images gleaned from emblem books, the paintings of other artists, and other visual modes. Indeed, the so-called lovesick maiden and doctor's visit genre themes seem to have been inventions of the artists themselves, working in response to intellectual theories that were ancient, universal, and intrinsically intertwined with their contemporary culture.

Medical texts were, of course, available in Dutch. Some of the more controversial though not necessarily more important Latin works were eventually translated, but many significant classical treatises remained accessible only in the ancient tongue. The knowledge of the ancients was nevertheless available in abbreviated form to vernacular readers. Authorities such as Avicenna, Galen, and Hippocrates were copiously cited in popular medical compendiums and home manuals that distilled ancient knowledge into common Dutch prose.[4] The condensed, simplified informa-

2. See Margaret Sullivan, "Bruegel's Proverbs: Art and Audience in the Northern Renaissance" (1991).

3. On the social status of painters, see John Michael Montias, *Artists and Artisans in Delft* (1982); and the exhibition catalogue *Children of Mercury: The Education of Artists in the Sixteenth and Seventeenth Centuries* (1984). On the Aristotelian imagery of artists in the Renaissance and beyond, see Raymond Klibansky, Erwin Panofsky, and Fritz Saxl, *Saturn and Melancholy: Studies in the History of Natural Philosophy, Religion, and Art* (1964).

4. The most popular seventeenth-century Dutch medical compendiums were written by Johan van Beverwijck, particularly *Schat der gesontheyt* (1638). Vernacular manuals written for midwives and devoted exclusively to the medical problems of women owed much to the ancient treatises of Galen, Hippocrates, and Trotula of Salerno. Examples are the "rose garden" tracts, popular until the eighteenth century, which stemmed from Eucharius Roesslin's *Der Swangern Frawen uud heb ammē roszgartē* (1513), translated into Dutch by T. Van der Noot in 1516 as *Roseghaert van den bevruchten vrouwen*. References to humoral

tion in these books was limited to the basic data necessary to maintain a household's health, and probably commanded the same audience as, say, *Family Circle* and *Woman's Day* do today. The medical content of the lovesick maiden and doctor's visit paintings, then, exists on two levels. On the one hand, some of the medical paradigms reflected in these works would have been familiar to the lay public, who knew them not so much as medical facts but as part of the contemporary wisdom on which they based their lives. Lay folk could also have been aware of basic medical theory as it was simplified for presentation in vernacular handbooks or in the popular emblem books of the day, for, in the seventeenth century, medicine had not yet become established as the special preserve of a professional elite. On the other hand, much of the medical procedure reflected in these paintings is not superficial or anecdotal but detailed and technical. Apart from the fact that basic medical knowledge was perceived as essential for daily life, a relatively sophisticated knowledge of medicine was regarded as essential to the makeup of a cultured gentleman.[5] Indeed, it is very possible that physicians who studied and taught at the Leiden medical school were the major patrons for these paintings.[6]

The lovesick maiden theme has been interpreted variously throughout history, most often as a moralizing sermon against women who became pregnant outside of marriage, a humorous look at the foibles of young love, or a tongue-in-cheek satire aimed at quack doctors.[7] It is unlikely, however, that the scandal of

medicine and gynecological material also appear in marriage manuals such as Nicolas Venette, *Venus minsieke gasthuis, waer in beschreven worden de bedryven der liefde in den staet des houwelijks, met de natuurlijke eygenschappen der manen en vrouwen, hare siekten, oirsaken en genesingen* (1688), translated from the first French edition of 1687. The nationality of an author was not a determining factor in whether a book would be published in Dutch. Among the authors cited here (Dutch and otherwise) whose works on women's illnesses were translated in their entirety into Dutch are Hermann Boerhaave, Hippocrates, François Mauriçeau, Ambrose Paré, Gerard van Swieten, Thomas Sydenham, Thomas Willis, and Robert Whytt.

5. For the popular perception of medical knowledge and the role that medicine played in education, see John Henry, "Doctors and Healers: Popular Culture and the Medical Profession" (1991).

6. The number of potential patrons was actually quite large. More than one hundred doctoral dissertations on the subject of women's illnesses were published in the seventeenth century, most of them originating at Leiden and Utrecht. See appendix.

7. For moralizing interpretations of the lovesick maiden theme, see primarily Jan Baptist Bedaux, "Minnekoorts- zwangerschaps- en doodsverschijnselen op zeventiende-eeuwse schilderijen" (1975); Sturla J. Gudlaugsson, *The Comedians in the Work of Jan Steen and Contemporaries* (1975); Otto Naumann, *Frans van Mieris the Elder* (1981), 1:102; Simon

unwed motherhood would have been publicly memorialized in so many paintings, even in the relatively progressive Netherlands. Since the days of the early church, sexual activity outside of wedlock was thoroughly condemned, if not always avoided.[8] A respectable family would not have greeted the illegitimate fruits of such adulterous adventures with the tolerance and good humor typical of many of these paintings. It is also true that some of the physicians officiating in these female sickrooms seem to be cast as comic figures in the tradition of Molière, though many are depicted as grave, serious men who show apprehension and concern for their patients. The assumption that all of these doctors are satirical figures or that their patients are suffering from unwanted pregnancy or adolescent psychological upset is an interpretation attributable to popular twentieth-century bias. Pre-Enlightenment medicine made no distinction between mental and physical illness. Every detail of these paintings points to the existence of a serious medical condition familiar to a large number of physicians and widely afflicting their female patients in the seventeenth century.

The nineteenth-century physician Henry Meige was the first to suggest that the lovesick maiden pictures might depict a medical reality. Working within the scientific context of his time, Meige identified the illness depicted in these paintings as chlorosis, a particular type of anemia associated with puberty in girls which was widely diagnosed in the nineteenth century. Meige identified the symptoms suggested in the paintings—heart palpitations, erratic pulse, general pallor, digestive problems, appetite disorders, depression, and so on—and also noted that not all the physicians in the scenes are depicted as charlatans. He concluded that these paintings portray neither pregnancy nor some mythical or satirical condition but rather an illness prevalent among the women of his

Schama, "Wives and Wantons: Versions of Womanhood in Seventeenth-Century Dutch Art" (1980); Leonard Slatkes, *Vermeer and His Contemporaries* (1981), 141; Peter C. Sutton et al., *Masters of Seventeenth-Century Dutch Genre Painting* (1984), 226, 300, 313; and Sutton, *Jan Steen: Comedy and Admonition* (1982–83).

8. For discussion of the origins of the church's stand regarding sexual morality among women, premarital sex, and illegitimacy, see Vern L. Bullough and James Brundage, *Sexual Practices and the Medieval Church* (1982); and Shulamith Shahar, *The Fourth Estate: A History of Women in the Middle Ages* (1983). On illegitimacy as a disgrace to the community in the early modern Netherlands, see Donald Haks, *Huwelijk en gezin in Holland in de 17de en 18de eeuw* (1985), chap. 3; and Florence Koorn, "Illegitimiteit en eergevoel: Ongehuwde moeders in Twente in de achttiende eeuw" (1987).

day.[9] Meige's observations, however, were not absorbed into the interpretive realm of art history. Modern historians have only recently begun to investigate the wider social and moral ramifications of the lovesick maiden theme.[10] The main task of my book, therefore, is to examine these paintings as serious documents with reference to medical treatises of the time. My investigation suggests that in the seventeenth century, especially in the Netherlands, which claimed to have the best medical schools in all of Europe, the health problems of women assumed a new priority. Contemporary gynecological texts, which treated uterine disorders as a universal plague, commanded an international audience. These treatises described all women as endangered, though certain types were held to be more susceptible than others. These included women who were unmarried, celibate, or unwilling to limit their activities to the home. The ramifications of such sex-specific illness for the heightened social and intellectual aspirations of women in the seventeenth century must not be underestimated.

Today we might question how women could have been perceived as inherently unhealthy and intellectually inferior at a time when feminine consciousness was strong. It is thus important to recognize the tremendous power and authority held by the medical establishment throughout history. Early physicians saw themselves not only as preservers of women's health but also as their moral guardians. All aspects of life were inextricably linked with the maintenance of health, a notion that has returned with the more holistic views of modern health professionals.

The combined image of women, art, and medicine presented in this book owes much to the prior achievements of modern scholars in several disciplines. Art historians have, within the past twenty-five years, made great strides in interpreting genre paintings not as actual reflections of reality but as vehicles for the education and enlightenment of their audiences.[11] They have addressed the image of the housebound woman in Dutch painting by citing a wide range of interdisciplinary sources which suggest

9. See Henry Meige, "Les peintres de la médecine: Le mal d'amour" (1899); and idem, "Les médecines de Jan Steen" (1900).

10. See especially Einar Petterson, "*Amans Amanti Medicus:* Die Ikonologie des Motivs *Der ärztliche Besuch*" (1987).

11. See Eddy de Jongh, *Portretten van echt en trouw: Huwelijk en gezin in de Nederlandse kunst van de zeventiende eeuw* (1986); idem, *Zinne- en minnebeelden in de schilderkunst van de zeventiende eeuw* (1967); and Sutton et al., *Masters of Seventeenth-Century Dutch Genre Painting.*

that domesticity was a moral imperative imposed on women from without.[12] This method has also been used effectively by social historians, who, in choosing images that reinforce the historical record, achieve much the same result as art historians who reinforce images with historical context.[13] Historians of medicine have also succeeded in uncovering the social implications of disease by studying now extinct "illnesses" such as uterine hysteria and intellectual melancholia.[14] The field of comparative literature has yielded further important studies that investigate the relationship between disease and culture from the literary point of view.[15] There are also scholars who combine art, literature, social history, and medical history to interpret images in an all-inclusive historical context.[16] Finally, the broad field of women's studies provides important gender contexts for viewing images of women.[17]

This study, then, is clearly not "art historical" in the strict sense of the term. Rather, it presents an inclusive image of pre-Enlightenment women derived from many disciplines. In so doing it enlarges the comic and satirical aspects of the lovesick maiden pictures by also viewing them as reflections of real medical and moral concerns. The image of the female sickroom takes its place as a seventeenth-century topos alongside the many paintings of good wives washing, spinning, and caring for their children—as a

12. See Wayne E. Franits, *Paragons of Virtue: Women and Domesticity in Seventeenth-Century Dutch Art* (1993).

13. See Simon Schama, *The Embarrassment of Riches: An Interpretation of Dutch Culture in the Golden Age* (1987).

14. See especially Sander L. Gilman et al., *Hysteria beyond Freud* (1993); Stanley W. Jackson, *Melancholia and Depression from Hippocratic Times to Modern Times* (1986); Ilza Veith, *Hysteria: The History of a Disease* (1965); and Étienne Trillat, *Histoire de l'hystérie* (1986). Scholarly interest in the history of hysteria has undergone a recent renaissance. For a comprehensive overview of sources and methodologies, see Mark S. Micale, "Hysteria and Its Historiography: A Review of Past and Present Writings" (1989).

15. See especially Lawrence Babb, *The Elizabethan Malady: A Study of Melancholia in English Literature from 1580 to 1642* (1951); Bridget Gellert Lyons, *Voices of Melancholy: Studies in Literary Treatments of Melancholy in Renaissance England* (1971); Mary Frances Wack, *Lovesickness in the Middle Ages: The "Viaticum" and Its Commentaries* (1990).

16. See especially Sander L. Gilman, *Disease and Representation: Images of Illness from Madness to AIDS* (1988); and Elaine Showalter, *The Female Malady: Women, Madness, and English Culture, 1830–1980* (1985).

17. The field of women's studies is vast and cannot be summarized here. See especially historical studies in Renate Bridenthal and Claudia Koonz, eds., *Becoming Visible: Women in European History* (1977); and Susan Rubin Suleiman, ed., *The Female Body in Western Culture: Contemporary Perspectives* (1986); the art-historical studies in Linda Nochlin, *Women, Art, and Power and Other Essays* (1988); and Norma Broude and Mary D. Garrard, eds., *Feminism and Art History: Questioning the Litany* (1982); and feminist medical investigations in Sara Delamont and Lorna Duffin, eds., *The Nineteenth-Century Woman: Her Cultural and Physical World* (1978).

female archetype. But instead of reinforcing "proper" behavior by illustrating a perfect model, the lovesick maidens reminded their audiences of the negative consequences of digressing from the ideal. The medical subtext of these paintings delineated the life-style most congenial to the maintenance of health, defined correct societal roles, alluded to women's intellectual and physical limitations, and, by extension, clarified what was best for the larger common good as far as the female sex was concerned.

I

HYSTERIA AS A
UTERINE DISORDER
A Brief History

Accrding to the scheme of Greek science that dominated medicine until the eighteenth century, the body was intrinsically linked with the cosmos. Like the stars and planets, the human body was thought to comprise four elements and their associated qualities: earth (cold and dry), air (warm and wet), water (cold and wet), and fire (hot and dry).[1] These in turn were associated with four bodily humors and their related physical dispositions: earth with black bile and melancholia, air with blood and sanguinity, water with phlegm and the phlegmatic type, and fire with yellow bile and the choleric type. Astrology played an important role, for the planets were also associated with particular humors and qualities. Saturn, for example, dominated melancholics and the element earth, whereas Luna was associated with phlegm and the realm of water. Likewise, Venus, Jupiter, and Sol were sanguine planets, associated with air and blood, while Mars, the red planet, was considered fiery and choleric. Mercury was changeable, taking its nature from the planet that was closest to it at any particular time.[2] The planets ruled everything on earth, and their influence was felt in every realm of being.

1. The concept of the bodily humors was familiar by the time of Hippocrates in the fifth century B.C. The formal explanation of humoral theory, however, is generally credited to him. See Hippocrates, *The Nature of Man*, in *Works of Hippocrates*, vol. 4 (1923–31).

2. See Galen of Pergamon, *Art of Physick* (1652). For secondary sources on humoral medical principles, see Benjamin Farrington, *Greek Science* (1961); Lester S. King, *The*

Physicians trained in Greek medical theory viewed illness as the result of a combination of humoral imbalance and astrological influences. An excess of one or another humor or the inordinate influence of a particular planet affected the whole person, though the imbalance might show itself in an isolated organ or system. Healing was accomplished by reestablishing harmony throughout the body, which physicians attempted to do by attracting positive astrological influences, by introducing substances of opposing qualities, by removing the offending humor, or by a combination of all three. To this end they rated all substances from which medicines were made and the illnesses to which they were applied on a sliding scale from 1 to 4 according to the degree of heat and moisture associated with them.[3] Both hysteria and melancholia, for example, were thought to be illnesses that heated and dried the body. Doctors therefore alleviated the hot symptoms by administering cold, wet substances, theoretically dousing the inflammation much as one would throw a bucket of water to put out a fire. Citrus fruits were commonly prescribed as ameliorators of "hot" complaints, not because they contain vitamin C (as we know today) but because they produce cool, wet juice. Physicians further attempted to remove excess humors by bleeding and by purging the body with enemas and emetics. These efforts, some of them barbarous by modern medical standards, were common methods of achieving the bodily equilibrium needed to restore a patient to health.

Early medicine was also concerned with maintaining long-term health. Because they believed that all aspects of human life were ruled by a dominant humor, doctors prescribed entire daily regimens for their patients. They routinely checked astrological configurations and natal horoscopes before prescribing routines capable of amending their patients' natural humoral makeup. Thus, physicians were concerned not only with factors such as food, drink, sleep, and exercise but also with a person's occupation, sexual habits, frequency of bathing, and choice of friends, who had to be compatible by humor and astrological sign. Even jewelry

Growth of Medical Thought (1963), 43–85; Owsei Temkin and C. L. Temkin, eds., *Ancient Medicine* (1967). For medieval and Renaissance applications of the principles of ancient medicine, see Benjamin Lee Gordon, *Medieval and Renaissance Medicine* (1959); Edward Grant, ed., *A Source Book in Medieval Science* (1974), 700–808; Nancy G. Siraisi, *Medieval and Early Renaissance Medicine* (1990); Owsei Temkin, *Galenism: The Rise and Decline of a Medical Philosophy* (1973).

3. See Luisa Cogliati Arano, *The Medieval Health Handbook: Tacuinum Sanitatis* (1976), a facsimile of an illuminated manuscript herbal that rates the qualities of healing substances.

and the colors of one's clothing were controlling factors in the maintenance of health. Any physician today who was so intimately involved in the details of patients' lives might be accused of invasion of privacy.[4]

Although healing and maintaining health often involved the use of complex charts and celestial maps, a physician would make the ultimate diagnosis of humoral dominion by visual examination. In accord with Aristotelian theories of physiognomy, the outward appearance of the body was presumed to be a mirror of its interior workings. Appearances not only advertised celestial and humoral affinities but also displayed the condition of the soul. Doctors therefore looked for both physical and personality traits associated with specific illnesses when diagnosing their patients. The emotions, or "passions," were thought capable of producing changes in the temperature and humidity of the body. Cold, dry passions such as grief, envy, or fear, were believed to contract the heart, causing the production of black bile. Conversely, warm, moist passions such as love and joy expanded the heart, stimulating the production of blood. Thus, illness could be perceived as either the cause or the result of a particular emotional state.[5]

The physical and mental symptoms associated with uterine disorders are documented in hundreds of medical treatises written over a period of four thousand years. A systematic review of these symptoms would yield many pages of vivid description. The most often mentioned physical indications, however, were stomach and back pains, vomiting, excessive urination, appetite disorders, dizziness, listlessness, weakness, heart palpitations, convulsions, fainting, distended abdomen, swollen feet, headache, pallor, and a weak or irregular pulse. Medical texts from the Renaissance on vividly describe the psychic symptoms as well, the most common of which were weeping, sighing, anxiety, timidity, disturbed sleep, sadness, despair, depression, and violent mood swings.[6] Symptoms such as these were believed to be caused by inflammation, suffocation, or displacement of the womb, or a

4. See Madeleine Pelner Cosman, "Machaut's Medical Musical World," in *Machaut's World: Science and Art in the Fourteenth Century*, eds. Madeleine Pelner Cosman and Bruce Chandler (1978), 1–36; and John Scarborough, "Botany, Pharmacy, and the Culinary Arts" (1987).

5. See Jackie Pigeaud, *La maladie de l'âme: Étude sur la relation de l'âme et du corps dans la tradition médico-philosophique antique* (1981).

6. For lengthy and detailed descriptions of these symptoms, see Gideon Harvey, *Morbus Anglicus: or The anatomy of consumptions* (1674), 18–20; Edward Jorden, *A Briefe Discourse of*

combination of these factors, depending on the authority one followed.

Interest in the history of hysteria has undergone an international renaissance among scholars in many disciplines.[7] The historical picture is complicated by the fact that both the popular perception of hysteria and its medical definition have changed over time in response to continually evolving social conditions and perceptions of women. The origin of the view of hysteria as a uterine disorder has been traced to the ancient Egyptians, whose belief in the unstable womb as a source of illness in women was perpetuated by Greek and Roman authorities. Early Christian theorists melded the ancient wandering womb syndrome with belief in the supernatural intervention of saints and demons, an approach that was generally disavowed by secularized medicine during the Renaissance. Seventeenth- and early eighteenth-century theorists initiated the shift from gynocentric to neurocentric models of hysteria by implicating both the brain and the uterus in the disease. Not until the investigations of Freud in the nineteenth century was hysteria viewed as a purely psychiatric disorder that could afflict both sexes.[8] Thus, a 1970 dictionary described hysteria as "a condition variously characterized by emotional excitability, excessive anxiety, sensory and motor disturbances, and the simulation of organic disorders," a purely psychiatric definition that betrays nothing of the word's uterine origin. The same dictionary, however, unwittingly retained an allusion to the term's ancient association, defining *hysterical* as "emotionally uncontrolled and wild," a state of mind linked to women by the ancients "because women seemed to be hysterical more than men."[9]

Even the origin of the word *hysteria* is a subject of debate. Though the term is obviously derived from the Greek word for uterus (*hystera*), the traditional belief that it was first used in Hip-

a *Disease Called the Suffocation of the Mother* (1603), 15–16; Thomas Sydenham, "Of the Epidemick Diseases from the Year 1675 to the Year 1680," in *The whole Works of that excellent practical physician, Dr. Thomas Sydenham* (1729), 202–5.

7. See the comprehensive historiographical essay by Mark S. Micale, "Hysteria and Its Historiography: A Review of Past and Present Writings," (1989).

8. Nineteenth-century surveys of hysteria include Glafira Abricossoff, *L'hystérie aux XVIIᵉ et XVIIIᵉ siècles* (1897); Gaston Amselle, *Conception de l'hystérie* (1907); and Henri Cesbron, *Histoire critique de l'hystérie* (1909). Modern survey studies include Sander L. Gilman et al., *Hysteria beyond Freud* (1993); Ilza Veith, *Hysteria: The History of a Disease* (1965); Étienne Trillat, *Histoire de l'hystérie* (1986); and George Randolf Wesley, *A History of Hysteria* (1979).

9. *Webster's New Twentieth-Century Dictionary* (1970), s.v. "hysteria."

pocratic treatises dating from the fifth century B.C. is now questioned.[10] The use of the noun *hysteria*, designating a specific group of symptoms afflicting women, is thought to have made its first appearance in the sixteenth century. Nonetheless, the word *hysterikos* (or in Latin *hysterica*), meaning "of the womb," is ubiquitous in texts devoted to uterine disorders dating from the Renaissance onward. Uterine suffocation (*suffocatione uteri*), uterine strangulation (*uteri strangulatu*), uterine fits (*furor uterinus*), hysterical passion (*passione hysterica*), green sickness (*chlorosis*), vapors, and many other terms were applied to the set of symptoms and associations that connoted a disordered womb. For simplicity's sake, and so as not to complicate needlessly my discussion of the works of art that form the core of this study, I use the word *hysteria* in a manner that is consistent with the context of the time in which it appears, emphasizing those symptoms and cures that eventually became part of the medical tradition of the seventeenth century, the period of the lovesick maiden pictures. The pre-Freudian type of uterine hysteria I refer to as *furor uterinus* or *hysterico passio*, descriptive terms broad enough to include all the organic disorders of the uterus mentioned by early physicians—suffocation, strangulation, dislocation—while avoiding confusion with the more familiar psychological syndrome.

Ancient Gynecological Theories

From the beginning of recorded history, women have been perceived as dominated by their wombs. In fact, the earliest extant medical treatises on any topic, two Egyptian papyruses dating from the second millennium B.C., describe the "wandering womb" syndrome, in which the uterus supposedly roams throughout the body violently compressing vital organs.[11] The Kahun Papyrus (ca. 2000 B.C.) ascribes nearly all pain experienced by women to the womb, claiming, "When [a woman's] eyes ache, it is the 'fall of the womb in her eyes.' Likewise, if a woman's feet

10. See Helen King, "Once Upon a Text: Hysteria from Hippocrates" (1993).

11. Veith, *Hysteria*, 3–7, 307. See also Henry Ernest Sigerist, *A History of Medicine*, vol. 1, *Primitive and Archaic Medicine* (1951). For a translation of the Ebers Papyrus, see Bendix Ebbell, trans., *The Papyrus Ebers, the Greatest Egyptian Medical Document* (1937). For discussion of the gynecological content of Egyptian papyruses, see James V. Ricci, *The Genealogy of Gynaecology: History of the Development of Gynaecology throughout the Ages, 2000 B.C.–1800 A.D.* (1950), 12–16.

hurt, the pain is caused by the 'falling of the womb.' "[12] A later Egyptian work, the Ebers Papyrus (ca. 1550 B.C.), recommends cures designed to lure the uterus back into the abdomen as if it were an independent living organism. This was to be accomplished by fumigating the vagina with sweet-smelling vapors to attract the womb back to its proper place or, conversely, inhaling foul-smelling substances—fumes of wax or hot coals—to repel the organ and drive it from the upper parts of the body.[13] In addition to being totally autonomous and mobile, the womb was believed to require nourishment; many of the symptoms suffered by women—depression, hallucinations, pain in various parts of the body—were ascribed to "starvation" of the organ. Accordingly, Egyptian physicians would fumigate the vagina with "dry excrement of men" in an effort to gratify the womb's "appetite" for sex.[14] Unlike later Christian physicians, the ancient Egyptians did not invoke prayers and incantations in the treatment of the wandering womb. Rather, they perceived the condition as an organic ailment and treated it with what they considered rational means based on their "observations" of the migratory nature of the uterus.

The Egyptian belief in the wandering womb was perpetuated by the Greek Hippocratic writers, whose medical works form a corpus that dates from the late fifth or early fourth century B.C. Several of these books—*On the Diseases of Women*, *On Diseases of Young Girls*, and the *Aphorisms*—contain gynecological material.[15] Although the treatises present some inconsistencies, they contain several persistent motifs, such as humoral theory, that would recur throughout the centuries to come. Within the Hippocratic system women were considered phlegmatic, their bodies dominated by water. Because the natural condition of a woman's body was

12. Ricci, *Genealogy of Gynaecology*, 12–13.

13. Ibid., 16.

14. See Ebbell, *Papyrus Ebers*.

15. Hippocrates, *Des maladies des femmes*, in *Oeuvres complètes d'Hippocrate*, trans. Émile Littré, vol. 8 (1851), bk. 1, par. 7, 32; ibid., bk. 101, pars. 123–27. See also Marie-Paule Duminil, "La mélancolie amoureuse dans l'Antiquité" (1985), 91–110. The relationship between the Hippocratic notion and that of the ancient Egyptians is a point of contention among historians of science who disagree as to whether Hippocrates had recourse to actual Egyptian sources or arrived at the wandering womb theory independently. See the commentary and translation by Ann Ellis Hanson, "Hippocrates: 'Diseases of Women' I" (1975); Monica H. Green, "The Transmission of Ancient Theories of Female Physiology and Disease through the Early Middle Ages" (1985), 13–22; and King, "Once Upon a Text," 4–5.

wet, lack of moisture upset the balance of humors, adversely affecting the uterus.[16]

Hippocratic writers noted that the disease seemed to occur primarily in older women who, as widows or spinsters, were deprived of sexual intercourse. They concluded that "if women have intercourse, they are more healthy; if they don't they are less healthy. This is because the womb becomes moist in intercourse and not dry: when a womb is drier than it should be, it often suffers violent dislocation."[17] In its search for nourishment and moisture, physicians believed, the womb wandered lightly and unimpeded, crowding and compressing the other organs. The resulting symptoms varied depending on the position of the womb within the body. Pressure on the lungs, for example, impeded the flow of air, causing difficulty in breathing and choking. If the womb nudged the heart, nausea and anxiety resulted. Should the uterus become lodged in the head, the result was pain, drowsiness, and lethargy. Other symptoms ascribed to the wayward womb included fainting, swollen feet, lower back pain, grinding of the teeth, perverted appetite, and difficulty sleeping.[18] Hippocratic theorists maintained that the womb was better served by wandering to the liver or the lungs, where it could gather moisture from these naturally wet organs and then comfortably retreat to the abdomen.[19] If, however, the uterus remained lodged where it did not belong for as much as six months, death was inevitable.[20] Hippocratic cures, like those attempted by the Egyptians, were based on the erroneous supposition that an unobstructed channel within the body connected the womb to the head. Since the uterus was an independent entity, remedies for driving it back to the nether regions by placing unpleasant smelling substances to the nose, or luring it back to the abdomen by applying fragrant douches or fumigations to the vagina, were effective only temporarily. Hippocratic texts strongly recommended marriage as the best cure for single women and condemned virginity as unnatural and dangerous.[21]

The Greek belief in the wayward nature of the uterus comple-

16. Hippocrates, *Maladies*, vol. 8, bk. 1, pars. 7, 32; bk. 101, pars. 123–27.
17. Ibid., bk. 1, pars. 7, 73–75. See also Hanson, "Hippocrates," 583.
18. Hanson, "Hippocrates," 573.
19. Ibid., 576.
20. Ibid., 574.
21. Hippocrates, *Maladies*, vol. 8, bk. 1, pars. 73–75.

mented the ancient view of the female sex in general. The place of women in the homocentric society of ancient Greece is nowhere better stated than in Plato's *Timaeus*, written in the mid-fourth century B.C. At the end of this comprehensive treatise dedicated to the description of the universe, Plato, as if in an afterthought, makes "a brief mention . . . of other animals" and, incidentally, women. Included among the lower creatures of the earth is the "womb or matrix of women," which he calls "the animal within them." This beast so longs to create children that, "when remaining unfruitful long beyond its proper time, [it] gets discontented and angry, and wandering in every direction through the body, closes up the passages of the breath, and, by obstructing respiration, drives them [women] to extremity, causing all varieties of disease."[22] The impossibility of the uterus's making an unimpeded voyage throughout the body seems not to have occurred either to Plato or to the Hippocratic writers, whose inaccurate observations of female anatomy were adopted by succeeding generations of Roman physicians.

The Hippocratic tradition survived in the writings of the Roman Aulus Cornelius Celsus (fl. A.D. 20–30), whose work is the first systematic treatise on medicine known to us. Celsus was not a practicing physician but a knowledgeable layman whose writings were intended for the educated Roman public. His chapter "On Diseases of the Womb" follows the Hippocratic format, describing uterine suffocation as "a malignant disease" which, "returning frequently to some females at last becomes habitual."[23] Celsus recommended the traditional therapeutic method for luring and repelling the womb by smell, and observed that his patients tended to void copious amounts of limpid urine. He also advocated exercise and bloodletting, remedies that would become universal in later centuries. The works of Celsus did not influence the course of Roman medicine; they were, however, rediscovered during the Renaissance, and were widely read and admired by professional physicians for their medical content.[24]

A more extensive discussion of female complaints occurs in the writings of Aretaeus of Cappadocia (ca. A.D. 81–138), known in

22. Plato, *Timaeus* (1949), 74. See also D. F. Krell, "Female Parts in *Timaeus*" (1975).

23. *Aul. Cor. Celsus on Medicine, in Eight Books*, vol. 1 (1831), chap. 4, 20, 307. See also Heinrich von Staden, "'Apud nos foediora verba': Celsus' Reluctant Construction of the Female Body" (1991).

24. Thomas Clifford Albutt, *Greek Medicine in Rome* (1921), 202.

historical hindsight as the "Latin Hippocrates."[25] Aretaeus, who considered the contrary womb to be "like an animal within an animal," included "hysterical suffocation" among the chronic diseases of humankind. His colorful description of the uterus resembles that of Plato: "In the middle of the flanks of women lies the womb, a female viscus, closely resembling an animal; for it is moved of itself hither and thither in the flanks, also upwards . . . and also obliquely to the right or to the left; it is likewise subject to prolapse downwards."[26] According to Aretaeus, the uterus was "altogether erratic" during its wanderings, capable of violently compressing other organs and even causing death. Although his description of the wandering womb is traditional, Aretaeus made some startling new observations. He noticed, for example, that "the affection occurs in young women, but not in old," thereby directly contradicting the Hippocratic assertion that widows and elderly virgins were more susceptible.[27] Aretaeus also observed that the symptoms of hysteria could affect men, and concluded that there was a form of the disease unconnected with the uterus. The inclusion of young women among the victims of uterine furies became an established fact of gynecological theory for the next two thousand years, though Aretaeus' assertion that men could also be "hysteric" was thrust into oblivion for several centuries.

Not all Roman theorists accepted the wandering womb theory. The *Gynecology*, written by Soranus of Ephesus (fl. A.D. 98–138), was an important early treatise that denied the possibility of uterine migration. Possessed of a thoroughly independent turn of mind, Soranus rejected the Hippocratic theory of the four humors and denied the supposition that the uterus was capable of movement. He argued that "the uterus does not issue forth like a wild animal from the lair, delighted by fragrant odors and fleeing bad odors, rather it is drawn together because of stricture caused by inflammation."[28] Also contrary to Hippocratic tradition, Soranus believed that prolonged virginity was actually beneficial to women, who, as a result, were spared the dangers of childbirth.[29] Future generations of medical theorists ignored Soranus' concept of a stationary womb. This is all the more remarkable because the

25. Veith, *Hysteria*, 21–22.
26. *The Extant Works of Aretaeus, the Cappadocian* (1856), bk. 1, chaps. 5 and 6.
27. Ibid., bk. 2, chap. 11.
28. Soranus of Ephesus, *"On Acute Diseases" and "On Chronic Diseases"* (1950), 887.
29. [Soranus of Ephesus], *Soranus' "Gynecology"* (1956), 40–41. See also the discussion of Soranus' gynecological theories in Green, "Transmission of Ancient Theories," 23–32.

same observation was also made by Galen of Pergamon (ca. A.D.
130–ca. 210), whose writings formed the foundation of medieval
and Renaissance medicine.

Galen adhered to many Hippocratic beliefs, synthesizing and
modifying them according to his own vision. He believed in the
existence of both male and female semen, and maintained that re-
tention, or "repression," of this substance led to corruption of the
blood and cooling of the body in both sexes. He reasoned that the
symptoms of hysteria were caused by "repressed semen" and ag-
gravated by sexual abstinence. Galen recognized that hysteria oc-
curred particularly among widows, and above all in those who
had been fertile and receptive to the advances of their husbands.
Like Soranus, however, he denied the theory of uterine migration,
concluding that "we must consider as totally preposterous the
opinion of those who, by means of this reasoning, make the
womb into an animal."[30] Despite Galen's fervent denial of uterine
mobility, he continued to perpetuate the standard Hippocratic
odor therapy whereby the womb was attracted or repelled accord-
ing to its own sensory whims.[31] The advances of Galen and Sora-
nus in the area of female anatomy were largely forgotten in the
Christian era.

Medieval Gynecological Theories

Monica Green, in her careful examination of the history of early
gynecology, convincingly demonstrated that medieval gyneco-
logical theory derived predominantly from three ancient au-
thors—Hippocrates, Galen, and Soranus.[32] After the fall of Rome,
the basis of medical theory, like the Empire itself, was split geo-
graphically. In the East, Soranus' theories were eclipsed by those
of Galen when the ancient traditions became absorbed into Islamic
medicine. Western theorists by contrast tended to neglect Galen in
favor of Soranus, though several Greek texts were translated into
Latin and became available to monastic houses. Hippocrates had
little direct influence in either the East or the West, though his the-
ories showed up frequently as a result of Galen's acceptance of the

30. Galen of Pergamon, *On the Natural Faculties* (1916), 44.

31. Galen of Pergamon, *De compositione medicamentorum secundum locus*, bk. 9, chap. 10,
ed. and trans. Karl Gottlob Kuhn, in *Claudii Galeni opera omnia*, 20 vols. (1821–22), 13:320.

32. Green, "Transmission of Ancient Theories," cites the influential Hippocratic works
On the Diseases of Women (De morbis mulierum), *Diseases of Young Girls*, and *Aphorisms*. See
also King, "Once Upon a Text," 1–25.

Hippocratic tradition.[33] Until the eleventh century, then, medieval gynecological theory was based entirely on ancient Greek and Roman medical precepts.[34]

Eastern and Western gynecological traditions converged in the southern Italian town of Monte Cassino in the eleventh century, where a drug merchant named Constantinus Africanus had brought several Arabic medical treatises from North Africa. They effectively transformed gynecological theory, for what had before been two separate medieval traditions were now fused into something new as Galenic and Hippocratic theory became synthesized with Arabic medicine.[35] This phenomenon marks the first sustained effort to create new medical texts and traditions rather than collect and comment on the old ones. Subsequently the medical school at Salerno adopted a gynecology based on Galenized Arabic theory, spiced with a sprinkling of Hippocrates and blended into a Christian matrix. The theories of Soranus that had survived in fragmentary form owing to monastic copiers were largely ignored.

Medieval gynecology was first and foremost a sphere of the male medical establishment, which by this time was inexorably linked with Christian monastic society. It is not surprising, then, that the misogynist elements of ancient medicine found eager acceptance in this monkish milieu.[36] The early church's persistent distrust of the female children of Eve may help to explain why

33. Hippocratic works were translated into Latin as early as the seventh century, and many medieval manuscripts contained excerpts from the corpus. The name Hippocrates, however, would not regain its former luster until the corpus was translated from the original Greek in the sixteenth century. See Green, "Transmission of Ancient Theories," 316; George Walter, " 'Peri Gynaikeion A' of the Corpus Hippocraticum in a Mediaeval Translation" (1935); and King, "Once Upon a Text," 35–64.

34. The ancients lived on in medical encyclopedias such as Oribasius' (326–403) *Iatrikae synagogai* and Paul of Aegina's (610–41) *De re medica*. See Green, "Transmission of Ancient Theories," 77–80.

35. See Mary Frances Wack, *Lovesickness in the Middle Ages: The "Viaticum" and Its Commentaries* (1990), for a scholarly discussion of Constantinus Africanus, a translation of the *Viaticum*, and an examination of its various commentaries. See also Karl Sudhoff, "Salerno, Montpellier und Paris um 1200" (1928).

36. The literature on the philosophical, religious, and medical justifications for medieval misogyny is vast. Among the works most relevant to this study are Marie-Thérèse D'Alverny, "Comment les théologiens et les philosophes voient la femme" (1977); Marylin B. Arthur, "Early Greece: The Origins of the Western Attitude toward Women" (1973); Vern L. Bullough, "Medieval Medical and Scientific Views of Women" (1973); Vern L. Bullough, Brenda Shelton, and Sarah Slavin, *The Subordinated Sex: A History of Attitudes toward Women* (1988); Danielle Jacquart and Claude Thomasset, *Sexuality and Medicine in the Middle Ages* (1988), 173–77; Aline Rousselle, *Porneia: De la maîtrise du corps à la privation sensorielle, IIᵉ–IVᵉ siècles de l'ère chrétienne* (1983); and Monica H. Green, "Constantinus Africanus and the Conflict between Religion and Science" (1990).

Galen's denial of uterine mobility seems to have been dismissed by medieval physicians in spite of his preeminence in all other aspects of medicine. Instead, gynecological theory championed Hippocratic ideas that tended to reinforce the debasement of unmarried women by reference to their unstable wombs.[37] Such selective theorizing allowed medieval medicine to combine belief in the uterine origin of hysteria with elements of Christian morality and mysticism. Hippocrates was not translated into Arabic, and his influence was felt mainly by means of secondary references in Galen. Nonetheless, the Hippocratic belief in the wandering womb and the dangers of sexual abstinence became hallmarks of medieval gynecological theory.

Under Christianity the popular image of the victim of *furor uterinus* changed from a woman beset by organic physical illness to one plagued by demons and at the mercy of supernatural forces.[38] The ancient medical texts on which medieval medicine was based make no mention of the role of demons and saints in women's illnesses. The existence of Satan, however, lies at the very core of Christianity. Medieval spinsters and maidens who accepted the teachings of the Catholic church believed that the troublesome uterus could be tamed by exorcism, consisting of prayer and physical chastisement. A tenth-century Latin document designed for the purpose clearly illustrates this popular Christian belief. The dedication reads: "To the pain in the womb. . . . O womb, womb, womb, cylindrical womb, red womb, white womb, fleshy womb, bleeding womb, large womb, neufredic womb, bloated womb, O demoniacal one!" The invocation firmly melds the image of the wandering uterus with the concept of demonic possession:

> In the name of God the Father, God the Son and God the Holy
> Spirit. . . . O Lord Zebaoth, look at our infirmity, at our weak-

37. Veith, *Hysteria*, 96. See also Thomas Francis Graham, *Medieval Minds: Mental Health in the Middle Ages* (1967).

38. Demonic possession and its relation to female hysteria is a subject of debate among historians. See Jean Céard, "The Devil and Lovesickness: Views of Sixteenth-Century Physicians and Demonologists" (1993); Stuart Clark, "The Rational Witchfinder: Conscience, Demonological Naturalism, and Popular Superstitions" (1991); Nicholas P. Spanos and Jack Gottlieb, "Demonic Possession, Mesmerism, and Hysteria: A Social-Psychological Perspective on Their Historical Interrelations" (1979); Gilbert H. Glaser, "Epilepsy, Hysteria, and 'Possession': A Historical Essay" (1978); and Mary Frances Wack, "From Mental Faculties to Magical Philters: The Entry of Magic into Academic Medical Writing on Lovesickness, Thirteenth–Seventeenth Centuries" (1993).

ness, direct Thy attention toward the form of our nature and do not despise us, the work of Thy hands. . . . Stop the womb of Thy maid N. and heal its affliction, for it is moving violently.

I conjure thee, O womb, in the name of the Holy Trinity, to come back to the place from which thou shouldst neither move nor turn away, without further molestation, and to return, without anger, to the place where the Lord has put thee originally. I conjure thee, O womb, by the nine choirs of angels and by all the virtues of heaven to return to thy place with every possible gentleness and calm, and not to move or to inflict any molestation on that servant of God, N. . . .

I conjure thee, O womb, by our Lord Jesus Christ . . . who expelled demons . . . not to occupy her head, throat, neck, chest, ears, teeth, eyes, nostrils, shoulderblades, arms, hands, heart, stomach, spleen, kidneys, back, sides, joints, navel, intestines, bladder, thighs, shins, heels, nails, but to lie down quietly in the place which God chose for thee, so that this maid of God N. be restored to health.[39]

The Catholic respect for celibacy and virginity presented a medical dilemma regarding *furor uterinus*. The church considered virginity a blessing, not a liability, and prized chastity in women above all other virtues. The ancient view of sex as a natural bodily function unrelated to social stigma or religious morality was in direct opposition to the Christian mandate. Thus, the prized state of virginity could not be viewed negatively, nor could sexual intercourse be permitted as a curative measure, for the church sanctioned the act only as a means of procreation. Sexual pleasure was considered sinful even in marriage, and erotic urges were believed to be instigated by demons and unholy spirits. Basic to Christianity was the belief that the biological inferiority of women made them dangerous to men.[40]

What could a woman do if chants and exhortations failed to budge the troublesome womb? Such cases demanded the practical knowledge of the ancients, which could be found in the gynecological texts produced by the Salerno school. Foremost among these are the so-called Trotula treatises, which bear the incipits

39. Quoted in Gregory Zilboorg, *A History of Medical Psychology* (1941), 130–31.

40. See Helen Rodnite Lemay, "Some Thirteenth- and Fourteenth-Century Lectures on Female Sexuality" (1978); [Albertus Magnus], *Women's Secrets, A Translation of Pseudo-Albertus Magnus' "De Secretis Mulierum" with Commentaries* (1992); and, in general, Paul Diepgen, *Frau und Frauenheilkunde in der Kultur des Mittelalters* (1963).

Cum auctor and *Ut de curis*.[41] They were written in the thirteenth
century by Trota of Salerno, though the adjective form of the
name, Trotula, is more often used. The authorship of these trea-
tises is a point of debate among historians of medicine; the texts
themselves, however, claim female authorship, and the sex of the
author was accepted without question until recent times.[42] The
Trotula texts do, in fact, take a generally sympathetic tone, largely
devoid of Christian moralizing. They were the most widely cir-
culated medical works on gynecology and obstetrics from the
thirteenth through the fifteenth centuries and remained viable for
at least a century after their first printing in 1544.[43]

The Trotula texts are decidedly Galenic in content, and typically
Salernitan in their acceptance of the Hippocratic concept of the
wandering womb. Both treatises describe the syndrome, but the
less theoretical *Ut de curis* limits comment to a short passage de-
scribing the perils of celibacy: "There are certain women who do
not engage in carnal commerce, either because of a vow or because
they are bound to religion, or because they are widows. . . .
When they have the desire to have sex but do not do so, they incur
grave illness."[44] The *Ut de curis* recommends treating women with
a pessary designed to lessen pain, but ignores ancient citations in
favor of local Salernitan authors. The more theoretical *Cum auctor*,
by contrast, includes citations to many ancient authors and de-
votes much more lengthy comment to the condition of uterine
suffocation. Echoing Galen, the *Cum auctor* names a "superabun-
dance of spoiled seed" as a primary cause of uterine fits. It notes
that "especially does this happen to those who have no husbands,
widows in particular and those who previously have been accus-
tomed to make use of carnal intercourse. It also happens in virgins
who have come to marriageable years and have not yet husbands
for in them abounds the seed which nature wished to draw out by
means of the male."[45]

41. These two treatises are often referred to as "Trotula Major" and "Trotula Minor." A
third text, *De ornatu*, also attributed to Trotula, is mainly cosmetic in substance. See the
analysis of the two specialized gynecological treatises in Green, "Transmission of Ancient
Theories," 252–314.

42. See H. P. Bayon, "Trotula and the Ladies of Salerno: A Contribution to the Knowl-
edge of the Transition between Ancient and Mediaeval Physic" (1940); John F. Benton,
"Trotula, Women's Problems, and the Professionalization of Medicine in the Middle Ages"
(1985); and Moshe Stuard, "Dame Trot" (1975).

43. See M.-R. Hallaert, ed., *The "Sekenesse of wymmen": A Middle English Treatise on
Diseases of Women* (1982), 20.

44. Paris, Bibliothèque National MS. lat. 7056, fol. 8v., 29, quoted in Green, "Trans-
mission of Ancient Theories," 276.

45. Trotula of Salerno, *Passionibus mulierum curandorum* (1940), 10–11.

Furor Uterinus *in Medieval Art*

The earliest ancestor of the seventeenth-century Dutch love-sick maiden pictures dates from the time of the Trotula treatises. Ashmole 399, a late thirteenth-century manuscript housed in the Bodleian Library, contains four pages of illustrations unaccompanied by text on both sides of folios 33 and 34 (figs. 2–5).[46] Each page contains two miniatures, constituting eight distinct yet related scenes that make up an illustrated narrative. The miniatures themselves are very freely drawn and beautifully colored in light blue and rose pen wash. They are bound among several other texts and illustrations of an obstetrical and gynecological nature. Women are prominently represented in each scene. The subject is therefore assumed to be gynecological, though the folios are inserted not where they would logically belong, among the pages of the *Cum auctor*, which appears in folios 21 through 26, but in a treatise titled *De stomacho*.[47] In fact, Ashmole 399 is a compilation of vaguely related material that may have been bound and rebound many times over the course of seven centuries. The appearance of a group of gynecological illustrations within a text

46. Oxford, Bodleian Library MS. 399, Eng. 1292, fols. 33–34v. The manuscript is dated ca. 1292, but the eight miniatures in question may well have been added in the fourteenth century. See Andrew G. Watson, *Catalogue of Dated and Datable Manuscripts c. 435–1600 in Oxford Libraries* (1984); Otto Pächt and J. J. G. Alexander, *Illuminated Manuscripts in the Bodleian Library* (1972); Lucy Freeman Sandler, *Gothic Manuscripts, 1285–1385* (1986).

47. The major scholarly studies of Ashmole 399 are Loren MacKinney, *Medical Illustrations in Medieval Manuscripts* (1965); MacKinney and Harry Bober, "A Thirteenth-Century Medical Case History in Miniatures" (1960); MacKinney and Bober, "La prima autopsia" (1984); Charles Singer, "Thirteenth-Century Miniatures Illustrating Medical Practice" (1915–16); Karl Sudhoff, "Weitere Beitrage zur Geschichte der Anatomie im Mittelalter, 2" (1914); and Charles H. Talbot, *Medicine in Medieval England* (1967), 81–82. These authorities disagree not only about subject matter but also about the original organization and authorship of the miniatures in Ashmole 399. The art historian Harry Bober believed that the verso of folio 34 (see fig. 5) is in a different hand than the others, an opinion borne out by differences in the style and character of the drawings. Although they may have been added later, the last two miniatures (or perhaps the last four) fit well with the narrative illustrated in the previous scenes. Charles Singer did not label the illustrations but believed that folio 34, depicting the death, autopsy, "consultation," and departing physician, was originally intended to precede folio 33. In light of the probability that these miniatures were added to an already existing group of six, it is logical to accept MacKinney's rather than Singer's order, beginning with folio 33 and ending with folio 34 verso. MacKinney saw the eight illustrations as a whole, culminating in a moral exhortation for women to follow the advice of their doctors, but did not interpret them in light of gynecological tradition. Singer did not connect the miniatures as a narrative group but came closer than MacKinney to giving them a proper gynecological context. Talbot suggested that the illustrations relate directly to the condition of uterine suffocation described and defined by the Trotulan text which appears elsewhere in the manuscript.

dealing with the stomach should not be cause for discounting the obvious.[48]

The opening scene at the top of folio 33 (fig. 2) depicts a woman who has fallen on the ground in a faint, her eyes rolling upward and her arms falling limp at her sides. Two alarmed female attendants support her head, while a little dog lies curled at her feet. To the right are a physician, dressed in the academic cowled robe and cap befitting his station, and another figure who appears to be tonsured and who is probably a cleric. Both gesture toward the fainting woman. In this, as in three other scenes, a blank scroll unfurls from the doctor's hand. These scrolls were intended to contain words and captions related to the miniatures, which were left unfinished. Historians accept the scene as a depiction of a seriously ill woman under the care of a physician.[49] In fact, several aspects of the illustration allude specifically to *furor uterinus* as the condition from which the woman suffers. According to every medical authority, fainting was one of the common symptoms of uterine suffocation or dislocation. Trotula maintained that "sometimes the womb is choked; sometimes it is lifted upwards. . . . Sometimes women faint."[50] The artist suggests that the woman's womb has wandered upward by depicting her head as greatly enlarged in comparison not only with her body but also with the more natural proportions of the other figures in the scene. Furthermore, the physician clearly points with one hand to his patient's head, possibly indicating the resting place of her errant womb. The pathetic little dog curled up at the woman's feet, its tail between its legs and its tongue hanging out, seems to be suffering in sympathy with its mistress. The historian Charles Singer suggests that the animal has been killed

48. Other tracts contained in Ashmole 399 include several prescriptions for gynecological conditions dispersed throughout. The most recent identification of the substance of the manuscript is:

 13v: schematic diagram of female genitalia
 14ra–15ra: ten fetus in utero figures from Muscio, *Gynaecia*
 15rb–16rb: Constantinus Africanus, *De genitalibus membris*
 18r–21r: Constantinus Africanus, *De coitu*
 21r–26r: Trotula, *Cum auctor*
 26r–27r: Anon., *De spermate*
 27r–31v: Richardus Anglicus, *De anathomia*

For discussion of a similar loosely combined medical text containing gynecological material interspersed with herbal, physiognomic, and astrological treatises, see Hallaert, *Sekenesse of wymmen*, 19.

49. MacKinney and Bober, "A Thirteenth-Century Medical Case," 252.

50. Trotula, *Diseases of Women*, 10.

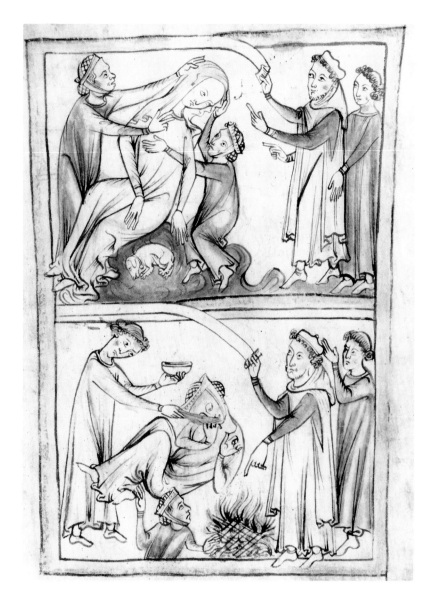

Fig. 2 MS. Ashmole 399, fol. 33r., late 13th c. Bodleian Library, Oxford.

to provide medicine for the woman.[51] But the dog wears a collar, which identifies it as a pet rather than a sacrificial victim. The convention of the beloved pet dog mimicking the moods of its mistress also occurs in later Dutch seventeenth-century genre paintings (see fig. 76). Perhaps it serves a similar function in this scene.

The miniature at the bottom of the page corresponds distinctly to Trotula's description of uterine seizures and to the therapeutic meaure of repelling and attracting the womb by means of smell. It

51. Singer, "Thirteenth-Century Miniatures," 32.

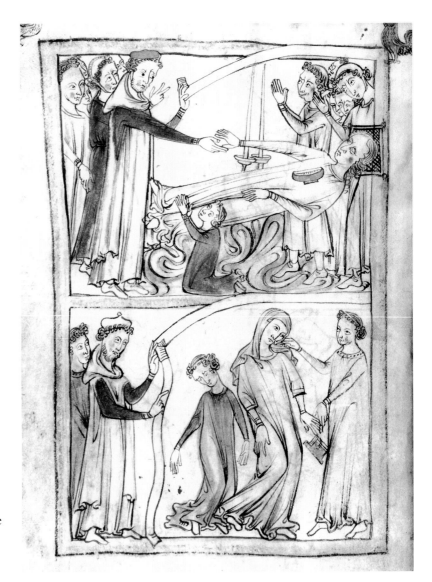

Fig. 3 MS. Ashmole 399, fol. 33v., late 13th c. Bodleian Library, Oxford.

depicts an attempt to revive the ailing woman, who now lies collapsed on the ground, completely unconscious. One of the two female companions holds a shallow dish with one hand and with the other applies what appears to be a feather to the woman's nose. The physician stands to the right, accompanied by his clerical attendant, and points to a glowing fire on the ground before him. The contorted pose of the suffering woman, her legs drawn up to her chest and her arms contracted inward, recalls Trotula's description of the symptoms of uterine suffocation: "Sometimes the woman is convulsed, her head is brought to her knees, she lacks sight and cannot speak; her nose is twisted, her lips are compressed, she grits

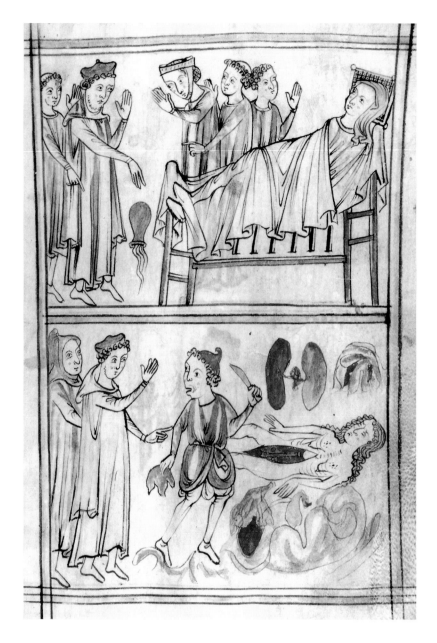

Fig. 4 MS. Ashmole 399, fol. 34r., late 13th c. Bodleian Library, Oxford.

her teeth."[52] Another Salernitan gynecological manuscript describes similar contortions: "The suffocacyon makyth the matryce [womb] to arise . . . and makyth her to swonne [swoon] and makyth her also to courbe [curve] togedyr her hed and har kneys."[53] Historians of medicine see the feather placed to the nose of the vic-

52. Trotula, *Diseases of Women*, 10–11.
53. Singer, "Thirteenth-Century Miniatures," 36, quoting a paraphrase of Isaac Judeus, an author translated by Constantinus Africanus, contained in MS. Douce 37, Western

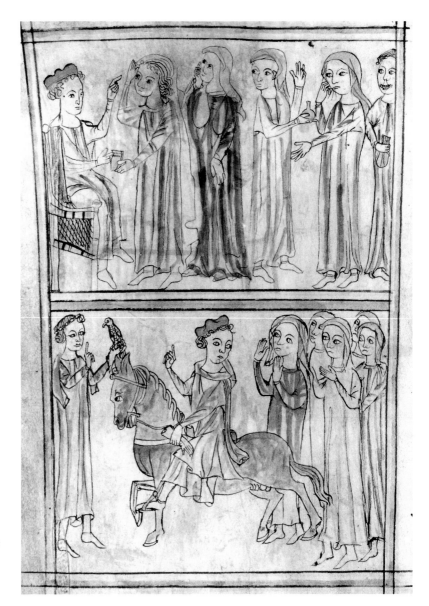

Fig. 5 MS. Ashmole 399, fol. 34v., late 13th c. Bodleian Library, Oxford.

tim as a method of reviving her, and suggest that it has been dipped in an inhalant of oil, water, or vinegar.[54] The feather, however, refers even more specifically to the traditional method of repelling the errant womb by smell. Singer quotes a direct reference to the use of a feather in cases of uterine suffocation: "Tak a fethyr & wet hit in hott water and wete well her face ther with and makyth hote

21,611, fols. 20 recto and verso, fifteenth century. See Monica H. Green, "Obstetrical and Gynecological Texts in Middle English" (1992).

54. Singer, "Thirteenth-Century Miniatures," 34. See also Sudhoff, "Weitere Beitrage," 373.

your hondys [hands] and . . . meve [move] ofte her chynne and
putte to har nosse thyngys of strong savor. . . . At her wyket
[wickett: the vulva] lete har tak a fumygacyon of good savour."[55]
Likewise, Trotula recommended applying "remedies which have a
heavy odor," such as "burnt wool" and "burnt linen cloth" to the
nose in order to drive the uterus from the upper body.[56] A later
Middle English treatise reinforces Trotula's advice, suggesting not
only that stinking substances be held to a victim's nose, but also
that she "hang her head over smoke" when in the throes of a fit.[57]
The effectiveness of this measure was justified by Aretaeus, who
maintained that the womb "retreats inwardly if the uterus be made
to smell a foetid fumigation, and the woman also attracts it in if she
herself smells fragrant odours."[58] Even Soranus, who rejected the
concept of the wandering womb, noted that smoldering sub-
stances were the most effective in curing uterine disorders, and
listed burnt hair, extinguished candles, wool, skins, rags, and
squashed bedbugs as substances that emitted especially repellent
odors when set on fire.[59] The practice of employing fetid, smoky
smells to revive a woman who has fainted became standard medi-
cal practice for the next thousand years. Until the late seventeenth
century it was justified by the ancient belief that the uterus was an
independent animal with a distinct abhorrence of certain smells.
As late as 1895, long after the stationary uterus had become a mat-
ter of anatomical knowledge, medical handbooks still suggested
that strong-smelling herbs, called antihystericals, be employed to
revive women who had swooned.[60]

The top miniature of folio 33 verso (fig. 3) continues the saga of
uterine woes. Historians disagree as to whether the woman is sup-
posed to be seriously ill or dead, for details of the composition
support both suppositions.[61] Two crowing roosters perched at the
upper margin of the page set the time as the morning of the next
day.[62] The woman who only yesterday was alive and functioning
lies immobile on a bier, her eyes sunk deep into her head. Two fu-

55. Singer, "Thirteenth-Century Miniatures," 36.

56. Trotula, *Diseases of Women*, 33.

57. Hallaert, *Sekenesse of wymmen*, 53.

58. Aretaeus, *Extant Works*, 68.

59. Soranus, *Gynecology*, 152.

60. Adolf von Strümpell, *A Text-Book of Medicine for Students and Practitioners* (1895), 813. The Strümpell manual was reprinted several times in the early years of the twentieth century.

61. MacKinney and Bober, "A Thirteenth-Century Medical Case," 252; Singer, "Thirteenth-Century Miniatures," 32.

62. I am indebted to Charles Klaus for this observation.

neral candles have been placed beside her, and what appears to be a
bowl or vessel rests on her chest. Several mourners cluster at her
head, and a child kneels at her feet. They raise their arms implor-
ingly toward the physician, who approaches with several atten-
dants and takes the hand of the supine woman in his. Ordinarily
this scene might logically be interpreted as a sad end to the story
begun on the other side of the page. But in fact the tale is not yet
over. Several treatises describe a deathlike swoon that could come
over women in the throes of a "fit."[63] Trotula claimed that "the
pulse seems to vanish if it is not felt for deeply."[64] Another Salerno
source asserted that "when the breth may not come in ne out the
body ys as dede as that ys cause that somen othershyll [sometimes]
by [be] asyounyng [swooning] as they were dede. . . . And the
suffocacyon makyth the matryce [womb] to arise to the hert & har
pulse ys styll."[65] The association of a condition mimicking death
in cases of *furor uterinus* comes from ancient medical tradition.
Galen recounted being called to the house of a female patient to
certify her death. Though the lady gave no visible signs of life,
Galen was able to ascertain that she still lived by putting smolder-
ing shards of wool to her nose, thus reviving her.[66] Perhaps the
vessel on this woman's chest serves a similar purpose. According
to medieval texts, a bowl of water could indicate, by the motion of
the water's surface, whether the victim was still breathing.[67] The
medieval physician in the miniature, like the ancient physician
Galen, knowing the ability of *furor uterinus* to simulate death,
reaches for the woman's hand in order to "feel deeply" for her
pulse.

Evidently the physician is successful in reviving his patient, for
she appears again in the miniature at the bottom of the page. Here
she is accompanied by two attendants, one of whom again holds
an object to her mistress's nose while the physician and his aide
stand to one side. Historians have read conflict into this scene, sug-
gesting that the patient, having rejected the physician's cure, is
throwing away her medicine and that the angry doctor is repri-
manding her.[68] Assumptions about emotional content in medieval

63. Trotula, *Diseases of Women*, 10. See King, "Once Upon a Text," 34, for mention of
some ancient treatises describing a deathlike state.
64. MS. Douce 37, fol. 20, quoted in Singer, "Thirteenth-Century Miniatures," 36.
65. Ricci, *Genealogy of Gynaecology*, 213.
66. Albertus Magnus, *Women's Secrets*, 132; Trotula, *Diseases of Women*, 2.
67. Talbot, *Medieval England*, 81.
68. MacKinney and Bober, "A Thirteenth-Century Case," 253.

art are dangerous, however, for facial expressions and body language were highly codified for representation and rarely conform to modern customs or psychological interpretations. The expression on the doctor's face is if anything considerably more placid than in earlier scenes. Here again the pose of the ailing woman, arms hanging limp at her sides, legs bent as if to buckle under her, is similar to the pose in the top miniature on the other side of the page (fig. 2). This would indicate that the woman is beginning to swoon once again. The object that she has dropped more closely resembles a medieval book bound between boards than a medicine flask. Presumably the woman was reading when she felt the need for another strong-smelling whiff of uterine repellent. The object placed to her nose by the female attendant may be a pin rolled in wool and steeped in aromatic substances or a small pharmacist's spatula or spoon containing some pungent material.[69] Once again, ancient Hippocratic odor therapy makes an appearance in the Middle Ages.

The climax of the gynecological narrative comes on folio 34 recto (fig. 4). The top miniature shows the woman once again in her bed accompanied by three attendants. The physician who stands at her feet has apparently dropped a urine flask, which has fallen upside down before him, its contents spilling out. Historians of medicine have interpreted this scene as illustrating the approaching death of the patient, probably because an autopsy scene shares the page at the bottom.[70] Indeed, *furor uterinus* was considered a mortal illness capable of causing death, especially if fits continued for six months or longer. The autopsy scene has elicited much comment from historians of medicine on account of its unusually realistic depiction of the internal organs. Typical anatomical illustrations of the time tended to present body parts according to stereotyped schemata, their shapes and contours regularized and formalized almost beyond recognition.[71] This was especially true of the uterus, which appears simply as a smooth flask with a narrow neck and rounded body on folio 14 of the same manuscript (fig. 6). This artist, however, evidently had firsthand knowledge of the forms and shapes of the major internal organs. He may even have attended a medical autopsy or anatomy lesson. Whatever the

69. Singer, "Thirteenth-Century Miniatures," 32.

70. Ibid., 30; see also MacKinney and Bober, "A Thirteenth-Century Case," 253.

71. See Peter Murray Jones, *Medieval Medical Miniatures* (1984), 36–55. Typical of the formulaic look of medieval anatomical illustrations is Wellcome MS. 49, fol. 36 verso.

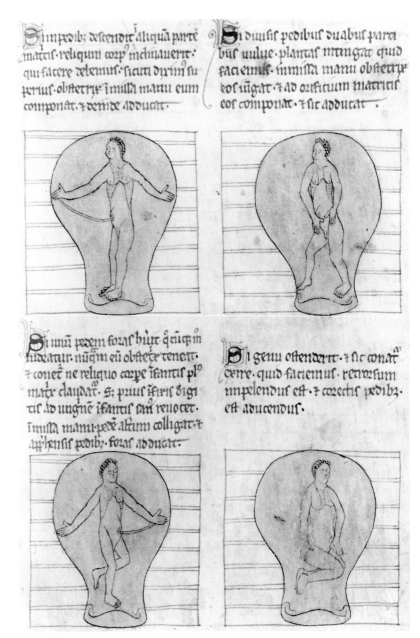

Si in pedibus descendit aliquam partem matris reliquum corporis inclinaverit qui facere debemus sicut diximus superius obstetrix inmissa manu eum componat et deinde adducat.

Si divisis pedibus duabus partibus vulve plantas tangat quid faciemus inmissa manu obstetrix eos iungat et ad orificium matricis eos componat et sic adducat.

Si unum pedem foras habuerit quicumque iudeatur nunquam eum obstetrix teneat et conetur ne reliquo corpore infantis plus matrix claudat. Sed prius infantis digitos ad unguem infantis suum revocet. inmissa manu pedem alterum colligat et applicatis pedibus foras adducat.

Si genu ostenderit et sic conatur exire quid faciemus retrorsum impellendus est et correctis pedibus est adducendus.

Fig. 6 MS. Ashmole 399, fol. 14r., late 13th c. Bodleian Library, Oxford.

reason for its startling naturalism, this miniature is usually cited as one of the earliest and most realistic illustrations of anatomical dissection.

The scene shows the physician and his clerical assistant directing the postmortem examination at some distance from the corpse. A knife-wielding subordinate has girded up his robes between his legs so as not to soil them in his dirty task. He has the coarse, slack-

jawed face of an illiterate hired hand and, by all appearances, is not of the same professional class as the university-educated physician who directs him. Authorities have noted the difference in appearance between the physician and the dissector, even assuming that the physician is threatening a "low surgeon" who has been "interrupted in his nefarious task" of cutting up a stolen corpse.[72] A more likely scenario is that the physician has simply employed a subordinate to do an autopsy so he may discover the cause of death.[73] This is the more historically plausible interpretation, as it was common practice for early physicians to leave the messy work of dissection to underlings. They would sometimes direct the operation from a raised platform, pointing to various organs as they were revealed by assistants.[74] The physician pictured here is conforming to standard medical practice in not performing a "hands-on" autopsy.

The woman's body has been cut open and most of the major internal organs removed and placed about her. They may be identified as the kidneys (appearing quite oversized) and intestines, positioned above the corpse on the picture plane, with the heart, lungs, and stomach placed below the body. The dissector holds the liver, which is lobed like the hepatica leaf, in his right hand. Historians of medicine, looking through twentieth-century eyes, have identified the smooth, elongated form still visible within the body as the spinal column, though neither pelvis nor ribs nor any other skeletal formation is visibly attached to it. The rounded object just visible between the corpse's upper ribs would then be the lower diaphragm.[75] A contemporary team of anatomists have proposed a radically different interpretation. The woman, they claim, was pregnant and had attempted an abortion by inserting a mandrake plant in her vagina. The mandrake caused the woman's death; therefore, the dissector holds not the liver but the plant, which he is showing to the physician.[76] Apart from the fact that

72. Singer, "Thirteenth-Century Miniatures," 31.

73. Sudhoff, "Weitere Beitrage," 373; MacKinney and Bober, "A Thirteenth-Century Case," 252.

74. The most famous illustration of such an autopsy is an "Anatomy Lesson" from Johannes de Ketham, *Fasciculos medicinae* (Venice, 1495). See A. Hyatt Mayor, "Artists as Anatomists" (1963–64): 201; and Charles Singer, "The Figures of the Bristol Guy de Chauliac MS. (circa 1430)" (1917): 73–74.

75. Singer, "Thirteenth-Century Miniatures," 30; MacKinney and Bober, "A Thirteenth-Century Medical Case," 252.

76. F. R. Weedon and A. P. Heusner, "A Clinical-Pathological Conference from the Middle Ages" (1960).

many medieval illustrations of mandrake plants exist, and they look nothing like the hepatica-shaped form held by the dissector, such an interpretation demonstrates how the lack of text in these miniatures inspires specialists from the historical and clinical branches of the same discipline to arrive at highly divergent conclusions.[77]

None of the scholars who have lent their expertise and experience to the analysis of this illustration have noticed a disturbing anomaly in the autopsy scene: singularly absent from the array of internal organs surrounding the corpse is the woman's uterus, the one organ peculiar to her sex, and the one that, if we are to believe the evidence of the five preceding miniatures, was the cause of the victim's sorry fate. It is therefore unlikely that the artist forgot to include the uterus in the autopsy. What is more probable is that modern anatomists have not identified the organ in the miniature because it does not correspond to what we now know to be its proper appearance and position within the body. The medieval view of the womb was derived from ancient sources, which described the uterus as shaped like a round bottle with a narrow neck, a form that reflects the characterization of woman herself as the "weaker vessel" (see fig. 6).[78] This peculiar simile resulted from the belief that the vagina and uterus of women were not separate anatomical components but combined to form a single, self-contained organ.[79] The appearance of the uterus was compared to that of the male sexual organs inverted. Anatomists believed that the generative organs of fetuses of both sexes were the same, but that the natural coldness of females hindered their organs from being thrust forward at birth as they were in males, who were naturally warm.[80] Thomas of Salerno's description of the womb affirms this myth: "Its neck is to be compared with the penis, and its internal cavity to the *oschum* or scrotal pouch; the female organ is

77. Mandrake plants have distinctive red tomatolike fruit, bushy green leaves, and anthropomorphic forked roots. The roots were used as talismans against infertility, not to induce abortion. There is nothing represented in the "anatomy lesson" of Ashmole 399 that suggests, by either color or shape, the red fruit, green leaves, or brown roots of such a plant. For herbal illustrations of mandrake plants, see Laurinda S. Dixon, "Bosch's *St. Anthony* Triptych: An Apothecary's Apotheosis" (1984).

78. The phrase originates with 1 Peter 3:7, "Likewise, ye husbands, dwell with them according to knowledge, giving honor unto the wife, as unto the weaker vessel."

79. For a discussion of uterine pot and vessel imagery throughout history, see P. J. Vinken, "Some Observations on the Symbolism of the Broken Pot in Art and Literature" (1958).

80. Hallaert, *Sekenesse of wymmen*, 27.

inverted or turned inward; the male everted or turned outward."[81] The anatomist Mondino de'Luzzi (ca. 1265–1326), though progressive in many of his discoveries, affirmed the standard medieval perception of the uterus, describing it as having "a sort of rotundity and it hath a long neck below."[82] In agreement with the traditional Galenic description, the majority of early anatomical illustrations represent the uterus as looking like an inverted bottle.

If the miniatures of Ashmole 399 were meant to chronicle a case of uterine dislocation, the womb should appear detached from its moorings and resting in a place where it would not ordinarily be found. The smooth white form partially visible between the upper ribs could therefore be seen as the rounded base of the bottle-shaped womb. The long tubelike shape identified by some as the spinal column would then be the distended vagina, from which the uterus has become detached in its displacement toward the upper body.[83] Anatomists looking for a recognizable image of uterus, fallopian tubes, and ovaries in this autopsy scene would be disappointed, as this depiction of the female generative organs lacks the realism of the other organs depicted in the miniature. It is likely that the illustrator had never seen a female autopsy, since women were rarely dissected publicly. He therefore would have been forced to rely on the traditional paradigm of uterine construction in his depiction of the womb.

The last two miniatures on folio 34 verso (fig. 5) are a fitting coda to the gynecological narrative. The top illustration shows the seated physician dispensing medical advice to a group of women. The scene has been interpreted variously as a depiction of the noble husband of the deceased lady receiving from her friends a casket containing her heart, and as a portrayal of the effect of her death on other women, who decide to invoke the physician's aid.[84] It makes sense that the figures lined up before the physician should be women seeking his advice, for each indicates her ailment by means of pose and gesture. The first woman points to her head as the source of her trouble, the next points to her eyes, the third holds a small medicine bottle, the fourth places her hand to her

81. Thomas of Salerno, *Anatomia vivorum*, chap. 40, a thirteenth-century work quoted in Ricci, *Genealogy of Gynaecology*, 222.

82. Mondino de'Luzzi (ca. 1265–1326), quoted in Grant, *Sourcebook*, 733.

83. Wellcome MS. 49, fol. 38, illustrates a similar elongated vaginal canal and detachment of vagina and womb.

84. Sudhoff, "Weitere Beitrage," 374; MacKinney and Bober, "A Thirteenth-Century Case," 255.

face as she vomits, while a fifth woman holds a medicine bag and
smiles broadly, showing her teeth, an unusual facial expression in
medieval art. All five women appear again in the bottom minia-
ture, bidding farewell to the physician as he rides away on horse-
back. He raises his finger and looks over his shoulder, as if to
admonish his flock not to court disaster by refusing the time-
honored dictums of the medical establishment.

The eight miniatures of Ashmole 399 illustrate the story of a
woman driven to illness and finally to death by the inescapable
reality of her sex. The subliminal message, however, is more sub-
tle and was aimed at both physicians and their female patients. The
concept of the dangerously fickle uterus, which could be tamed
only by appeasing its appetites, reflected the common belief that
women were predisposed to congenital weakness and ill health
from the moment of birth. The idea of the woman driven to dis-
traction because of unnatural celibacy or "much thinking" rein-
forced the Christian demand for female conformity to patriarchal
ideals, effectively barring women from traditionally male intellec-
tual pursuits and relegating them to the home or the convent.[85]
The selective reinterpretation of ancient gynecology within a
Christian matrix emphasized marriage and motherhood as sanc-
tioned ways for women to attain and maintain their health. The
traditional Marian virtues of humility, docility, and sexual subser-
vience embodied in the institution of marriage could therefore be
seen as both pleasing to men and good for women. The message
expressed in the eight miniatures of Ashmole 399 is as much moral
as it is medical.

Renaissance Gynecological Theories

The Christian concept of supernatural intervention in cases of
furor uterinus remained strong in the popular imagination
throughout the fifteenth and sixteenth centuries.[86] An early
sixteenth-century German panel painting clearly illustrates this
belief (fig. 7). The work, which is part of a larger altarpiece dedi-
cated to miraculous cures of women by the Virgin Mary, shows a
young girl languishing in bed while her desperate parents pray at

85. Hallaert, *Sekenesse of wymmen*, 29.
86. See Céard, "The Devil and Lovesickness."

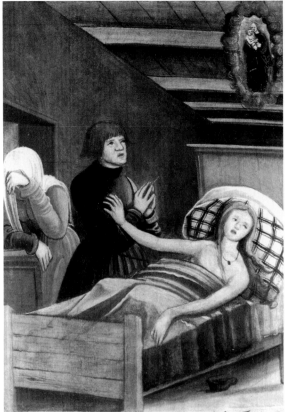

a in frau vj wochen wredent vnd in
vn vermist so bald si gen zell verlobt ward
sie mit der hilff der muter gotz aller ding
frisch vnd gesunt

Fig. 7 Panel from the *Altar of the Miracles of the Virgin Mary*, ca. 1520. Alte Galerie, Joanneum, Graz.

her side.[87] The caption beneath the scene claims that the girl suffered for six weeks from her disorder and was restored to health through the miraculous intervention of the Holy Mother. The work illustrates the fact that Christianity considered prayer a powerful tool in mediating the effects of *furor uterinus*.

Among the more vocal early opponents of supernatural intervention in disease was Paracelsus, an outspoken nonconformist who denounced both classical tradition and Eastern occultism as irrelevant to proper healing. Even a rebel such as Paracelsus, however, could not escape two thousand years of medical dogma. Although he rejected the intervention of supernatural forces in disease, Paracelsus returned to the ancient Hippocratic notion that

87. See Lucille B. Pinto, "The Folk Practice of Gynecology and Obstetrics in the Middle Ages" (1973): 518–19; and Wilhelm Theopold, *Mirakel, Heilung zwischen Wissenschaft und Glauben* (1983), 110–11.

physical and mental illness were linked. He classified uterine disorders among the diseases that caused irrational behavior in women. Likewise, his explanation of hysteria did not question its uterine origin. Paracelsus blamed the souring of menstrual matter, much "like wine returning into vinegar," which caused a tension of the skin and of the lining of the womb. The resulting contraction of the uterus was believed to force the rest of the body into sympathetic spasms, causing "vapor and smoke [to] come out of the womb to the organs around it."[88]

Paracelsus theorized that uterine hysteria was the true cause of the dancing mania that spread throughout Germany and the Netherlands from the fourteenth through the sixteenth centuries. Sometimes called Saint Vitus' dance, Saint John's dance, or the dancing plague, the ailment was characterized by uncontrolled leaps, screams, convulsions, and delirious dancing, after which the victims fell senseless to the ground. While in the throes of their bizarre disease, sufferers made annual pilgrimages to chapels dedicated to Saints Vitus and John, who were associated with the illness. Women were mainly affected, especially spinsters and prostitutes, and it was recorded in Cologne that more than one hundred unmarried women were seen raving about the city during a single outbreak.[89] The church enlisted the aid of Saints Vitus and John in exorcising the controlling demons. Paracelsus, however, declared that "the saints have nothing to do with this disease," which he called *chorea lasciva*.[90] He maintained that the dancing mania was initiated by imagining the sexual act, a fantasy that set the blood in motion, altering the vital spirits and causing involuntary joy and spasmodic dancing.[91]

Paracelsus considered *chorea lasciva* to be a form of uterine hysteria causing madness, and noted that "this dance which we find in whores does not come from nature or laughing veins . . . but from recklessness and disgraceful living in which there is neither reason nor sense. Others are not whores, but dance without thinking." No admirer of the female sex, Paracelsus believed that natural weakness predisposed chaste and promiscuous women alike to

88. Paracelsus, *The Diseases That Deprive Man of His Reason* (1567), trans. Gregory Zilboorg, in *Four Treatises by Theophrastus von Hohenheim Called Paracelsus* (1941), 142.
89. J. F. C. Hecker, *The Dancing Mania of the Middle Ages* (1970), 4.
90. Paracelsus, *Diseases*, 157.
91. Hecker, *Dancing Mania*, 10.

this passion "since women have more imagination and restlessness and are more easily conquered by the very strength of their nature."[92] Departing from classical tradition yet betraying his Christian upbringing, Paracelsus did not recommend sex as a cure for Saint Vitus' dance. Instead, he aimed to "expell lewd thoughts by shuting them [the victims] in dark, unpleasant places with bread and water without mercy." He also suggested that a "good beating" would quickly return a raving woman to her senses.[93] Because Paracelsus considered *chorea lasciva* to be caused by the influence of the mind upon the body, historians of medicine seeking clues to the origin of psychology often cite this disorder as an early form of mental illness.[94]

A series of engravings by Hendrick Hondius after a lost original by Pieter Brueghel the Elder show the victims of *chorea lasciva* as they appeared on the occasion of a Saint John's Day pilgrimage (figs. 8 and 9).[95] The prints form part of a series of three, traditionally titled *Pilgrimage of the Epileptics to the Church at Molenbeek* (1642). The first of the series does not depict the dancers but shows two peasant bagpipers playing while walking along a road in advance of the sufferers, who are shown in the next two prints. Each of these depicts two dancers, women well beyond maidenhood, who are accompanied by a pair of men who restrain them. The women display all the symptoms of *chorea lasciva*—pain and dejection, uncontrolled screaming, swooning, and convulsive movements. All four have enlarged abdomens, indicating bellies inflated with sour uterine vapors. Their male companions wear expressions of sympathy and concern for the women they accompany.

Though dated much earlier, Hondius' prints correspond closely to a description of Saint Vitus' dancers recorded in a Strasbourg chronicle published in 1698: "The town-council benevolently took an interest in the afflicted. They divided them into separate parties, to each of which they appointed responsible superintendents to protect them from harm, and perhaps also to restrain their

92. Paracelsus, *Diseases*, 157.

93. Paracelsus, *On the Origin of Suffocatio Intellectus*, in *Four Treatises*, 180–81.

94. See Annemarie Leibbrand and Werner Leibbrand, "Die 'Kopernikanische Wendung' des Hysteriebegriffes bei Paracelsus" (1975).

95. See H. Arthur Klein, *Graphic Worlds of Pieter Bruegel the Elder* (1963), 68–71; and Simone Bergmans, "Un fragment peint du pèlerinage des épileptiques à Molenbeek-Saint-Jean, oeuvre perdue de Pierre Bruegel L'Ancien" (1972).

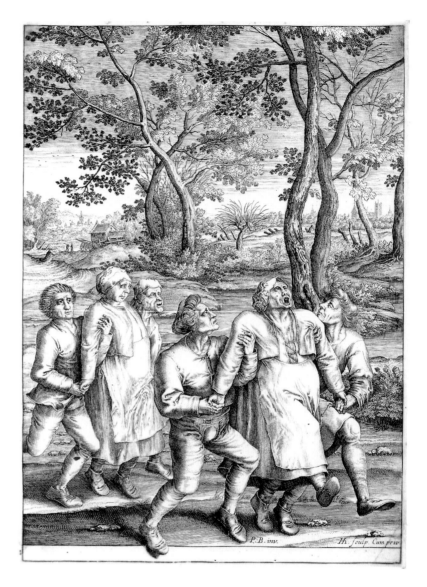

Fig. 8 Hendrick Hondius, after Pieter Brueghel the Elder, *Pilgrimage of the Epileptics to the Church at Molenbeek* II, 1642, engraving. Rijksmuseum, Amsterdam.

turbulence. They were thus conducted on foot . . . to the chapels of St. Vitus.''[96] Some sufferers hired their companions; others chose them from among the members of their families. Often the men were instructed to dance along with the women in order to hasten their fatigue.[97] Loud, raucous bagpipe music was played for the same purpose, to urge the women toward inevitable exhaustion. Once they arrived at their destination, victims of *chorea lasciva* were calmed by the soothing sounds of harps and lutes, then

96. *Journal of Koenigschoven* (Strasbourg, 1698): 1085, quoted in Hecker, *Dancing Mania*, 5.

97. Ibid., 12.

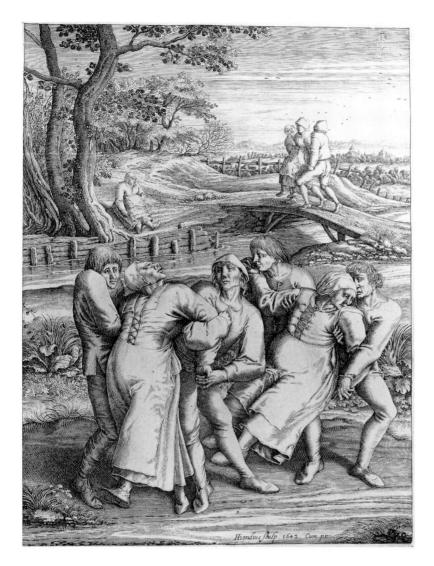

Fig. 9 Hendrick Hondius, after Pieter Brueghel the Elder, *Pilgrimage of the Epileptics to the Church at Molenbeek* III, 1642, engraving. Metropolitan Museum of Art, Elisha Whittelsey Collection, Elisha Whittelsey Fund, 1949 (49.95.2249).

they were exorcised by priests. One of the prints, however, illustrates quite another type of cure, albeit one sanctioned by Paracelsus himself. In the upper background (see fig. 9) a pair of men have escorted a victim to the middle of a footbridge and are lifting her over the edge, apparently with the intention of tossing her into the stream. This vignette illustrates Paracelsus' belief that "the best cure, and one which rarely fails, is to throw such persons into cold water."[98] As if in affirmation, a lone woman sits calmly, if somewhat dazed, at the river's edge, evidently cured of her dancing mania by an abrupt dip in the cold river. The fact that Hondius

98. Paracelsus, *On the Origin of Suffocatio Intellectus*, 182.

chose to copy Brueghel's scene in 1642, so long after the master's death in 1569, points to a continued fascination with the subject of *furor uterinus* beyond the Renaissance.

In the wake of Paracelsus physicians began to deny openly the intrusion of Christian mysticism into practical medicine, thus paving the way for the scientific revelations of the next century.[99] The "new" rationalism of the sixteenth century arose from the Renaissance revival of antiquity, which, ironically, meant a return to the old Hippocratic theory of the wandering womb. Among the new wave of rational physicians was the French surgeon Ambrose Paré (1517?–90), who successfully blended "new" classical elements into the "old" Christian matrix. Despite the fact that Paré was an expert anatomist, he accepted the Hippocratic theory of uterine migration, deftly combining it with Galen's theory of poisonous vapors. He defined hysteria as "strangulation of the womb . . . because the womb, swoln or puffed up by reason of the access of gross vapors and humors that are contained therein, and also snatched as it were by a convulsive motion, by reason that the vessels and ligaments distended with fulness, are so carried upwards against the midriff and parts of the breast, that it maketh the breath to be short, and often as if a thing lay upon the breast and pressed it."[100] Like Galen, Paré blamed suppression of the menses, which caused putrefaction of female "seed." Symptoms occurred not only in virgins and widows but also in married women who abstained from sexual relations. The best cure for married women, according to Paré, was to engage in frequent and "wanton copulation with their husbands."[101] Virgins and widows, however, had to content themselves with such exercise as was acceptable for gentlewomen. Paré also advocated less dignified curative measures, such as pulling the pubic hair of his female patients.

Paré's ideas were not entirely new, but he did institute some innovations that would become standard in later centuries. He maintained, for example, that *furor uterinus* seemed to occur more often in upper-class women, whereas "maids that live in the countrie are not so troubled with those diseases, because there is no such lying in wait for their maiden-heads, and also they live sparingly and hardily, and spend their time in continual labor."[102] In

99. See Andrew Wear and R. French, eds., *The Medical Renaissance of the Sixteenth Century* (1985).

100. [Ambrose Paré], *The Workes of the famous Chirurgion Ambrose Parey* (1649), 632.

101. Ibid., 639.

102. Ibid., 647.

addition, Paré emphasized the sexual aspects of hysteria and felt no qualms about recommending marriage and sexual activity as cures. He suggested that avoidance of sex, resulting in suppression of the menses, would turn women into *viragines*, "that is to say, stout, or manly women," with beards and voices "like unto a mans." He cited a literary source from Greek antiquity as proof of the detrimental effects of enforced celibacy: "In the citie *Abdera* (saith Hippocrates) *Phaethusa* the wife of *Pytheas*, at the first did bear children and was fruitful, but when her husband was exiled, her flowers [menstrual flow] were stopped for a long time: but when these things happened, her bodie became manlike and rough, and had a beard, and her voice was great and shrill. The verie same thing happened to *Namysia* the wife of *Georgippus* in *Thasus*."[103] The belief that *furor uterinus* was a disease of the upper classes, that physical labor and sexual intercourse could cure the condition, and that sexual abstinence caused women to lose their femininity became standard in the next century.

Ironically, the revival of antiquity not only humanized the treatment of women formally thought to be possessed by evil demons but also reinforced the Platonic view of women as inferior.[104] One of the more influential proponents of this idea was François Rabelais (1483–1553). He is primarily remembered today as a cleric and author of the famous satires *Gargantua* and *Pantagruel*; but Rabelais, who demonstrated the diverse interests of many scholars of his era, had been formally trained as a physician. He took his degree at the prestigious medical school at Montpellier, subsequently lectured there on Hippocrates and Galen, and wrote several commentaries on classical medicine.[105] Although his literary references were intended to be ironic, they reflect the view of *furor uterinus* from both the popular and the medical viewpoints. The discussion of the womb in *Pantagruel* clearly affirms the Platonic idea of the female sex commonly held by Renaissance medical authorities. Speaking of women, the physician Rondibilis, the alter ego of the author himself, says:

> Plato, you will recall, was at a loss as to where to class them, whether among the reasoning animals or the brute beasts. For Na-

103. Ibid., 638.

104. See Massimo Ciavolella, "Métamorphoses sexuelles et sexualité féminine durant la Renaissance" (1988); Joan Kelly-Gadol, "Did Women Have a Renaissance?" (1977); and Ian Maclean, *The Renaissance Notion of Woman: A Study in the Fortunes of Scholasticism and Medical Science in European Intellectual Life* (1980).

105. Veith, *Hysteria*, 107–8.

ture has placed in their bodies, in a secret and intestinal place, a cer-
tain animal or member which is not in man, in which are engen-
dered, frequently, certain humors, brackish, nitrous, boracious,
acrid, mordant, shooting, and bitterly tickling, by the painful
prickling and wriggling of which—for this member is extremely
nervous and sensitive—the entire feminine body is shaken, all the
senses ravished, all the passions carried to a point of repletion, and
all thought thrown into confusion. To such a degree that, if Nature
had not rouged their foreheads with a tint of shame, you would see
them running the streets like mad women.

Rabelais called the uterus "an animal, in accordance with the doc-
trine of the Academics. . . . For if movement, as Aristotle says, is
a sure sign of something animate, and if all that moves of itself is
to be called an animal, then, Plato was right, when he called this
thing an animal."[106]
Rabelais echoed Paracelsus in his belief that the womb's antics
could be controlled voluntarily by mental and physical discipline.
He suggested that if women wished to remain celibate, they
should attempt to distract the womb by becoming absorbed in ac-
tivities of a mundane physical nature. Even if Rabelais reflected
the prevalent societal suspicion of independent, unmarried
women, he greatly admired "those virtuous women who have
lived modestly and blamelessly, and who have had the courage to
rein in that unbridled animal and to make it obedient to reason."[107]
Although *Pantagruel* is a work of fiction, its witty, satirical view of
women could have come from any sixteenth-century medical
treatise, and it carried the weight of scientific authority in the pop-
ular sphere.
The later sixteenth century produced two physicians, Johann
Weyer (Wier) (1518–88) from the Netherlands and the English-
man Edward Jorden (1578–1632), who both attempted independ-
ently to revise the opinion of women in medical circles.[108] Weyer
and Jorden were sensitive to women and their unique medical
problems, and both advocated practical treatment of gynecologi-

106. François Rabelais, *Pantagruel* (1946), 477.
107. Ibid., 478.
108. Johann Weyer [Wier], *De praestigiis daemonum* (1568); and Jorden, *Briefe Discourse*
(1603). The complete title of Jorden's treatise is *A Briefe Discourse of a Disease Called the Suf-*
focation of the Mother. Written uppon occasion which hath beene of late taken thereby, to suspect pos-
session of an evill spirit, or some such like supernaturall power. Wherein is declared that divers strange
actions and passions of the body of man, which in the common opinion are imputed to the Divell, have
their true naturall causes, and do accompany this disease.

cal disorders. Inspired by the notorious witch trials that resulted in the execution of many innocent women, Weyer and Jorden vociferously denied the existence of witches and blamed the symptoms of *furor uterinus* on natural causes. In their efforts to educate the public regarding the impossibility of demonic intervention in disease, both physicians advocated a return to the objectivity of the ancient Greeks.[109]

Jorden's treatise, published in 1603, brought the study of hysteria into the seventeenth century. His theories were significant in suggesting an organic relation between mind and body in *furor uterinus*. He still viewed the illness as a uterine disorder, and did not deny the ability of the womb to "rise up toward the midriff . . . compressing other parts," but he added that the symptoms of "suffocation of the Mother," could also stem from noxious vapors rising from the uterus or from the sympathy of another organ to the womb's distress.[110] Jorden's treatise blamed the psychic symptoms of the disease on the brain, which he believed to be especially susceptible to uterine vapors. He accepted the old theories of sexual abstinence and interrupted menstruation as instigators of *furor uterinus* and added "perturbations of the minde" to the roster. Jorden further revolutionized the treatment of the disorder by ministering to both the mind and the body. He was the first of many theorists to suggest that friends and family members of the victim should involve themselves in the cure by helping to alleviate the emotional tensions suspected of causing the condition.

Seventeenth-Century Gynecological Theories

As any student of history realizes, ideas and cultural trends do not always organize themselves in neat hundred-year increments. This is especially true when we attempt to define the character of the seventeenth century, a time of tremendous social, artistic, and scientific upheaval that drew heavily on the past yet also set the stage for the Enlightenment and the industrial age. The seventeenth century saw the foundations of civilization torn down and pieced back together again as the dogmatic philosophy of the an-

109. See Sydney Anglo, "Melancholia and Witchcraft: The Debate between Wier, Bodin, and Scott" (1976); and G. S. Rousseau, "'A Strange Pathology': Hysteria in the Early Modern World, 1500–1800" (1993).
110. Jorden, *Briefe Discourse*, 5–5v.

cients gradually yielded to the evidence of empirical observation. The geographic and celestial boundaries of the universe expanded dramatically with the discoveries of Columbus, Galileo, Newton, and Huygens. Knowledge of the human body followed suit, as medicine flourished apart from the classical tradition with the discoveries of Vesalius, Descartes, and Harvey.[111] Yet seventeenth-century physicians held firmly to the conviction that female anatomy predisposed women to weakness and instability.

Several diverse perceptions of *furor uterinus* were current in the seventeenth century, and no single definition suffices to encompass all of the varied theories and practices current at that time. The picture is further complicated by the vast amount of historical medical literature, in addition to new works, that was in print and available to the literate public.[112] Like modern medicine, seventeenth-century medicine was international in scope. Most treatises were first published in Latin, the universal language of educated persons. Even so, some of the more important books were translated into vernacular languages and quickly assimilated into the popular sphere. This occurred because the sharp division between lay and professional practitioners that prevails today did not exist in the seventeenth century, and also because published books were so few and far between by today's formidable standards that they were more quickly assessed and commented on. Medical treatises were also quite different in nature from the intimidating technical writings that appear in specialized journals today. Like the paintings and plays of the time, they were filled with classical myths, political opinions, social commentary, poetry, jokes, and proverbs. The most distinct feature of seventeenth-century medical works is their insistent reliance on quotations from ancient authorities. The concept of originality in scientific writings was not highly prized as it is today, and the myriad quotations of early authors lent an air of authority and scholarly credence to the contemporary literature.

Robert Burton's *Anatomy of Melancholy*, though first published in 1621, is an invaluable survey of Renaissance medical theory. Burton, an educated layman, wrote his treatise in response to the

111. See A. Rupert Hall, *The Revolution in Science, 1500–1750* (1983).

112. The ancient and medieval treatises were widely available in the seventeenth century and were printed separately and as parts of large collections of gynecological works, among them Conrad Gesner and Caspar Wolff, *Gynaecorium* (1566); Victorius Benedictus Faventinus, *Trotulae antiquissimi autoris curandorum* (1550); and Israel Spach, *Resume of the Gynaecology of the Sixteenth Century* (1597). See Ricci, *Genealogy of Gynaecology*, 255–56.

popular fascination with the concept of the melancholic genius. It is therefore as much a work of popular philosophy as it is a medical book, a vast compendium of two thousand years of science, philosophy, poetry, history, and religion fashioned into medical discourse. Brilliantly and engagingly written, *The Anatomy of Melancholy* was absorbed quickly into the conventional wisdom, becoming an important influence on both literature and art.[113] Although most of Burton's three-volume treatise deals with manifestations of melancholia in men, he did devote a chapter to a type of melancholy associated exclusively with women.

Like Jorden, Burton attributed the varied symptoms of "maids', nuns' and widows' melancholy" to a misplaced uterus and spoiled menstrual blood poisoning the body by means of noxious vapors. Emotional trauma, idleness, and celibacy aggravated the condition. Burton accepted marriage as the surest remedy, and suggested that "noble virgins" unable to find husbands equal to their station should engage in physical labor and lead simple, disciplined lives. He justified the suggestion by citing the fact that servants and peasants seldom fell prey to the disease, echoing the earlier observation of Paré. Burton, a cleric who claimed to be celibate, forcefully criticized "popish monasteries" that "bind and enforce men and women to vow virginity to lead a single life, against the laws of nature." He was equally critical of "hard-hearted parents . . . those careless and stupid overseers, that, out of worldly respects, covetousness, supine negligence" endangered the health of their virgin daughters by postponing their marriage.[114] With this illuminating social observation Burton, apparently embarrassed by the path along which his reflections had led him, abruptly ended his discussion of female melancholia by asking: "But where am I? Into what subject have I rushed? What have I to do with Nuns, Maids, Virgins, Widows? I am a Bachelor myself, and lead a Monastick life in a College. . . . Lest you should think that I do plead, Some certain Maid's or Widow's need, I'll say no more."[115] Burton's *Anatomy of Melancholy*, with its editorial commentary, its retellings of ancient myths and colorful anecdotes, was well received by the lay public and medical profes-

113. Paul Jordan-Smith, *Bibliographia Burtoniana: A Study of Robert Burton's "The Anatomy of Melancholy," with a Bibliography of Burton's Writings* (1931), records that *The Anatomy of Melancholy* exists in eight seventeenth-century editions.

114. Robert Burton, *The Anatomy of Melancholy* (1977), 414–19.

115. Ibid., 419.

sionals alike. The book both reflected and encouraged the English preoccupation with melancholy that was already evident in the popular spheres of Elizabethan drama and portraiture.[116]

Willis, Sydenham, and the Leiden Connection

The university at Leiden was a major center of learning in the seventeenth century. Founded in 1575 by William the Silent, it was the first university in the Netherlands, and quickly established itself as an international center for the study of medicine. Leiden also led the world in the study of international law and Oriental languages, both new fields that served Dutch colonial aims. The university was very much part of the international Latin-speaking scholarly community, and of the 11,076 students who attended between 1626 and 1650, over half were foreigners.[117] Much has been written about the advancements in science and technology that originated within the relatively liberated environment of this Protestant school. Indeed, the university at Leiden led the world in challenging the dogmas of Galenic medicine that had governed all aspects of science for two thousand years.[118] It is also true, however, that the university, though cosmopolitan and innovative by seventeenth-century standards, was also in many ways provincial and traditional. Its theologians, for example, when confronted with the age-old superstition that a guilty witch could float on water, justified the belief by stating that witches were melancholy

116. For discussion of melancholic imagery in drama, see Lawrence Babb, *The Elizabethan Malady* (1951); idem, "Hamlet, Melancholy, and the Devil" (1944); idem, "Love Melancholy in the Elizabethan and Early Stuart Drama" (1943); idem, "Melancholy and the Elizabethan Man of Letters" (1941). See also John W. Draper, *The Humors and Shakespeare's Characters* (1970); Lionel Charles Knights, *Drama and Society in the Age of Jonson* (1957); Bridget Gellert Lyons, *Voices of Melancholy: Studies in Literary Treatments of Melancholy in Renaissance England* (1971).

117. R. W. Innes Smith, *English-Speaking Students of Medicine at the University of Leyden* (1932), x. On the foreign population at Leiden and the cosmopolitan nature of the school, see Gerrit Arie Lindeboom, *Boerhaave and Great Britain* (1974). Smith notes that English students predominated among the foreign pupils at the University at Leiden and that the first student to enroll in the medical school in 1581 and the first to receive his M.D. in 1610 were both from the British Isles.

118. For discussions of Leiden University, see Anthony Grafton, "Civic Humanism and Scientific Scholarship at Leiden" (1988); Theodoor Herman Lunsingh Scheurleer and Guillaume Henri Marie Posthumus Meyjes, eds., *Leiden University in the Seventeenth Century: An Exchange of Learning* (Leiden, 1975); H. Wansink, *Politieke wetenschappen aan de Leidse universiteit 1575–1650* (1981); and Guillaume Henri Marie Posthumus Meyjes, *Geschiedenis van het Waalse college te Leiden 1606–1669: Tevens een bijdrage tot de vroegste geschiedenis van het fonds Hallet* (Leiden, 1975).

and therefore flatulent, which is why they floated.[119] Ancient dogma and medieval superstition flourished alongside intellectual inquiry at Leiden.[120]

Perhaps it was the confluence of ancient tradition and contemporary social relevance attached to the illness of *furor uterinus* that caused Leiden to become a modern center for the study of this ancient disease. The university produced at least thirty-two medical dissertations on the subject between the years 1625 and 1696, more than any other European university; Utrecht ranked second with eighteen. All but one of these was written between 1650 and 1696, a period that corresponds with the appearance of the lovesick maiden theme in the works of Leiden painters.[121] The evidence of such a large number of dissertations indicates an increased fascination with the subject of women's illnesses during the last half of the century, and it is safe to assume that the actual number of doctors specializing in women's diseases was even higher, as degree candidates were often allowed to substitute a written examination for the dissertation. Furthermore, the phenomenon of the practicing physician who never completed requirements for the M.D. was common in the seventeenth century. It is possible that many such doctors specialized in the study of women's illnesses while still attending university.[122]

This increased interest in women's ailments corresponds in time with the publication of the works of the Leiden-trained Englishman Thomas Willis (1621–75). Willis's writings were also available to the Dutch public, for his treatises were translated from the original Latin into Dutch even before they appeared in the author's native English.[123] His most dramatic contribution to the history of

119. Robert Bartlett, *Trial by Fire and Water: The Medieval Judicial Ordeal* (1986).

120. See Edward Grant Ruestow, *Physics at Seventeenth- and Eighteenth-Century Leiden: Philosophy and the New Science in the University* (1973), for discussion of ancient dogma versus new science in the university curriculum.

121. The beginning of the Dutch fascination with hysteria has been linked to a treatise by Johannes Lange, *Medicinalium epistolarium miscellanea varia et rara* (1554), directed at young girls in Brabant and cited in Emile Schwarz, *Chlorosis: A Retrospective Investigation* (Brussels, 1951). Einar Petterson, "*Amans Amanti Medicus*: Die Ikonologie des Motivs *Der ärtzliche Besuch*" (1987): 218, lists fifteen doctoral dissertations from the Utrecht and Leiden medical schools written on the subject of hysteria during the last half of the seventeenth century. There were, however, many more. See appendix.

122. See Oskar Diethelm, *Medical Dissertations of Psychiatric Interest Printed before 1750* (1971), 1–31.

123. Thomas Willis, *Affectionum quae dicuntur hystericae et hypochondriacae pathologica spasmodica* (1671); published in Dutch as *D'Algemeeine en bysondere . . . wercking der genees-middelen* (1677); published in English as *Dr. Willis's practice of physick, being the whole works of that renowned and famous physician* (1684).

gynecology was his firm denial of the theory of uterine displacement. A serious anatomist, Willis conducted autopsies on women who had purportedly died of *furor uterinus*, often finding healthy, stationary wombs.[124] He concluded that "the womb is of so small bulk in Virgins and Widows, and is so strictly tied by neighboring parts round about, that it cannot of itself be moved, or ascend from its place."[125] In his chapter "On the Passions commonly called Hysterical, or Fits of the Mother," Willis stated the results of his observations: "Among diseases of women, the hysterical affection is . . . of unknown nature and hidden origin. . . . Its cause escapes us and its therapy is uncertain. . . . We immediately blame the bad influence of the uterus which, for the most part, is not responsible."[126] Ten years after Willis presented his views, another English physician, Thomas Sydenham (1624–89), corroborated them in his essay "Of the Small-pox and hysteric Diseases."[127] Sydenham further believed that an imbalance of the mind-body relationship could cause disturbances in whatever part of the body was most vulnerable, and cautioned that the "hysterical passion" could take on the form of any disease. Historians of psychology therefore credit him with being one of the first to define hysteria as an affliction of the mind.[128]

As is often the case throughout history when a scientific paradigm is shattered, the reforms of Willis and Sydenham were not immediately accepted by the medical establishment. Indeed, it was some time before their revolutionary theories became assimilated into the popular wisdom.[129] Among those who continued to defend the old theory of uterine migration was William Harvey, the same physician who set forth the dramatic theory of the circulation of blood in 1628. In his chapter "On Parturition" Harvey declared: "No one of the least experience can be ignorant what

124. Veith, *Hysteria*, 133; and Rousseau, "Strange Pathology," 140–41.

125. Willis, *Practice of Physick*, 69.

126. Ibid., 138.

127. See *The entire works of Dr. Thomas Sydenham, newly made English from the originals* (1742). See also Robert S. Kinsman, ed., *The Darker Vision of the Renaissance* (1974); Rousseau, "Strange Pathology," 138–45; and Ilza Veith, "On Hysterical and Hypochondriacal Afflictions" (1956).

128. See Veith, "On Hysterical and Hypochondriacal Afflictions"; Jeffrey M. N. Boss, "The Seventeenth-Century Transformation of the Hysteric Affection and Sydenham's Baconian Medicine" (1979); John P. Wright, "Hysteria and Mechanical Man" (1980).

129. For a discussion of the lay and professional responses to the overturning of scientific paradigms, see Thomas S. Kuhn, *The Structure of Scientific Revolutions* (1962).

grievous symptoms arise when the uterus either rises up or falls down, or is in any way put out of place, or is seized with spasm.''[130] Following ancient dogma, he considered *furor uterinus* incurable and "brought about by unhealthy menstrual discharges or from over-abstinence from sexual intercourse when the passions are strong.''[131] Other physicians, presented with incontrovertible anatomical evidence that the womb could not wander, nonetheless still talked of spontaneous movement: "And so the womb, though it be so strictly attached to the parts we have described that it may not change place, yet often changes position, and makes curious and so to speak petulant movements in the woman's body. These movements are various . . . ascending, descending, convulsive, vagrant, prolapsed. The womb rises to the liver, spleen, diaphragm, stomach, breast, heart, lung, gullet and head.''[132] Even in Leiden, where the theories of Willis and Sydenham were argued within the medical school curriculum, the case was continually made both for and against the English reforms. The Hippocratic archetype was slow to die. In general, most seventeenth-century physicians continued to draw on ancient dogma and medieval superstition when defining and treating female complaints.

The seventeenth-century image of the unstable woman, enslaved by the appetites of her wandering "mother," was further enforced by the acceptance in medical circles of Arabic astrological theory. While surgeons and anatomists were making great strides in discovering the actual workings of the human body, disease pathology remained tied to the influences of the stars and planets. Claude Dariot's treatise *A briefe and most easy introduction to the astrological judgment of the starres* serves as a basic introduction to the concept of astrological healing.[133] Following ancient tradition, Dariot placed women under the influence of the moon, which ruled all waters, including women's monthly flow. His description of the typical lunar physiognomy, "a round face and faire eyes

130. William Harvey, *The Works of William Harvey, M.D.* (1847), 542.

131. Ibid., 545.

132. Jean Liébault, *Trois livres appartenans aux infirmitez et maladies des femmes. Pris du Latin de M. Jean Liébaut, Lyon,* 5. See also Michel Foucault, *Madness and Civilization* (1965), 143–44.

133. Claude Dariot, *A briefe and most easy introduction to the astrological judgment of the starres* (1557), also published in 1583 and 1598. Dariot's concepts are repeated in William Lilly, *Christian astrology modestly treated of in three books* (1647), and in many other astrological handbooks. See also John Henry, "Doctors and Healers: Popular Culture and the Medical Profession" (1991), 203–5.

. . . and a soft body," was close to the standard of female beauty in sixteeenth- and seventeenth-century Europe.[134] By contrast, the traditional lunar features have never been especially admired in men. A face "sufficiently naked of heares, especially around the mouth," for example, a phlegmatic physiognomic characteristic essential for female beauty, was certainly not consistent with accepted standards of masculinity.[135] Accordingly, lunar personalities also tended to be seen as female in nature. Adjectives pertaining to the lunar type such as "bashful, fearful, weake of courage, gentle of behavior and obedient" describe qualities that were highly prized in women, but in descriptions of men they were converted into the unflattering characteristics of "cowardice and stupidity."[136]

The dominance of the moon, in combination with the uterine tendency toward waywardness, further reinforced women's "naturally" contrary and capricious nature.[137] Lunar influence could cause insanity; hence the origin of the modern word *lunatic.* An abundance of the cold, moist humor of phlegm could result in sloth and fatigue, qualities that, along with mental instability, came to define the essential feminine nature.[138] An anonymous seventeenth-century print titled "L'influence de la lune sur la tête des femmes" (The influence of the moon on the head of women) clearly illustrates the widely held view of women dominated by the night planet (fig. 10). It depicts five women dancing together in the dark as a full moon shines above them, sending rays down to crescents that crown their heads. Their folly has been discovered by a group of gesticulating men in the background, who express horror and dismay at the demented display. The engraving sums up the essence of a seventeenth-century Parisian doctoral disser-

134. Dariot, *A briefe and most easy introduction,* 33.

135. Bartolommeo della Rocca Coccles, *The Contemplation of Mankinde, contayning a singular discourse after the art of phisiognomie, on all the members and partes of man, as from the heade to the foote* (1571), 149.

136. Ibid., 149; and Dariot, *A briefe and most easy introduction,* 33–35.

137. Inconstancy was considered a lunar characteristic because the moon does not remain unchanging in the night sky but goes through phases. For seventeenth-century mention of women as lunar and therefore susceptible to the effects of the moon, see Nicolas Venette, *Venus minsieke gasthuis, waer in beschreven worden de bedryven der liefde in den staet des houwelijks, met de natuurlijke eygenschappen der manen en vrouwen, hare siekten, oirsaken en genesingen* (1688), 363; Jorden, *Briefe Discourse,* 2; Robert Turner, *De morbis foemineis* (1686), 9–10.

138. On the lunar personality presented in Shakespeare's plays, see Draper, *Humors and Shakespeare's Characters,* 29–39.

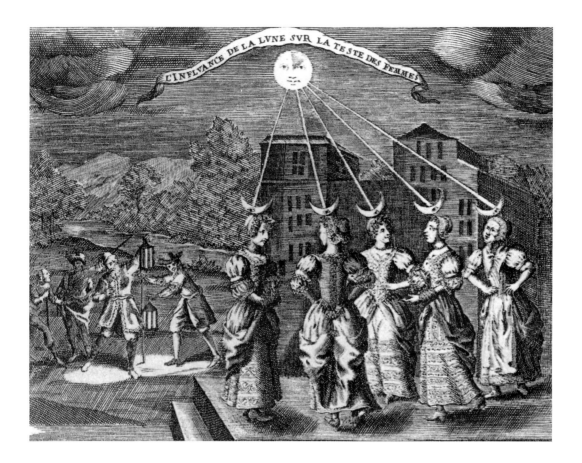

L'INFLVANCE DE LA LVNE SVR LA TESTE DES FEMMES

tation, "La sphere de la lune composée de la tête de la femme," which cited the influence of the moon as proof that woman was an "imperfect work of nature."[139]

Dariot was selective in his listing of lunar types; he included not only "fishers and fools" but also those women—"queens, ladies, widows"—who either lived well or were celibate. He reserved the influence of Venus, the second, more positive female planetary presence, for "mothers, wives, embroiderers and cooks."[140] Indeed, Adriaen Collaert's print after Maarten de Vos of *Venus and Adolescence* (1581) includes girls sewing in a bower among the children of Venus (fig. 11).[141] Likewise, Dutch paintings often combine sewing women and venereal imagery in domestic surround-

Fig. 10 L'influence de la lune sur la tête des femmes, 17th c., from Gustave Reynier, La femme au XVIIᵉ siècle, ses ennemis et ses défenseurs. Paris, 1921. Photo: Syracuse University Photo Center.

139. Reproduced in Gustave Reynier, *La femme au XVIIᵉ siècle, ses ennemis et ses défenseurs* (1921), fig. 17.

140. Dariot, *A briefe and most easy introduction*, 37.

141. The print is part of a series devoted to the seven planets and ages of man. See Ilja M. Veldman, "De macht van de planeten over het mensdom in prenten naar Maarten de Vos" (1983): 42.

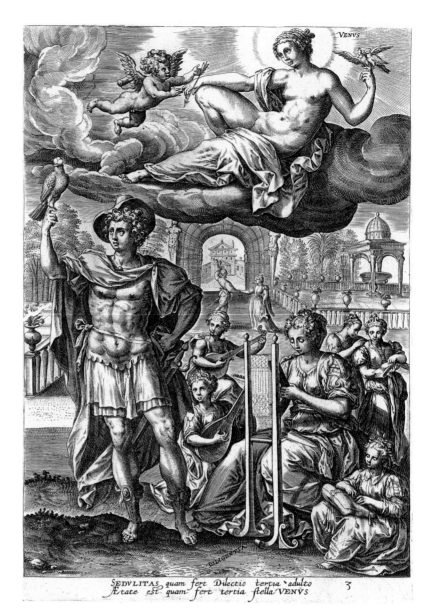

Fig. 11 Adriaen Collaert, after Maarten de Vos, *Venus and Adolescence*, 1581, engraving from *The Seven Planets and Ages of Man* series. Rijksprentenkabinet, Amsterdam.

ings. Gerrit Dou's *Lacemaker* (1663) (fig. 12), for example, pictures a sewing woman juxtaposed with strong secondary allusions to the venereal realm.[142] The woman's task is associated with Venus, as are the roses and the songbook placed prominently on the edge of the nichelike space that encloses her. Astrological theory con-

142. See Rhonda Baer, "The Paintings of Gerrit Dou (1613–75)" (1990), cat. 90. For a discussion of Dou's painting as an image of domestic diligence, see Wayne E. Franits, "The Virtues Which Ought to Be in a Complete Woman" (1987), 34–41.

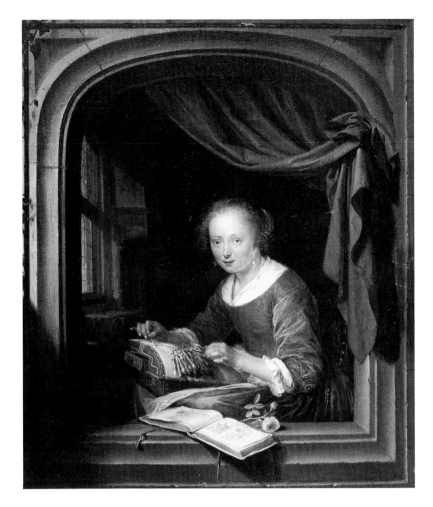

Fig. 12 Gerrit Dou,
The Lacemaker, 1663.
Staatliche Kunst-
halle, Karlsruhe.

sistently associated music with love, and the rose was the special flower of Venus because of its sweet fragrance and pink or red color.[143] Dou's painting suggests, then, that not all women were doomed to everlasting lunar influence. The negative control of the moon could be mitigated by marriage, motherhood, and adher-

143. Since Roman times roses were symbolic of the realm of Venus, and the association was made in many seventeenth-century emblem books. For Renaissance herbal and planetary associations with the flower, see Marsilio Ficino, *Les trois livres de la vie* (1582), 124–25. John Gerard, *The herball, or General historie of plantes* (1636), bk. 3, chap. 181 ("Of Roses"), associates the rose with Cupid, "The Boy of faire *Venus, Cythera's* Darling." The association of the music of stringed instruments with the venereal realm is part of common wisdom even today. For a survey of the idea reflected in art, see Albert P. de Mirimonde, *Astrologie et musique* (1977). In art and literature the combination of roses with music is an unarguable allusion to the realm of Venus. For discussion of the venereal association of roses and music in Dutch portraiture, see Eddy de Jongh, *Portretten van echt en trouw: Huwelijk en gezin in de Nederlandse kunst van de zeventiende eeuw* (1986), 80–81.

ence to positive venereal domestic duties such as sewing and cook-
ing. In this way, astrological medical theory, in combination with
ancient notions of female anatomy, encouraged women to marry
and to work, though their work was defined and confined by the
domestic sphere.

II

"OUTWARD MANIFESTATIONS"
Symptoms and Diagnosis

By the seventeenth century, the language of gesture was not only relevant to the practices of medicine, public oratory, drama, and education, but had become absorbed into contemporary experience as a necessary social skill.[1] Dutch intellectuals, who were multilingual citizens of the world and connoisseurs of classical knowledge, practiced gestural communication in their dealings with clients in foreign nations. Constantine Huygens, for example, carefully taught his son Christiaan to practice "by what gesture and demeanor kings must be confronted as well as slaves."[2] This early education prepared Christiaan Huygens for his first encounter with the ancient sculptural masterpiece *Laocoön*, in which he found "a supreme illustration of how gesture and attitude convey extremes of emotion."[3] His experience reveals that, in the public sphere, gestures were

1. Modern studies include Moshe Barasch, *Gestures of Despair in Medieval and Early Renaissance Art* (1976); and Jan Bremmer and Herman Roodenburg, eds., *Gestures in History: A Cultural History of Gestures from Antiquity to the Present* (Ithaca, 1992). For discussion and illustration of gestures in seventeenth-century art as social conventions related to portraiture, see Eddy de Jongh, *Portretten van echt en trouw: Huwelijk en gezin in de Nederlandse kunst van de zeventiende eeuw* (1986), 50–53 and passim.

2. Quoted in Alfred Gustave Herbert Bachrach, *Sir Constantine Huyghens and Britain, 1596–1687: A Pattern of Cultural Exchange* (1962), 299.

3. Ibid.

an integral part of daily life and social communication in the Netherlands.

The seventeenth-century language of formalized gesture, which had roots in Aristotelian physiognomic theory and ancient classical oratory, also played an important role in English drama, a genre that was well known and highly respected in the Netherlands.[4] Several historical accounts praise the effectiveness of English actors in communicating non-verbally with Dutch-speaking audiences by means of gesture. Fynes Moryson, the world traveler and social critic, described how "when some cast off Players of England came into those partes, the people not understanding what they sayd, only for their action followed them with wonderful concours."[5] The city archives of Leiden record the presence of an English actor, Willem Pedel, who, by "various beautiful and chaste performances with his body, without using any words," communicated his meaning eloquently.[6] It was through the English dramatic tradition that some of the postures and trappings of fashion and behavior entered the popular Dutch consciousness.[7]

Aside from its effectiveness in popular dramatic entertainment, gesture was recognized by many seventeenth-century scientific authorities as having a variety of practical applications. Indeed, gesture was perceived as a "universal language" that could, in some instances, be superior to the spoken word in communicating meaning and emotion. Because gesture allowed easy and instant exchange of information with alien cultures, explorers and entrepreneurs found sign language invaluable in communicating with natives of the Americas and the Indies.[8] Enlightened educators put the language of gesture to further practical use in teaching the deaf, providing the origins of standard modern hearing-impaired

4. J. G. Riewald, "New Light on English Actors in the Netherlands, c. 1590–c. 1660" (1960): 69; see also Bertram Leon Joseph, *Elizabethan Acting* (1951).

5. [Fynes Moryson] *Shakespeare's Europe: Unpublished Chapters of Fynes Moryson's Itinerary. Being a Survey of the Condition of Europe at the End of the Sixteenth Century* (1903), 304; and Moryson, *An Itinerary* (1971).

6. Riewald, "New Light on English Actors," 69.

7. Many scholars have traced the transmission of certain gestures reflecting "cultural attitudes" (especially melancholia) from England to the Continent by way of dramatic traditions. See especially Lawrence Babb, *Sanity in Bedlam* (1959); idem, "Love Melancholy in the Elizabethan and Early Stuart Drama" (1943); John W. Draper, *The Humors and Shakespeare's Characters* (1970); Z. S. Fink, "Jacques and the Malcontent Type" (1935); Lionel Charles Knights, *Drama and Society in the Age of Jonson* (1957); and Bridget Gellert Lyons, *Voices of Melancholy: Studies in Literary Treatments of Melancholy in Renaissance England* (1971).

8. H. J. Norman, "John Bulwer: The Chirosopher" (1943): 589.

communication.[9] Dutch painters, whose audience spanned all of Europe and whose craft required communication beyond the limitations of the spoken word, could scarcely have failed to employ the art of gesture in their works.

The language of gesture and pose was the subject of many treatises dating from ancient times. A significant source for the study of gesture is John Bulwer's *Chirologia*, subtitled *The Natural Language of the Hand and Chironomia: Or the Art of Manual Rhetoric* (1644). An important seventeenth-century compendium of gestures, this book claimed to be a scientific summation of centuries of physiognomic and oratorical tradition. The *Chirologia* was written in the belief, drawn from ancient medical authority, that "gestures of the body reflect the state of the mind."[10] Bulwer's rationale was a Christian one, based on the theory that the movements of the hands and body had somehow escaped the linguistic pandemonium that followed the destruction of the Tower of Babel. Hence, Bulwer and his contemporaries viewed the hands as natural, spontaneous signifiers and communicators of inner thought.[11] The *Chirologia* owed much to the venerable traditions of Ciceronian public oratory and Aristotelian physiognomy, and was one of several treatises on gesture that appeared from the Renaissance onward.[12] It was influential in many disciplines, and was an important factor in the international movement to standardize gestures for practical application. Moreover, Bulwer's text is relevant to the history of art because it was the first treatise to be systematically and copiously illustrated, and would have been a natural source for artists seeking to enhance the communicative power of their images.

Historians differ in their assessment of Bulwer's book as an influence on Dutch artists.[13] The case against the *Chirologia* is

9. Juan Pablo Bonet, *Reduction de las letras y arte para enseñar a ablar los mudos* (Simplification of the Letters of the Alphabet and Method of Teaching Deaf-Mutes to Speak) (1620); James R. Knowlson, "The Idea of Gesture as a Universal Language in the Seventeenth and Eighteenth Centuries" (1965).

10. John Bulwer, *Chirologia: Or the Natural Language of the Hand and Chironomia: Or the Art of Manual Rhetoric* (1974), xiii.

11. See Obadiah Walker, *Some instructions concerning the art of oratory* (1659).

12. Among the earlier works on gesture and physiognomy were Giovanni Bonifacio, *L'arte de' Cenni* (1616); and Giovanni Piero Valeriano, *Ieroglifici* (1615).

13. Bulwer's influence is supported by Otto Naumann, *Frans van Mieris the Elder (1635–1681)* (1981), 1:94–121; Peter Sutton, *Pieter de Hooch* (1980), 60 n. 15; and W. G. Hellinga, "De bewogenheid staalmeesters; enkele beschouwingen over wegen en grenzen der interpretatie" (1957): 180–81. The case against Bulwer was briefly stated by Eddy de Jongh in his review of Peter Sutton, *Pieter de Hooch* (1980): 185.

based primarily on the assumption that it was not known in seventeenth-century Holland. Evidence of the symbiotic relationship between Holland and England, however, especially in the field of scientific inquiry, strongly negates this argument.[14] Books were, after all, portable, and could easily have accompanied visitors across the channel or been sent by way of one of the many established postal routes between the two countries.[15] Furthermore, the illustrations in Bulwer's book are headed by descriptions written in the international scholarly language of Latin, so artists would not have needed a reading knowledge of English to make sense of them. Granted it cannot be known if any particular painter consulted Bulwer as a source for his depictions of gestures and poses. Still, the body language that is reflected and codified in the *Chirologia* was a science of ancient origin that, by the seventeenth century, had become absorbed fully into the popular sphere. Artists need not actually have been familiar with the *Chirologia*, for common knowledge and contemporary experience borrowed from the same ancient store of learning as did the more specialized fields of medicine, education, and literature.

Seventeenth-century artists and doctors were, in a sense, bound by a common purpose. Both were required by the mandates of their professions to study the outward appearance of the body for clues to its hidden emotional state. Dutch painters accomplished this with great success, and were renowned for infusing portraits and genre scenes with the transient qualities of character and mood. Although their purposes were, of course, different, physicians also believed that "the body betrays the mind" and relied strongly on gesture in the diagnosis of disease.[16] Both artistic depiction and medical diagnosis taught the reverse as well—that

14. The cosmopolitan, international nature of seventeenth-century Dutch society and the easy and frequent communication between England and the Low Countries is documented by many historians. See especially David William Davies, *Dutch Influences in English Culture, 1558–1625* (1964); Kenneth Harold Dobson Haley, *The Dutch in the Seventeenth Century* (1972); John J. Murray, "The Cultural Impact of the Flemish Low Countries on Sixteenth- and Seventeenth-Century England" (1957); R. W. Innes Smith, *English-Speaking Students of Medicine at the University of Leyden* (1932); C. H. Wilson, *England and Holland* (1946); Abraham Wolf, *A History of Science, Technology, and Philosophy in the Sixteenth and Seventeenth Centuries*, vol. 2 (1968).

15. Wilson, *England and Holland*, 34–35. Wilson notes that by 1667 there were three government postal routes serving England and the Netherlands, between the cities of Harwich and the Brill, Dover and Ostend, and Falmouth and Groyne. In addition, numerous passenger ships made the journey frequently.

16. Levinus Lemnius, *The Touchstone of Complexions* (1576), 156.

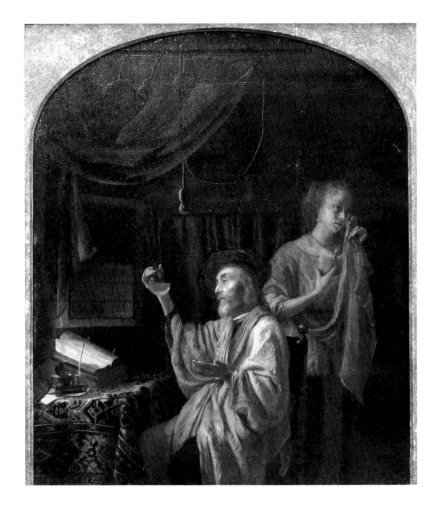

Fig. 13 Godfried Schalcken, *Visit to the Doctor*, 1669. Wallraf-Richartz-Museum, Cologne. Photo: Rheinisches Bildarchiv, Köln.

"the soul reflects the temper of the body."[17] Not surprisingly, artists recognized and recorded the physical and emotional symptoms of *furor uterinus* with a combination of sensitivity and clinical accuracy worthy of the best physicians.

Some of the attitudes taken by ailing women in seventeenth-century paintings have their origins in the codified body language of the time, while others illustrate specific symptoms of *furor uterinus*. The common symptoms of difficult breathing, rapid heart palpitations, and the feeling of an orb or obstruction rising up to the throat, for example, are suggested by images of women who anxiously place their hands to their breast and throat as if attempting to halt the disturbing sensations (figs. 13, 14, 25, 61, colorpl. 6). Occasionally these women, though fully clothed, wear only

17. Thomas Walkington, *The optick glasse of humors* (1607), 9. See also Thomas Wright, *The Passions of the Minde in Generall* (1604), 178–79.

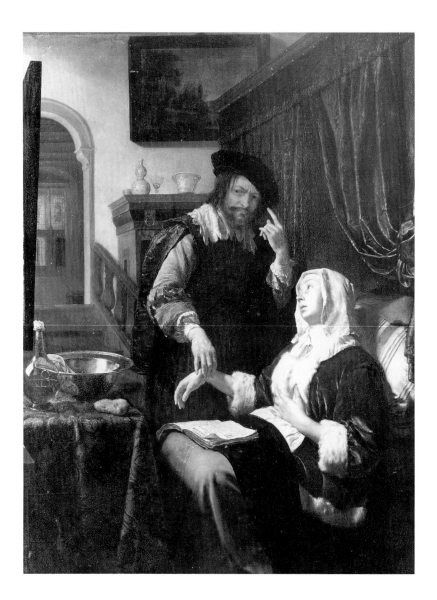

Fig. 14 Franz van
Mieris, *The Doctor's
Visit*, 1657.
Kunsthistorisches
Museum, Vienna.

one shoe, an indication that perhaps their feet have become swol-
len—a common symptom of *furor uterinus*—causing them to kick
off one or both slippers for comfort (figs. 50, 65).[18]

The audience for the lovesick maiden pictures would have rec-
ognized other, more stylized gestures as indicators of the under-

18. Many seventeenth- and eighteenth-century treatises describe swollen feet as a symp-
tom of *furor uterinus.* See especially Robert Turner, *De morbis foemineis* (1686), 34; and Wil-
liam Rowley, *A treatise on female, nervous, hysterical, hypochondriacal, bilious, convulsive dis-
eases; appoplexy and palsy; with thoughts on madness, suicide, etc., in which the principal disorders
are explained from anatomical facts, and the treatment formed on several new principles* (1788), 7.
The image of the shoeless woman has been interpreted by art historians as having domestic
and sexual connotations. See Wayne E. Franits, *Paragons of Virtue: Women and Domesticity in
Seventeenth-Century Dutch Art* (1993), 77–79; and Donald Posner, "The Swinging Women
of Watteau and Fragonard" (1982): 85–86.

Fig. 15 Gestus M.,
"Sollicitè cogito,"
from John Bulwer,
*Chirologia: Or the
Natural Language
of the Hand.*
London, 1644.
National Library
of Medicine,
Bethesda, Md.

lying emotional distress characteristic of *furor uterinus.* Indeed, the hands of ailing women are posed in at least three formalized gestures which Bulwer illustrated and identified as indicating trouble of mind. The most easily explained is the head-on-hand pose reminiscent of the muse in Dürer's *Melancolia I* (fig. 89; see figs. 1, 30, 66, 76, colorpls. 1, 3). By the seventeenth century, the pose had become synonymous with the condition of melancholia. Its appearance and description in Bulwer's text (fig. 15) pays homage to its universal meaning: "To apply the hand passionately unto the head is a sign of anguish, sorrow, grief, impatiency and lamentation; a *dolorous* expression of the hand. The head is the natural hieroglyphic of health, and the hand, of relief and protection, as being the champion of the head. Hence, in the straits of imminent perils or dolores calamity, they usually meet in committee of safety."[19] Though traditionally associated with portraits of scholars, students, and artist-geniuses, the gesture also occurs frequently in paintings of female hysterics.[20] The physician Jacques Ferrand explained that women borrowed this gesture not because of any propensity for intellectual pursuits but as the result of "constantly thinking of desires," which caused them to do "the same thing as the scholar."[21]

19. Bulwer, "Gestus M," in *Chirologia.*
20. For copious illustrations of the head-on-hand gesture as a signifier of mental anguish throughout history, see Raymond Klibansky, Erwin Panofsky, and Fritz Saxl, *Saturn and Melancholy: Studies in the History of Natural Philosophy, Religion, and Art* (1964).
21. Quoted in Lawrence Babb, *The Elizabethan Malady: A Study of Melancholia in English Literature from 1580 to 1642* (1951), 134.

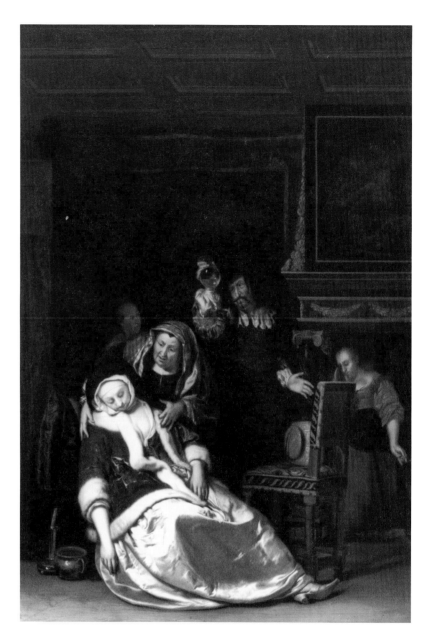

Fig. 16 Franz van
Mieris, *The Doctor's
Visit*, ca. 1667.
Museo Franz Mayer,
Mexico City.

Another gesture that occurs frequently within the confines of
the seventeenth-century female sickroom is that of a woman
whose arms rest weakly at her sides, hands dangling helplessly
from limp wrists (figs. 16, 17, 23, 62, colorpl. 2).[22] Such a posture
would of course be expected of a person debilitated by illness, but
its appearance in paintings from the fourteenth century on seems
intentionally limited to the female sickroom. Indeed, the pose is

22. Naumann, *Frans van Mieris,* 1:103, explains the gesture as indicating the woman's
state of mind on realizing that she is pregnant.

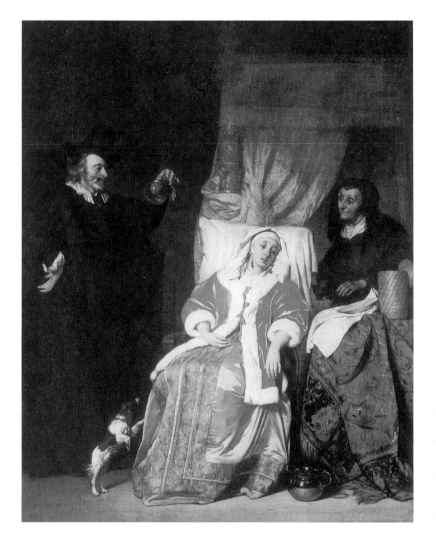

Fig. 17 Gabriel Metsu, *Sick Lady and the Doctor*, ca. 1665. Hermitage, St. Petersburg. Photo: Metropolitan Museum of Art, New York.

adopted by the medieval woman in Ashmole 399 (fig. 2), and would have been recognized by the seventeenth century as connoting deep distress and emotional imbalance. Bulwer's text (fig. 18) illustrates the attitude as "Despero" (I despair) and describes it thus: "To appear with fainting and dejected hands is a posture of fear, abasement of mind, and abject and vanquished courage, and of utter despair. The prophet Isaiah calls this habit of dejection or consternation, the faint hand, or the hand fallen down, faint heart and abject spirit."[23] Limp, "fainting" hands were a sign of utter exhaustion and mental depression, resulting from the depletion of bodily moisture and spirit by the overheated uterus.

A third gesture relevant to the illness of *furor uterinus* appears in Samuel van Hoogstraten's painting *The Anemic Lady* (ca. 1670)

23. Bulwer, *Chirologia*, 37.

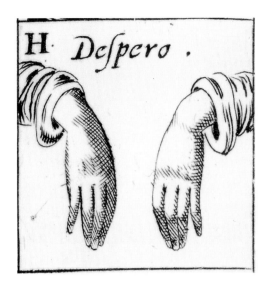

Fig. 18 Gestus H, "Despero," from John Bulwer, *Chirologia: Or the Natural Language of the Hand.* London, 1644. National Library of Medicine, Bethesda, Md.

(fig. 19). Here a young girl gazes at us through languid, half-closed eyes while a distinguished-looking physician examines her urine. The position of the maiden's hands, which she holds in front of her body, fingers intertwined, is distinctive and apparently unique in depictions of the female sickroom. Bulwer presents a lengthy explanation, drawn from ancient sources, of the emotional connotations of this gesture (fig. 20). Illustrated as "Tristitia animi signo" (I show mental anguish), it is described in part thus:

> To hold the fingers inserted between each other across is their sluggish expression who are fallen into a *melancholy muse*. . . . Hence (to sit with hands compressed) in the Adage, is all one with (to do nothing, to indulge in laziness, to be in the way of others); for, this gesture is thought to have a tacit force to damp the lively spirit of mirth and friendly communication. . . . Those that deny themselves to those with whom they converse . . . minding not what others do or say, by a mental sequestration withdraw their souls, as 't were from their bodies, and while they over prize their private thoughts . . . they seem to do no other than to make a solecism in society. (The ancient Romans) thought it also witchcraft but to sit by one that had a practical design upon health by the receipt of any medicine either inwardly or outwardly applied.[24]

Hoogstraten's use of the gesture of intertwined hands therefore embodies several salient aspects of his subject's disease. "Anguish

24. Ibid., 39–40.

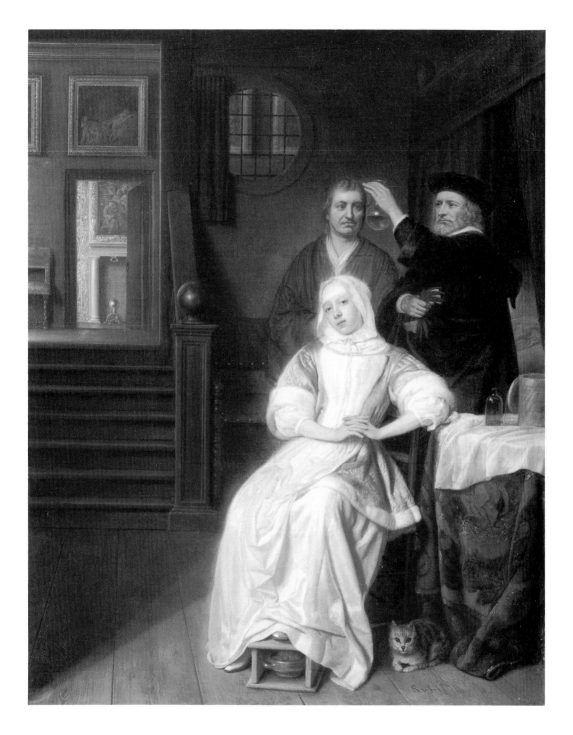

Fig. 19 Samuel van Hoogstraten, *The Anemic Lady*, ca. 1670. Rijksmuseum, Amsterdam.

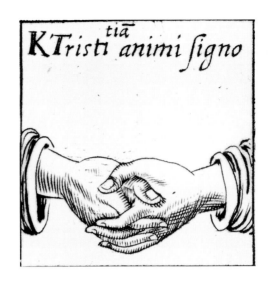

Fig. 20 Gestus K, "Tristitia animi signo," from John Bulwer, *Chirologia: Or the Natural Language of the Hand.* London, 1644. National Library of Medicine, Bethesda, Md.

of mind" akin to a "melancholic muse" was, of course, an emotional symptom of *furor uterinus*, as was the withdrawal from society into a private world of whim and fantasy. The association of sloth with this gesture, however, recalls the traditional medical link of *furor uterinus* with physical inactivity. Furthermore, the ancient interpretation of the pose as a powerful talisman against the practical aims of physicians may allude to a tendency of female sufferers to resist the cures of their doctors.

The hand position of Hoogstraten's "anemic lady" hints at her state of mind while her listless pose and languid gaze are clues to her physical condition. The source of her debility, however, is suggested by the cat that crouches at her feet. The presence of this animal is not unusual in itself, for cats often appear in works of art, though they are more common in pictures of witches and in genre scenes featuring amorous women or prostitutes. The belief that cats were the "familiars" of witches was part of the folklore assembled in the famous *Malleus maleficarum* (Hammer of Witches), the fifteenth-century handbook used by inquisitors during the witch-burning holocaust.[25] Nonetheless, scholars have not viewed the presence of cats in Dutch genre paintings as anything other than domestic props, despite the fact that they appear frequently in blatantly erotic scenes outside the context of witchcraft. Like much seventeenth-century common wisdom, the association of cats with *furor uterinus* is justified in the annals of the history of

25. See Heinrich Kramer and James Sprenger, *Malleus maleficarum* (1971).

science.[26] No less an authority than Aristotle described cats as
wanton and forward in their mating. In fact, Aristotle claimed
that female cats actually instigate the sexual act, enticing males to
mate: "Females are very lascivious, and invite the male, and make
a noise during intercourse."[27] Aristotle's association of cats with
heightened and unseemly sexuality among women became ab-
sorbed into the common wisdom and appeared in Sebastian
Brant's moralizing book *Das Narrenschif* (Ship of Fools). Brant's
chapter "Of Adultery" describes a promiscuous wife who solicits
lovers "like a cat," and continues its rhyming discourse by claim-
ing that such women

> Become so bold and shameless then
> That deep they sink into the mire
> And only think of their desire.[28]

Hoogstraten's crouching cat suggests both the cause and the
cure of the woman's illness. Humoral theory associated cats with
the hot, dry phase of melancholia, which explains why they often
appear near open fireplaces in scenes of sexual license and prosti-
tution.[29] An example is Cornelis van Kittensteyn's popular print ti-
tled *Tactus* (Sense of Touch), where a cat sits near the billowing
flames and smoke of an open hearth as two lovers engage in erotic
foreplay (fig. 21). The cat reinforces the heat of sexual passion dis-
played by the couple and further intimates that the woman is in
fact a prostitute.[30] Similarly, Hoogstraten's cat sits near the hot
charcoal burner placed at the sick woman's feet. The animal's po-
sition suggests the heated condition of the woman's womb,
which, like a cat, hungers for sexual intercourse. The cat becomes
a symbol for the uterus, which was also perceived as a roving,
amoral creature. By gazing directly outward at the viewer,
Hoogstraten's sick young woman offers herself sexually, fulfilling

26. The suggestion of literary sources for cats as signifiers of prostitution in art comes
from an unpublished paper (1992) by Claudia E. Goldstein, a graduate student at Syracuse
University.

27. Aristotle, *History of Animals* (1862), 5.2.103.

28. Sebastian Brant, *The Ship of Fools* (1944), 136–38.

29. See Henry Peacham, *Minerva Britanna, or A garden of heroical devises, furnished, and
adorned with emblems and impresas of sundry natures, newly devised, moralized, and published*
(1612).

30. For a discussion of this print as an image of prostitution, see Linda Stone-Ferrier,
Dutch Prints of Daily Life: Mirrors of Life or Masks of Morals? (1983), 141.

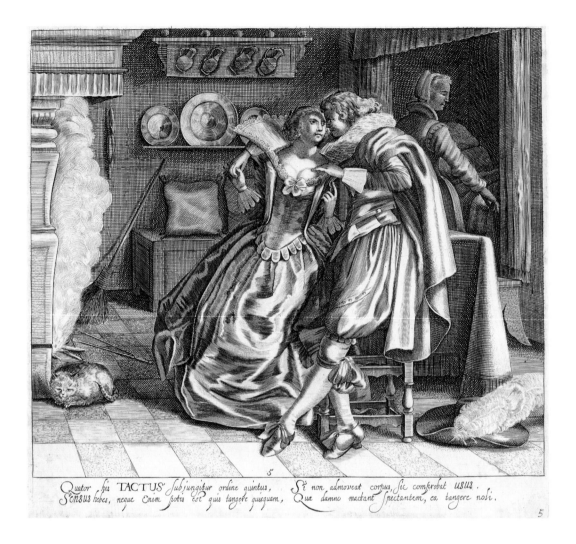

Fig. 21 Cornelis van Kittensteyn, after Dirck Hals, *Tactus* (Touch), engraving, ca. 1630–63. George Peabody Gardner Fund. Courtesy Museum of Fine Arts, Boston.

William Harvey's characterization of female hysterics as being like animals in heat.[31]

Artists eloquently depicted not only the stylized poses and gestures of despair adopted by their female subjects but also the ashen color of their skin. Indeed, one of the major physical signs of *furor uterinus*, and one that was documented without fail by artists, was an extreme deathlike pallor which gave the face a grayish-green cast (see colorpls. 2, 7). Trotula in the thirteenth century described the complexion of afflicted women as "leaden or green."[32] The

31. William Harvey, *Exercitationes de generatione animalium* (1651), 545; see also G. S. Rousseau, "'A Strange Pathology': Hysteria in the Early Modern World, 1500–1800" (1993), 132–33.

32. See M.-R. Hallaert, ed., *The "Sekenesse of wymmen": A Middle English Treatise on Diseases of Women* (1982), 7.

same observation was made throughout the seventeenth century by physicians who explained the peculiar jaundice as a result of pollution of the blood by yellow bile. The characteristic corpselike pallor of female hysterics caused their illness to be known as *chlorosis*, or the "green sickness."[33]

Other symptoms are also evident in the faces of female hysterics. Bernard Mandeville, a Dutch physician who trained in the seventeenth century at Leiden and later moved his medical practice to England, expressed the ancient belief that the face and eyes are the mirrors of the soul when he wrote: "Physicians bid us feel the pulse, and inspect the tongue and urine of the Patient; but there are other things to be taken notice of in the Eyes and Face of sick people."[34] Other physicians wrote copiously on the subject of facial expression as a means of diagnosing *furor uterinus*. Their clinical descriptions tended to emphasize the eyes, in combination with other physical indications, as important clues in diagnosing the controlling "passions" in illness. Doctors noted, for example, that the eyes of hysterics usually appeared hollow and dry—the result of depleted moisture caused by the heated uterus. Sometimes the women were reported to gaze fixedly, seemingly intent on some "far-off, imagined object" or "dazzled" by some "delightful inner vision."[35] Their eyes could just as often appear "dim" and troubled, "concealing the lust with which they burn."[36] Often "cryes and howling tears" could yield suddenly to "a strange fit of laughing, to the amazement of their visitors."[37] Some victims babbled incoherently, while others developed the capacity to speak in tongues.[38] The demeanor of lovesick maidens depicted in art parallels clinical medical texts which subjectively interpret facial expression in the diagnosis of disease. Significantly, these women often wear "far-off" expressions, as if their minds were somehow divorced from their bodies (figs. 22, 23, 38, colorpl. 5). Sometimes their features are contorted with emotion;

33. See especially Jacques Ferrand, *Erotomania; or, A treatise discoursing of the essence, causes, symptomes, prognosticks, and cure of Love, or erotique melancholy* (1640), 120; Edward Jorden, *A Briefe Discourse of a Disease Called the Suffocation of the Mother* (1603), 15; Thomas Sydenham, "Of the Epidemick Diseases from the Year 1675 to the Year 1680," in *The whole Works of that excellent practical physician, Dr. Thomas Sydenham* (1729), 303.

34. Bernard Mandeville, *A treatise of the hypochondriack and hysterick passions* (1976), 79.

35. Ferrand, *Erotomania*, 107.

36. Ibid.

37. Gideon Harvey, *Morbus Anglicus: or The anatomy of consumptions* (1674), 140–41.

38. Richard Blackmore, *A Treatise of the Spleen and Vapours, or Hypocondriacal and Hysterical Affections* (1725), 121.

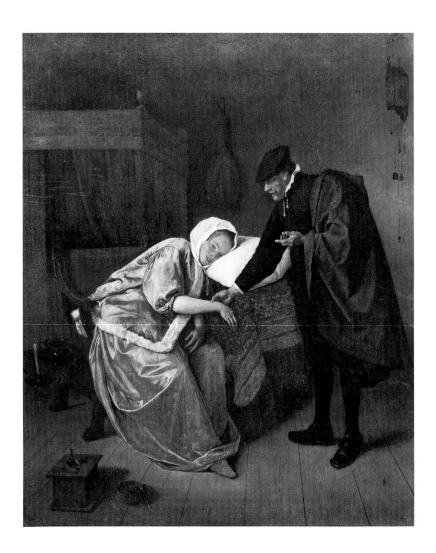

Fig. 22 Jan Steen,
The Sick Woman,
ca. 1665–67.
Rijksmuseum,
Amsterdam.

at other times the women stare vacantly ahead, their mouths
curved into faint smiles. The most common image in art shows
the victims of uterine furies apparently "cast into a trance . . . pos-
sibly diverted with some merry phansies or rare visions of their
sweet-hearts."[39] The best artists were able to capture the fleeting
subtleties of gaze and expression in their female subjects in ways
that allowed the informed viewer both to identify the medical con-
dition from which the women suffered and to empathize with
their misery. Through careful delineation of body language and
facial expression, painters granted gesture and physiognomy the
same importance they were given in medical diagnosis. As a re-

39. Ibid., 40.

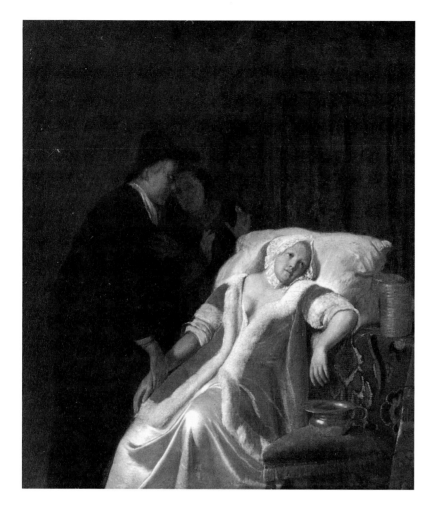

Fig. 23 Jacob Ochtervelt, *Lovesick Maiden*, ca. 1665–68. Rijksdienst Beeldende Kunst, The Hague, NK 1984.

sult, Dutch paintings offer a synthesis of medical knowledge and common wisdom that would have been appreciated at all levels of seventeenth-century society.

Uroscopy

Many paintings of female sickrooms show a physician holding a small, glass flask to the light, eyeing it with serious concentration (see figs. 13, 16, 17, 19, 25, 43, 62, 76, colorpl. 2). Scholars properly recognize this as the process of uroscopy, the diagnosis of illness accomplished by the examination of urine for peculiarities of color, smell, texture, and taste.[40] The interpretation of the pres-

40. For a brief survey of the pose of the urine examiner in art, see Jan Baptist Bedaux, "Minnekoorts- zwangershaps- en doodsverschijneselen op zeventiende-eeuwse schilderijen" (1975): 17–28.

ence of urine analysis in these paintings has, however, been conditioned by modern definitions of proper medical procedure. Most scholars assume that the practice was fraudulent in the seventeenth century and, consequently, see all urine examiners as charlatans engaged in duping their gullible patients.[41] In fact, the majority of classically trained physicians in the seventeenth century did not question the importance of uroscopy as a diagnostic tool. Like the early scientific disciplines of alchemy and astrology, however, the practice of medicine was not limited to those holding university degrees in the subject. Untrained amateur "piss prophets" abounded, and their fees were lower than those of legitimate physicians. As a result, critics questioned the effectiveness of uroscopy only when done incorrectly or by untrained practitioners.[42] But the physicians in Dutch paintings often wear academic apparel, advertising their membership in the guild of physicians and their possession of a university degree.[43] These doctors would have viewed uroscopy as an effective diagnostic tool dating from earliest antiquity.

Lacking the sophisticated, sanitary chemical tests used by modern doctors, early physicians had to rely on sight, taste, and smell in testing for vital signs such as the presence of blood, sugar, and acid in urine.[44] Indeed, some of the observations recorded in treatises on urine seem outrageous by modern standards, such as the claim, made by Arnauld of Villanova, that the urine of a rabies victim contained tiny dogs swimming around in it.[45] Neverthe-

41. Eddy de Jongh et al., *Tot lering en vermaak* (1976), refers to the "outmoded diagnosis by means of uroscopy." See also Peter Sutton, *Jan Steen: Comedy and Admonition* (1982–83): 22.

42. James Primrose [Primerosius], *Traité de Primerose sur les erreurs vulgaires de la médicine, avec des additions tres-curieuses par M. de Rostagny* (1689), 121, refers to the "jugement trompeur des urines." See also John Henry, "Doctors and Healers: Popular Culture and the Medical Profession" (1991), 203–5.

43. Identifying the costume of these physicians is made difficult by the fact that, in seventeenth-century Leiden, doctors often combined elements of formal academic dress with everyday attire. For example, wide-brimmed lay hats were often worn by Doctors of Medicine instead of the more formal round corded bonnet. Robes were always black, open in front, and pleated behind. Some academic robes, however, more closely resembled short jackets with slashed sleeves; others had sleeves reaching to the elbow; and still others were long, reaching to the heels, with winged sleeves. Holders of the degree of Doctor of Medicine wore a green flap collar. See W. N. Hargreaves-Mawdsley, *A History of Academical Dress in Europe until the End of the Eighteenth Century* (1963), 175–78.

44. Medical texts often included examples of colors with which to compare urine samples. See, for instance, Wellcome MS. 49, fol. 35, which illustrates a table of twenty flasks containing urine ranging in color from white to dark brown. The colors were linked with specific illnesses and stages of life, with gold signifying perfect digestion.

45. Henry Ernest Sigerist, "Bedside Manners in the Middle Ages: The Treatise 'De Cautelis medicorium' Attributed to Arnauld of Villanova" (1946).

less, some observations have stood the test of history. One example is the belief, dating from the Arabic writings of Avicenna, that the urine of pregnant women develops a pearly film if left standing for several days.[46] Although this ancient medical axiom was still being debated in the seventeenth century, it was finally proved in 1928 that the stimulation of bacterial growth by the hormones of pregnancy indeed causes a film to develop over the urine of pregnant women.[47]

It is not surprising that smelling and tasting human waste was abhorrent to the lay public, who ridiculed and reviled the practice in popular plays, emblems, and prints.[48] The humor inherent in the practice of uroscopy provided plenty of opportunity for lampooning the medical profession, as an engraving dating from the mid-seventeenth century clearly illustrates (fig. 24). Titled *"Le Bassin,"* the print shows a solemn, dignified doctor, robed and bespectacled as befits an academic, who points meaningfully to a chamber pot that threatens to spill its foul contents onto a table holding a bottle of medicine, some pills, and a sprig of flowers. The inscription satirizes the physician's discriminating sense of smell and taste.

Physicians, for their part, were well aware that they could be duped by their prankish patients. A passage from Rodricus à Castro's *Medicus-politicus* (1662) gives the impression that seventeenth-century doctors tempered their belief in uroscopy with shrewd discrimination where the motives of the public were concerned:

> Girls come with urines and ask the doctor to inspect them. Take notice, while they talk with you, whether they are half laughing, or appear suffused with shame; it is an indication . . . whether it is a matter of a furtive mistress whose menses are deficient and who wishes to know whether she is pregnant, or of an honest woman for other reasons, or assuredly, whose marriage is being spent in sterility and who desires to know the cause of the sterility. Whatever it may be, you will have acted justly and prudently if you state that you are unwilling and moreover are not obliged publicly to diagnose for someone else other than the person whose urine it is.[49]

46. *A Treatise on the Canon of Medicine by Avicenna* (1930), 318–19. See also John of Gaddesen, *Rosa anglica practica medicinae* (1492), 104.

47. See Thomas Rogers Forbes, *The Midwife and the Witch* (1966), 34. Among Dutch vernacular books, see Pieter van Forest [Forestus], *Het onzeker ende bedrieghlick oordeel der wateren* (1626); and Johan van Beverwijck, *Schat der ongesontheyt* (1642).

48. See Sturla J. Gudlaugsson, *The Comedians in the Work of Jan Steen and Contemporaries* (1975); and Henry Meige, "Les médecins de Jan Steen" (1900): 187–90.

49. Rodricus à Castro, *Medicus-politicus* (1662), 216–17.

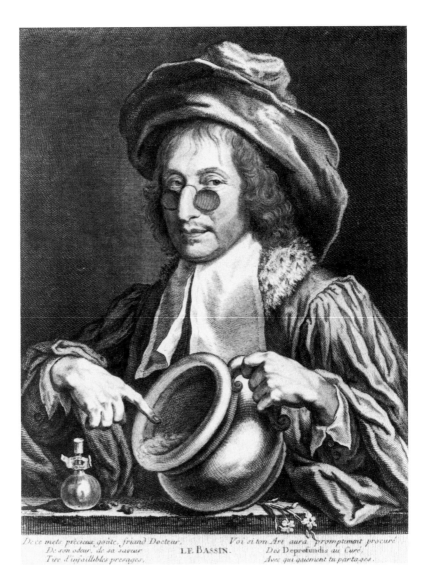

Fig. 24 *Le bassin,*
17th c., from Eugen
Holländer, *Die
Medizin in der
klassischen Malerei.*
Stuttgart, 1950.
Photo: Syracuse
University Photo
Center.

De ce mets précieux goûte, friand Docteur,
De son odeur, de sa saveur LE BASSIN. *Des Deprofundis au Curé,*
Tire d'infaillibles presages, *Avec qui gaiement tu partages.*
Voi si ton Art aura promptement procuré

Centuries earlier, Giles of Corbeil (d. ca. 1220) had recommended
a similar policy of aloofness under fire, counseling physicians not
to "reveal your pure self to that corrupt horde; let it see only the
hem of your teachings, a hem which it is not worthy to touch."[50]
No doubt the process of uroscopy was inexact at best, and undig-
nified, unpleasant, and fraudulent at worst. Still, when practiced
by a qualified physician who could astutely note accompanying
physical and emotional symptoms in his patients, uroscopy was
considered a legitimate and effective method of diagnosis, as uri-
nalysis continues to be to this day.

50. Giles of Corbeil, *Interpretation of the Urine,* trans. M. McVaugh, in *A Source Book in
Medieval Science,* ed. Edward Grant (1974), 750.

What did physicians see in the urine of their female patients? The liquid in the bottles held aloft in paintings is usually colorless and transparent so that details of the sickroom may be seen right through it. Ancient medical authorities (notably Celsus) described such watery urine as a symptom of *furor uterinus*, and seventeenth-century authors followed suit.[51] Thomas Sydenham, for one, recorded that the condition was "all the more certain whenever a large quantity of limpid crystalline urine has been voided."[52] Other treatises similarly reported the appearance of urine voided by hysterics as clear, pale, "low coloured," wheyish, thin, limpid, or resembling clear water.[53] Thomas Willis noted that "women of delicate constitution and long indisposed" tended to void "each morning a great quantity of clear, watery urine with no sediment," an observation reinforced by the chamber pots prominently painted by artists among the common accouterments of the female sickroom.[54] Willis further claimed that thin, transparent, copious urine was more common in young women because the "crudities are still in the body and are not being eliminated."[55] Although a watery texture and color were symptomatic of the earlier stages of *furor uterinus*, urine tended to be thick and red in the later stages, signifying too long a "concoction" within the body. Indeed, artists occasionally painted flasks containing turbid, reddish urine (fig. 14), though they more often chose to paint the urine of ailing women as clear and thin. This was certainly a more tasteful choice, but it was also a medically correct one, for light-colored urine was associated with the young, ripe girls whom painters, for unabashedly prurient reasons, preferred to portray as languishing for want of "love."

Pulse-Taking

Another activity that occupies physicians in paintings of ailing women is the taking of the pulse, a diagnostic measure as familiar today as it was in the seventeenth century (see figs. 1, 14, 22, 23, 26, 30, 38, 42, 50, 61, colorpls. 1, 3, 5, 6). Sometimes the two ac-

51. Ibid., 749.

52. Sydenham, *Epidemick Diseases*, 305.

53. Noted by Giles of Corbeil in the thirteenth century. See also Robert Burton, *The Anatomy of Melancholy* (1932), 307; Mandeville, *A treatise of the hypochondriack and hysterick passions*, 25; John Purcell, *A treatise of vapours, or, hysterick fits* (1707), 116.

54. Thomas Willis, *Dissertation sur les urines* (1683), 47.

55. Ibid., 50. See also Beverwijck, *Schat der ongesontheyt*, 453–68.

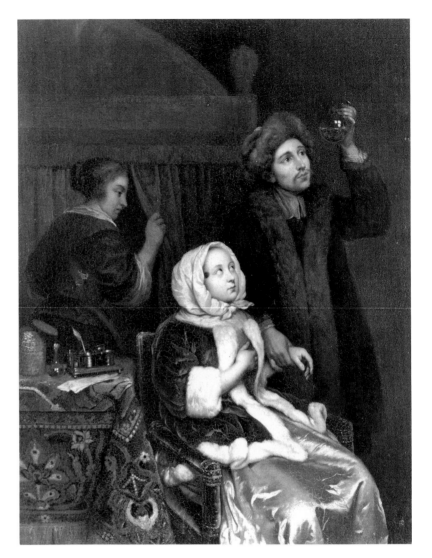

Fig. 25 After Caspar Netscher, *The Sick Lady with Her Physician*. The Royal Collection © 1993 Her Majesty Queen Elizabeth II. Photo: Royal Collection Enterprises, London.

tivities of uroscopy and pulse-taking are shown being performed simultaneously, a practice that was recommended when the urine appeared healthy despite physical and emotional indications to the contrary (fig. 25).[56] Galenic medicine borrowed knowledge of the pulse from the ancient Egyptians.[57] Like the idea of the wandering womb, which was also Egyptian in origin, the concept of the pulse was part of the legacy of the classical past on which seventeenth-century medicine was based. Not until William Harvey's discovery of the circulation of the blood, however, was

56. See Emmet Field Horine, "An Epitome of Ancient Pulse Lore" (1941): 227.
57. See Jerome J. Bylebyl, "Galen on the Nonnatural Causes of Variation in the Pulse" (1971).

the true significance of the pulse recognized. Most seventeenth-century physicians accepted the ancient explanation that the heart and arteries acted like organic bellows, drawing in air and blood by dilation and expelling fumes by contraction.[58] The Galenic axiom echoed the dictates of common sense: the stronger and more regular the pulse, the healthier the patient. In cases of *furor uterinus* the pulse tended to be irregular, rapid and weak just before an attack of fainting and languid, slow, and intermittent at other times.[59] Some physicians claimed that no pulse could be felt in women debilitated by the disease and cautioned against premature pronouncement of death in such cases.[60]

Physicians carefully monitored changes in the pulse in order to chart the cause and progress of *furor uterinus*.[61] They accepted the ancient Galenic theory that the pulse, whose purpose was to expel vapors emanating from the heart, directly reflected the emotional condition of the patient.[62] The connection was remarked by Celsus, who wrote that "feeling of the mind is often apt to excite the pulse."[63] Thus, the sudden influx of a warm passion such as love (or anger, as the case may have been) would temporarily dilate the heart and open the bodily passageways, causing a sudden change in the character of the pulse. Popular emblems and proverbs, borrowing from medical tradition, reflected this phenomenon in what became known as the "minne-pols," or "pulse of love."[64]

In one of the more obvious conflations of myth, popular wisdom, and medical tradition, the "pulse of love" was a common topic of discussion in seventeenth-century medical treatises describing *furor uterinus*. Its legitimacy was underscored by the solemn authority of Galen himself, who wrote of a particularly frustrating case in which the cause of a woman's illness eluded him:

> After I had diagnosed that there was no bodily trouble, and that the woman was suffering from some mental uneasiness, it happened

58. See John Floyer, *The physician's pulse-watch; or, An essay to explain the old art of feeling the pulse, and to improve it by the help of a pulse-watch* (1707).

59. Described in Ferrand, *Erotomania*, 115; and Jorden, *Briefe Discourse*, 8. See also Floyer, *Physician's pulse-watch*, 33.

60. Purcell, *A treatise of vapours*, 82. See also Helen King, "Once Upon a Text: Hysteria from Hippocrates" (1993), 63.

61. See Marek-Marsel Mesulam and Jon Perry, "The Diagnosis of Love-Sickness: Experimental Psychophysiology without the Polygraph" (1972).

62. Horine, "Epitome," 207–11.

63. Celsus, *De medicina* (1953–61), 1:255.

64. Discussed in Bedaux, "Minnekoorts," 31–32; de Jongh et al., *Tot lering*, 233–355; and Wolfgang Stechow, "The Love of Antiochus with Faire Stratonica in Art" (1945).

that, at the very time I was examining her, this was confirmed. Somebody came from the theatre and said he had seen Pylades dancing. Then both her expression and the colour of her face changed. Seeing this, I applied my hand to her wrist, and noticed that her pulse had suddenly become extremely irregular. This kind of pulse indicates that the mind is disturbed. . . . So on the next day I said to one of my followers, that, when I paid my visit to the woman, he was to come a little later and announce to me, "Morphus is dancing to-day." When he said this, I found that the pulse was unaffected. Similarly also on the next day, when I had an announcement made about the third member of the troupe, the pulse remained unchanged as before. On the fourth evening I kept very careful watch when it was announced that Pylades was dancing, and I noticed that the pulse was very much disturbed. Thus I found out that the woman was in love with Pylades, and by careful watch on the succeeding days my discovery was confirmed.[65]

The instance related by Galen was doubtless inspired by the legend of Antiochus, whose unrequited love for his beautiful stepmother, Stratonice, was diagnosed by the reaction of his pulse to her presence in his chamber. Robert Burton seems to have been the first seventeenth-century author to explain Galen's discovery by reference to the ancient myth.[66] Other medical theorists followed, inspired by the impressive classical scholarship demonstrated in Burton's *Anatomy of Melancholy*. Knowledge of the pulse of love reached the lay public in the Netherlands through Johan van Beverwijck's best-selling medical handbook, *Schat der ongesontheydt* (which cites Burton) and Jacob Cats's vernacular re-telling of the Antiochus and Stratonice myth.[67] The medical notion of a *minnepols* responsive to the presence of a beloved became part of the cultural ambience of the seventeenth century.

Several paintings allude to the pulse of love by showing a young man entering the sickroom as a physician takes a girl's pulse. One such work by Jan Steen (fig. 30, colorpl. 3) shows the woman looking upward as if suddenly reviving from her feverish lethargy, directing her gaze toward a young man standing in the door-

65. Quoted in Arthur John Brock, ed. and trans., *Greek Medicine: Being Abstracts Illustrative of Medical Writers from Hippocrates to Galen* (1929), 213–14.

66. Robert Burton, *The Anatomy of Melancholy, What It Is: With All The Kindes, Causes, Symptomes, Prognostickes, And Several Cures Of It* (1621), 2:294.

67. The story appears in Beverwijck, *Schat der ongesontheyt*, 133; and Jacob Cats, *Alle de wercken* (1665), 3:46–63. See also Bedaux, "Minnekoorts," 31–35; de Jongh et al., *Tot lering*, 234; and Sutton, "Jan Steen," 22.

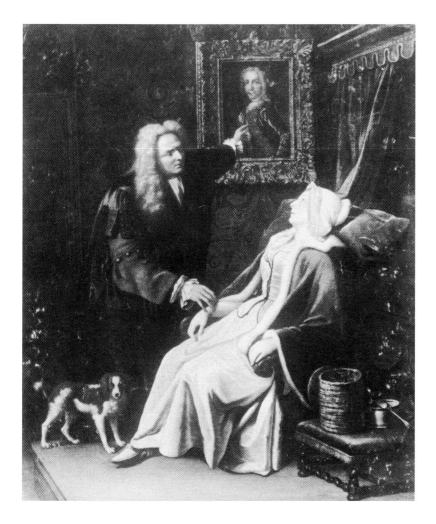

Fig. 26 Cornelis de Man, *Doctor's Visit*, late 17th c. Location unknown.

way. The scene corresponds to medical texts that instruct physicians to take the woman's pulse at the moment her suspected lover enters the room. Another suggested means was to read a list of names and note changes in the woman's pulse in response to each of them. Once identified, the object of the woman's doting passion could be united with her in marriage, thus satisfying the hungry craving of her womb.[68]

An interesting variation on the theme of the pulse of love appears in a painting titled *Doctor's Visit* by Cornelis de Man (fig. 26).[69] Here a wigged and robed physician tests his patient by simultaneously taking her pulse and pointing to a portrait of a gentleman hanging on the wall of the bedchamber. Evidently the

68. Lemnius, *Touchstone*, 1.

69. The location of the painting is unknown. See Bedeaux, "Minnekoorts," 31–32; and Jongh et al., *Tot lering*, 233.

Fig. 27 "Contentment in conceat," from Otto van Veen, *Amorum emblemata.* Antwerp, 1608. By permission of the Houghton Library, Harvard University.

subject of the portrait enjoys a privileged place in the woman's heart and in her life, for not just any man could claim the privilege of having his image hung in her private boudoir. Presumably he is her husband or lover, and is either dead or temporarily absent. The suffering of the woman and the quickening of her pulse in response to the physician's gesture indicate the cause of her ailment as abstinence-induced *furor uterinus.* Although, for obvious reasons, blooming young virgins were more often depicted by artists as lovesick than older women, the appearance of this subject, who is no longer a girl yet still possesses a womanly attractiveness, points to the possibility of widowhood as the cause of her ailment. Indeed, authors from Galen to Paré had maintained that *furor uterinus* would often occur in a widow who "hath been used to the companie of a man," and Burton noted that among the "heap of other accidents" that could instigate symptoms of hysteria in a woman was "the absence of her husband: which is an ordinary passion for our goodwives."[70] An emblem from Otto van Veen's popular *Amorum emblemata* of 1608 (fig. 27) translates the absence of a lover into visual and literary terms similar to Cornelis de

70. [Ambrose Paré], *The Workes of the Famous Chirurgion Ambrose Parey, translated out of the Latine and compared with the French by Tho. Johnson* (1649), 632; Burton, *Anatomy* (1621), 357–58.

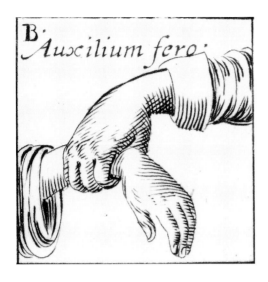

Fig. 28 Gestus B, "Auxilium fero," from John Bulwer, *Chirologia: Or the Natural Language of the Hand.* London, 1644. National Library of Medicine, Bethesda, Md.

Man's painting. The emblem shows a cupid gazing longingly at a painting of his beloved. The accompanying inscription, written in Latin, English, and Italian, is translated as "Contentment in conceit." The poetic quatrain emphasizes the inadequacy of thoughts and images as replacements for the physical presence of a loved one. Medical theory concurred, for virgins were thought to suffer uterine fits as a consequence of unfulfilled sexuality, and widows and married women were held to be afflicted for lack of sexual intercourse.

The act of taking the pulse, like the pose of the urine examiner, was an attitude associated with the earliest physicians. As an essential part of medical caregiving the act of grasping the wrist of another person—usually a male authority figure gently taking hold of a woman's wrist—became absorbed into the seventeenth-century language of gesture. Bulwer's *Chirologia* illustrates the pose (fig. 28), an attitude indistinguishable from the physician's common method of taking the pulse, as "Auxilium fero" (I bring aid). The description that follows applies to all people who, at some time in their lives, have been compelled to entrust their health and well-being to another: "The intention to afford comfort and relief . . . assurance, place, security, and promised safety and salvation. It is an expression much desired by those who are in distress and are not able to shift for themselves. . . . The 'helping hand' promising a willingness to help."[71] Bulwer's description applies emphatically to the relationship between physician and pa-

71. Bulwer, *Chirologia,* 58–59.

tient depicted in art. Paintings of the female sickroom conflate the diagnostic measure of pulse-taking with the "willingness to help" suggested by this procedure. As a result, the physical weakness and emotional instability experienced by these women is emphasized and reinforced.

Like other gestures derived from ancient tradition, that of the hand grasping another's wrist appeared in settings that were not overtly medical, alluding inescapably to the care, support, and sympathy linked in the popular mind with its ancient medical context. Thus, the gesture associated with debilitated women under the care of their physicians becomes all the more meaningful when utilized in the context of other male-female relationships. The attitude occurs, for example, in Bartholomeus van der Helst's double portrait (1654) of Abraham del Court and his wife, Maria de Keerssegieter, who were married in 1650 (fig. 29). Here Abraham and Maria, dressed in fashionable French clothing, sit in a lush landscape setting. The husband, bound by marital vows to care for his spouse until death, leans with touching deference toward his young, childlike wife, taking her wrist gently in his left hand. Historians have explained the meaning of his gesture as related to many emblem images and antique sources that cite hand-holding as a signifier of marital fidelity.[72] The husband in van der Helst's painting does not hold his wife's hand, however, but cradles her wrist. Abraham del Court's pose parallels Bulwer's illustration, which pictures a gesture of hope and support associated since ancient times with the humanitarian practice of medicine.

Appetite Disorders

Two paintings by Jan Steen, *Doctor's Visit* (ca. 1663–65) and *The Love Offering* (ca. 1664–68), illustrate another important symptom of *furor uterinus*, that of perverted appetite. The paintings are similar in that they depict listless young women, their bodices unlaced, in the company of friends and family. Both works also include a mischievous young man who confronts the girl with a dead herring in one hand and a bunch of onions in the other. The

72. See Christopher Brown, *Art in the Seventeenth Century* (1976), 50–51. For an interpretation of hand-holding between men and women as a gesture of marital faith, see de Jongh, *Portretten*, 50–53 and passim.

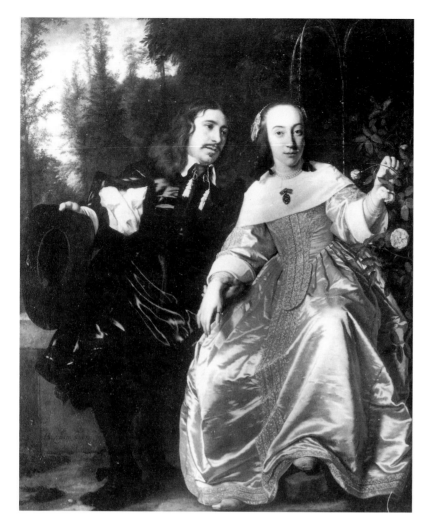

Fig. 29 Bartholemeus van der Helst, *Portrait of Abraham del Court and His Wife, Maria de Keerssegieter*, 1654. Museum Boymans-van Beuningen, Rotterdam.

Doctor's Visit (fig. 30, colorpl. 3) shows the boy (who bears the features of the artist) looking out at the viewer, laughingly mocking the ailing maiden. *The Love Offering* (fig. 31) lacks the presence of a doctor but nonetheless depicts a feverish, debilitated maiden gazing appreciatively at the youth's gifts, thus inspiring the title under which the work now hangs.[73] Scholars have interpreted the herring as a symbol of folly, unchastity, and licentiousness; this reading, however, does not account for the onions, which are at least as prominent in the painting as the fish.[74] One interpretation views the combination of onions and herring in these two paintings as symbols of the male testicles and penis on account of their

73. According to Sutton, "Jan Steen," 24, the composition was repeated in a third Steen painting, now lost.
74. Ibid., 23.

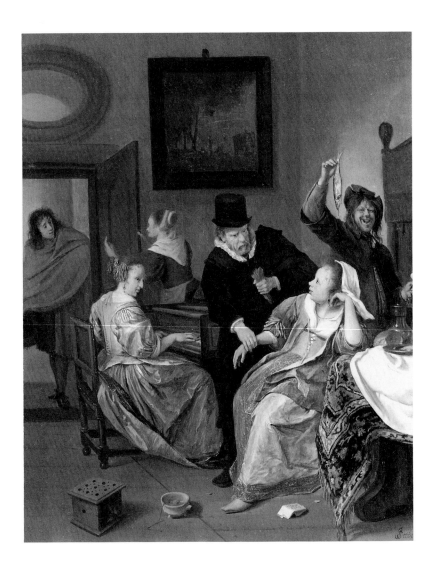

Fig. 30 Jan Steen, *Doctor's Visit*, ca. 1663–65. Philadelphia Museum of Art: John G. Johnson Collection.

visual juxtaposition in the scene. If, as it is traditionally assumed, the girl is pregnant, the herring would therefore signify "the unsalted truth," in this case, the revelation of her condition. This interpretation finds support in the Dutch expression "to give someone a red herring" ("iemand een bokking geven"), a form of rebuke.[75]

A lewd Freudian reading, though supportable by seventeenth-century Dutch literary sources and visual innuendo, is not the only way to see Steen's herring-onion combination. Herring was also considered a very healthy food. The proverb "Haring in het land,

75. See P. J. J. van Thiel, "Frans Hals' portret van de Leidse rederijkersnar Pieter Cornelisz, van der Morsch, alias Piero (1543–1628)" (1961); and Dirk Bax, *Hieronymus Bosch: His Picture Writing Deciphered* (1979), 218–19.

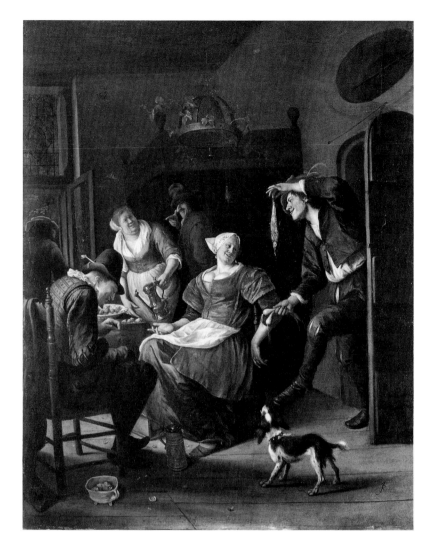

Fig. 31 Jan Steen, *The Love Offering*, ca. 1664–68. Musée d'Art Ancien, Brussels.

Dokters aan den kant" (the more herring in a land, the poorer the doctors) attests to the healthful status of the fish and is a parallel to the common contemporary English saying, "An apple a day keeps the doctor away."[76] Furthermore, humoral theory rated all fish cold and wet, and physicians prescribed eating them as a remedy for fevers as well as "hot livers and burning agues."[77] Onions also enjoyed a reputation for healthfulness, as their hot, dry qualities effectively mediated the cold, wet characteristics of phlegmatic

76. Roelof Murris, *La Hollande et les hollandais au XVIIᵉ et au XVIIIᵉ siècles vus par les fran-çais* (1925); François-Michel Janiçon, *État présent de la république des Provinces-unies, et des pais qui en dépendent* (1730), 1:443.

77. William Vaughan, *Directions for health, both natural and artificiall: Approved and derived from the best Physitians* (1626), 21–22.

persons. Naturally phlegmatic women were instructed to eat on-
ions as a means both to induce menstruation and to "clarify the
voice."[78]

Steen's deliberate choice of herring and onions in his two depic-
tions of ailing girls may also suggest *anorexia*, or perverted appe-
tite. This symptom of *furor uterinus* had been noted since the time
of Hippocrates, and was continually emphasized in seventeenth-
century descriptions of womb disorders.[79] With the advent of
Christianity, withdrawal from healthy food became an expression
of piety and goodness among women and was a distinguishing
characteristic of many female saints. Later, among Protestants,
anorexia was perceived as a negative condition, associated with
overzealous celibacy, rather than as the admirable quality that dis-
tinguished the "good girls" of Catholicism.[80] Bernard Mandeville
described the disgusting food cravings evidenced by such ailing
young women, referring to "the fanciful hankering after Trash,
generally observed in Green-sickness Girls." Such "hankerings"
were more insistent than the food preferences of normal people,
approaching "violent eagerness of Longing."[81] In *The virgin un-
mask'd* Mandeville further claimed that the young virgin suffering
from *furor uterinus* was not

> able to endure the sight of Bread, Loath[es] the best of Food, and in
> an instant, get[s] an aversion to twenty things, which she used to
> admire before; whilst she'll run raving Mad for strange, nasty, and
> unnatural messes, that no human stomach, of people in their senses,
> ever craved; with an appetite so uncommon, and unaccountable,
> that if it be not satisfied, and she is denied, or any way hindred in her
> frentick lusts, she'll swoon away, be thrown into convulsions, and
> such agonies that have often proved fatal.[82]

78. Ibid., 27.
79. Trotulan treatises also named anorexia as a symptom of womb disorders. See Hal-
laert, *Sekenesse of wymmen*, 29. The symptom is also described by Giorgio Baglivi, Thomas
Sydenham, George Cheyne, Robert Whytt, and other seventeenth- and eighteenth-
century authorities.
80. For an examination of anorexia in medical, cultural, and religious contexts, see Ru-
dolf M. Bell, *Holy Anorexia* (1985).
81. Mandeville, *A treatise of the hypochondriack and hysterick and passions*, 241. Mande-
ville's treatises, though printed after his death in the early eighteenth century, drew on
seventeenth-century case histories.
82. Bernard Mandeville, *The virgin unmask'd; or, Female dialogues betwixt an elderly maiden
lady, and her niece . . . on several diverting discourses, on love, marriage, memoirs, and morals, etc.
of the times* (1709), 120–21. See also Purcell, *A treatise of vapours*, 11.

All discussions of *furor uterinus* addressed the symptom of perverted appetite, but one famous case in particular bears repeating because it is especially relevant to Jan Steen's inclusion of herring and onions in his two paintings. Bernard Mandeville's *Treatise of the hypochondriack and hysterick passions* repeats a well-known instance of young girls who craved a "great quantity of herrings, and the infected onion; that were devoured without the least injury to the parties that fanciyd them."[83] The herring and onions associated with ailing girls in Steen's paintings therefore underscore the medical context of the scenes, as the case cited by Mandeville would have been known to physicians schooled in the ailments of women. Thus, the grateful smile of the girl in *The Love Offering* can be read as an acknowledgment of the fact that the young lad's unusual gift is important to her very well-being, and the impish boy in the *Doctor's Visit* could be seen as making fun of the bizarre appetite fixations of such girls. Thus, the herring and onions suggest both a symptom and, by their sexual connotations, a cure for the womb's cravings.

Physicians looked for many things when confronted with the task of diagnosis. The symptoms of *furor uterinus* were many, for the womb was believed capable of infecting every organ in the body. Revealing gestures (codified by the social conventions of the times), unusual facial expressions, odd food cravings, erratic pulse, and watery urine were some of the outward manifestations of the internal disorder caused by an afflicted uterus. These symptoms are accurately reflected in the sickroom scenes of artists, for the realms of medicine and painting shared the same popular culture.

83. Mandeville, *A treatise of the hypochondriack and hysterick passions*, 241.

III

THE WOMB INFLAMED,
THREATENED, AND DENIED
Instigators of Disease

The primary malefactor in diseases of women was always the womb, but the emotions, or "passions," played their role as instigators and perpetrators of uterine distress. The relationship between the state of a woman's mind and the condition of her body was an axiom of Galenic medicine, and had been noted long before Edward Jorden incriminated the passions as the major culprits in *furor uterinus*. Ancient humoral theory rated the emotions as hot, cold, wet, or dry, and it was believed that strong feelings could instigate physical symptoms of matching qualities. For example, "warm" passions such as love, hate, or anger heated the body, causing increased activity and, in severe cases, manic, choleric behavior.[1] By contrast, "cold" passions such as grief or loneliness were capable of cooling the body into a phlegmatic lethargy. Women, because of their innate weakness, were considered more prone than men to emotional upsets.[2] Robert Burton, for example, claimed that "many things cause fury in women, especially if they love or hate overmuch, or envy, be much grieved or angry."[3] Jorden's 1603 medical treatise on the "suffocation of the mother" blamed the "stirring of the affections

1. See Timothie Bright, *A Treatise of melancholie* (1586), 133.
2. Jacques Ferrand, *Erotomania; or, A treatise discoursing of the essence, causes, symptomes, prognosticks, and cure of love, or erotique melancholy* (1640), 11.
3. Robert Burton, *The Anatomy of Melancholy* (1932), 269.

of the mind" for the "coming of the fits" in women.[4] As an independent entity with its own willful personality, the uterus was believed capable of responding, even before the brain, to emotional stimuli. Women were not only considered frail from birth, dominated by lunar influences and bedeviled by their unstable wombs, but were also thought to be inordinately subject to emotional disturbances.

The unity of mind and body and the emotional vulnerability of women were ancient concepts that became absorbed into the conventional wisdom of the day. Though originally medical, these ideas were also reflected during the seventeenth century in the realms of philosophy, emblem literature, art, and popular culture. Metaphors for the mind-body relationship took many forms, but the most common was the Platonic image of the rational soul at sea in a bodily vessel. The analogy was borrowed by Roman Stoic philosophers, who described the individual in the throes of intense emotion as a shattered, storm-tossed ship.[5] The metaphor was very popular in the Renaissance and remained so in the seventeenth century, when the ancient belief in the dangers of the passions gave way to the concept of good and bad "oceans." Passions could indeed raise a tempest, but they could also, like gentle breezes, carry their human burden smoothly forward in life.[6]

The painter Dirck Hals illustrated the symbiotic relationship between emotional and physical well-being in two remarkable paintings of women in which their passions are reflected in paintings-within-paintings of ships at sea (figs. 32, 33, colorpl. 4). Neither work was intended to be self-consciously medical, but the appearance of the old Platonic simile indicates the extent to which ancient philosophies had become absorbed into the popular consciousness. Each painting depicts a woman alone in her room, apparently just having read a letter to which she is reacting emotionally. The appointments of the rooms are similar; each contains a window, a chair, and a painting on the back wall. In other respects, however, the works are dramatically different. One woman sits placidly smiling before a painting of a ship sailing on a calm sea

4. Edward Jorden, *A Briefe Discourse of a Disease Called the Suffocation of the Mother* (1603), 4.

5. Lucius Anaeus Seneca, *Moral Essays* (1928), 1:131. For a history of the metaphor of the ship on the ocean as the soul and body beginning with Plato, see Kathleen M. Grange, "The Ship Symbol as a Key to Former Theories of the Emotions" (1962).

6. See Juan Luis Vives, *An introduction to wysedome* (1540), fol. E5–6; Timothy Nourse, *A discourse upon the nature and faculties of Man, in several essays* (1697), 106–7.

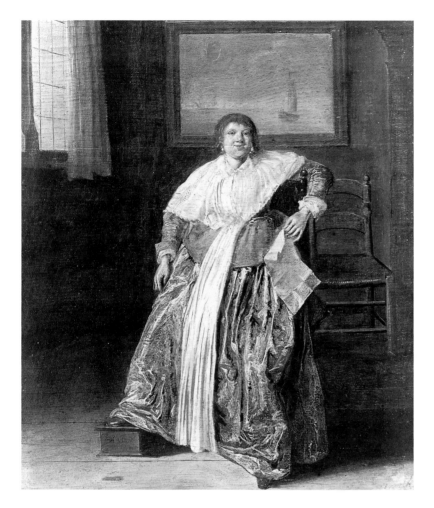

Fig. 32 Dirck Hals,
*Seated Woman with
a Letter*, 1633.
Philadelphia
Museum of Art:
John G. Johnson
Collection.

and holds her open letter delicately in her left hand (fig. 32). In striking contrast, the other woman is highly agitated (fig. 33). Her skirts swing with the force of her movement as she vigorously tears up her letter. Historians have suggested a common source for the two paintings in vernacular Dutch literature, specifically two verses by Jan Harmensz. Krul which compare the fortunes of love with the constantly changing sea.[7] A similar analogy occurs in popular emblems of the day, such as in Otto van Veen's book *Amorum emblemata* (1608). Veen's proverb "It is good sayling before the wynd" is illustrated by an emblem of lovers sailing on a calm sea, with Cupid as their navigator (fig. 34). Conversely, the vicissitudes of love, embodied by the proverb "Love never un-

7. Eddy de Jongh, *Zinne- en minnebeelden in de schilderkunst van de zeventiende eeuw* (1967), 52. See also Peter Sutton et al., *Masters of Seventeenth-Century Dutch Genre Painting* (1984), 207.

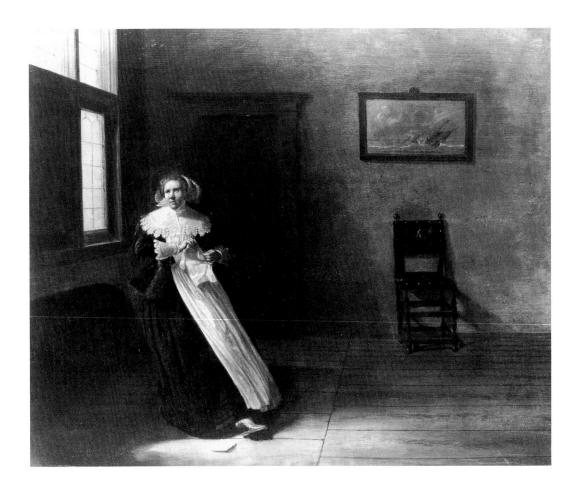

Fig. 33 Dirck Hals,
*Woman Tearing Up
a Letter*, 1631.
Landesmuseum,
Mainz.

troubled," are illustrated by the image of a grieving lover who has
turned his back on an agitated sea (fig. 35).

Dirck Hals's choice of women as carriers of emotion was proper
for his time, in view of the common belief that women's bodies
were much more susceptible to the influence of emotions than
were men's. Seventeenth-century medical literature followed an-
cient tradition, employing the comparison between violent seas
and heightened passions specifically in discussions of women.
The similie appears in Jorden's treatise on the "suffocation of the
mother," where women's bodies are compared to "shipps tossed
in the sea, exposed to all manner of assaults and dangers."[8] A few
years later Burton borrowed the analogy, declaring, "As the sea
waves so are the spirits and humours in our bodies tossed."[9] Bur-
ton also claimed that the receipt of "unexpected news" was capa-

8. Jorden, *Briefe Discourse*, 22v.
9. Burton, *Anatomy*, 241.

AMORVM.

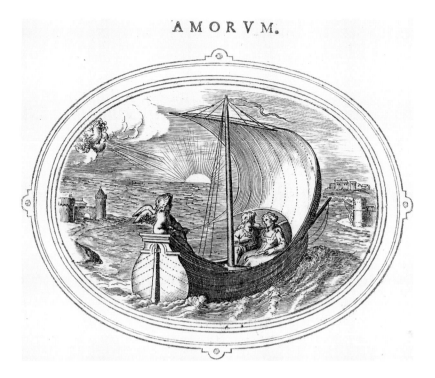

Fig. 34 "It is good sayling before the wynd," from Otto van Veen, *Amorum emblemata*. Antwerp, 1608. By permission of the Houghton Library, Harvard University.

AMORVM.

Fig. 35 "Love never untroubled," from Otto van Veen, *Amorum emblemata*. Antwerp, 1608. By permission of the Houghton Library, Harvard University.

ble of inflaming the bodily humors.[10] The torn letter (fig. 33) would therefore be interpreted medically as having agitated the heightened passions of the troubled woman. Indeed, the letters that appear in female sickroom scenes, thrown on the floor, placed on side tables, or held by suffering maidens, can be similarly interpreted (figs. 30, 42, 61, colorpls. 3, 6).

In a medical context, then, Dirck Hals's two paintings make an instructive comparison. One illustrates calm passions, calm seas, and the ideal of placid femininity (fig. 32). It recalls Cicero's metaphor of the calm sea as the unperturbed soul: "Just as the sea is understood to be calm when not even the lightest breath of air ruffles its waves, so a peaceful, still condition of the soul is discernible when there is no disturbance . . . to ruffle it."[11] By contrast, the image of the emotionally agitated woman (fig. 33) recalls Francis Bacon's belief that "as the sea would of itself be calm and quiet, if the winds did not move and trouble it . . . the mind . . . would be temperate and stayed, if the affections, as winds, did not put it into tumult and perturbation."[12] The painting on the wall of a ship leaning into blustery wind and waves recalls the unquiet passions that endanger the equilibrium necessary for health and happiness. The comparison is reinforced by the sharply off-center composition.

Dirck Hals could have been influenced by any number of visual or literary sources, and we may never know what served as the direct inspiration for his two paintings. His use of paintings-within-paintings, however, recalls an ancient medical analogy that served as a common source for a metaphoric view of the emotions in the seventeenth century. The womb was believed to be especially sensitive to passions, and images of sick women utilize the device of the painting on the wall to reinforce this fact and to suggest the nature of the illness from which they suffer. Often sickrooms are hung with images of Venus or bucolic paintings of shepherds and shepherdesses making love in the open air, an unmistakable allusion to the sexual nature of *furor uterinus* and to coitus as the certain cure (figs. 1, 19, 38, 66, colorpls. 1, 5). Paintings of quite different subjects point to other characteristics of the illness. The association of *furor uterinus* with uncontrolled passions and the willful, "animal" nature of the womb is the

10. Ibid., 337.
11. Marcus Tullius Cicero, *Tusculan Disputations* (1927), 441–43.
12. Francis Bacon, *The Advancement of Learning* (1920), 108–211.

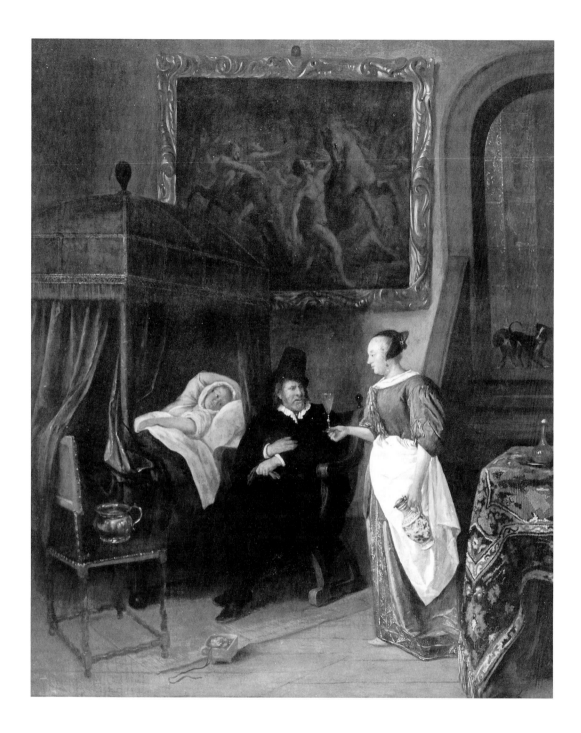

subtext of a painting that appears in the background of a work by Jan Steen on the doctor's visit theme (fig. 36). Here, a large, prominent canvas hung on the wall of a young maiden's bedchamber shows a centaur making off with a woman (possibly an allusion to the ancient legend of the abduction of Hippodamia) as a

Fig. 36 Jan Steen, *Doctor's Visit*, ca. 1668–70. Mauritshuis, The Hague.

nude male figure attempts to control a wild horse. Other elements of the main scene—prominent chamber pot, attending physician, languishing patient—point unequivocally to the popular lovesick maiden theme. Art historians have traditionally interpreted the painting on the wall as a moral allusion to the "unbridled passion" that has supposedly gripped the young woman.[13] Uncontrolled sexual passion was certainly a factor in *furor uterinus*, and the association of horses with sexual potency, a notion that dated from ancient times, was still common in the seventeenth century.[14] It is not necessary, however, to go outside the medical context in search of an explanation. In fact, medical treatises abound with references to the emotions as "wild beasts" and instructions on "bridling" the passions through industry and physical exercise. Burton declared that it was a "common experience, and our sense will inform us how violently brute beasts are carried away with this passion, horses above the rest, *furor est insignis equarum*"— strong passions are notable in horses.[15] Burton's analogy became internationally popular. It appeared in Johan van Beverwijck's *Schat der gesontheyt*, where an untranslated quotation from Burton comparing the passions to "so many wilde horses" heads the chapter on the emotions.[16]

Although physicians employed the imagery of unbridled horses when referring to uncontrolled emotions, the subtheme of animal violence and struggle in Steen's painting specifically recalls the Platonic perception of the womb as an animal, frenetic and uncontrolled in its wayward whims and appetites. Nicolas Venette's popular book on the "mysteries of conjugal love" quotes Plato in describing the womb as an "animal which moves when it loves or hates anything."[17] The progressive iatrochemist Thomas Willis employed the intensely violent imagery of "unbridled horses,

13. Eddy de Jongh et al., *Tot lering en vermaak* (1976), no. 63, links the painting of lapiths and centaurs to Achille Bocchi's emblem book, *Symbolicarum quaestionum de universa genere* (Bonn, 1555). See also Jan Baptist Bedaux, "Minnekoorts- zwangerschaps- en doodsverschijneselen op zeventiende-eeuwse schilderijen" (1975): 40–42; Baruch David Kirschenbaum, *The Religious and Historical Paintings of Jan Steen* (1977), 98; Otto Naumann, *Frans van Mieris the Elder (1635–1681)* (1981), 1:103; and Leonard Slatkes, *Vermeer and His Contemporaries* (1981), 141.

14. See Pliny the Elder, *Historie of the World* (1601), 310.

15. Burton, *Anatomy*, 3:44.

16. Johan van Beverwijck, *Schat der gesontheyt* (1638).

17. Nicolas Venette, *Venus minsieke gasthuis, waer in beschreven worden de bedryven der liefde in den staet des houwelijks, met de natuurlijke eygenschappen der manen en vrouwen, hare siekten, oirsaken en genesingen* (1688), 29. Venette's book is a Dutch translation of the original French edition, *Tableau de l'amour conjugal considéré dans l'estat du mariage* (1687).

pushed forward with spurs" in his discussion of the humoral ex-
plosions and nerve spasms implicated in his unique theory of hys-
teria.[18] Burton, a more conventional medical writer, noted that
"fits" occurred when women became "violently carried away
with this torrent of inward humors, and though very modest of
themselves, sober, religious, virtuous . . . yet cannot make resis-
tance."[19] Even Rabelais's popular satire *Pantagruel*, which ex-
presses disdain for the appetites of the wandering womb, enjoins
"virtuous women who have lived modestly and blamelessly" to
summon their courage and "rein in that unbridled animal."[20]
Steen's painting-within-a-painting is less a moralistic sermon
against the suffering woman's sin than a vivid reference to the
power of her womb to rage unbridled within her and a recogni-
tion of the struggle required to tame it.

Boiling Blood and Hot Passion: The Womb Inflamed

Most seventeenth-century treatises followed ancient tradition,
metaphorically viewing the female body as a large cooking pot in
which *furor uterinus* occurs "when the entrails are heated, when all
simmers within the body . . . and all the juices are consumed."[21]
Iatrochemical theorists attributed the "boiling blood" of hysteria
to heating caused by the excessive fermentation of humoral crudi-
ties within the body.[22] As with much early medical lore, the hu-
moral analogy between the passion of love and the heat of fire was
absorbed into common wisdom, where it permeated all facets of
the culture. Otto van Veen's *Amorum emblemata*, for example, de-
votes no fewer than thirteen emblems and epigrams to the associ-
ation of love with fire. "Love inwardly consumeth," "Love en-
kindleth love," "Loves fyre is unquenchaeable," "Soon kindled
soon consumed," and "Love liveth by fyre" are some of the pop-
ular literary associations. The image of Cupid tending a chemist's

18. Thomas Willis, "Of Convulsive Diseases," in *Dr. Willis's practice of physick, being the whole works of that renowned and famous physician* (1684), 2. For a discussion of iatrochemis-
try, see Chapter 1.

19. Burton, *Anatomy*, 365.

20. François Rabelais, *Pantagruel* (1946), 478.

21. Hippolyte-Jules de la Mesnardière, *Traité de la mélancolie* (1636), 10. See Helen King, "Once Upon a Text: Hysteria from Hippocrates" (1993), 32, for ancient references to the womb as a heated oven.

22. John Purcell, *A treatise of vapours, or, hysterick fits* (1707), 100.

Fig. 37 "Loves teares are his testimonies," from Otto van Veen, *Amorum emblemata.* Antwerp, 1608. By permission of the Houghton Library, Harvard University.

alembic illustrates the proverb "Loves teares are his testimonies" (fig. 37). In words that evoke Jacques Ferrand's medical analogy, the accompanying quatrain compares the lover's heart to a furnace, his sighs to the wind that blows the fire, and his eyes to the heated alembic.[23] Many visual references to heat—of the womb, the blood, or the passions—can be observed in paintings of the female sickroom. They recall the simile of the womb as a vessel which, when heated, causes continual simmering of the bodily humors.

Physicians justified the frequent occurrence of such a "hot" illness among naturally "cold" Dutch women by citing several unique characteristics of their culture. An important factor was the habit, common in Holland, of placing portable charcoal burners beneath the skirts for warmth. The physician Gideon Harvey viewed these *chauffrettes*, which continuously heated the lower body, as a major instigator of uterine furies. They caused women who used them to "fall into debility . . . exhausted . . . dried by the heat of their bodies."[24] This deliberate heating of the lower body, in combination with other notorious national characteristics, encouraged the widely held medical view that Dutch women

23. Otto van Veen [Vaenius], *Amorum emblemata* (1608), 288–89.
24. Gideon Harvey, *Morbus Anglicus: or The anatomy of consumptions* (1674), 23.

were especially susceptible to uterine furies. Physicians believed that the risk of heating the womb was increased by celibacy and augmented by lustful thoughts, listening to lewd jokes, talking with companions about sex, flirting with men, eating rich foods, abusing wine, and smoking tobacco. Such activities were considered warm, and were thought to increase the already abnormal heat of the uterus in celibate women.[25]

Paradoxically, though instigated by heat, *furor uterinus* manifested itself in extreme coldness of the flesh and extremities. Thomas Sydenham stated this observation vividly, noting that "dead bodies are not colder."[26] This phenomenon occurred when the body's natural cooling moisture was finally consumed by the combined factors of inflamed womb, warm passions, and the application of external heat. Edward Jorden considered northern European women especially susceptible because the natural coldness of their climate tended to "drive the humors inward," where they became stagnant, thick, and gross.[27] This effect was exacerbated by the retention of menstrual fluid or by the heated womb's hunger. As if in affirmation, the ailing women depicted by Dutch artists are often shown bundled in blankets or wearing fur-lined jackets while other occupants of their sickrooms are normally dressed. The bed-warmer pans prominently placed near them offer further evidence of the chill of their bodies (figs. 38, 74, color-pls. 5, 8). Moreover, the attitude of lethargy that typifies these women was a characteristic of people dominated by cold humors, who were described as "sleepy, slow, pale, with watery urine."[28]

The traveling Englishman Fynes Moryson noted incredulously that in Holland "the women, as well at home, as in the churches, to drive away cold, put under them little pannes of fier, covered with boxes of wood, boared full of holes on the top. And this sordid remedy they carry with them."[29] In the absence of underwear, which had not yet come into fashion, these little warmers must

25. See Trotula of Salerno, *Passionibus mulierum curandorum* (1940), 13; Jean Astruc, *A Treatise on the Diseases of Women* (1762), 242; Ferrand, *Erotomania*, 171; and Robert James, *A Medical Dictionary* (1745), 3, s.v. "hysteria."

26. Thomas Sydenham, "Of the Epidemick Diseases from the Year 1675 to the Year 1680," in *The Whole Works of that excellent practical physician, Dr. Thomas Sydenham* (1729), 376. See also Bernard Mandeville, *A treatise of the hypochondriack and hysterick passions* (1976), 276; and Mesnardière, *Traité*, 10.

27. Jorden, *Briefe Discourse*, 21.

28. Andrew Boorde, *The breviarie of health, wherein doth folow remedies for all maner of sicknesses & diseases the which may be in man or woman* (1598), 146.

29. Fynes Moryson, *An Itinerary* (1971), pt. 3, bk. 2, chap. 4, 94.

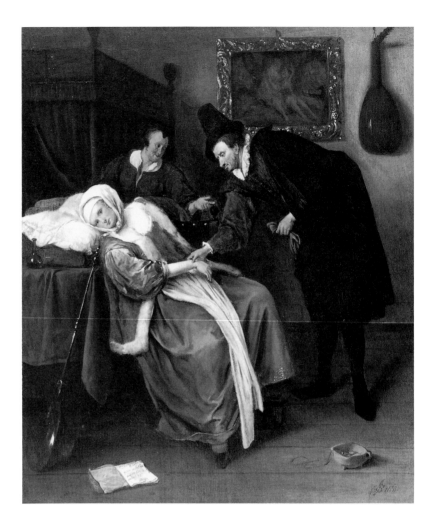

Fig. 38 Jan Steen, *The Doctor's Visit*, ca. 1663. Bequest of Mr. and Mrs. Charles Phelps Taft, The Taft Museum, Cincinnati, Ohio.

have been a necessity during the cold northern European winters. As we have seen, physicians implicated these footwarmers in the disease of *furor uterinus*. They also used the metaphorical image of the female body as a vessel warmed by the application of exterior heat in describing women afflicted by uterine furies induced by sexual abstinence. Employing the familiar terminology of alchemy, Jacques Ferrand portrayed such women as "similar to alembics flatly resting upon cylinders without one's being able to see the fire from without, yet if one looks beneath the alembic . . . one will find in both places a fiery furnace."[30] The analogy closely parallels the function of footwarmers in the everyday lives of Dutch women.[31]

30. Ferrand, *Erotomania*.
31. Illustrated in de Jongh et al., *Tot lering*, 96. See also Slatkes, *Vermeer*, 132.

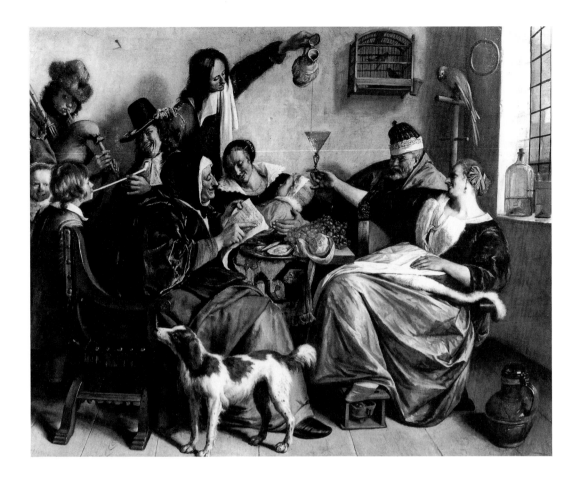

All of Jan Steen's lovesick maiden pictures show a ceramic charcoal burner placed on the floor away from the suffering maiden and outside the three-sided box that usually enclosed it (figs. 1, 22, 30, 31, 36, 38, 42, 50, colorpls. 1, 3, 5). Other painters show the empty box placed beneath a young woman's voluminous skirts, its open side turned toward the viewer, gaping suggestively between the woman's legs (figs. 19, 76). Steen documented the usual appearance and use of these warming implements in many paintings that depict the clay vessel comfortably enclosed within its box underfoot or beneath a woman's skirts (fig. 39). Yet in his lovesick maiden paintings the vessel always stands apart from its box. Why would a woman purposely remove her charcoal burner from its wooden enclosure and place it on the floor several feet away from her? Why, too, does this aberration appear only in Jan Steen's paintings of ailing women? In fact, there is a strong medical precedent for associating a clay firepot placed outside its footwarmer box with an inflamed womb that has wandered from its proper

Fig. 39 Jan Steen, *The Way You Hear It Is the Way You Sing It*, ca. 1663–65. Mauritshuis, The Hague.

place in the abdomen. Given common contemporary references to the womb as a vessel and the female abdominal cavity as a box (a slang term that is current today), this image becomes a conspicuous visual equivalent for the heated, displaced womb implicated in *furor uterinus*.

Although decorative iron braziers were sometimes favored by wealthy women, the footwarmers pictured in Steen's sickrooms are usually the more modest and breakable clay pots. The pictorial analogy of the womb as an earthenware vessel containing hot coals was derived from ancient Greek medical tradition, which described the uterus as a fragile vessel and equated abortion and birth with the breaking of the uterine "pot."[32] The characterization of the womb as a brittle vessel was absorbed into the Christian medical tradition. It appears in the *Ancren Rewle*, a medieval nun's catechism, as a panegyric to virginity: "She who bears a precious liquor or a precious drink, such as balsam, in a frail vessel . . . would not she go out of the way of a crowd, unless she were a fool? This brittle vessel is woman's flesh. Of this brittle vessel the Apostle saith: 'We have this treasure in earthen vessels.' . . . This brittle vessel's more brittle than any glass, for, be it once broken, it is never mended."[33] The image of the womb as a fragile vessel was favored by Dutch moralists, to whom a broken pot became a metaphor for defloration.[34] It follows that Dutch painters absorbed the analogy. It appears rather blatantly in a painting by Pieter Aertsen depicting the sexually charged subject of *Christ and the Adulteress* (1559) (fig. 40). Here, a woman sits in the foreground of the scene, surrounded by fruits and birds all symbolic of erotic meaning. She is seated in the midst of a pile of clay cooking pots, and she places her fingers suggestively in the mouth of one that she holds between her thighs.[35] The visual equation of clay vessel and female sexual organ is obvious, and its presence in Dutch paintings is a device of long standing with roots in many cultural contexts.

The misplaced firepots in Steen's sickrooms do not, however,

32. See P. J. Vinken, "Some Observations on the Symbolism of the Broken Pot in Art and Literature" (1958): 162–63; and Gail Kern Paster, *The Body Embarrassed: Drama and the Disciplines of Shame in Early Modern England* (1993), for other woman-vessel analogies in literature.

33. *The Nun's Rule, Being the Ancren Rewle, Modernized by James Morton* (1926).

34. See Vinken, "Some Observations," 156. The image of a broken pot as a symbol for defloration also occurs in Jacob Cats, *Spiegel vanden ouden ende nieuwen tijdt* (1632), 47.

35. See Ardis Grosjean, "Toward an Interpretation of Pieter Aertsen's Profane Iconography" (1974).

hold the "precious liquor" contained by the fragile uterine vessels of antiquity. Instead they are filled with coals, some of which glow red-hot. The medical analogy between coals and burnt humors was applied to both sexes in terms of humoral fires instigated by the hot passion of love. Levinus Lemnius compared the charred material that remained within the body to "charcoales, which beinge fired, appeare glowing hot . . . but being quesled they look black."[36] The coals contained in the clay braziers in female sickrooms therefore remind us of smoldering humors inflamed by unfulfilled passions.

The charcoal burners in Jan Steen's paintings suggest not only the condition of the womb but also the moral character of his women. An example is *The Drunken Couple* (ca. 1668–72) (fig. 41), in which a *chaufrette* suggests a sexual reference quite different from that indicated in the lovesick maiden paintings. Here the scene is not a sickroom but a brothel, and the woman is not a chaste maid but an exhausted prostitute. She reclines sleeping or unconscious on a bench, her head and arm clumsily draped over the knee of her drunken male companion.[37] On the dirty floor be-

Fig. 40 Pieter Aertsen, *Christ and the Adulteress*, 1559. Städelschen Kunstinstituts, Frankfurt am Main.

36. Levinus Lemnius, *The Touchstone of Complexions* (1576), 147–48.
37. See de Jongh et al., *Tot lering*, 246.

Fig. 41 Jan Steen,
The Drunken Couple,
ca. 1668–72.
Rijksmuseum,
Amsterdam.

neath and between her indecorously spread legs is a clay firepot, chipped and half filled with dull, spent coals. Its visual relationship to the woman's womb is unmistakable, for it is placed between her legs and tipped at an angle parallel to the position of her pelvis. In a comical aside, Steen paints a curious cat gazing intently up the woman's skirt toward the source of her heat. The woman's depleted energy, in combination with the tipped placement of the firepot, alludes obliquely to the night's heated passion, now cooled and exhausted. The cat draws attention to the cause of the woman's spent humors (recall that female cats were said to be licentious and to solicit the sexual favors of their mates).[38] The chipped pot and spent coals associated with Steen's prostitute are meant to be read in the same way as the pristine clay vessels and glowing embers belonging to the virginal young women who inhabit his sick-

38. See Chapter 2, pages 70–72, on the erotic association of women with cats.

rooms. The dual concepts of the womb as a source of heat and as a breakable vessel are represented by a single object—the clay firepot.

Abstinence: The Womb Denied

Love, or more specifically the lack of it, was clearly an important factor in seventeenth-century perceptions of *furor uterinus*. The conspicuous erotic references in paintings of the female sickroom reinforce the ancient link between sex and illness in women. As we have seen, the painting-within-a-painting accomplishes this purpose, drawing the viewer's attention to the erotic subtext of the main scene. Cupid himself sometimes appears as a small cavorting figure poised atop a doorjamb or mantel (figs. 42, 50, 66) or disguised as a mischievous small boy seated prominently in the foreground, playing with a collection of arrows (fig. 1, colorpl. 1). Even though women are always the victims in these paintings, the condition of "lovesickness" was not confined to the female sex in the seventeenth century. Men suffered from it, too, as the poetry, drama, music, and art of the time unequivocally and vociferously proclaim.[39] Male lovesickness, however, was considered a type of heroic melancholia—"erotomania"—induced by the hot passion of love igniting the bodily humors and leaving smoky black remains to settle in the spleen or liver.[40] The cause in women was the troublesome womb or "mother," which, inflamed by hot passions or disturbed by abstinence, affected the rest of the body by crowding organs, exhaling poisonous vapors, or creating sympathetic reactions, depending on whose theory one followed. The word *love*, when applied to women, did not carry the same idealistic, Neoplatonic, chivalric connotations as when applied to men. Since hysteria was considered an illness with a purely physical origin in the uterus, physicians spoke of love, when discussing women, as a thinly disguised euphemism for sexual intercourse.

Seventeenth-century treatises defined *furor uterinus* as a disease

39. For the medieval literary background of heroic lovesickness, see Mary Frances Wack, *Lovesickness in the Middle Ages: The "Viaticum" and Its Commentaries* (1990). The topic of male lovesickness is the predominant subject of Ferrand, *Erotomania*; Burton, *Anatomy*, 495–540; and André du Laurens [Laurentius], *A discourse of the preservation of the sight: of melancholike diseases; of rheumes, and of old age* (1599).

40. Described in Ferrand, *Erotomania*, 56.

Fig. 42 Jan Steen,
The Lovesick Maiden,
ca. 1661–63.
Bayerische
Staatsgemälde-
sammlungen,
Munich.

common to the entire female sex, regardless of age or marital sta-
tus. This concept was not universally shared by ancient authority.
Hippocrates, for example, viewed hysteria as a disease primarily
of widows and older women, whereas the Roman Aretaeus
claimed that only young girls were afflicted. Seventeenth-century
authorities believed in the innate vulnerability of all women,
though it became fashionable to link the afflicted womb with the
unsatisfied desire for "love," and to perceive certain women as
more threatened than others. Jean Astruc's *Treatise on the Diseases
of Women*, which drew on case histories gathered from the 1660s to
the 1720s, expanded on Burton's list of endangered women,
which had included "maids, nuns, and widows."[41] For Astruc,
"virgins, ripe for the embraces of men," and "young widows, de-

41. Burton, *Anatomy*, 414.

prived of able and vigorous husbands," were associated in the same breath with "married women coupled with impotent, or old men."[42] Such women fell victim to the disease by retaining menstrual seed "in hot and salacious bodies—an affection proper to virgins and young widows, though it could happen to young wives whose husbands are either impotent or hated."[43] Physicians further noted that married women who had not borne children were also prone to displacement of the womb.[44] Although women of any age or marital status were deemed prone to uterine fits, the majority of Dutch paintings voyeuristically depict attractive young girls rather than mature women. The same emphasis manifests itself in seventeenth-century medical texts that emphasize virginity as a major factor. Gideon Harvey notes, for example, that "young blossom'd girls seem to be troubled with another evil, to augment the fire of their doting passion, and that's their mother, which must ever and anon be a burning up to their throats upon the least disturbance of their amours."[45] Virginity was, after all, a condition common to all women, at least at one time in their lives, whereas widowhood was restricted to those who, owing to naturally strong constitutions or good luck, managed to survive or avoid childbearing and outlive their husbands.

The earliest medical texts associated symptoms of *furor uterinus* in girls with the onset of menstruation, an event that was held to coincide with the first stirrings of sexuality. The susceptibility of virgins to uterine furies was recorded by Hippocrates, who maintained that marriageable young girls were apt to fall into a kind of melancholy madness.[46] The ancient axiom was repeated in Trotula's famous manual for women: "It [womb displacement] also happens in virgins who have come to marriageable years and have not yet husbands for in them abounds the seed which nature wished to draw out by means of the male."[47] Seventeenth-century theorists took up the thread, maintaining, as Burton writes, that "generally women begin Pubesce as they call it, at fourteen years old, and then they begin to offer themselves, and some to rage. Such girls do not live but linger."[48] Some believed that the first

42. Astruc, *Treatise on the Diseases of Women*, 242.
43. James, *Medical Dictionary*, 3, s.v. "hysteria."
44. Jorden, *Briefe Discourse*, 22v.
45. Harvey, *Morbus Anglicus*, 23.
46. Hippocrates, quoted in Ferrand, *Erotomania*, 96.
47. Trotula, *Passionibus*, 11.
48. Burton, *Anatomy*, 541.

menses initiated the most serious type of *furor uterinus*. Gideon Harvey, for one, believed that "Women in this case require the presidency of cure, as being the first occasion of that sin, and first cause of the curse, witness else mother Eve."[49]

The wombs of inexperienced virgins, it seems, were especially sensitive to the presence of men. Medical treatises maintain that it was not uncommon for maidens to suffer five or six "fits" a day and to lie unconscious for eight or nine hours at a time.[50] The Anglo-Dutch physician Bernard Mandeville's entertaining popular text *The virgin unmask'd* records the suspected cause of such symptoms, couched in an amusing conversation between a "maiden lady" and her young niece, who asks: "But if man was not a venomous creature, how would it be possible that a hale, plump girl, of a good complexion, should in so little a time, after conversing with him, turn thin visaged, pale, yellow, and look as if she was bewitched?"[51] Jacques Ferrand advised parents to "have a strict eye over daughters, and not suffer them to converse with young men . . . because at this time they have an extreme raging desire over all their body."[52] Burton further scolded parents for endangering the health of their virgin daughters by delaying marriage beyond the first "stirrings" of the hungry womb, though Nicolas Venette thought that twenty was a decent age for girls to marry.[53] According to seventeenth-century accounts, *furor uterinus* was so prevalent among young, unmarried girls that it became known in medical circles as *morbus virgineus*, the "disease of virgins."

If medical and artistic references to ripe young virgins suffering from lack of sexual intercourse are more numerous, the plight of older women—widows and celibate spinsters—was not ignored by physicians and painters. Since the time of Galen and Hippocrates, widows were considered prone to *furor uterinus* caused by the supposed retention and corruption of menstrual seed. This phenomenon was especially common in postmenopausal women, whose stale menses were no longer periodically released.[54] Following in the medieval Trotula's footsteps, seventeenth-century phy-

49. Harvey, *Morbus Anglicus*, 25.
50. See Mandeville, *A treatise on the hypochondriack and hysteric passions*, 275.
51. Bernard Mandeville, *The virgin unmask'd; or, Female dialogues betwixt an elderly maiden lady, and her niece* (1709), 120.
52. Ferrand, *Erotomania*, 96.
53. Venette, *Venus*, 129.
54. *The Extant Works of Aretaeus, the Cappadocian* (1856), 475.

sicians routinely considered celibate older women highly susceptible to uterine fits.[55] Levinus Lemnius considered widows "troublesome, slippery, inconstant and unquiet . . . because they have tasted the delights of love, which sticking in their minds makes them more greedy after them, than maids are."[56] Older women and nuns living in enforced celibacy were held to be "overheated . . . sorrowful and prevented from satisfying inclinations to venereal commerce."[57]

Perhaps the most appealing painting of an ailing mature woman is Gerrit Dou's *Dropsical Woman* (1663) (fig. 43).[58] The painting, one of Dou's best-loved masterpieces, shows a suffering older woman in a well-appointed upper-class interior setting. She is attended by two female companions, one of whom weeps at her side, and a physician, who examines a urine flask held up to the light. In the foreground are a lectern upon which rests an imposing book—probably a Bible—and a basin that holds a large bottle. The painting was originally accompanied by two shutters, which have since been joined to make a single painting (fig. 44). The subject is a simple still life consisting of an ornate metal pitcher and a clean white cloth placed on a round platter. Given the grave emotional tenor of the painting, Christopher Wright has concluded that "the stout lady is genuinely ill and this is not one of the many pictures of imaginary illness brought on by love which were so often painted."[59] Likewise, Ella Snoep-Reitsma believes that the painting depicts a deathbed scene. She explains the instruments of cleansing on the joined exterior panels as symbols of moral purity, an interpretation based on Dou's appropriation of traditional iconographic elements that symbolize the purity of the virgin. She concludes that the exterior panels present a moralistic message. If the soul of the woman pictured in the main panel is pure, her death will be a welcome respite. According to Snoep-Reitsma, the medical context of Dou's painting is subservient to

55. Trotula, *Passionibus*, 110.

56. Lemnius, *Touchstone*, 147–48. See also Phillip Barrough, *The method of phisick, containing the causes, signes, and cures of inward diseases in mans body, from the head to the foot* (1583), 150; Boord, *Breviarie*, 11; Burton, *Anatomy*, 235; Jorden, *Briefe Discourse*, 19–23v.; and [Ambrose Paré] *The Workes of the Famous Chirurgion Ambrose Parey, translated out of the Latine and compared with the French by Tho. Johnson* (1649).

57. James, *Medical Dictionary*, 3, s.v. "hysteria."

58. See Rhonda Baer, "The Paintings of Gerrit Dou (1613–1675)" (1990), cat. 87a and 87b.

59. Christopher Wright, *The Dutch Painters: One Hundred Seventeenth-Century Masters* (1978).

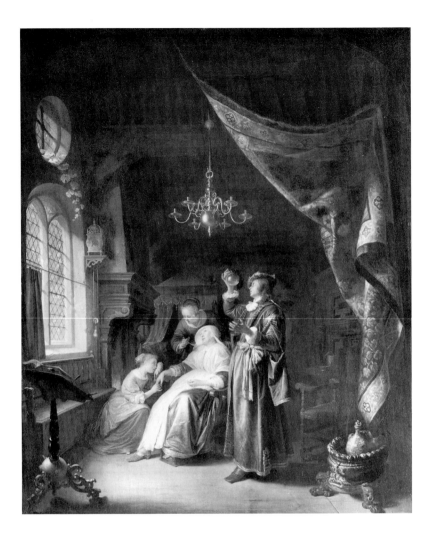

Fig. 43 Gerrit Dou,
Dropsical Woman,
1663. Musée du
Louvre, Paris.

its moral message, which is, stated simply, that purity triumphs over sickness and death.[60]

The works of Gerrit Dou, who, like Jan Steen, came from Leiden, show a sensitivity to medical subject matter that may have been occasioned by the large number of potential patrons among the physicians and students associated with the city's famous medical school.[61] Like Steen's lovesick maiden pictures, Dou's *Dropsical Woman* contains a clear allusion to the anatomical structure of the female generative organs, embodied not in a smoldering charcoal burner but in a large basin and wine bottle placed deliberately in the right foreground of the scene (fig. 45). The large round basin,

60. Ella Snoep-Reitsma, "De waterzuchtige vrouw van Gerard Dou en de betekenis van de lampetkan" (1973).

61. See Ivan Gaskell, "Gerrit Dou, His Patrons, and the Art of Painting" (1982).

meant to hold cooling water, is supported by curiously formed legs and feet, only two of which are visible. These pudgy supports give the wine cooler a distinctly anthropomorphic look, recalling a substantial human belly balanced on stocky legs. Perhaps it was this anthropoid structure, in combination with the cold water contained in the basin, that first inspired some eighteenth-century

Fig. 44 Gerrit Dou, *Basin, Pitcher, and Cloth*, wings for *Dropsical Woman*, 1663. Musée du Louvre, Paris.

Fig. 45 Gerrit Dou,
Dropsical Woman
(detail).

observer to call Dou's suffering matron "dropsical." In fact, medieval gynecological treatises used the term "dropsy of the mother" to describe the symptoms of retained menses and swelling of the abdomen associated with *furor uterinus* in postmenopausal women.[62] In any case, it is not only the wine cooler, sugges-

62. See M.-R. Hallaert, ed., *The "Sekenesse of wymmen": A Middle English Treatise on Diseases of Women* (1982), 39.

tive though it is, but also the bottle within it that ultimately alludes to the illness from which Dou's matron suffers. The stoppered wine bottle has a round body and a narrow, elongated neck, and is decorated with a swirling, marbled texture that recalls vines or tendrils. The elaborate vessel was evidently a studio prop, for it appears in several other paintings by Dou.[63]

Within the traditional iconographic context of the womb as vessel, Dou's elaborate bottle becomes an embodiment of the diseased womb. As I have mentioned in connection with the charcoal burners in Steen's paintings, the uterine vessel was a common cultural conceit traditionally employed by writers and painters to illustrate erotic subject matter.[64] The association was blatant even in furniture for churches, as in a carved misericord (ca. 1531) found in the choir stalls of the Flemish church of Ste. Materne (fig. 46).[65] Here, a man covers his exposed genitals with his hand as he laughingly chases a demure woman who holds a large pitcher in front of her abdomen. Later artists, as we have seen, borrowed the erotic convention of the womb vessel as a not so subtle allusion to sexual intercourse in brothel scenes.[66] Likewise, Dou's long-necked bottle also alludes to the female sexual organ, though its meaning and appearance owe more to anatomical illustration than to literary convention.

The image of the womb shaped like a round bottle with a narrow neck had been proposed by medical authorities since ancient times, and appears among the gynecological illustrations of Ashmole 399 (fig. 6). This peculiar simile resulted from the belief that the vulva, vagina, and uterus of women were not separate anatomical components but a single, self-contained organ. Not until the late seventeenth century, when the Dutch anatomist Jan Swammerdam injected wax into the uterus, was its actual shape revealed. His discovery, and the subsequent heated controversy with his colleague Regnier de Graaf, was spurred by the docu-

63. It also appears in *The Doctor* (Vienna, Kunsthistorisches Museum, Baer, cat. 62.1); *Woman at the Clavichord* (London, Dulwich Picture Gallery, Baer, cat. 111.1); and *Lady at Her Toilet* (Rotterdam, Museum Boymans-Van Beuningen, Baer, cat. 114.1).

64. See Vinken, "Some Observations"; and Grosjean, "Towards an Interpretation."

65. The misericord comes from a church in Walcourt, Belgium. See Louis Maeterlinck, *Le genre satirique, fantastique et licencieux dans la sculpture flamande et wallonne; les miséricordes de stalles (art et folklore)* (1910), 177.

66. See Eddy de Jongh, "Erotica in vogelperspectief; de dubbelzinnigheid van een reeks 17de eeuwse genrevoorstellingen" (1968–69): 26.

Fig. 46 Misericord carving, Church of Ste. Materne, ca. 1531. From Louis Maeterlinck, *Le genre satirique, fantastique et licencieux dans la sculpture flamande et wallone; les miséricordes de stalles (art et folklore).* Paris, 1910. Photo: Syracuse University Photo Center.

mented fascination with gynecological theory that dominated Dutch medical schools in the seventeenth century.[67] The majority of physicians, however, adhered to the ancient Galenic view of uterine construction. The French physician Jacques Duval's description reflects the anatomical paradigm held by most seventeenth-century doctors: "If you imagine the vulva completely turned inside out . . . you will have to envisage a long-mouthed bottle hanging from a woman, a bottle whose mouth rather than base would be attached to the body."[68] Nicolas Venette made the comparison even more clearly: "A bottle gives a quite good idea of the shape of the womb."[69]

67. See Gerrit Arie Lindeboom, "Jan Swammerdam (1637–80) and His Biblia Naturae" (1982).

68. Jacques Duval, *Des hermaphrodits, accouchemens des femmes et traitement qui est requis pour les releuer en santé* (1612), 375. See also James, *Medical Dictionary*, 3, s.v. "uterus."

69. Venette, *Venus*, 25.

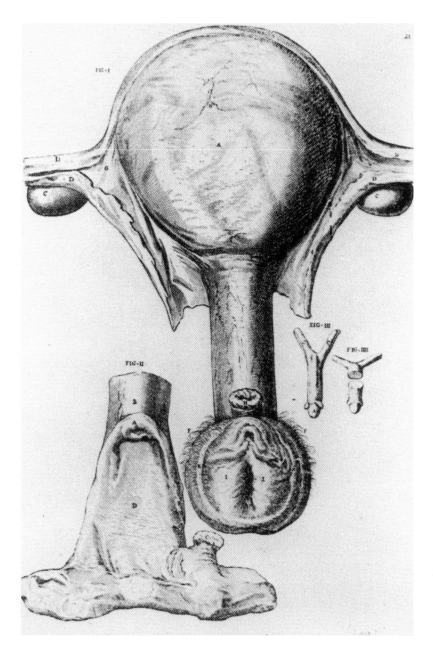

Fig. 47 Uterus, from Hieronymus Fabricius, *De formato foetu*. Frankfurt am Main, 1624. National Library of Medicine, Bethesda, Md.

Seventeenth-century medical illustrators anatomized the womb accordingly, giving it the appearance of a bottle turned upside down (figs. 47, 48, 78). The uterus diagrammed by Ambrose Paré (fig. 48) is especially interesting with reference to the bottle in Dou's painting. Here the illustrator gave the uterus a distinctly phallic shape in response to the prevalent belief that male and female sexual organs were essentially the same, but, owing to lack

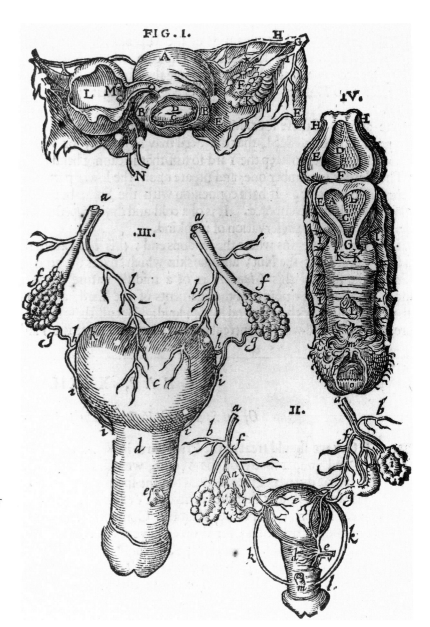

Fig. 48 Uterus, from *The Workes of the Famous Chirurgion Ambrose Parey, translated out of Latine and compared with the French, by Tho. Johnson.* London, 1678. National Library of Medicine, Bethesda, Md.

of heat, the female generative system remained in the body whereas the male genitalia were thrust outward. Thus, the vagina appears as an inside-out penis and the rounded womb as an inverted scrotum, undeveloped and imperfect.[70] The diagram also carefully delineates the many blood vessels attached to the uterus. These were believed to contain not only blood but also "spermatic fluid," and were described as running "everywhere, in a

70. Ibid., 20.

winding incurvated direction." Physicians noted these vessels and Venette described them as formed "into various windings and curls," and as being "like the tendrils of vines."[71] Dou's bottle, with its marbled and tendriled design, therefore corresponds to descriptions and illustrations of the uterus reproduced in medical texts.

The cooling function of Dou's anthropomorphic basin also suggests a medical directive associated with diseases of nuns, widows, and "ancient maids." In fact, the bottle's placement within a wine-cooling basin echoes doctors' efforts to stabilize the heated uterus by means of cooling baths.[72] Both Trotula and Paracelsus recommended the cold-water cure without reservation, and seventeenth-century physicians continued to champion it as an effective remedy for uterine furies.[73] Baths were valued for their ability to cool the womb and supply needed moisture to a body dried by excess heat. Jacques Ferrand suggested that women "bathe the privy parts" in cool water daily for several weeks.[74] Other doctors recommended a bath of ice water, for the hotter the womb, the colder the remedy.[75] Dou's choice of a wine cooler to contain the uterine vessel therefore reflects actual medical practice applied to women presumably made sick by sexual abstinence. Its upright stance within a wide enclosing basin recalls a marginal illustration that appears in a fifteenth-century Trotulan manuscript (fig. 49).[76] Here a little naked woman, her hair done up in a protective turban, cools her private parts by sitting in a large tub filled with water. The woman's relative size and position within the medieval tub correspond metaphorically to the bottle and basin in Dou's painting. She and the bottle are the same—the "weaker vessel" described by Saint Peter (1 Peter 3:7).

Dou further indicates the cause of his woman's complaint—enforced celibacy—by giving the woman's chamber a distinctly ecclesiastical air. Aside from the presence of a large Bible in the left foreground, the windows of the room—two lancets topped by a "rose," which is in turn bisected by two leaded bars in the form of

71. Ibid., 26. See also James, *Medical Dictionary*, 3, s.v. "uterinus furor."

72. See Hallaert, *Sekenesse of wymmen*, 35; Robert Turner, *De morbis foemineis* (1686), 31; and John Sadler, *The sicke womans private lookingglass wherein methodically are handled all uterine affects, or diseases arising from the wombe* (1636), 73.

73. Trotula, *Passionibus*, 5. Paracelsus' theory is discussed in Chapter 1.

74. Ferrand, *Erotomania*, 313. See also Purcell, *A treatise of vapours*, 214, 217.

75. Pierre Pomme, *Essai sur les affections vaporeuses des deux sexes* (1760), 32, 39.

76. See Anna Delva, *Vrouwengeneeskunde in Vlaanderen tijdens de late middeleeuwen* (1983).

Fig. 49 Liber Trotula,
MS. 593, fol. 5v.,
15th c. Stadsbiblio-
theek, Bruges.

a cross—strongly recall the typical clerestory fenestration of a
Gothic church. The graceful vine growing through the window
also appears in marriage portraits, and has been interpreted by art
historians as signifying piety and chaste marital love because of its
habit of clinging to upright walls.[77] Its presence in the sickroom
fulfills a similar purpose, signifying chastity and faith. It would
appear that Dou's ailing woman has turned from the pleasures of
the flesh to the contemplation of God, and in so doing has suc-
cumbed to uterine furies, a disease common to devout nuns and
celibate older women.

Dou's painting, when viewed in a medical context, suggests the
health problems associated with female autonomy, whether vol-
untary or enforced by the circumstances of life. The instruments
of cleanliness on the exterior panels serve the same iconographic
function as the whisk broom hanging on the wall to the left of the
fireplace in a *Doctor's Visit* by Jan Steen (fig. 50). Such brooms are

77. See Eddy de Jongh, *Portretten van echt en trouw: Huwelijk en gezin in de Nederlandse kunst van de zeventiende eeuw* (1986), 47–50.

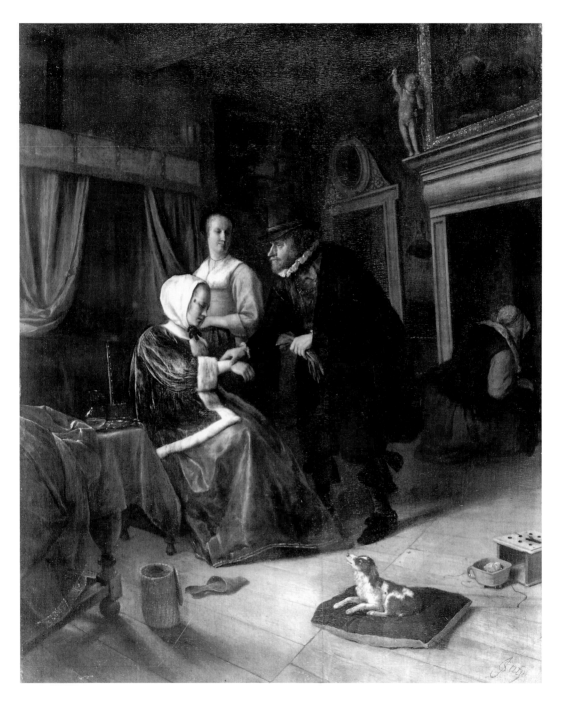

Fig. 50 Jan Steen,
Doctor's Visit,
ca. 1663–65.
Mauritshuis,
The Hague.

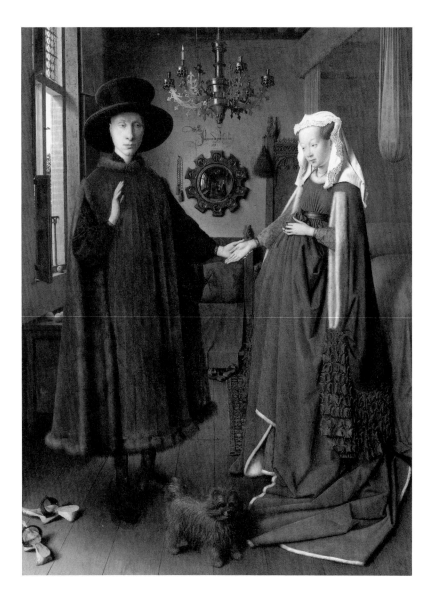

Fig. 51 Jan van
Eyck, *Portrait of
Giovanni* (?) *Arnol-
fini and Giovanna
Cenami* (?) (*Arnolfini
Marriage Portrait*),
1434. National
Gallery, London.

the secularized progeny of the broom representing marital chas-
tity that hangs on the back wall in Jan van Eyck's *Arnolfini Mar-
riage Portrait* (fig. 51) and the pitchers and basins signifying purity
in early Netherlandish paintings of the Virgin annunciate, such as
Robert Campin's *Mérode Altarpiece* (fig. 52).[78] Indeed, a copy of
Campin's work by Jacques Daret (fig. 53) substitutes a whisk
broom for the basin and a pitcher seen in the original. Here, the
broom alone represents the immaculate chastity of the annunciate

78. For discussion of whisk brooms as symbols of purity and domestic virtue, see
Wayne E. Franits, *Paragons of Virtue: Women and Domesticity in Seventeenth-Century Dutch
Art* (1993), 97–100.

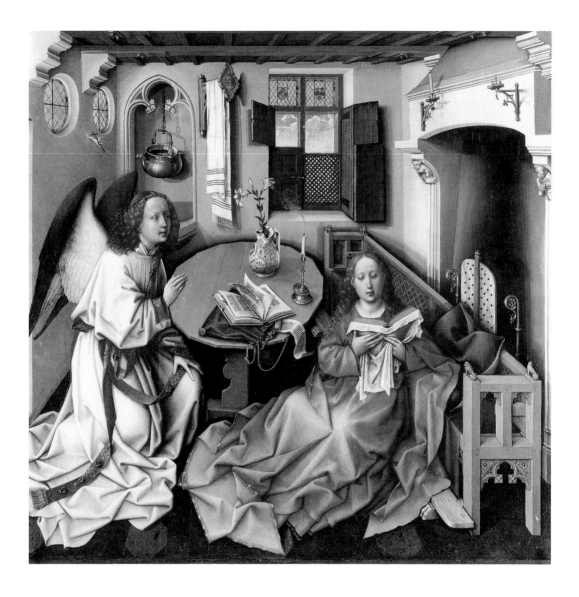

Virgin.[79] Allusions to chastity are appropriate accompaniments to an image of abstinence-induced *furor uterinus*, the proper name for the ailment from which Dou's matron suffers.

References to celibacy would be especially pertinent if Dou's ailing matron were a widow. This is a distinct possibility, for there is no sign of a husband or lover in the room, yet a weeping young girl (possibly a daughter) appears at her side. Since the early days of the church, remarriage for women after widowhood was frowned upon, and sometimes a second marriage was not

Fig. 52 Robert Campin, *Triptych of the Annunciation (Mérode Altarpiece)* ca. 1430, center panel, *The Annunciation*. Metropolitan Museum of Art, Cloisters Collection, New York, 1956 (56.70).

79. Illustrated in Carla Gottlieb, "The Brussels Version of the Mérode Annunciation" (1957).

Fig. 53 Jacques Daret, *Annunciation*, 1434. Musée d'Art Ancien, Brussels.

blessed.[80] Saint Jerome went so far as to liken the remarriage of a widow to a dog returning to its vomit.[81] Likewise, Dutch moralists suggested that the seemly course for such women was to reconsecrate their lives to celibacy and avoid the pleasures of the flesh for the rest of their lives.[82] Only the age of Dou's ailing woman differentiates her from the many contemporary paintings of lovesick maidens enduring the nasty consequences of pro-

80. See James A. Brundage, "The Merry Widow's Serious Sister: Remarriage in Classical Canon Law" (1995).

81. See Katharina M. Wilson, "Marginalized Women in Literary and Historical Perspective" (1991).

82. See Franits, *Paragons*, 161–94.

longed virginity. The cleansing implements on the exterior pa-
nels allude to chastity, but to its related dangers, not its virtues.
A physician might have considered purity, in the traditional
sense of virginity or celibacy, to have been the cause of the
woman's complaint, not the instrument of her moral salvation.
Rather than exalting the woman's purity, the painting draws
attention to the perils of enforced celibacy and the martyrdom of
widowhood.

Idleness and Luxury: The Womb Threatened

Sexual inactivity and heated passions were not the sole causes of
uterine furies in women. The ailment could also be exacerbated by
idleness and luxury. Thus, even a married woman was not neces-
sarily free from the torment of her greedy "mother" if she were of
a particular social station and enjoyed the comforts of the good
life. Slothfulness cooled the body and encouraged the buildup of
humoral waste, much as standing water putrefies and becomes
filthy.[83] Writing of *furor uterinus*, Thomas Sydenham echoed the
common belief that "an idle and sedentary life is often the sole
cause of the disease."[84] Although laziness was unhealthy for both
sexes, women were considered more prone to sloth because of
their inherent weakness. Thus, woman's adorable helplessness
also doomed her to *furor uterinus*, especially when a privileged life-
style was augmented by city living, which Burton believed often
led to a sedentary, voluptuous life. Burton took the high-minded
tone of a biblical moralist when he castigated the upper classes for
their dangerous habits:

> He or she that is idle, be they of what condition they will, never so
> rich, so well allied, fortunate, happy, let them have all things in
> abundance and felicity that heart can wish and desire, all content-
> ment, so long as he or she or they are idle, they shall never be
> pleased, never well in body and mind, but weary still, vexed still,
> loathing still, weeping, sighing, grieving, suspecting, offended
> with the world, with every object, wishing themselves gone or

83. Henry Cuffe, *The Differences of the ages of mans life: together with the originall causes,
progresse, and end thereof* (1607), 100–101; see also Jorden, *Briefe Discourse*, 22v.
84. Sydenham, *Epidemick Diseases*, 308.

dead . . . thense their bodies become full of gross humours . . .
their minds disquieted, dull, heavy, etc., care, jealousy, sullen fits,
weeping fits, seize too familiarly on them.[85]

Burton's tirade against sloth reflects a growing concern of the
seventeenth and eighteenth centuries, which exalted the simple life
above the good life. The rugged outdoor existence of peasants was
cited by social critics, moralists, and medical authorities as worthy
of emulation by the sedentary urban elite. The physician George
Cheyne echoed these larger concerns, claiming that "when man-
kind was simple, plain, honest and frugal, there were few or no
diseases."[86] The idealization of manual labor not only reminded
people of the morally upright, severe, and frugal old way of liv-
ing, but also indirectly helped preserve the dwindling manual la-
bor force needed to support the comfortable lives of the wealthy.[87]
Just as the clergy linked materialism with sin and restraint with
virtue, physicians associated luxury with illness and the simple life
with health. In the case of women, exhortations to engage in
physical labor kept the more forward of their sex from encroach-
ing on the intellectual territory of men. Hence, the repression of
willful idleness was not only a general call for economic stability
and distribution of wealth but also a plea for social responsibility
among women.[88]

The negative effect of physical inactivity on the female body is
the subtext of an engraving by Abraham Bosse, *The Foolish Vir-
gins* (fig. 54). The engraving, which illustrates a biblical parable,
depicts five fashionable young women sleeping soundly in a richly
appointed sitting room. The theme of the interior decor, which
features two paintings of Venus and/or Diana and Cupid, a paint-
ing of an amorous couple attended by Cupid, and a winged putto
with bow and arrow (perhaps Cupid again) as part of the wall fab-
ric design, hints strongly at an erotic message. But it is the large,
flaming hearth that warms the five girls and their little cat which
represents the physical consequences of their sloth. The untended
fire rages, sending great billows of smoke up the chimney. The

85. Burton, *Anatomy*, 244. See also Mandeville, *A treatise of the hypochondriack and hysteric passions*, 249.

86. Cheyne, *English malady*, 20.

87. William Temple, *Observations upon the United Provinces of the Netherlands* (1673), 141.

88. See Lawrence Babb, *The Elizabethan Malady: A Study of Melancholia in English Liter-
ature from 1580 to 1642* (1951), 33; and Stanley W. Jackson, *Melancholia and Depression from
Hippocratic Times to Modern Times* (1986), 71.

Ces Vierges au lieu de veiller, Contraines à leur propre bien, Tandis que le luxe et le jeu Ainsi leur Esprit débauché,
En attendant l'espous celeste, Par foiblesse, ou par nonchalance; Charment ces pauures Insensées; Sans auoir ny Guide, ny Phare,
Perdent le temps à sommeiller, Elles ne considerent rien, Leurs Lampes sans huile et sans feu, Dans l'obscurité du Peche,
Tant leur paresse est manifeste. Et n'ont ny soing ny preuoyance. Sont pesle-mesle renuersées. Par sa propre faute s'esgare.

image is a powerful medical analogy to the heated womb and the poisonous vapors that issue from it when the body is lulled by indolence. Intended as a contemporary evocation of the biblical legend of the wise and foolish virgins, Bosse's scene would also have been read in the contemporary popular context as a warning against the consequences of virginity when accompanied by physical inactivity and the privileges of idleness and luxury.

Fig. 54 Abraham Bosse, *Les vierges folles*, mid-17th c. From the Art Collection of the Folger Shakespeare Library, Washington, D.C.

IV

THE WOMB OCCUPIED,
RESTORED, AND SATIATED
Corporeal Cures

Working Women: The Womb Occupied

Doctors preached that a restive womb occupied an indolent body. Hence, listlessness is one symptom that is unfailingly represented by ailing women in paintings of seventeenth-century sickrooms (fig. 55). The medical term for this enervated state was *tristitia*, defined as a kind of indifference or weariness of spirit causing bodily torpor. The condition was believed to be caused by the heated womb, which dried the body and sapped its energy. Physical inactivity was not only a symptom of *furor uterinus*, however, but also a well-known instigator of the disease. Purposeful sloth had been considered a sin since the earliest days of the church, and it became ever more loathsome in Protestant Europe, where work was viewed as a source of personal and social salvation.[1] Physicians confirmed the danger of physical inactivity, noting that uterine fits rarely occurred in lower-class women "inur'd

1. This belief was put forth in the medieval era by the Salerno school of medicine and was advanced in the seventeenth century in William Temple, *Observations upon the United Provinces of the Netherlands* (1673), 141. For discussions by modern historians, see Lawrence Babb, *The Elizabethan Malady: A Study of Melancholia in English Literature from 1580 to 1642* (1951), 33; Stanley W. Jackson, *Melancholia and Depression from Hippocratic Times to Modern Times* (1986), 71; Bridget Gellert Lyons, *Voices of Melancholy: Studies in Literary Treatments of Melancholy in Renaissance England* (1971), 5–6; Frank Reyner Salter, ed., *Some Early Tracts on Poor Relief* (1926), 97–103.

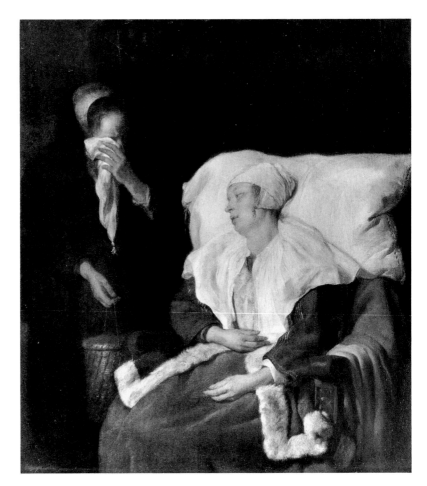

Fig. 55 Gabriel
Metsu, *The Sick
Woman*, ca. 1655–59.
Preussischer Kultur-
besitz Gemälde-
galerie, Staatliche
Museen, Berlin.
Photo: Jorg P.
Anders, Berlin.

to sweat and labour."[2] Ladies of wealth and high birth were the
most vulnerable, as Robert Burton asserted in the *Anatomy of Mel-
ancholy*, where he writes: "For seldom should you see an hired ser-
vant, a poor handmaid, though ancient, that is kept hard to her
work and bodily labour, a coarse country wench, troubled in this
kind, but noble virgins, nice gentlewomen, such as are solitary
and idle, live at ease, lead a life out of action and employment, that
fare well, in great houses and jovial companies . . . (*grandiores vir-
gines*)."[3] Burton's description echoes Ambrose Paré's observation
that country maids who worked hard and engaged in plenty of
raucous sex were not bothered by such diseases.[4] The claim that
uterine fits were rare in lower-class women was repeated many

2. John Purcell, *A treatise of vapours, or, hysterick fits* (1707), 39.
3. Robert Burton, *The Anatomy of Melancholy* (1932), 417.
4. [Ambrose Paré], *The workes of the Famous Chirurgion Ambrose Parey, translated out of the
Latine and compared with the French by Tho. Johnson* (1649), 640.

times in the seventeenth century and became even more prevalent in eighteenth-century treatises on women's complaints.[5] Medical theorists thus viewed the health of women as governed not only by their sex but also by their class.

Doctors prescribed marriage and physical work for victims of *furor uterinus*, and assured their upper-class patients that they would be better off managing clean, thrifty households than striving to improve their naturally weak minds. The frontispiece of *The Accomplisht-Ladys Delight* by Hannah Woolley (1675), which shows women cooking, applying cosmetics, and distilling medicinal elixirs, clearly delineates the activities in which they could safely excel (fig. 56). That is, women could become "accomplished," but only in the limited sphere of family and home. The healthiest life was a rugged one of self-denial and hard work in which the tantalizing and readily available pleasures of rich food, soft beds, intellectual pursuits, and leisure time were purposefully forgone. The renewed insistence that women confine themselves to the domestic sphere was encouraged by several seventeenth-century demographic trends, not the least significant of which was an increase in the number of upper-middle-class city dwellers. In the earlier days of rustic farms, housewifery went well beyond the duties that modern women generally assume. A farm, even a small one, was a sort of self-sufficient multipurpose factory, employing a full-time labor force that produced most of the things commonly used by the occupants. The housewife supervised all household activities: she oversaw the seasonal harvests; sewed the family's clothing; disciplined the servants and woke them in the morning; saw to it that soap, candles, and herbal medicines were properly made; supervised the brewing of beer, the smoking and salting of meat, the making of butter and cheese, the preserving of food for the winter, and the maintenance of livestock. In addition to these daunting duties, the housewife was directly involved in the daily routines of the household—cooking, washing, mending, and teaching her female children the skills they would need as grown women.[6] Middle-class urban living became more common in the seventeenth century, especially in the Netherlands. The decline of the family as a self-contained domes-

5. See Chapter 7 for further discussion of eighteenth-century attitudes.

6. On the division of labor in the northern European household of the preindustrial age, see Alice Clark, *Working Life of Women in the Seventeenth Century* (1919); and Richard T. Vann, "Toward a New Lifestyle: Women in Preindustrial Capitalism" (1977).

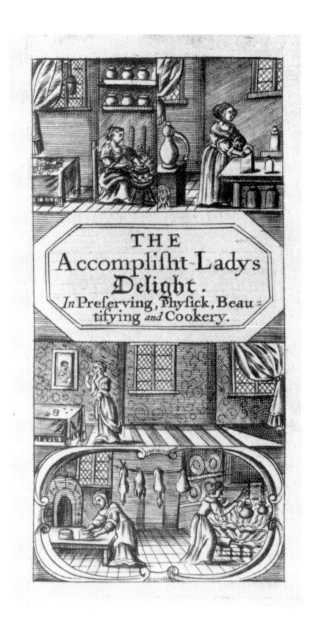

Fig. 56 Hannah Woolley, title page, *The Accomplisht-Ladys Delight. In Preserving, Physick, Beautifying and Cookery*. London, 1675. Beinecke Rare Book and Manuscript Library, Yale University. Photo: Yale University, Beinecke Library.

tic economic unit marked the beginning of modern capitalism and ushered in the concept of the bourgeois leisure class.[7] Women had less to do and were consequently more often tempted to lapse into the sloth that physicians warned would produce gynecological problems.

7. On the emergence of the leisure class in the age of capitalism, see Maurice Herbert Dobb, *Studies in the Development of Capitalism* (1947); Christopher Hill, *Reformation to Industrial Revolution: A Social and Economic History of Britain, 1530–1780* (1969). On the extent of urban living in the Netherlands, see A. M. van der Woude, "Variations in the Size and Structure of the Household in the United Provinces of the Netherlands in the Seventeenth and Eighteenth Centuries" (1972).

Physical work was thus considered essential not only for the proper running of the household but also for maintaining a woman's health, even if she could well afford to hire servants.[8] As Johannes Lange's *Treatise on the Vapors* claimed, *furor uterinus* never occurred "in married women occupied in house cleaning."[9] As we have seen, astrological medicine, in combination with anatomical theory, further encouraged women to marry and to work. Woman's inherent lunar nature could be mitigated by marriage, motherhood, and adherence to homely duties such as sewing and cooking.[10] The simple food, manual labor, and delights of the marriage bed prescribed by physicians were meager substitutes for the privileges of high social rank, though they were doubtless effective in keeping women from the exalted realms of male endeavor. Doctors counseled their female patients to take an active hand in the physical drudgery of housework and child rearing even though they could afford to do other things in their leisure time. Upper-class women were further advised to maintain a constant state of pregnancy so that the womb would be occupied at all times with its biological function. Dutch art is filled with images of the ideal housewife—subservient to her wealthy husband—working alongside her kitchen maids and actively raising small children. The various domestic tasks depicted in paintings constitute a veritable encyclopedia of housework, and have been carefully explored by several authors as embodiments of the ideal of Dutch domesticity.[11] Painting after painting shows women of all ages dressed in elegant furs and satins who don aprons to care for their children, wash clothes, mend, spin, and sweep (see fig. 57). Even in formal group portraits where entire families are portrayed, the women wear aprons and appear busy at their simple tasks of sewing, washing, and preparing food.

Such placid scenes of domestic virtue would seem to verify the words of Dutch moralists who called the home a "citadel," em-

8. See Wayne E. Franits, "Housewives and Their Maids in Dutch Seventeenth-Century Art" (1992).

9. Johannes Lange, *Traité des vapeurs* (1689), 201.

10. Claude Dariot, *A briefe and most easy introduction to the astrological judgment of the starres* (1557), 37–41.

11. For interpretations of household scenes in the context of the Dutch patriarchal call for domesticity among women, see especially Wayne E. Franits, *Paragons of Virtue: Women and Domesticity in Seventeenth-Century Dutch Art* (1993). See also Eddy de Jongh, *Portretten van echt en trouw: Huwelijk en gezin in de Nederlandse kunst van de zeventiende eeuw* (1986); Simon Schama, *The Embarrassment of Riches: An Interpretation of Dutch Culture in the Golden Age* (1987), 375–480; David R. Smith, *Masks of Wedlock: Seventeenth-Century Dutch Marriage Portraiture* (1982).

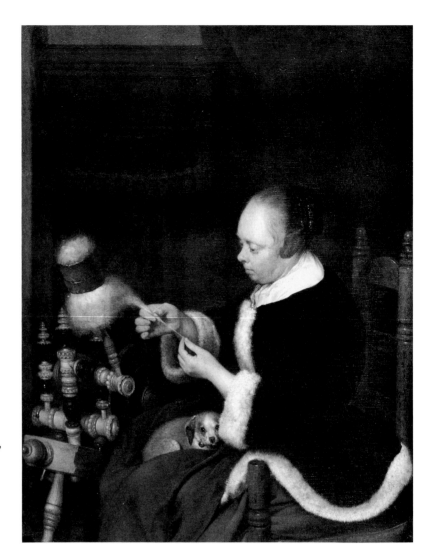

Fig. 57 Gerard ter Borch, *Wool Spinner*, ca. 1652–53. Willem van der Vorm Foundation, Museum Boymans-van Beuningen, Rotterdam.

bodying the virtues of sobriety, frugality, piety, humility, and loyalty.[12] This was certainly the case for husbands, who enjoyed uninhibited intellectual and social freedom reinforced by a solid home life, ordered and maintained by faithful, industrious wives. For the majority of women, however, home was a prison, though a prison made bearable by the love and approval not only of spouse and family but also of society at large. Domestic captivity was presented attractively by three powerful social directives: the proscriptions of doctors against idleness and sexual abstinence as instigators of uterine fits; the abundant praise heaped on the ideal of the virtuous, hardworking wife by contemporary moralists;

12. See Schama, *Embarrassment*; and Franits, *Paragons*.

and the new romantic ideal of married companionship based on love and mutual respect, which first entered the domestic sphere in the seventeenth century.[13]

Jacob Cats declared that "in our Netherlands . . . there are no yokes for the wife, nor slaves' shackles or fetters on her legs."[14] The eminent Dutch moralist evidently believed that women remained at home because they liked it there. Indeed, this is the undeniable message of many paintings of domestic scenes which reflect the novel concept of voluntary and happy domestic captivity. One such work is Hendrick Sorgh's *Family of Eeuwout Prins* (1661) (fig. 58), in which the wife, Maria van der Graeff, patiently attends two small children while her husband reads in the background.[15] Above her head a gilded bird cage hangs from the ceiling, an image that recalls several popular emblems that combine the concepts of love and subjugation. One such emblem from Daniel Heinsius' *Emblemata aliquo amatoria* (1620) (fig. 59) demonstrates love's captivity by illustrating a bird that enters its cage voluntarily. The accompanying motto reads, "I put myself in bonds" ("Perch'io stesso mi strinsi"), and the presence of Cupid suggests that the small winged captive is bound only by the confines of love. Bird cages appear frequently in paintings of women in domestic environs (figs. 12, 39).[16] Sometimes, as in the *Family of Eeuwout Prins*, the bird declines to escape even though its cage door is wide open, an image that implies not only voluntary imprisonment but also the security and protection of captivity. If love were not a force powerful enough to keep a woman housebound, such emblems served to remind her of the moral obligations inherent in marriage and the salutary effects of domesticity. This is the message of Denis Lebey de Batilly's *Regii mediomatricum praesidis emblemata* (1596) (fig. 60), in which an emblem illustrates a scene of two women in a room with an open bird cage. The accompanying

13. The image of wifely virtue was vigorously put forth in Jacob Cats's popular *Houwelijck; dat is de gansche gelegentheyt des echten staets* (1625). For discussion of Dutch domestic scenes in the context of Cats's book, see Franits, *Paragons*. For discussion of the concept of mutual love in marriage, see Rosalind K. Marshall, *Virgins and Viragos: A History of Women in Scotland from 1080–1980* (1983), 64–88.

14. Cats, *Houwelijck*, 367.

15. See de Jongh, *Portretten*, no. 57.

16. Eddy de Jongh, "Erotica in vogelperspectief: de dubbelzinnighjeid van een reeks 17de eeuwse genrevoorstellingen" (1968–69): 48–52, interprets birds in Dutch paintings as erotic symbols. Franits, *Paragons*, 80–83, interprets caged birds as embodiments of domesticity. For Petrarchan readings of bird emblems, see Mario Praz, *Studies in Seventeenth-Century Imagery* (1964), 97–99.

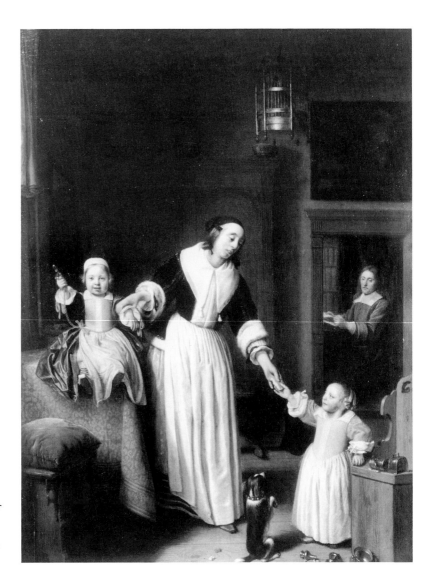

Fig. 58 Hendrick Sorgh, *The Family of Eeuwout Prins*, 1661. Historisch Museum, Rotterdam.

Latin phrases refer to enforced servitude which, if long endured, has the power to transform even the most intractable natural inclinations. Burton, however, cited "loss of liberty, servitude, imprisonment—even in rich surroundings, but at another's command," as a cause of illness, and encouraged women to busy themselves about the house in order to take their minds off their restricted condition.[17] The parallel in Dutch life and art becomes clear: the gilded cage of matrimony, home, and family was presented not as a place of confinement for women but as a haven to be voluntarily and gratefully entered.

17. Burton, *Anatomy*, 98, 343–44.

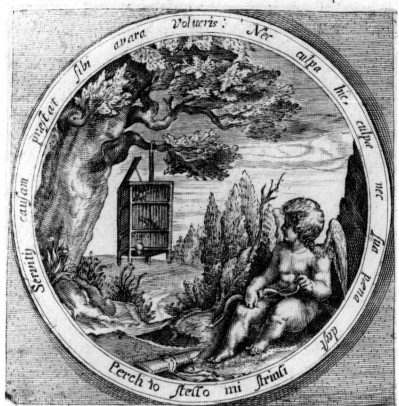

Fig. 59 "Perch' io stesso mi strinsi," from Daniel Heinsius, *Emblemata aliquo amatoria*. Leiden, 1620. By permission of the British Library, London.

The Smoldering String: The Womb Restored

Throughout history, treatises devoted to women's illnesses express deep concern for the state of "syncope" or "paroxysm," terms used in reference to a swoon or faint preceded by irregular or rapid heart palpitations.[18] Paintings that depict beautiful, voluptuous young women in states of collapse often combine concern for the seriousness of the occasion with a certain prurient fascination with the reclining female body (figs. 16, 23, 61, 62, 64, 69, colorpl. 6). The subject also afforded artists the opportunity to contrast the physical torpor of the unconscious woman with the anxious flurry of activity surrounding her. The sense of apprehension expressed in these paintings was justified by Edward Jorden's description of a fit as "the very image of death, where the pulse is scarcely or not at all perceived, the breath is gone."[19] The ability of

18. See Robert Turner, *De morbis foemineis* (1686), 63.

19. Edward Jorden, *A Briefe Discourse of a Disease Called the Suffocation of the Mother* (1603), 10–11.

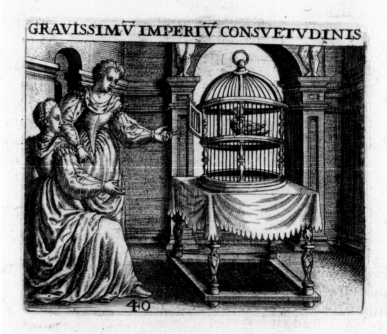

Dionyſij Lebei-Batillij Emblemata.

XL.

AD IANVM IACOBVM BOISAR-
dum, Veſuntinum.

GRAVISSIMV̄ IMPERIV̄ CONSVETVDINIS

Aſſuetus cautæ caueam ſic diligit ales,
Vt non quum poſſis, liber abire velit,
Seruitium vitæ longæ aſſuetudinis vſu
Naturam in multis ingenium�q̃ nouat.

L 3 AD CLAV-

Fig. 60 "Gravissi-mu[m] imperiu[m] consuetudinis," from Denis Lebey de Batilly, *Dionysii Lebei Batillii: regii mediomatricum praesidis emblemata.* Frankfurt, 1596. By permission of the Houghton Library, Harvard University.

such faints to mimic death was noted by the ancients and illus-trated in the pages of Ashmole 399 (fig. 3). Jorden echoed tradition when he described victims lying "like a dead corpse three hours together—or two or three days," and related instances of women who were revived as long as a week after being pronounced dead.[20] Some texts suggest that such women be kept unburied for three or

20. Ibid. See Chapter 1, page 32, for a historical discussion.

Fig. 61 Willem van Mieris, *Sick Woman*, 1695. Hermitage, St. Petersburg.

four days to see if they corrupted.[21] One physician related a horrifying account of a patient, believed dead of *furor uterinus*, who suddenly revived after an autopsy was begun on her body.[22]

Paintings of fainting women correspond closely to descriptions and recommendations found in medical books. Most of the ailing women in Dutch art, for example, appear seated upright in chairs rather than lying in bed. Even when a woman is depicted in a state of total asthenia, she remains upright, though her bed may be visible nearby. The poses of these women reflect medical instructions for treatment of a paroxysm, which suggest that the woman be

21. See John Sadler, *The sicke womans private lookingglass wherein methodically are handled all uterine affects, or diseases arising from the wombe* (1636), 65; Purcell, *A treatise of vapours*, 165.

22. Sadler, *Sicke womans private lookingglass*, 63.

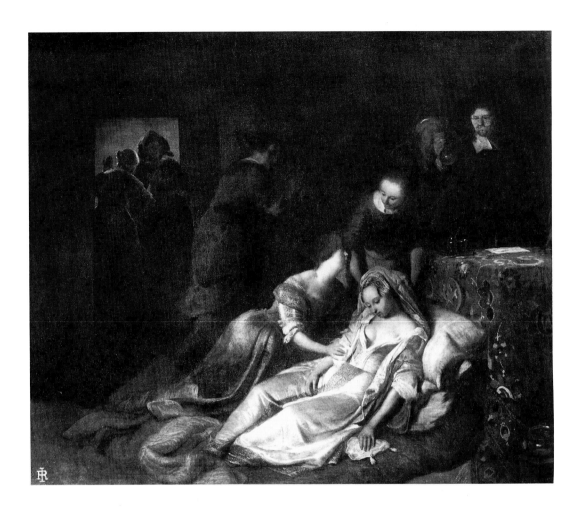

Fig. 62 Jacob Ochtervelt, *The Faint*, 1677. Museum Ca' d'Oro, Venice. Photo: Osvaldo Böhm photo archive.

placed erect, preferably in a chair, with her head propped up.[23] This position was presumed to ease the flow of moisture throughout the body and encourage the downward movement of the uterus back to the abdomen. Furthermore, physicians maintained that soft beds tended to increase heat; hence, mats and pillows stuffed with straw, leaves, willow, or horsehair were preferred to down and feather beds.[24] And indeed paintings show women seated in chairs with large pillows placed behind their backs, lying on the floor propped against a bed, or, more commonly, seated with the upper body leaning on a pillow placed on a side table. In many instances their dresses are open and their stays undone, cor-

23. See Phillip Barrough, *The method of phisick, containing the causes, signes, and cures of inward diseases in mans body, from the head to the foot* (1583), 150.

24. See Thomas Walkington, *The optick glasse of humors* (1607), 29; Jacques Ferrand, *Erotomania; or, A treatise discoursing of the essence, causes, symptomes, prognosticks, and cure of love, or erotique melancholy* (1640), 256.

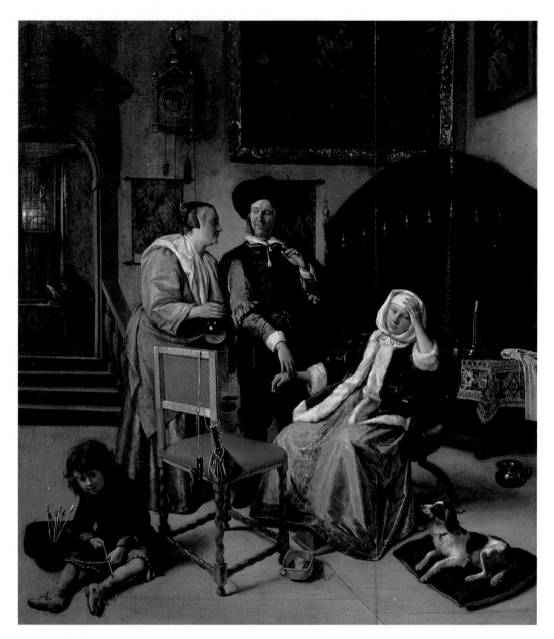

1. Jan Steen,
The Doctor's Visit,
ca. 1663. Wellington
Museum, Apsley
House, London.
Photo: By courtesy of
the Board of Trustees
of the Victoria & Albert
Museum.

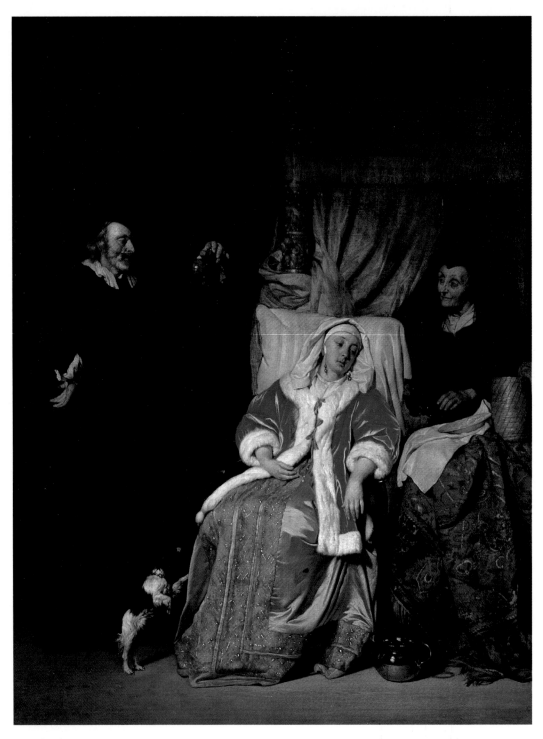

2. Gabriel Metsu,
Sick Lady and the Doctor,
ca. 1665. Hermitage,
St. Petersburg. Photo:
Metropolitan Museum
of Art, New York.

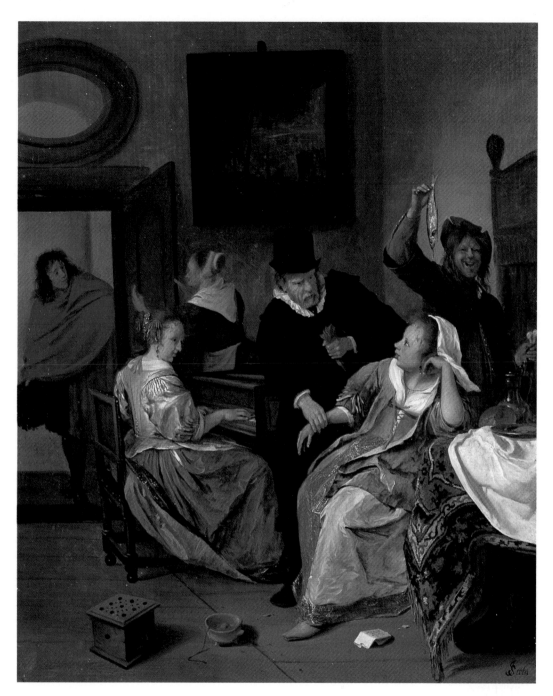

3. Jan Steen, *Doctor's Visit*, ca. 1663–65. Philadelphia Museum of Art: John G. Johnson Collection.

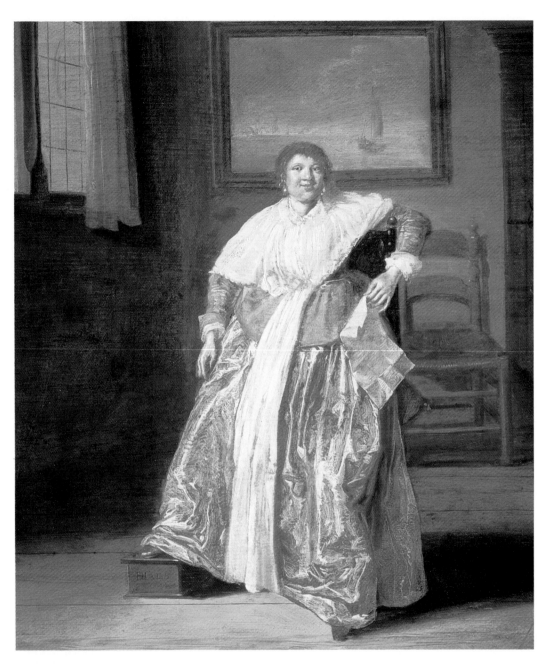

4. Dirck Hals, *Seated Woman with a Letter*, 1633. Philadelphia Museum of Art: John G. Johnson Collection.

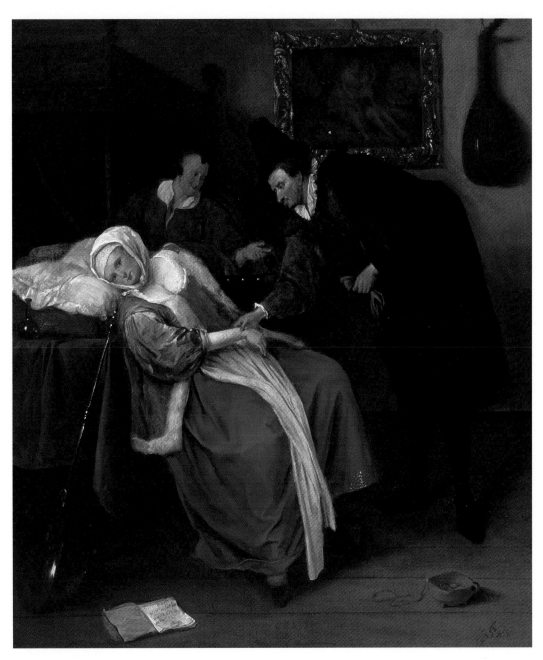

5. Jan Steen, *The
Doctor's Visit*, ca. 1663.
Bequest of Mr. and
Mrs. Charles Phelps
Taft, Taft Museum,
Cincinnati, Ohio.

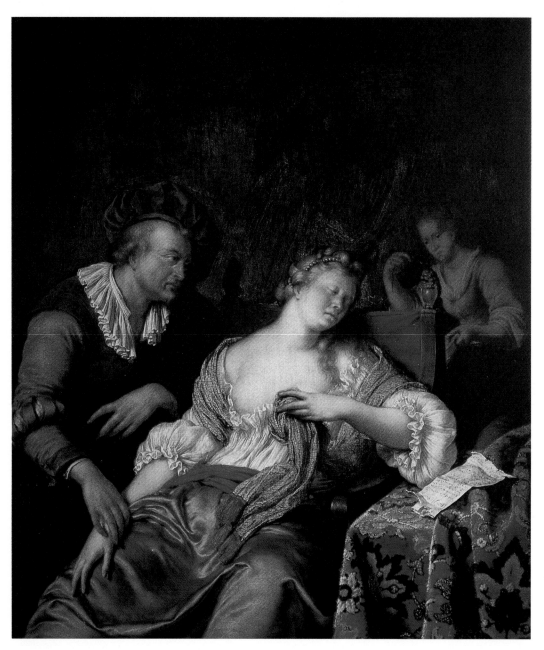

6. Willem van Mieris,
Sick Woman, 1695.
Hermitage,
St. Petersburg.

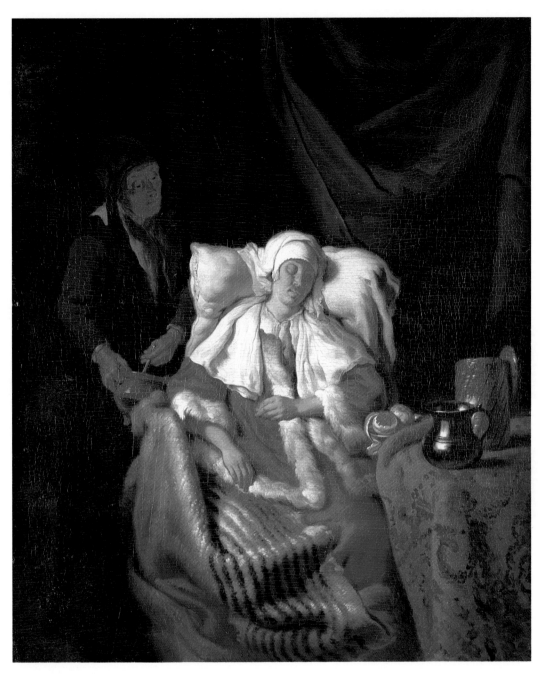

7. Gabriel Metsu,
The Sick Woman,
ca. 1650–60.
Wadsworth Athenaeum,
Hartford. Gift of Dr.
and Mrs. Charles C.
Beach.

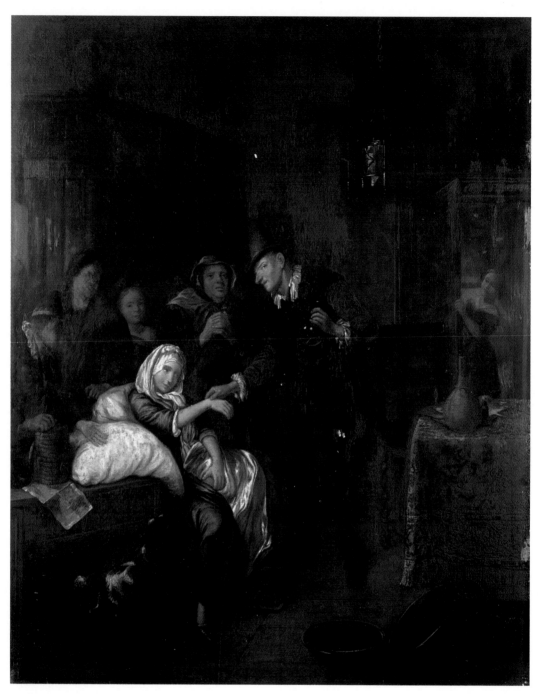

8. After Jan Steen,
*A Medical Practitioner
Taking a Girl's Pulse and
Examining a Flask of
Her Urine.* Wellcome
Institute Library,
London.

responding to further directions that "strings of petticoats [be] untied, stays unlaced, and nothing left to bind or contain them."[25] In addition to offering a tantalizing glimpse of ripe bosom, such depictions reflect the medical belief that tight clothes tended to constrict the veins. Doctors even discouraged the wearing of necklaces by women in the throes of uterine fits.

Another remedy employed against fainting appears in most of Jan Steen's sickrooms. These paintings invariably show a string or ribbon trailing across the floor with one end stuck in the coals of the omnipresent charcoal burner (figs. 1, 22, 30, 31, 36, 38, 42, 50, colorpls. 1, 3, 5). Traditionally art historians have interpreted this image, unique to Steen's paintings, as a seventeenth-century pregnancy test. If the woman reacted negatively to the smell of the ignited string, she was diagnosed as pregnant. This explanation has formed the basis for at least two erroneous inferences regarding the lovesick maiden theme—that the physicians attending these women are quacks and charlatans, and that the "lovesickness" from which the women suffer is a euphemistic allusion to pregnancy. The references that accompany scholarly discussions of the string and firepot usually cite early articles written by J. B. F. van Gils, which quote Dutch plays that supposedly describe the ribbon test.[26] In fact, neither the oft-cited articles nor the plays mention pregnancy at all; rather, they refer to the burnt ribbon as a restorative for women who have fainted.[27] Early in the twentieth century Frederick W. Schmidt-Degener offered an interpretation based on a proper reading of all sources when, in describing one doctor's visit painting by Jan Steen, he wrote, "To bring [the patient] around, her mother has burnt an apron string."[28]

25. Jean Astruc, *A Treatise on the Diseases of Women* (1762), 272.

26. J. B. F. van Gils, "Een detail op de doktersschilderijen van Jan Steen" (1920); idem, "Een detail op doktersschilderijen van Jan Steen" (1921); also maintained by Paul Zumthor, *Daily Life in Rembrandt's Holland* (1963), but with no documented references. Plays cited are Jacob Campo Weyerman, *Oog in 't zeil* (1780; cited by van Gils [1920]) and Thomas Asselign, *Jan Klaaz of gewaande dienstmaagt* (1682; cited by Cornelius Wilhelmus de Groot, *Jan Steen; beeld en woord* [1952], 52–54).

27. Cornelius Hofstede de Groot, *Beschreibendes und kritisches Verzeichnis der Werke der hervorragendsten Hollaendischen Maler des XVII Jahrhunderts* (1908–27), vol. 4, no. 146, describes a lost picture by Jan Steen which supposedly depicted a fainting maiden and bore the inscription "Als ik my niet verzind / Is deze Meid met kind" (Unless I am mistaken, this girl is with child). The picture has been lost or destroyed, however, and there is no way to verify the existence of such an inscription or to judge whether it was authentic or added at a later date.

28. Frederick W. Schmidt-Degener, *Jan Steen* (1927), 10.

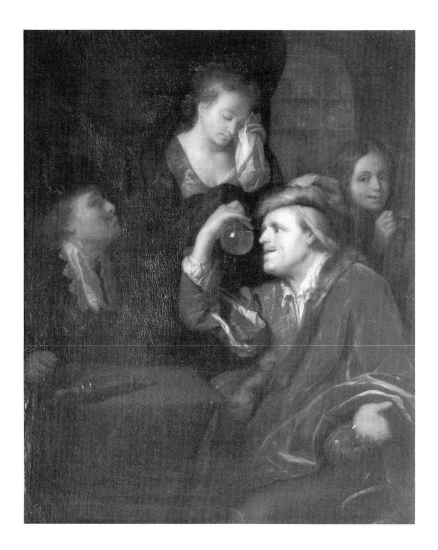

Fig. 63 Gotfried Schalcken, *Doctor's Visit*, ca. 1660–70. Rijksdienst Beeldende Kunst, The Hague, B1115.

Nonetheless, despite Schmidt-Degener's correct interpretation, the misidentification of the string and firepot as a supposed pregnancy test is still being repeated. Though spurious, this reading is understandable in the context of our own experience: after all, pregnancy is what usually springs to mind when a young, robust woman faints for no apparent reason. The swooning women in Dutch art, however, should not be diagnosed from the standpoint of modern medical or moral standards. That is not to say that artists never depicted women in a state of unwanted pregnancy. The *Doctor's Visit* by Gotfried Schalcken (ca. 1660–70) (fig. 63), for example, represents just such a situation.[29] The painting shows an

29. See Jan Baptist Bedaux, "Minnekoorts- zwangerschaps- en doodsverschijnselen op zeventiende-eeuwse schilderijen" (1975): 25; and Peter C. Sutton et al., *Masters of Seventeenth-Century Dutch Genre Painting* (1984), 300.

otherwise healthy girl weeping at a doctor's office. She is accompanied by her angry father (or aged husband), and an impish little boy who makes a lewd hand gesture. The urine flask held aloft by the physician reveals the hazy image of an infant floating within it, confirming pregnancy as the cause of the woman's distress. The painting presumably admonishes against yielding to temptation.[30] For the most part, however, the subject of pregnancy outside of marriage was rare. Its depiction in art would have been viewed by most people as offensive, even shocking.[31]

If not a pregnancy test, then, what purpose do Jan Steen's ubiquitous strings and firepots serve in the context of seventeenth-century medicine? The proper source for this image occurs in medical texts that describe a smoldering string or ribbon held to the nose as a specific against fainting in cases of *furor uterinus*. The tradition of restoring consciousness by placing foul-smelling substances to the nostrils survived to modern times in the form of smelling salts. Until the early years of the twentieth century, however, this practice was justified by the ancient assertion that the uterus was an independent animal with distinct preferences for certain tastes and smells. This perception, which dates from the time of the ancient Egyptians, was maintained by ancient and medieval medical authorities whose treatises formed the basis of the seventeenth-century medical curriculum.[32] The practice of employing fetid or smoky odors to drive the womb from the upper body or placing fragrant, sweet-smelling substances in or near the vagina to entice it back was standard medical practice for over two thousand years.

The theory of uterine attraction and repulsion through the sense of smell was perpetuated by seventeenth-century authorities, who never failed to mention it in discussions of fainting caused by *furor uterinus*. The effectiveness of fetid odors in cases of syncope and

30. The painting was once accompanied by a pendant (now in the Mauritshuis, The Hague) titled *The Useless Lesson*, which shows a seated young woman and a bird escaping from a small box placed before her on a table. Eddy de Jongh et al., *Tot lering en vermaak* (1976), 224–27, links the scene with an emblem from Jacob Cats, *Sinne- en minnebeelden*, and interprets it as a moral admonition.

31. For discussion of the stigma of illegitimate birth, see Vern L. Bullough and James Brundage, *Sexual Practices and the Medieval Church* (1982); Donald Haks, *Huwilijk en gezin in Holland in de 17de en 18de eeuw* (1985); Florence Koorn, "Illegitimiteit en eergevoel; ongehuwde moeders in Twente in de achttiende eeuw" (1987); Shulamith Shahar, *The Fourth Estate: A History of Women in the Middle Ages* (1983). For discussion of Protestant proscriptions against adultery, see Roberta Hamilton, *The Liberation of Women: A Study of Patriarchy and Capitalism* (1978), 50–63.

32. See Chapter 1 for historical discussion.

paroxysm continued to be upheld even after belief in the mobility of the uterus had died out. Iatrochemists, for example, justified the practice by claiming that good and bad smells attract and repel not the womb but the spirits.[33] Yet Edward Jorden, writing in 1603, echoed the more commonly held perceptions of seventeenth-century physicians. Accepting the ancient belief in the animal nature of the womb, he wrote that "the matrix is delighted with sweet savours," whereas "evil smells—by stirring up the expulsive facultie of the matrix, are a meanes of shortening the fit."[34]

Other texts, such as Phillip Barrough's *Method of phisick*, agreed that "the matrice flieth from stinking things, and it followeth and embraceth odiferous things."[35] Sweet smells, like soft beds, could, however, instigate a fit rather than mitigate it. Hence, physicians more often suggested repelling the womb by applying an "antihysterical odor" to the head as opposed to luring it by means of fragrant douches.[36] One text suggested that "the first thing a physician does when attending a hysteric is to see if strong stinking scents are inoffensive or beneficial."[37] The most effective odors were produced by burning organic substances, such as the squashed bedbugs suggested by Soranus or, more palatably, newly snuffed candles, partridge feathers, wool and linen cloth, or old shoes.[38] The most often mentioned were feathers and linen string, the latter described by Thomas Sydenham as "a piece of deep blue ribband . . . burnt under the patient's nose."[39] Jorden's text describes a case of syncope where "those that attended [the patient] applied partridge feathers upon coals to her nostrils." He further relates that the woman was so insensate that she did not feel the pain of a coal from the charcoal burner when it accidentally fell on her breast.[40] Sometimes the sulfurous odors produced

33. See Richard Blackmore, *A Treatise of the Spleen and Vapours, or Hypocondriacal and Hysterical Affections* (1725), 122–23. See also Ilza Veith, *Hysteria: The History of a Disease* (1965), 16.

34. Jorden, *Briefe Discourse*, 22.

35. Barrough, *The method of phisick*, 153.

36. See Purcell, *A treatise of vapours*, 11.

37. Ibid., 123.

38. See Barrough, *The method of phisick*, 150.

39. Thomas Sydenham, *Of the Epidemick Diseases from the Year 1675 to the Year 1680*, in *The whole Works of that excellent practical physician, Dr. Thomas Sydenham* (1729), 327. See also Robert James, *Medical Dictionary* (1745), 2, s.v. "hysterica."

40. Jorden, *Briefe Discourse*, 16.

by burning organic material caused sneezing, which was also viewed as beneficial in cases of fainting. Thus, feathers not only were burned but also were used to tickle the nose, as a sudden sneeze was thought capable of abruptly forcing the uterus back into place.[41] This simple remedy was suggested in ancient Egyptian papyruses and echoed in the writings attributed to Hippocrates.[42] Trotula affirmed another benefit of tickling, claiming that the great Galen once tickled an unconscious woman to determine whether or not she was alive![43]

Paintings of women's sickrooms reveal these medical traditions. They often feature extinguished candles placed on bedside tables, a possible reference to the "snuffe of a candle" believed effective in bringing unconscious women around.[44] Many paintings show a servant running to the fireplace with ribbon in hand, or a weeping maid holding a glowing string as she approaches her fainting mistress (figs. 16, 50, 61, colorpl. 6). One of Jacob Ochtervelt's sickroom scenes actually shows a woman's attendants attempting to revive her by holding a string to her nose (fig. 64). Indeed, the physician Robert Turner recommended having on hand "such stinking things that may be gotten speedily" in case a patient should suddenly swoon.[45] It would have been a convenient safeguard to keep a smoldering linen ribbon in a charcoal burner for instant access; thus the omnipresent string and charcoal burner in the paintings of Jan Steen. Like the other accouterments of the feminine sickroom, the smoldering string takes its meaning from medical theory and practice, whence it became part of popular culture and art.

Clysters and Phlebotomy: The Womb Relieved

Paintings of the female sickroom, particularly Jan Steen's lighter works, sometimes depict a large piston enema syringe held threateningly aloft by a leering old crone or a mischievous boy

41. See Barrough, *The method of phisick*, 273, quoting Galen; Purcell, *A treatise of vapours*, 178–79.

42. Hippocrates, 35th aphorism, quoted in Veith, *Hysteria*, 15.

43. Trotula, *Passionibus mulierum curandorum* (1940), 1.

44. Barrough, *The method of phisick*, 150.

45. Turner, *Morbis foemineis*, 66.

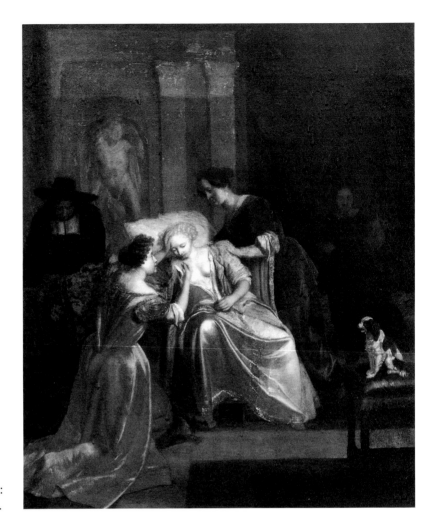

Fig. 64 Jacob
Ochtervelt, *The
Doctor's Visit,*
1680–82.
Suermondt-
Ludwig-
Museum, Aachen,
on loan from the
Bundesrepublik
Deutschland. Photo:
Anne Gold, Aachen.

(figs. 65, 66).[46] The practice of administering enemas in cases of
furor uterinus was recommended by Hippocrates and described in
Trotula's medieval texts.[47] These syringes, or clysters, were part of
the specified treatment of uterine fits and were employed in three
ways. As emetics, clysters were applied rectally to purge corrupt
humors and to irrigate the internal organs.[48] They were also ap-

46. For the medical history of the clyster, see Julius Friedenwald and Samuel Morrison,
"The History of the Enema with Some Notes on Related Procedures" (1940); William Lie-
berman, "The Enema" (1946); Piero Lorenzoni, *La giuliva siringa: Storia universale del clis-
tere* (1969); J. F. Montague, "History and Appraisal of the Enema" (1934); and H. C. Win-
chester, *All about Enemas* (1966).

47. See Hippocrates, *Des maladies des femmes,* vol. 6 of *Oeuvres complètes d'Hippocrate*
(1851), bk. 1, par. 7, 32; bk. 101, pars. 123–27; Trotula, *Passionibus,* 2; idem, *Medieval Wom-
an's Guide to Health: The First English Gynecological Handbook* (1981), 103.

48. See Timothie Bright, *A Treatise of melancholie* (1586), 277; Ferrand, *Erotomania,* 269;
François Mauriceau, *Tractact van de siektens der swangere vrouwen, en der gene die eerst gebaert
hebben* (1683), 60; and Blackmore, *A Treatise of the Spleen,* 127.

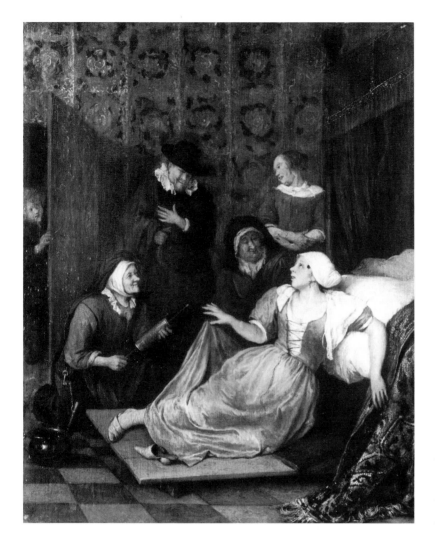

Fig. 65 Jan Steen, *Doctor's Visit*, ca. 1665. Museum der bildenden Künste, Leipzig.

plied vaginally to cool and moisten the heated womb or, in the tradition of Trotula, to lure the uterus back by means of fragrant douches.[49] When used this way, clysters were often made of sweet-smelling rose water or oil of violet.[50] Finally, clysters employed as refrigeratives consisted of cold water in which herbs rated high on the cold scale, such as endive, plantain, or poppy, were dissolved. Physicians suggested that clysters be administered frequently, at least daily for several weeks or months.[51] The treatment was designed to relieve the symptoms of *furor uterinus* either indirectly,

49. See Trotula, *Passionibus*, 5; Ferrand, *Erotomania*, 264; Purcell, *A treatise of vapours*, 190.

50. See Simon Harward, *Phlebotomy: or, A treatise of letting of bloud* (1973), 20; Ferrand, *Erotomania*, 264; and Blackmore, *Treatise of the Spleen*, 126.

51. See Bright, *A Treatise of melancholie*, 276; Sydenham, *Epidemick Diseases*, 330.

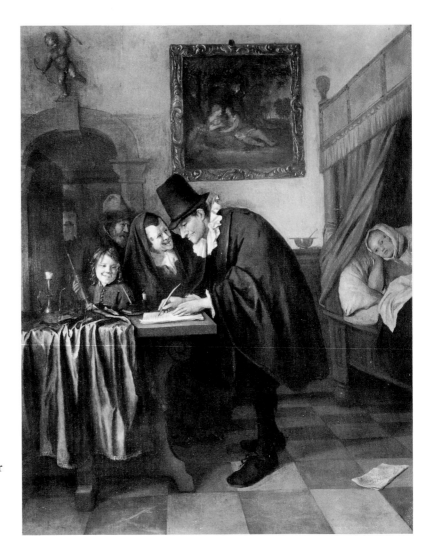

Fig. 66 Jan Steen,
Doctor's Visit, ca.
1665. Willem van der
Vorm Foundation,
Museum Boymans-
van Beuningen,
Rotterdam.

by ridding the body of putrefying waste, or directly, by cooling or
enticing the vagrant uterus back into position.

It follows that paintings and caricatures depicting clysters often
feature women, since the methods of administering such medica-
tion were too suggestive to be ignored. Such depictions therefore
conflate two standard cures for uterine disorders in a single im-
age—clysters and, by innuendo, sexual intercourse.[52] Artists cap-
italized on the prurient potential of vaginal clysters, especially
those used to relieve symptoms caused by sexual abstinence.
Abraham Bosse's illustration of the administering of a clyster is an
excellent example (fig. 67). The print shows a pale, suffering

52. See Laurinda S. Dixon, "Some Penetrating Insights: The Imagery of Enemas in
Art" (1993).

C.Dankertz exc

De Patiēt — Nadien de Medecyns Me-juffrow ordineerō / tot koeling van u brant en binne coortsen heet / Dees sachte medecyn, zoo siet my hier gereet- / on ū te helpen hebt geē vreese voor beseeren

De Oude — Sacht Meester barrebier dit sou my beter voegen / gy sout dees zieke bruyt, licht handlen wat te hart / ic weet me wel hoet hoort, want raecten gy het hert / haer bruydegom en uy die souden nietwel noegen.

De Bruyt — Wat maeckt gy al geraes om tgeē ic moet begeri / want wist ic niet dat sulcs myn brant: hertepyn / zou helpē kleet het met dan nu dat het moet syn / zoo comt ic bē gereet te dulden het clisteren.

woman, identified in the caption as a "bride," lying weakly in bed. She looks wide-eyed and expectantly at a dashing young man who approaches her holding a large phallic clyster at a salacious angle. The sick girl's mother coaxes him onward as a young maid follows, carrying a commode that the patient will need upon successful completion of the procedure. The poem that accompanies the print refers to the "mysterious malady" from which the woman suffers, and to her desire to be rid of it by means of the young man's "cure." Given the seventeenth-century medical context, the scene is easily read as a double allusion to both the clyster and sexual intercourse as antidotes to uterine furies. Bosse's print, however, like the mythical "pregnancy tests" misattributed to Jan Steen's paintings, has suffered from interpretations that owe more to modern assumptions than to contemporary reality. It has been suggested, for example, that the young barber-surgeon holding the clyster is about to perform an abortion, even though there is nothing about his costume or demeanor that supports such a con-

Fig. 67 Cornelis Dankertz, after Abraham Bosse, *The Clyster*, ca. 1660. National Library of Medicine, Bethesda, Md.

Hinc dolor; inde fuga, grauis.

DE DVOL MI STRVGGO, ET
DI FVGGIR MI STANCO

Quid, Cerue, Creſſa fixus arundine
Laxas habenas præcipiti fugæ?
Hæc ſors amantis, quem fuga concitat:
Mentem intus exeſt vulnus atrox nimis.
D 3 Prin-

Fig. 68 Hadrianus
Junius, "Hinc dolor:
inde fuga, gravis,"
from *Hadriani Iunii
medici emblemata.*
Antwerp, 1569. By
permission of the
Houghton Library,
Harvard University.

clusion.[53] The supposition that the sick woman is to be relieved of
an unwanted pregnancy is refuted by knowledge of the prescribed
use of clysters in treating women's illnesses as well as by the sec-
ondary images in the paintings that Bosse includes in the back-
ground of his scene. A painting or tapestry of a wounded stag
hunted by a man on horseback appears against the back wall of the
bedroom in the right-hand corner of the print. The wounded stag
was associated in emblem literature with unfulfilled desire and the
pain of habitual solitude (fig. 68).[54] Its appearance in Bosse's sick-

53. Simon Schama, "Wives and Wantons: Versions of Womanhood in Seventeenth-
Century Dutch Art" (1980).

54. For similar emblem images associating the wounded stag with painful love and un-
fulfilled passion, see Gilles Corrozet, *Hecatomgraphie* (1543); Hadrianus Junius, *Hadriani
Iunii, medici emblemata* (1575); Gabriel Rolenhagen, *Selectorum emblematum* (1613); Daniel
Heinsius, *Het ambach van Cupido* (1615).

room implies that the mysterious unnamed malady from which the bedridden woman suffers is not pregnancy but celibacy. The implication is further reinforced by the words of the young man holding the syringe, who reassures the ailing woman that she will be "refreshed" by his remedy, for she is "on fire," and his instrument is designed to enter her gently. Likewise, the syringes held teasingly aloft in Jan Steen's paintings not only illustrate the practical medical effectiveness of clysters, but also suggest abstinence or virginity as primary causes of women's complaints and sexual intercourse as a sure cure.

Frequently the administration of a clyster was followed by bloodletting, called phlebotomy, in the treatment of uterine disorders.[55] Though barbarous by modern medical standards, the practice of ridding the body of humoral waste or lessening a "plethora" of blood by bleeding was a legitimate method of healing from the time of Galen (ca. 130–200) up to the mid nineteenth century.[56] Isolated opposition to the practice among physicians had existed since the time of Hippocrates and continued throughout the seventeenth century.[57] In fact, several dissertations produced by Leiden graduates questioned the efficacy of phlebotomy, and some openly disapproved of the practice.[58] Nonetheless, bloodletting was embraced by the majority of seventeenth-century physicians, who employed it to relieve the symptoms of *furor uterinus*.[59] In cases of uterine suffocation caused by retained menses, physicians bled from an ankle vein.[60] The mechanistic theorist Simon Harward justified the procedure as a means of depleting "gross humors, when by their toughnesse they doe obstruct, or by their multitude oppresse the passages of transpirations, causing syncopes or swoonings."[61] In ripe, young women who were plump and "full of blood," bleeding was recommended from the hepatica (liver) vein in the right arm.[62] Traditionally, pa-

55. See Sadler, *The sicke womans private lookingglass*, 36; Blackmore, *Treatise of the Spleen*, 127.
56. See Peter Brain, *Galen on Bloodletting: A Study of the Origins, Development, and Validity of His Opinions, with a Translation of the Three Works* (1986); Audrey B. Davis and Toby Appel, *Bloodletting Instruments in the National Museum of History and Technology* (1977).
57. See Brain, *Galen on Bloodletting*, 3.
58. Gerrit Arie Lindeboom, *Dutch Medical Biography* (1984), mentions the dissertations of Paulus Barbette (1619–65), Cornelis Bontekoe (1640–85), Petrus Gequier (1634–80), Jean-Baptiste van Helmont (1577–1644), and Martinus van Dalen (b. 1646).
59. See Vivian Nutton, "Montanus, Vesalius, and the Haemorrhoidal Veins" (1983).
60. See Barrough, *The method of phisick*, 146; Ferrand, *Erotomania*, 262, 271, 338.
61. Harward, *Phlebotomy*, 109.
62. See Barrough, *The method of phisick*, 36; Ferrand, *Erotomania*, 261, 336; and Sadler, *The sicke womans private lookingglass*, 36.

tients were bled to the point of faintness, for young women were believed to suffer an excess of humors, and bleeding was employed to prevent blood vessels from bursting.[63] Phlebotomy continued to be practiced even after the principle of blood circulation was understood. During the latter half of the seventeenth century, progressive iatrochemists like Sydenham recommended phlebotomy as "a means for relieving violent fits . . . especially in younger women of a more florid and hale complexion," not because the practice relieved excess humors but because it "compresses the fury of the spirits and moderates the velocity of their flight."[64]

As an accepted practice, phlebotomy with all its apparatus was part of the medical context of Dutch art and life. Paintings often depict bleeding bowls—round basins with an indentation on one side to slip under the chin or arm for letting blood from those areas.[65] The actual procedure is illustrated in several images of ailing women. Eglon van der Neer's *A Lady Fainting after Having Been Bled* (fig. 69), for example, depicts a voluptuous young woman who lies in a graceful faint while a maid holds up her limp right arm. A tourniquet has been applied above the unconscious woman's elbow, and a bleeding bowl is placed on the floor in the left foreground.[66] Bleeding from the arm also appears in a painting by Jacob Toorenvliet (1666) in which a surgeon binds a female patient's arm after bloodletting (fig. 70). The ankle is the site of a phlebotomy procedure painted by Matthijs Naiveu, which shows a physician and a surgeon attending a sick woman whose foot is placed in a basin of warm water to facilitate the flow of blood (fig. 71).[67]

Illustrations of phlebotomy, like clyster scenes, could also allude to the erotic aspects of *furor uterinus*. An engraving by Abraham Bosse is a good example (fig. 72). It shows a dashing young man applying a tourniquet to the right arm of a fashionable woman while an assistant holds a bowl to catch the blood. As in Bosse's clyster scene, pictures-within-pictures supply clues to the

63. See Ferrand, *Erotomania*, 340; Purcell, *A treatise of vapours*, 192.
64. Sydenham, *Epidemick Diseases*, 330. See also Blackmore, *Treatise of the Spleen*, 121.
65. See Davis and Appel, *Bloodletting Instruments*, 9.
66. See ibid., 11, on the use of tourniquets.
67. See Carol Jean Fresia, "Quacksalvers and Barber-Surgeons: Images of Medical Practitioners in Seventeenth-Century Dutch Genre Painting" (1991), 100–104, for an interpretation of this painting in a theatrical context. The author sees Dutch genre paintings of bloodletting involving women as disguised allusions to medical abortions.

Fig. 69 After Eglon van der Neer, *A Lady Fainting after Having Been Bled*. The Royal Collection © 1993 Her Majesty Queen Elizabeth II. Photo: Royal Collection Enterprises, London.

subtext of the image. Hanging on the back wall of the woman's chamber are two images of a man and a woman, probably pendants of a double marriage portrait, and a larger painting beneath them depicting two men on horseback in a mountainous landscape setting. Viewed together, these images allude to the separation of husband and wife, necessitated by travel, which has brought on the woman's complaint. The words that accompany Bosse's engraving hint obliquely at the "pleasures" of phlebotomy in distinctly sexual terms. The woman begins by urging the surgeon onward—"Courage, Sir . . . puncture with confidence, make a good opening"—and continues with the exclamation "Oh gods, the gentle hand, the agreeable puncture! The recollection makes me smile once more." Finally, she reassures him by saying,

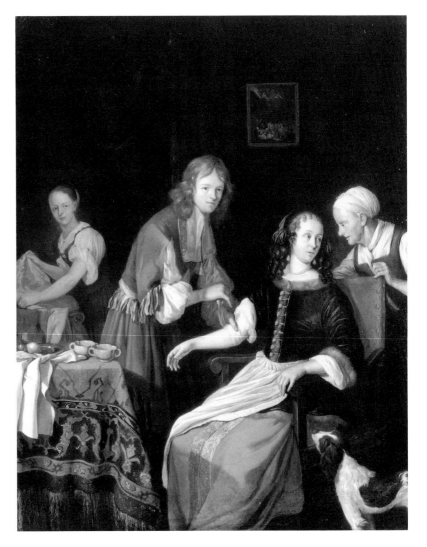

Fig. 70 Jacob
Toorenvliet,
*A Surgeon Bandaging
His Patient's Arm after
Bloodletting,* 1666.
Wellcome Institute
Library, London.
Photo: Wellcome
Centre Medical
Photographic
Library, London.

"If you should consider it necessary, then operate again. . . . I
shall endure as much as you may wish to do." Though in reality
phlebotomy undoubtedly weakened the body and aggravated ill-
ness, women preferred bleeding from the arm and foot to some of
the alternatives suggested in cases of *furor uterinus*, which included
directly alleviating retained menses by applying leeches to the
cervix.[68]

Diet: The Womb Mollified

As with any illness, physicians sought to mediate the symptoms
of uterine furies by prescribing foods and medicines opposite in

68. Prescribed by Paré, *Workes*, 639.

quality to the disease itself. Although one of the symptoms was coldness of the extremities, the illness itself was classified as a hot, dry affliction caused by the inflamed uterus's siphoning heat from the rest of the body. Thus, Galenic tradition required the application of cold, wet substances, such as the cold baths alluded to in Dou's *Dropsical Woman* (fig. 43), and the avoidance of hot, dry substances such as coffee, tobacco, and chocolate. Cooling, moisturizing counterhystericals were distilled into medicinal elixirs and included in the daily diet. Meals were to be simple affairs, consisting of lots of liquids and "soft, tender" foods such as dill, lettuce, eggs, fish, roses, violets, and fruit.[69] Some physicians, including Sydenham, who gave a recipe for a "hysteric julep," prescribed iron or steel filings suspended in liquid, not realizing

Fig. 71 Matthijs Naiveu, *A Physician Taking a Woman's Pulse Whilst a Surgeon Bleeds Her Foot.* Wellcome Institute Library, London. Photo: Wellcome Centre Medical Photographic Library, London.

69. See Marsilio Ficino, *The Book of Life* (1980), 10–18. The Ficinian diet is recommended in Bright, *Treatise of melancholie*, 257–61; Ferrand, *Erotomania*, 238–48; Jorden, *Briefe Discourse*, 24; André Du Laurens [Laurentius], *A discourse on the preservation of the sight* (1599), 365; Gideon Harvey, *Morbus Anglicus: or The anatomy of consumptions* (1674), 108–10; George Cheyne, *The English malady; or, A treatise of nervous diseases of all kinds, as spleen, vapours, lowness of spirits, hypochondriacal, and hysterical distempers, etc.* (1976), 103–15, among others.

Fig. 72 Abraham Bosse, *Bloodletting*, mid-17th c. From Eugen Holländer, *Die Medizin in der klassischen Malerei*. Stuttgart, 1950. Photo: Syracuse University, Photo Center.

that the illness they were treating was actually a form of anemia, yet recognizing the therapeutic effect on their female patients.[70]

Dietary cures for uterine fits are often depicted in paintings of the female sickroom, many of which include stoppered medicine flasks, wineglasses filled with light-colored liquid, and fine china dishes containing slices of lemons. A *Doctor's Visit* by Jan Steen (ca. 1668–70) (fig. 36), for example, shows a bedridden girl and her seated doctor being approached by a woman carrying a wineglass. Even though it seems that the doctor may be the intended recipient, the glass could just as easily be meant for the ailing girl, who also gazes expectantly toward it. Indeed, doctors favored the administration of a small amount of white wine for its ability to increase the vital spirits in women weakened by a fit.[71] The glass in Steen's painting need not contain wine, however, as medicines were commonly measured by the wineglass.[72]

70. Sydenham, *Epidemick Diseases*, 376. See also Blackmore, *Treatise of the Spleen*, 114, 170; Richard Browne, *Medicina musica: or, A mechanical essay on the effects of singing, musick, and dancing, on human bodies* (1729), 117.

71. They never prescribed red wine, however, which was considered too strong. See Thomas Cogan, *The haven of health, chiefly made for the comfort of students and consequently for all those that have a care of their health* (1612), 108–9; Du Laurens, *A discourse on the preservation of the sight*, 106; and Purcell, *A treatise of vapours*, 213.

72. See Bernard Mandeville, *A treatise of the hypochondriack and hysterick passions* (1976), 257.

The most effective dietary mediators of excess heat were citrus fruits, especially lemons, which were considered the most cooling because of their high acidity.[73] The application of cooling citrus fruit and juice to bodies heated by humoral fires was recommended by Aristotle and perpetuated in Ficino's *Triplici vitae*.[74] Seventeenth-century doctors, recognizing the healthful effects of citrus fruit despite having no knowledge of the properties of vitamin C, continued the tradition begun by the ancients.[75] Dishes of thinly sliced lemons or partially peeled oranges are often the only food appearing on bedside tables in paintings of female sickrooms (figs. 17, 42, 73, 76, colorpls. 2, 7). An extraordinary painting by a follower of Jan Steen housed in the Wellcome Institute in London illustrates clearly, if somewhat crudely, the power of citrus fruit to ease the symptoms of *furor uterinus* (fig. 74, colorpl. 8). The work shows an ailing girl, languishing in the tradition of Steen's many lovesick maidens, holding an orange to her crotch as if to force the cooling of her private parts. The orange, like the sliced lemons also pictured in female sickrooms, was supposed to douse the heat of the inflamed womb much as a bucket of water quenches a fire.

Marriage: The Womb Satiated

No matter what euphemisms were applied to the ravenous uterus—"inflamed," "restive," "wayward," or "hungry"—it was understood that the womb's ultimate quest was for male "seed," obtainable only through sexual intercourse. Hence, medical authorities, including both the most conservative and the most progressive seventeenth-century theorists, cited sexual deprivation as the primary cause of *furor uterinus*. That is not to say that women did not value chastity; the Christian ethic still instructed that young girls remain virgins until marriage, that nuns commit themselves to perpetual virginity as brides of Christ, that wives curb their lust, and that widows abstain in deference to so-

73. See John Floyer, *The physician's pulse-watch; or, An essay to explain the old art of feeling the pulse, and to improve it by the help of a pulse-watch* (London, 1707), 1:68.

74. See Ficino, *Book of Life*; Jean Starobinski, *Histoire du traitement de la mélancolie des origines à 1900* (1960), 38.

75. See Ficino, *Book of Life*, 10; Ferrand, *Erotomania*, 245; Floyer, *The physician's pulse-watch*, 68; Du Laurens, *Discourse*, 38; Mandeville, *Treatise of the hypochondriack and hysteric passions*, 10, 27, 32.

Fig. 73 Gabriel
Metsu, *The Sick
Woman*, ca. 1650–
60. Wadsworth
Athenaeum,
Hartford. Gift of
Dr. and Mrs.
Charles C. Beach.

cial decorum.[76] Sexual abstinence, though virtuous, was also perilous, however, and despite the profusion of cures designed to restore, relieve, appease, and occupy the smoldering womb, there remained but one sure remedy: the unfulfilled uterus must be satiated by sexual intercourse and childbirth within the lawful social confines of marriage. Even women to whom sexual intercourse was not permitted were allowed release by means of manual or chemical stimulation of the genitals. One seventeenth-century physician echoed the advice of ancient and medieval authorities when he stated delicately: "In hysterical women who are devoutly chaste the future is unhappy unless reason and honor suggest to

76. For discussion of the traditional Christian perception of virginity, see Joyce E. Salisbury, "Fruitful in Singleness" (1982).

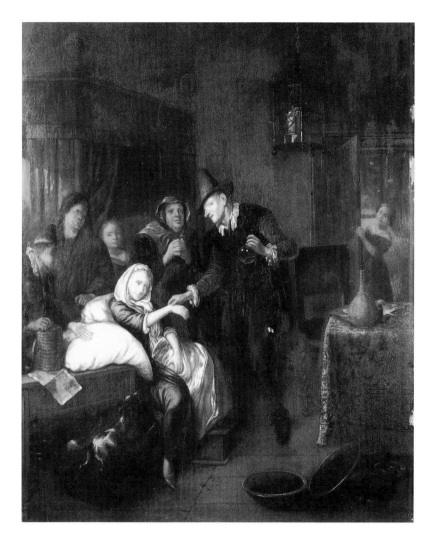

Fig. 74 After Jan Steen, *A Medical Practitioner Taking a Girl's Pulse and Examining a Flask of Her Urine.* Wellcome Institute Library, London. Photo: Wellcome Centre Medical Photographic Library, London.

them moments in which they can temper the fire of their burning uterus."[77] Masturbation was at best an ineffectual substitute recommended by some physicians only as a last resort. Matrimony was the most expedient cure, and doctors urged all single women still young enough to bear children to marry without delay.

The certainty of uterine furies in sexually mature girls was reason enough for a precipitous marriage, though such an action also achieved the practical effect of removing most women from the realm of social and intellectual influence at the earliest possible

77. See the dissertation of Renatus Chauvel, "An venus hystericarum medela?" (University of Paris, 1674). For Galen's views on female masturbation, see E. Frédéric Dubois, *Histoire philosophique de l'hypochondrie et de l'hystérie* (1837), 458. See also Rachel Maines, "Socially Camouflaged Technologies: The Case of the Electromechanical Vibrator" (1989): 3–11, 23; and G. S. Rousseau, "'A Strange Pathology': Hysteria in the Early Modern World, 1500–1800," in Sander L. Gilman et al., *Hysteria beyond Freud* (1993), 112–13.

Fig. 75 "Love is loves phisition," from Otto van Veen, *Amorum emblemata*. Antwerp, 1608. By permission of the Houghton Library, Harvard University.

age. Jacques Ferrand, citing Galen, declared that "all young wenches, when once they begin to be taken with this disease, should presently be married out of hand."[78] Levinus Lemnius quoted the Dutch proverb "Rype dochters zorghelycke ende broosche waere" (Ripe, carefree daughters are fragile wares), alluding with touching mercantile concern to the breakable uterine vessel of the medieval *Ancren Rewle*.[79] He recommended early marriage for the sake of the parents, so that a girl would not "offer herself to suitors . . . to the shame and disgrace of [her] family and kindred."[80] Burton berated parents for endangering their virgin daughters by delaying marriage for the wrong reasons: " 'Tis a general fault among most parents in bestowing of their children, the father wholy respects wealth, the mother good kindred."[81] He begged parents to consider the miseries of long engagements, especially in the case of daughters, who, like cats and dogs, "must be provided for in season, to prevent many diseases."[82] The consequences of delayed marriage could be serious. Not only could

78. Ferrand, *Erotomania*, 273–74.
79. Translation by Johanna Prins.
80. Levinus Lemnius, *The Secret Miracles of Nature* (1650), 308.
81. Burton, *Anatomy*, 654.
82. Ibid., 655.

Fig. 76 Jacob Ochtervelt, *Doctor's Visit*, ca. 1665. City Art Gallery, Manchester.

furor uterinus arise, but, as Ferrand stated, thwarted lovers were known to commit suicide by drowning or hanging.[83]

Most progressive physicians recognized the value of love and mutual attraction in marriage, for those were the qualities that would most certainly lead to pregnancy and thus the occupation of the restless womb. Doctors noted that it was always preferable to marry one's lover, but if such an arrangement proved impossible, "any vigorous young man, who may be amiable, if not beloved," would do.[84] Robert James's authoritative medical dictionary recommends likewise to "dispose the patient in marriage to a young and lusty man, by whose embraces the uterus being sa-

83. Ferrand, *Erotomania*, 97.
84. Astruc, *A Treatise on the Diseases of Women*, 2:368. See also Burton, *Anatomy*, 103.

Fig. 77 Jacob Ochtervelt, *The Gallant Drinker*, ca. 1665. Birmingham Museums and Art Gallery.

tiated [and] the matter in its vessels discharged."[85] If marriage was helpful, pregnancy was even more so. In deference to this belief, doctors recommended coitus in the middle of a woman's monthly cycle (the most fertile time) and further instructed that she become pregnant at least every other year.[86]

Paintings and emblems reinforced the medical belief that the surest cure for gynecological problems was to be "vigorously enjoyed" by men, which, according to Jean Astruc, "has good effect even in matrimony."[87] The popular conception of the curative

85. James, *Medical Dictionary*, vol. 3, s.v. "uterinus furor."
86. Astruc, *A Treatise on the Diseases of Women*, 447–61. See also Hubertus Tellenbach, *Melancholy: History of the Problem, Endogeneity, Rypology, Pathogenesis, Clinical Considerations* (1980), 108.
87. Astruc, *A Treatise on the Diseases of Women*, 367.

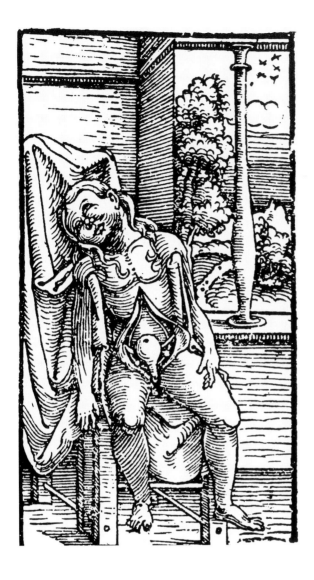

Fig. 78 Female genitalia, from Johann Drynander, *Arzneispiegel*. Basel, 1547. National Library of Medicine, Bethesda, Md.

powers of love are illustrated in a page from Otto van Veen's *Amorum emblemata*, which presents the image of Cupid as doctor, mimicking the physicians seen in numerous lovesick maiden paintings (fig. 75). Here Cupid takes the pulse and examines the urine of an ailing patient, accompanied by a motto that declares "Love is loves phisition." The text continues:

> By whome the harme is wroght the remedie is found,
> The causer of the smart, is causer of the ease,
> Hee cures the sicknesse best, that caused the disease,
> Love must the plaster lay, where love hath made the wound.[88]

88. Otto van Veen [Vaenius], *Amorum emblemata* (1608), 168–69; also illustrated in relation to the lovesick maiden theme in Susan Donahue Kuretsky, *The Paintings of Jacob Ochtervelt, 1634–1682* (1979).

The same analogy is made in a *Sick Lady* painted after Caspar Netscher (fig. 25), where a young girl places her hand over her palpitating heart and looks up with adoration at the handsome young physician who attends her. In so doing she mimics the rapt gaze of Cupid wounded by love's arrows in Veen's emblem. The painting makes a direct reference to the motto "Love is love's phisition," as it is the doctor himself who is both the cause of his patient's illness and the hope for her cure.

Dutch art is filled with contented housewives ministering to numerous happy children, and many marriage portraits attest to the warmth of conjugal love. Likewise, Steen's *Doctor's Visit* (ca. 1663) at the Wellington Museum in London (fig. 1, colorpl. 1) reinforces the health-giving powers of love, although from quite another point of view. The painting shows an ailing woman surrounded by Steen's typical allusions to the wandering womb—displaced firepot, erotic paintings, and a small boy playing Cupid in the left-hand corner. Instead of attending to her obvious need, however, the man of the house sits in a back room, engrossed in books and paperwork, neglecting his conjugal duty. The purse and keys hanging over the chair in the foreground suggest that not only the man but also the woman herself has overlooked the cure that would alleviate her condition. Both sloth and abstinence are the culprits here.

Two paintings believed to have been painted as pendants by Jacob Ochtervelt (figs. 76, 77) present the illness of *furor uterinus* and its cure, coitus.[89] One depicts a typical lovesick maiden—pale, languishing, bundled in fur, and surrounded by the standard props of the female sickroom (fig. 76). Her pet dog hangs its head in mimicry of its mistress's affliction, like the medieval puppy in Ashmole 399 (see fig. 2). The girl's mother gazes anxiously at the flask of pale urine being examined by a distinguished doctor, while the afflicted maiden leans against a pillow and rests her foot on a footwarmer box, its open side gaping evocatively between her spread legs.

If Ochtervelt's *Doctor's Visit* suggests abstinence as the cause of the girl's indisposition, its pendant (fig. 77) presents a sure cure for her ailment. Here, both the maiden and her little dog have perked up quite a bit. The girl has doffed her fur jacket in favor of a suggestively low-cut gown, and she entertains a male guest by of-

89. See Kuretsky, *Paintings of Jacob Ochtervelt*, nos. 34, 35.

fering to fill his flask from her wine jug. The young man holds his phallic-shaped wineglass in front of the woman's skirt just beneath the place where the tip of her pudenda would be. She in turn smilingly acknowledges his request by preparing to tip her ample jug to meet the rim of his glass. When overturned, the woman's wine flask would correspond in size, shape, and position on her body to anatomical diagrams of the uterus as an inverted bottle (fig. 78). The action of joining the mouth of the vessel to the young man's glass would suggest a prurient allusion to the sexual act. Ochtervelt's paintings, when viewed as a linked pair, recall an ancient remedy, advocated without exception by all seventeenth-century physicians as a natural and effective cure for the misery of uterine furies.

V

MIND AND BODY RECONCILED
"Psychological" Cures

Remedies ranging from bloodletting, baths, clysters, smoldering ribbons, and diet to manual labor and marriage were aimed directly at the uterus as a physical organism capable of activity and response apart from the body proper. But physicians also recognized ways of mediating the womb's debilitating effects which modern healers might define as "psychological." Because the passions were thought to respond to the condition of the body and vice versa, activities such as reading aloud, laughing, listening to music, and wearing certain colors were prescribed for their beneficial properties. Even the very words spoken by doctors to their patients were stipulated, for wise counsel was as effective as medicinal potions in curing *furor uterinus*. All of these measures, either singly or in combination, are represented in paintings of the female sickroom.

The emotions, in concert with air, food, sleep, exercise, and evacuations, were among the six "nonnaturals" of healing, that is, the six components of health capable of being controlled by individual choice.[1] Like the humors, emotions were believed to be hot, cold, dry, or wet to varying degrees. Thus, certain passions, especially the sanguine emotion of joy, were considered effective in

1. The concept of the six nonnaturals comes from the works of Galen and Constantinus Africanus and was reiterated by seventeenth-century theorists. See Mary Frances Wack, *Lovesickness in the Middle Ages: The "Viaticum" and Its Commentaries* (1990), 94.

revivifying a body supposedly cooled and dried by a heated uterus. Anything that instigated happiness—the presence of friends, a cheerful house, or even a new dress—was a useful antidote. Such prescriptions persisted into the late seventeenth century, when iatrochemists continued to recommend positive emotional stimulation for its ability to dissolve and dislodge stagnant menstrual blood.[2] Accordingly, the female sickrooms painted by seventeenth-century artists include many details designed to lighten the heavy mood of the suffering woman and reestablish bodily harmony. In general, sickroom interiors are richly appointed, hung with paintings and decorated with expensive furnishings. These are the rooms of well-born ladies of leisure, and they reflect the common belief that it was these women, never "working" women, who fell prey to uterine fits. The rich decor further conforms in every way to doctors' instructions that their female patients' rooms "not want ornament of picture; of gay and fresh colors, in such matter as shall be pleasant and delightful."[3] The emotions were believed to enter the body through the eyes. Thus, the more pleasant the environment of the sickroom, the more effectively the patient's mood would be lightened by the evocation of positive passions.

Especially notable in these pictures is the conspicuous richness of the ailing women's dress. This is most evident in Gabriel Metsu's *Sick Lady and the Doctor* (ca. 1665) (fig. 17, colorpl. 2), in which the woman's exquisite costume is beautifully and skillfully painted. The scene is familiar: a pale, listless maiden sits propped up on her pillow, a dish of refreshing sliced lemons at her side. A solemn doctor examines her urine as the girl's mother looks on, while her puppy, unused to being ignored, paws at her skirt. Despite her evident affliction, Metsu's maiden is dressed opulently, wearing dangling earrings, an amethyst-colored fur-trimmed velvet jacket, and a skirt of peach silk bordered with gold embroidery. Her lavish attire is all the more remarkable because she seems curiously oblivious to her own impressive gorgeousness, as if someone else had dressed her in jewelry, silks, and furs without her knowledge or cooperation. The woman's stylish costume, at such variance with her obvious illness, is nonetheless typical of the

2. See Jean Astruc, *A Treatise on the Diseases of Women* (1762), 272; and George Cheyne, *The English malady; or, A treatise of nervous diseases of all kinds, as spleen, vapours, lowness of spirits, hypochondriacal, and hysterical distempers, etc.* (1976), 78–99.

3. Timothie Bright, *A Treatise of melancholie* (1586), 263–64.

ailing women in Dutch art, and has specific relevance to the condition from which they suffer.

Seventeenth-century physicians in their treatment of *furor uterinus* followed Marsilio Ficino's instructions to surround melancholics with the colors of the positive planets—the pinks and greens of Venus, the blues of Jupiter, and the yellow-greens of Mercury—and to avoid the somber dark blues and earth tones associated with Saturn.[4] André Du Laurens (Laurentius) suggested that ailing women gaze at the colors rose, yellow, green, and white. Without exception these are the colors of the clothes worn by the women in sickroom scenes.[5] Especially favored were shades of pink and salmon, which would have served to represent the realm of Venus and mediate the effect of burned bodily humors. Jewelry possessed much the same talismanic function. Timothie Bright's *Treatise of melancholie* describes at length the healthful jewelry to be worn by women in the throes of a fit. He lists "brooches, chains, [and] rings with precious stones"—rubies to guard against fearful dreams, turquoise to comfort the spirit, and chalcedony to drive away madness, fear, and heaviness of heart.[6] Pearls were favored because they were engendered in water, and thus embodied powerful moisturizing properties.[7] Therefore, the rich costumes and precious jewelry worn by ailing women even in the midst of their suffering bear witness not only to their elevated social status but also to the nature of their illness.

All the activities that occurred in the female sickroom were healing measures prescribed by doctors. Robert Burton suggested that "mirth and merry company" be combined with the "fair objects . . . excellent beauties, attires, [and] ornaments" of sickrooms.[8] The mood was to be as light and cheerful as possible, for nothing hurt the body more than the passions of fear, grief, and anxiety. The most agreeable diversion was the cheerful company

4. Marsilio Ficino, *Les trois livres de la vie* (1582), 93–97, 124–25.

5. André Du Laurens [Laurentius], *A discourse on the preservation of the sight: Of melancholike diseases; of rheumes, and of old age* (1599), 105.

6. Bright, *Treatise of melancholie*, 102. The healing properties of stones is an ancient concept that persisted throughout the medieval and Renaissance eras in the writings of Albertus Magnus (*Liber aggregationis seu liber secretorum*), Leonardus Camillus (*Mirror of Stones*), Marbodeus (*Lapidarium*), and Pliny (*History of the World*), all of which were printed in several editions in the sixteenth and seventeenth centuries.

7. See Leonardus Camillus, *Mirror of Stones* (1750), 33; Bright, *Treatise of melancholie*, 102; John Purcell, *A treatise of vapours, or, hysterick fits* (1707), 210, 218; Richard Blackmore, *A Treatise of the Spleen and Vapours, or Hypocondriacal and Hysterical Affections* (1725), 177.

8. Robert Burton, *The Anatomy of Melancholy* (1932), 119–20.

of friends, a cure suggested earlier by Ficino and Paracelsus.[9] Physicians cautioned, however, that such companions be prudent and of known virtue, and that conversation remain genteel and agreeable.[10] Family and physicians were all enlisted in the task of entertaining the patient and were instructed never to leave her alone, for, as Burton admonished, "It is not enough for the physician to do his duty, the patient and friends must also do theirs."[11] And in fact gatherings of merrymaking folk are occasionally depicted sharing the sickrooms of suffering girls (figs. 30, 31, 66, colorpl. 3).

Physicians even wrote joke books that were specifically designed to be read aloud to the sick in an effort to engender joy and achieve the therapeutic effect of laughter. Samuel Rowlands's *Democritus, or Doctor Merry-man his medicines, against melancholy humors* (1607) and the anonymous *Antidotum melancholiae* (1670) for example, contained jokes and funny tales designed primarily for healing purposes (fig. 79). In addition, some of the general treatises on women's illnesses repeated outrageously funny case histories clearly intended to evoke laughter. Such is the case with Du Laurens's telling of the story of a deluded man who refused to urinate for fear he would drown. Supposedly the man was healed when his friends set a fire and asked him to put it out. Similar stories, such as the tale of the man who thought he was a brick and refused to drink for fear that he might dissolve, or the man who refused to walk because he believed his feet were made of glass, were told for their humorous effects.[12] True or false, such tales may well have evoked the laughter sought by physicians and family. Therefore, the merrymakers who surround the ailing women in Dutch paintings and the paintings-within-paintings of lowlife fools that sometimes appear on the sickroom walls (fig. 1) need not brand these scenes as lighthearted comedies. The medical context of *furor uterinus* suggests that they illustrate the importance of humor as a healing tool. Rather than commenting on the foolishness of the girls themselves, such imagery makes fun of their con-

9. See also Du Laurens, *Discourse*, 106; Jacques Ferrand, *Erotomania; or, A treatise discoursing of the essence, causes, symptomes, prognosticks, and cure of love, or erotique melancholy* (1640), 326–29; Blackmore, *Treatise of the Spleen*, 176.

10. See Astruc, *Treatise on the Diseases of Women*, 2:367.

11. Burton, *Anatomy*, 109. See also Edward Jorden, *A Briefe Discourse of a Disease Called the Suffocation of the Mother* (1603), 123.

12. Du Laurens, *Discourse*, 103.

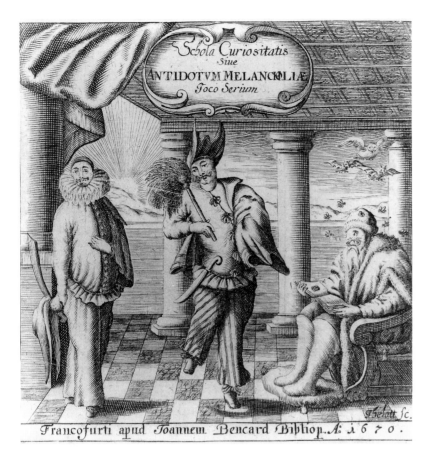

Fig. 79 Antidotum melancholiae, title page. Frankfurt, 1670. National Library of Medicine, Bethesda, Md.

dition in a way that was designed to cause healthy laughter in all concerned.

In a more serious vein, physicians also recommended the reading of Scriptures in cases of *furor uterinus* and advised women to meditate on the Bible and pray continually throughout their sufferings.[13] Franz van Mieris's *Doctor's Visit* (1657) (fig. 14) affirms the importance of religious meditation as good therapy for women. The painting shows a typical sickroom scene, but with the inclusion of a Bible, open to the first page of the New Testament, placed in the lap of the ailing girl. Likewise, Samuel van Hoogstraten's *Anemic Lady* (ca. 1670) (fig. 19), discussed earlier with reference to the gesture of interlaced fingers, projects the same message, though in a less direct way. Here, two works of art are visible in the background of the chamber, an erotic image of a

13. See Jorden, *Briefe Discourse*, 5; William Vaughan, *Directions for health, both natural and artificiall: Approved and derived from the best Physitians* (1626), 10; Burton, *Anatomy*, 105; Timothy Rogers, *A Discourse on Trouble of Mind* (1691), 10.

shepherd and shepherdess and a partial view of an engraving of Raphael's *School of Athens*. Seventeenth-century commentators believed that Raphael's painting depicted a religious subject and interpreted the work theologically.[14] Thus, its inclusion in the sickroom environment near the erotic painting suggests the dichotomy between the sensual and the spiritual realms. Art historians further interpret the two pictures as representing positive and negative examples for the sick girl.[15] Given the medical context of the scene, however, the erotic painting more likely represents the hungry longings of the maiden's unsatisfied womb, suggesting love as a cure. But the religious implication of *The School of Athens* points to an alternative cure that could be chosen by a maiden wishing to retain her virginity. She could, in Burton's words, "fortify [herself] by God's word" and engage in constant prayer.[16] Both measures—the spiritual and the physical—were prescribed for their cooling, calming effects on the restive, inflamed womb. Their presence in Hoogstraten's painting does indeed indicate a dilemma. The girl's choice is not sin versus virtue, however, but rather maidenhood versus marriage.

Music as Healing Therapy

Musical instruments and performance are also common components of lovesick maiden pictures. In a Jan Steen *Doctor's Visit* (ca. 1663–65) (fig. 30, colorpl. 3), for example, a woman playing a harpsichord gazes directly at the ailing girl as if to assess the effect of her performance. Music was a social accomplishment associated with the upper classes in the seventeenth century, and the ubiquitous presence of fine, expensive instruments in Dutch paintings adds to the aura of wealth and privilege that surrounds the people who play them. Scholars frequently interpret such mu-

14. The print after Raphael is probably the one engraved by Giorgio Ghisi for Hieronymus Cock in 1550. See Timothy A. Riggs, *Hieronymus Cock, Printmaker and Publisher* (1977), 267–69. For an explanation of the historical view of Raphael's *School of Athens* as a moral exemplum, see Harry B. Gutmann, "Medieval Content of Raphael's *School of Athens*" (1941).

15. See Eddy de Jongh, et al., *Tot lering en vermaak* (1976), 134–37; Jan Baptist Bedaux, "Minnekoorts- zwangerschaps- en doodsverschijneselen op seventiende-eeuwse schilderijen" (1975): 28–30.

16. Burton, *Anatomy*, 105. See also Vaughan, *Directions for health*, 5.

sical instruments, especially in family portraits, as references to concord, citing emblems from Ripa, Cats, Alciati, and others which personify Harmony as a woman playing a stringed instrument.[17] And yet musical instruments also appear as embodiments of lust and worldliness in *vanitas* still lifes, brothel scenes, and depictions of the artist's studio.[18] The music making that takes place in female sickrooms, however, belongs to neither of these iconographic traditions, but suggests a specific therapy associated with the treatment of *furor uterinus*.

The use of music as a practical healing device in illnesses affecting the passions was part of the Galenic tradition and, as such, was common in pre-Enlightenment medicine. In fact, there exist over six hundred medical treatises written before 1800 on the subject of the curative power of music.[19] The belief dates from ancient times and continues to the present day in the form of psychological "music therapy."[20] The concept originated with Plato, who perceived the body as held together and "tuned" by the four humors, much like a stringed instrument, and praised music as a means of bringing the body and soul into mutual harmony.[21] Medieval medicine continued to stress the therapeutic powers of music in

17. See Colin Eisler, *Paintings from the Samuel H. Kress Collection* (1977), 135; Eddy de Jongh, *Portretten van echt en trouw; Huwelijk en gezin in de Nederlandse kunst van de zeventiende eeuw* (1986), 40–45, 280–90; de Jongh et al., *Tot lering*, 105–7; Hans Joachim Raupp, "Musik im Atelier" (1978); David R. Smith, *Masks of Wedlock, Seventeenth-Century Dutch Marriage Portraiture* (1982), 63–64; and Peter Sutton, *Pieter de Hooch* (1980), 49.

18. See Cécile Deconinck, "Le luth dans les arts figurés des Pays-Bas au XVIe siècle: étude iconologique" (1979); Ian F. Finlay, "Musical Instruments in Seventeenth-Century Dutch Painting" (1953); Peter Fischer, *Music in Paintings of the Low Countries in the Sixteenth and Seventeenth Centuries* (1975); Eddy de Jongh, "Realisme et schijnrealisme in de Hollandse schilderkunst van de zeventiende eeuw," in *Rembrandt en zijn tijd* (1971), 178; Albert P. de Mirimonde, "La musique dans les allegories de l'amour. I. Venus" (1966); idem, "La musique dans les allegories de l'amour. II. Eros" (1967); idem, "Les sujets musicaux chez Vermeer de Delft" (1961); idem, "La musique dans les oeuvres hollandaises du Louvre" (1962); Hans Joachim Raupp, *Untersuchungen zu Künstlerbildnis und Künstlerdarstellung in den Niederlanden im 17. Jahrhundert* (1984), 266–87, 348–50.

19. See Werner F. Kümmel, *Musik und Medizin: Ihre Wechselbeziehungen in Theorie und Praxis von 800 bis 1800* (1977), 416–41.

20. For the history of music as a healing device, see Günter Bandmann, *Melancholie und Musik: Ikonographische Studien* (1960); B. Boehm, "Heilende Musik im greichischen Altertum" (1957); Nan Cooke Carpenter, *Rabelais and Music* (1954), 1–22; Ludwig Edelstein, "Greek Medicine in Its Relation to Religion and Magic" (1937); Robert Francheville, "Une thérapeutique musicale dans la vieille médecine" (1927); Dorothy M. Schullian and Max Schoen, eds., *Music and Medicine* (1948); Jean Starobinski, *Histoire du traitement de la mélancolie des origines à 1900* (1960): 1–101; Egon Wellesz, "Music in the Treatises of Greek Gnostics and Alchemists" (1951).

21. Plato, *Timaeus* (1949), 27–28. See also Carpenter, *Rabelais and Music*, 91.

mitigating the effects of humoral imbalance, a belief justified by the example of David's curing of Saul's insanity.[22] Ficino's Neoplatonic system of music therapy, intended primarily for scholarly melancholics, aimed to counteract the negative effects of Saturn with music of the "beneficial" planets—the sun, Jupiter, Venus, and Mercury. Ficino defined music as the medium between body and soul, the intercessor between the earthly and celestial realms, and he praised its effectiveness in curing cases of melancholy and plague. If the harmonies of the positive planets were heard frequently, he believed, the soul would take on the character of the music, having by natural sympathy attracted the appropriate planetary spirit.[23]

The positive effect of music was believed to be not merely emotional but also physical.[24] Thomas Wright declared in 1604 that musical sounds, woven together according to Plato's rules of mathematical harmony and the structure of the macrocosm, cause "mirth, joy, and delight which abate, expel and quite destroy contrary affections . . . rectify the blood and spirits . . . digest melancholy . . . bring the body into a good temper." He also believed that "all passions rise from music" and that music was a secret passage to the mind that made possible God's intervention in disease.[25] This theory was echoed in the treatises of Bright, Lemnius, Du Laurens, Ferrand, and Burton, who reiterated the medieval justification of the power of music by citing biblical precedent.[26] Bur-

22. Bartholomeus Anglicus de Glanvilla, *De proprietatibus rerum* (1535), 89. See also Carpenter, *Rabelais and Music*, 91. The case most familiar to art historians of music applied to melancholia is that of Hugo van der Goes as reported by Gaspar Ofhuys. See Wolfgang Stechow, *Sources and Documents in the History of Art: Northern Renaissance Art, 1400–1600* (1966), 16.

23. On Ficino's debt to Platonic music theory, see Ficino, *Trois livres*, 162–63; idem, *Contro alla peste* (1576), 92; and idem, *Commentarium in convivium Platonis de amore* (1944), 150–51; Starobinski, "Histoire," 72–78; and D. P. Walker, *Spiritual and Demonic Magic from Ficino to Campanella* (1958), 3–23.

24. See Armen Carapetyan, "Music and Medicine in the Renaissance and in the Seventeenth and Eighteenth Centuries" (1948); Gretchen Ludke Finney, "Music, Mirth, and the Galenic Tradition in England" (1962); Michel Foucault, *Madness and Civilization: A History of Insanity in the Age of Reason* (1965), 178; E. Ashworth Underwood, "Apollo and Terpsichore: Music and the Healing Art" (1947); Macleod Yearsley, "Music as Treatment in Elizabethan Medicine" (1935). For discussions of curative music in Elizabethan drama, see Lawrence Babb, *The Elizabethan Malady: A Study of Melancholia in English Literature from 1580 to 1642* (1951), 40–42; and Bridget Gellert Lyons, *Voices of Melancholy: Studies in Literary Treatments of Melancholy in Renaissance England* (1971), 52–55.

25. Thomas Wright, *The Passions of the Minde in Generall* (1604), 160–68.

26. See Bright, *Treatise of melancholie*, 247–48; Du Laurens, *Discourse*, 104–7; Andrew Boorde, *The breviarie of health, wherein doth folow remedies for all maner of sicknesses & diseases the which may be in man or woman* (1598), 77–78; Wright, *Passions*, 160; Vaughan, *Directions*

ton especially praised music for its ability to manipulate the mind, which he believed to be "harmonically composed" and therefore capable of being "roused up at the tunes of music." In addition to having the power to dispel disease, Burton claimed, music could drive away the devil himself.[27] The presence of both music and revelry in paintings of sickrooms also reflects Burton's belief that "mirth and merry company are not to be separated from music," for "corporal tunes pacify our incorporeal soul."[28]

Seventeenth-century Cartesianism and iatrochemical theory reinforced the belief in the medical effectiveness of music. Iatrochemists claimed that the vibrations of air caused by music were effective in softening and breaking down atrabilious materials such as stale menstrual blood and impacted black bile.[29] Likewise, followers of Descartes's mechanistic theory perceived music as affecting the arteries and vital organs of the body in a very direct way. Thus, Robert James's compendium of seventeenth-century medical knowledge imputes the effectiveness of music to the "outward impulsions of an elastic fluid, such as air," which, passing through the ears to the brain, "communicates tremblings to the membranes and vessels by vibrations." Calling on the biblical example of the walls of Jericho, which were tumbled by the sound of trumpets, James cites Cartesian mechanistic theory, claiming that "if any one doubts of this force of the air, let him consider, that it is in mechanics demonstrated, that the smallest percussion of the smallest body can overcome the resistance of any great weight which is at rest." Even in those insensible to the charms of music, the "tremulous motions of air . . . by sympathy invigorat[e] the motion of the spirits by agitating the nerves."[30] Thus, music was useful even when the patient was completely unconscious and incapable of hearing, for the desired effect was supposedly achieved by purely mechanistic means.[31]

for health, 122; Burton, Anatomy, 116–17; Ferrand, Erotomania, 326–29; Levinus Lemnius, The Secret Miracles of Nature (1650), 139–43; Richard Brocklesby, Reflections on ancient and modern music, with the Application to the Cure of Diseases (1749); Richard Browne, Medicina musica: or, A mechanical essay on the effects of singing, musick and dancing, on human bodies (1729), 47–48.

27. Burton, Anatomy, 116–17.

28. Ibid., 116–20. See also Bright, Treatise of melancholie, 247; and Du Laurens, Discourse, 40.

29. See Carapetyan, "Music and Medicine," 134; and Starobinski, "Histoire," 75.

30. Robert James, A Medical Dictionary (1745), vol. 4, s.v. "musica."

31. Browne, Medicina musica, 34–42.

By its power to shake the air, music caused the body to vibrate in sympathy.[32]

The use of music in medicine was not indiscriminate, for the body could be affected either positively or negatively, depending on the illness being treated and the type of music being performed. Physicians were precise in their directions as to specific modes, tempos, beat patterns, and instruments, and prescribed rhythmic music played on stringed instruments in the Dorian mode for cases of *passio hysterica*.[33] The ancient Roman physician Soranus had also suggested singing as a remedy for *furor uterinus*, and seventeenth-century authorities continued to encourage it, even if the voice was not naturally beautiful.[34] Doctors believed that the pressure of air on the singer's lungs clarified the blood and dissolved heavy humoral deposits.[35] Even though physicians acknowledged that it was difficult to get a depressed person to sing, the benefits were considered worth the effort, for "nobody dislikes his own singing."[36] At the same time, however, care had to be taken to avoid "melancholy and languishing" tunes, which would drive the spirits further into depression.[37]

The sound of stringed instruments had been highly favored since antiquity as a means of mollifying the effects of *furor uterinus*. Such instruments belonged to the astrological realm of Venus, illustrated in Adriaen Collaert's print *Venus and Adolescence* (after Maarten de Vos) where lute players accompany the sanguine children of Venus in a calm, pastoral setting (fig. 11). A lute also hangs on the wall in some of Steen's sickrooms (figs. 22, 38, colorpl. 5), suggesting, in one instance, a connection with Venus and love by its close proximity to a painting of an amorous couple that hangs next to it (fig. 38, colorpl. 5). When combined with the proper talismanic jewels, colors, and smells, music was a potent antidote to negative passions, for stringed instruments of all types—lutes, spinets, harpsichords, violins, guitars, and viols—were considered the progeny of Orpheus' lyre and David's harp.[38] Ficino even

32. Ibid., 32.

33. Ferrand, *Erotomania*, 46, 251, 314.

34. *Soranus' "Gynecology"* (1956), 167–68.

35. See Gretchen Ludke Finney, "Vocal Exercise in the Sixteenth Century Related to Theories of Physiology and Disease" (1968).

36. Browne, *Medicina musica*, 3–25.

37. Ibid., 30–31.

38. Thomas Cogan, *The haven of health, chiefly made for the comfort of students and consequently for all those that have a care of their health* (1612), 20–21.

advised melancholics to carry a "lyre" (probably a *lira da braccio*, an early prototype of the violin) with them constantly, so that music could be played whenever an attack of low spirits threatened.[39] Echoing Ficinian tradition, the music theorist Marin Mersenne (1588–1648) said of stringed instruments that "no other instruments represent the Orphic Music of antiquity so well."[40]

Seventeenth-century prints often picture stringed instruments in the hands of women, who, in the accompanying text, praise the power of music to soothe their passions. One such image, which depicts a wistful woman seated at a clavichord, illustrates the ability of music to ease the agitation of her soul caused by "l'exces de mes amours" (fig. 80). The keyboard instrument that she plays was considered a mechanized version of Ficino's "lyre," and served the same function as a transmitter of positive planetary influences. Likewise, the virginals and harpsichords for which Dutch instrument makers were famous produced sound by the plucking of strings, and therefore also belonged comfortably within the realm of Venus.[41] Many seventeenth-century instruments are still extant, and they bear witness to their planetary influence in inscriptions above the keyboard and in idyllic amatory scenes painted on their lids which praise the restorative power of Venus.[42] The virginal in Vermeer's painting *Lady at the Virginals with a Gentleman* (fig. 81), for example, bears the inscription *Musica Letitiae Co[me]s / Medicina Dolor[is]* (Music is the companion of joy, the medicine of sorrow).[43] The inscription is both a reference to the medical virtues of music and a sly allusion to the "virgin," the "companion of joy," who plays the virginal in the painting. Both passage and painting are echoed in the titles of many

39. Ficino, *Trois livres*, 20, 68, 163, 174; see also Paul Oskar Kristeller, "Music and Learning in the Early Italian Renaissance" (1947); and Walker, *Spiritual and Demonic Magic*, 19.

40. Marin Mersenne, *Harmonie universelle* (1636), 4:206.

41. The Ruckers family of Antwerp were internationally famous for their fine keyboard instruments, which, because of their distinctive appearance, can often be identified in Dutch paintings, especially those of Vermeer. For a history of keyboard chordophones, see Sibyl Marcuse, *A Survey of Musical Instruments* (1975), 234–318.

42. For analysis of the decoration of early musical instruments in a planetary context, see Emanuel Winternitz, *Musical Instruments and Their Symbolism in Western Art* (1967); idem, *Musical Instruments in the Western World* (1967); Laurinda S. Dixon, "Music, Medicine, and Morals: The Iconography of an Early Musical Instrument" (1981–82).

43. For discussions of inscriptions on musical instruments in Dutch paintings, see Lawrence Gowing, *Vermeer* (1952), 125; Peter C. Sutton et al., *Masters of Seventeenth-Century Dutch Genre Painting* (1984), 344; Leonard Slatkes, *Vermeer and His Contemporaries* (1981), 64.

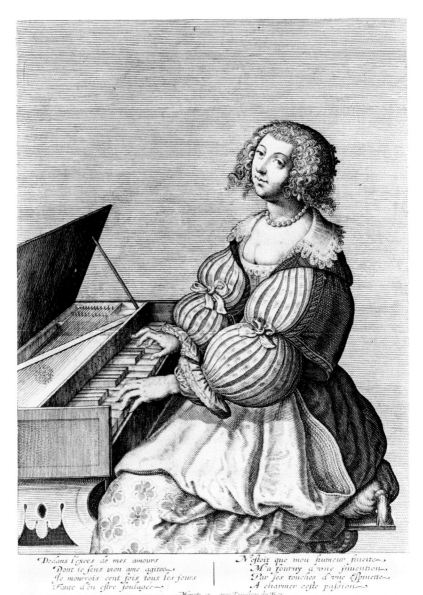

Decans l'excés de mes amours,
Dont ie sens mon ame agitee,
Ie mourrois cent fois tous les iours
Faute d'en estre soulagée.

N'estoit que mon humeur finette,
M'a fourny d'vne inuention,
Par les touches d'vne Espinette,
A charmer cette passion.

Auecq Priuilege du Roy.

Fig. 80 Artist unknown, *Woman at the Clavichord,* 17th c. French. From the Art Collection of the Folger Shakespeare Library, Washington, D.C.

seventeenth-century songs, such as John Blow's "Musik's the Cordial of a Troubled Breast" and Henry Purcell's charming "I Attempt from Love's Sickness to Fly."

Medical authorities also claimed a direct correlation between the rhythm and tempo of music and the strength and beat of the human pulse. The doctor in a Steen *Doctor's Visit* (fig. 30, colorpl. 3), for example, takes his patient's pulse as music is performed for her benefit, indicating an attempt to stabilize the pulse by means of

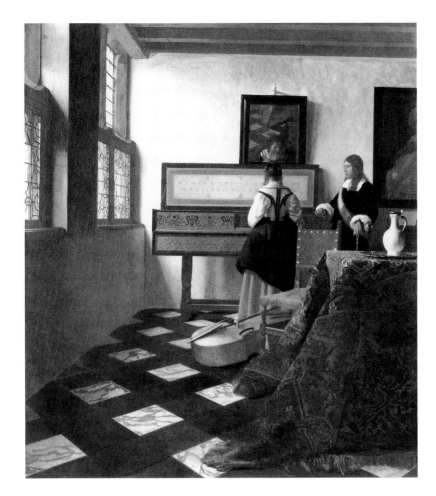

Fig. 81 Johannes Vermeer, *Lady at the Virginals with a Gentleman*, ca. 1660–65. The Royal Collection © 1993 Her Majesty Queen Elizabeth II. Photo: Royal Collection Enterprises, London.

music.[44] The belief that music could directly affect the pulse was of ancient origin, and had been completely assimilated into medical practice by the seventeenth century.[45] Some medical theorists attempted a musical notation of the pulse, indicating pitch relationships and rhythms for every possible permutation (fig. 82).[46] Two types of pulses were associated with *furor uterinus*—strong and quick just before a faint, and "small, languid, slow, intermitting"

44. See John Floyer, *The physician's pulse-watch; or, An essay to explain the old art of feeling the pulse, and to improve it by the help of a pulse-watch* (1707); Browne, *Medicina musica*, 13–14. See also Emmet Field Horine, "An Epitome of Ancient Pulse Lore" (1941).

45. Claimed by both Galen and Avicenna. See Horine, "Epitome," 240.

46. See Robert Fludd, *Pulsus. Seu, Nova et arcana pulsuum historia* (1629), 37, 75–77, 79–80, 87–88; Athanasius Kircher, *Musurgia universalis* (1650); and Josephus Struthius, *Sphygmicae artis jam mille ducentos annos perditae & disideratae libri V* (1555). For discussion, see Kümmel, *Musik und Medizin*, 36–48; and Horine, "Epitome," 240–43.

diagnosticam, ætiologicam, prognosticamque partes medicinę arcaniores se penetrasse sciat. Ex his enim complicatis, iterum 27 aliæ pulsuum differentiæ emergunt, iuxta quosdam; verùm sagaciores medici 15. vti prius simplicium pulsuum, ità hic complicatorum differentias ponunt, vt sequitur.

1 Magnus	Celer	Creber	Vehemens	Mollis	
2 Moderatus	Moderatus	Moderatus	Moderatus	Moderatus	
3 Paruus	Tardus	Rarus	Debilis	Durus	
4 Magnus	Moderatus	Moderatus	Moderatus	Moderatus	
5 Magnus	Celer	Moderatus	Moderatus	Moderatus	
6 Moderatus	Moderatus	Moderatus	Vehemens	Moderatus	
7 Moderatus	Celer	Creber	Vehemens	Durus	
8 Moderatus	Tardus	Rarus	Debilis	Mollis	musica [pulsuum in humano corpore.
9 Paruus	Celer	Creber	Vehemens	Durus	
10 Paruus	Moderatus	Moderatus	Moderatus	Moderatus	
11 Moderatus	Celer	Rarus	Debilis	Mollis	
12 Moderatus	Moderatus	Creber	Vehemens	Durus	
13 Moderatus	Moderatus	Rarus	Debilis	Mollis	
13 Paruus	Tardus	Moderatus	Moderatus	Moderatus	
15 Moderatus	Moderatus	Moderatus	Debilis	Mollis	

Atque

Fig. 82 Athanasius Kircher, *Musurgia universalis*. Rome, 1650. National Library of Medicine, Bethesda, Md.

afterward.[47] Thus, the weak, erratic pulse typical of the languor of uterine fits was indicated musically with notes of random variable length and pitch (fig. 83), whereas the rapid pulse preceding a faint might be notated as *creber* (frequent) (fig. 84), with many notes of short duration.[48] Samuel Hafenreffer's *Monochordon symbolico-biomanticum* illustrates many other notated pulses with labels such

47. Floyer, *The physician's pulse-watch*, 1:33, 122–28. See also Blackmore, *Treatise of the Spleen*, 10.

48. Samuel Hafenreffer, *Monochordon symbolico-biomanticum* (1650), 59, 65.

Undosus.

Vermium progreſſus, qui obſervavit
E 5 con-

Creber.

Fig. 83 "Pulsus undosus," from Samuel Hafenreffer, *Monochordon symbolico-biomanticum.* Ulm, 1650. National Library of Medicine, Bethesda, Md.

Fig. 84 "Pulsus creber," from Samuel Hafenreffer, *Monochordon symbolico-biomanticum.* Ulm, 1650. National Library of Medicine, Bethesda, Md.

as *intermittens, caprizans, tremulus,* and even *vacuus* (indicated by rests only). The rhythm, pitch, and tempo of the pulse were carefully considered before music of opposite characteristics was applied.[49] The music representing a well-regulated pulse (fig. 85), written by the physician François-Nicolas Marquet, shows two musical staves, one for the music and the other for the pulse.[50] Ideally the music would effectively stabilize an abnormal pulse by means of the intermediate element of vibrating air.

The power of music to order the humors, regulate the pulse, and temper the passions was manipulated by composers and performers for the benefit of their audiences. The perfectly balanced four-part harmony that characterized the sixteenth-century *ars perfecta,* for example, resulted from an effort to represent the four humors and their harmonious coexistence in sound. Composers and doctors alike believed that the human pulse could be directly affected by music. Mersenne declared that the best musical tempo was sixty pulses per minute, the pace of a healthy human heart, and the composers Monteverdi and Vivaldi, among others, gave

49. See Floyer, *The physician's pulse-watch,* 235.

50. François-Nicolas Marquet, *Nouvelle méthode facile et curieuse, pour connoitre le pouls par les notes de la musique* (1769).

Exemple du Poulx naturel regle

Menuet

Fig. 85 Exemple du poulx naturel regle, from François-Nicolas Marquet, Nouvelle méthode facile et curieuse, pour connoitre le pouls par les notes de la musique. Paris, 1769. Countway Medical Library, Harvard University. Photo: Steven Borack, Randolph, Mass.

directions for tempi which corresponded to the pulse beat characteristic of certain humors.[51] Early in the eighteenth century, Richard Browne's *Medicina musica* suggested alternating tempi in music played for melancholics—first a brisk *allegro* to get things moving, then a slow *adagio* to allow the body to rest, and finally a resumption of the *allegro* tempo.[52] Belief in the power of music to affect the passions was part of the musical "doctrine of the affec-

51. See Kümmel, *Music und Medizin*, 255.
52. See Browne, *Medicina musica*.

tions" that occupied baroque composers from the seventeenth through the mid-eighteenth centuries.[53] Later, the alternating fast-slow-fast musical movements favored by earlier physicians became a fixture of eighteenth-century classical sonata form, which sought to embody a perfect balance and harmony of musical elements. Mersenne affirmed the complete acceptance of the confluence of music and medicine in seventeenth-century common experience when he claimed that "health is so musical that disease is nothing but a dissonance, initiated or corrected by music."[54]

The Role of the Physician

What was the physician's role in the seventeenth century, and how is it revealed in paintings of the female sickroom? Historians have noted that some of the doctors who attend ailing women appear to be bumbling quacks (figs. 38, 42, 65, 66, colorpl. 5). Henry Meige, himself a physician, claimed in 1900 that Steen's doctors are the same as physicians everywhere, "ignorant pedants, often pretentious and almost always grotesque."[55] Other historians have recognized the resemblance of some of these doctors to the itinerant charlatans represented in the comic stage farces popular throughout Europe in the seventeenth century, most notably in the plays of Molière.[56] Indeed, the doctors in these plays are truly comic figures—ignorant, ridiculous, and utterly incompetent. On stage they were usually dressed in wildly inappropriate clothing—slashed doublets and colorful capes—resembling in appearance the equally distasteful Burgundian mercenary soldiers familiar to seventeenth-century audiences.[57] It is proper to note, however, that not all of the physicians who officiate in paintings of the female sickroom are negatively depicted. In fact, most are earnest fatherly types who seem genuinely concerned with their healing mission (see, e.g., figs. 17, 19, 22, 26, 30, 43, 76, colorpls.

53. See specifically the writings of Gioseffe Zarlino, *Istituzioni armoniche* (1558), 3:58. See also, for the doctrine of the affections, *New Grove Dictionary of Music and Musicians* (1980), 1:135–36; and Carapetyan, "Music and Medicine," 122.

54. Marin Mersenne, *Questions harmoniques* (1634), 102.

55. Henry Meige, "Les médecins de Jan Steen" (1900).

56. Sturla J. Gudlaugsson, *The Comedians in the Work of Jan Steen and Contemporaries* (1975); J. B. F. van Gils, *De dokter in de oude Nederlandsche tooneelliteratuur* (1917); Einar Petterson, "*Amans Amanti Medicus*: Die Ikonologie des Motivs *der ärztliche Besuch*" (1987): 212–14.

57. Van Gils, *Dokter*, 21.

2, 3). Even the satiric doctors who sometimes populate Jan Steen's pictures do not wear the loud costume of the quacks in Dutch plays; instead they are dressed in ruffs, shoes, and hose that, though decidedly unfashionable, are not garish or outlandish.[58] Art historians have noted that the anomalous appearance of some of the physicians officiating in female sickrooms is curious, especially in light of the serious and important medical research being done at the time at Leiden University.[59] How can the representation of physicians as vile charlatans on the one hand and discerning scholars on the other be justified?

The dichotomy is explained by the context of medical history. The second half of the seventeenth century was a time of great empirical discoveries that would decide the future direction of science. At the same time, however, the heritage of medieval superstition and ancient dogma continued to hold sway in traditional academic environs.[60] The seventeenth century witnessed an ideological battle between the ancients and the moderns, a conflict between old and new, experimental and theoretical science. The British Royal Society, which included the famous Dutch scientists Christian Huygens, Antonie van Leeuwenhoek, and Hermann Boerhaave, met regularly to review the great advances in physics, chemistry, astronomy, and anatomy that emerged during the seventeenth century. At the same time, however, members of this bastion of scientific liberalism witnessed attempts to produce vipers from the powdered lungs of reptiles, and held learned discourses on the miraculous properties of salamanders and unicorn horns.[61] The effects of the ground-breaking discoveries of this time would not be accepted by the majority of scientists for many years, and would not reach the general public for several generations. The advances in medicine and technology associated with Holland's golden age found no application in practical use, and

58. Gudlaugsson, *Comedians*, 14, notes that the physician in one Steen *Doctor's Visit* (Rijksmuseum, Amsterdam) wears a robe dating from 1570, hose popular in 1600, and shoes current in 1620.

59. Noted by Christopher Wright, *The Dutch Painters: One Hundred Seventeenth-Century Masters* (1978), 85; and Slatkes, *Vermeer*, 414.

60. See T. H. Jobe, "Medical Theories of Melancholia in the Seventeenth and Early Eighteenth Centuries" (1976); Lester S. King, *The Road to Medical Enlightenment* (1970); idem, "Attitudes toward 'Scientific' Medicine around 1700" (1965); Abraham Wolf, *A History of Science, Technology, and Philosophy in the Sixteenth and Seventeenth Centuries* (1968) 2:412–27.

61. See C. H. Wilson, *England and Holland* (1946), 93–94; and Wolf, *History of Science*, 63.

even well-educated people either ridiculed or ignored much current science. At the same time, however, many questioned the ability of traditional medicine, based as it was on archaic principles, to accomplish the purpose of healing. Lester S. King sums up the attitude of the age with the statement "What was old and comfortable was still old, but not comfortable."[62]

As the Galenic paradigm began to crumble, serious physicians openly confessed to the world what millions of their patients had suspected all along—that the old methods of healing were more likely to result in a hasty demise than a quick recovery. In an age when medical training was not standardized and expertise was widely divergent among practitioners, physicians themselves were often the first to criticize their profession.[63] It is to be expected that licensed, university-educated doctors would inveigh against those whom they perceived as untrained, posturing quacks. It is more surprising, however, to read numerous serious medical treatises filled with derogatory comments about the "honorable" profession of medicine. Bernard Mandeville, for example, who took his M.D. at Leiden, maintained that "the arrogance of physicians in general, and the great knowledge which they are obliged to pretend to, are deservedly censured, and ridiculed by all men of sense."[64] He recognized a universal fact of medicine: that doctors were (and are) only as good as their training allowed them to be. Unfortunately, an M.D. could be achieved in just a few months' time at most universities, and the rolls at Leiden are filled with the names of practicing doctors who never completed their degrees.[65] Even those graduates who published theses were not safe from criticism. Many "mongrell-physicians" were perceived as having "bought the title in foreign universities," a veiled allusion to the great numbers of doctors turned out with increasing rapidity by European universities during the seventeenth century.[66] Doctors applied the epithet "quack" to their own kind in response both to the inadequacy of classical medicine and to the

62. King, *Road*, 124.

63. See Vern L. Bullough, *The Development of Medicine as a Profession: The Contribution of the Medieval Universities to Modern Medicine* (1966); Charles D. O'Malley, *History of Medical Education* (1970).

64. Bernard Mandeville, *A treatise of the hypochondriack and hysterick passions* (1976), 34.

65. See Gerrit Arie Lindeboom, *Dutch Medical Biography* (1984); and R. W. Innes Smith, *English-Speaking Students of Medicine at the University of Leyden* (1932).

66. James Primrose [Primerosius], *Popular errours. Or the errours of people in physick* (1651), 19–21.

lack of regulation within the profession. Indeed, Robert James's medical dictionary, a work intended for the profession, found it necessary to remind readers of Montanus' saying, "Neither consult physicians, nor use medicines, and you'll soon recover."[67]

There were two main approaches to the science of healing in the seventeenth century: theoretical knowledge acquired by reading the ancient texts and attending university, and "empirical" practice gleaned by experience and experimentation. Although most people today would shun a physician who does not hold a university degree and a license to practice, the situation in the seventeenth century was somewhat different. In fact, at any one time there were usually more empirical healers at work in a city than university-graduated M.D.s.[68] Paracelsus mistrusted the philosopher-physicians from the great universities, and his belief that "some have learned so much that their learning has driven out all their common sense" was held by many.[69] In fact, Auleius Alardus (1544–1606), who taught medicine at Amsterdam, concluded that academically trained physicians were actually less esteemed by the public than untrained empirics: he published an earnest plea to remedy the situation.[70] Some of the most advanced medical theorists of the time, however, helped to perpetuate this belief. Mandeville, always critical of his profession, claimed that a university education, grounded in the medical "basics" of Galenic theory, Arabic astrology, and mathematics, made a man "no more capable of discharging the weighty office of a physician, than a man that should study opticks, proportions, and read of painting and mixing of colours for as many years, would, without having ever touched a pencil, be able to perform the part of a good history painter."[71] Likewise, Thomas Sydenham, when asked to recommend medical texts for students to read, replied tongue-in-cheek, "*Don Quixote* . . . It is a very good book, I read it still."[72] When William Harvey boldly claimed, however, in the preface to his seminal book on the circulation of blood, that "I profess to learn and to teach anatomy, not from books, but from dissections; not from the positions of the philosophers, but from the fabric of na-

67. James, *Medical Dictionary*, vol. 2, s.v. "hypochondria."

68. See John Henry, "Doctors and Healers: Popular Culture and the Medical Profession" (1991).

69. Quoted in Wolf, *History of Science*, 2:427.

70. Auleius Alardus, *Monitio ad ordines Frisiae de reformanda praxi medica* (1603).

71. Mandeville, *Treatise*, 34–35.

72. Quoted in Ilza Veith, *Hysteria: The History of a Disease* (1965), 138.

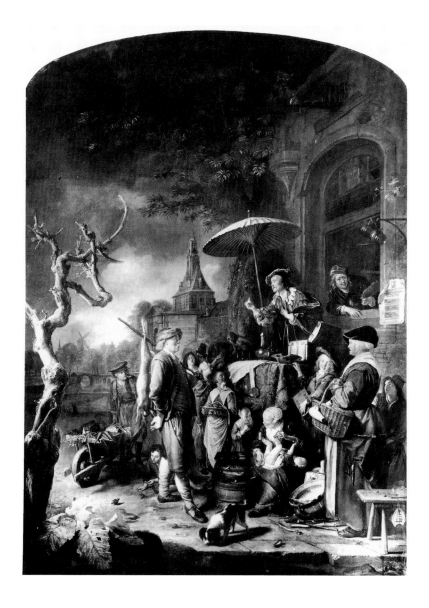

Fig. 86 Gerrit Dou, *The Quack Doctor*, 1652. Museum Boymans-van Beuningen, Rotterdam.

ture," his medical practice suffered as a result.[73] In an age when it was common for doctors never to touch their patients, "hands-on" experience was a novel idea. The Leiden medical school, ever progressive in its approach, was the first to acknowledge the importance of clinical studies in its curriculum and even hired a man with no formal medical education as a professor of surgery.[74]

Gerrit Dou's painting *The Quack Doctor* (fig. 86) aptly illustrates the popular perception of academic medicine in the seventeenth

73. Quoted in Wolf, *History of Science*, 2:412.
74. The surgeon Jacques de Beaulieu (1651–1714) was hired in 1699. See Lindeboom, *Medical Biography*, 89–90.

century.[75] It depicts a doctor selling his potions on the street under a Chinese umbrella while a crowd of common folk cluster around. Seated in a window behind the physician is the painter himself, who, by associating his profession with that of the doctor, reaffirms the historical unity of the two disciplines within the guild of Saint Luke. The professions of medicine and painting were traditionally linked in the medieval and Renaissance eras because Saint Luke, a physician, was honored with the privilege of painting the Virgin and Child. Furthermore, the materials of both professions—medicine on the one hand and paints on the other—were created by the same means of pulverization, distillation, and suspension in a liquid medium. Despite the labeling of Dou's physician as a quack, he is dressed in full academic regalia and surrounded by prominently displayed diplomas.[76] In fact, the official affirmations of his education and qualifications could not be any more impressive. Art historians interpret the painting as an allegory of deception: as the painter deceives visually, so does the doctor deceive his patients with his ineffective, outmoded cures.[77] But the common folk in Dou's painting are not willingly tricked, nor are they easily fooled: seated among the crowd is a young mother who wipes her baby's bottom in a scatological commentary on the doctor's exalted claims and limited abilities.[78] In a medical sense Dou's scene recalls André Du Laurens's caution to his readers "to be better prepared . . . to discern betwixt the ignorant and the learned, and the skillful in word only and those which are skillful in deed."[79] Likewise, Dou asks his viewers to compare the arts of painting and medicine, both disciplines based on learning, and both utilizing deception as a desirable, even necessary strategy.[80]

The Jekyll-and-Hyde image of the doctors who appear in paint-

75. See Rhonda Baer, "The Paintings of Gerrit Dou (1613–1675)" (1990), cat. 58.1.

76. For elements of academic regalia worn by Dutch physicians, see W. N. Hargreaves-Mawdsley, *A History of Academical Dress in Europe until the End of the Eighteenth Century* (1963), 175–78.

77. For interpretations of various elements of the scene in the context of emblem literature and/or seventeenth-century cultural consciousness, see Svetlana Alpers, *The Art of Describing: Dutch Art in the Seventeenth Century* (1983), 116–18; Jan Emmens, "De kwakzalver" (1981); Ivan Gaskell, "Gerrit Dou, His Patrons, and the Art of Painting" (1982); Richard Whittier Hunnewell, "Gerrit Dou's Self-Portraits and Depictions of the Artist" (1983), 114–16; Eddy de Jongh, *Zinne- en minnebeelden in de schilderkunst van de zeventiende eeuw* (1967), 70–74.

78. See Gaskell, "Gerrit Dou."

79. Du Laurens, *Discourse*, A3.

80. This is the observation of Carol Jean Fresia, "Quacksalvers and Barber-Surgeons: Images of Medical Practitioners in Seventeenth-Century Dutch Genre Painting" (1991), 259.

ings of the female sickroom reflects the dichotomy between theory and practice that divided the seventeenth-century medical profession and influenced the popular perception of medical practitioners.[81] The outdated costumes and makeshift academic regalia that Steen's comic doctors wear represent the useless archaic theories of the ancients that traditionally trained physicians still venerated. Steen used the same ploy in his religious and historical paintings when he wished to indicate the "antique." Twentieth-century viewers, familiar with the historical contributions of archaeology, associate togas and laurel wreaths with the stuff of ancient legends. But seventeenth-century viewers would have perceived even a slightly out-of-fashion costume as old enough to symbolize ancient or medieval history.[82] The apparent incompetence of some of Steen's doctors supports the common belief that their book learning had little effect on the health of their patients. Hiding their ignorance behind university degrees and Latin phraseology, such men valued erudition above competence. Mandeville called them "witty philosophers" whose talk "cures all Diseases by Hypothesis, and frightens away the Gout with a fine smile."[83] Even Mandeville, however, could not universally damn physicians, for "many are men of sense and learning, whom I esteem and honor."[84] Thus, serious, honest doctors share the sickroom with their lesser colleagues in paintings of ailing women, reflecting the two camps of popular seventeenth-century opinion regarding the practice of medicine.

Furor uterinus was perceived as the scourge of doctors, a true testing ground capable of separating effective healers from posturing incompetents.[85] Only the most excellent and scrupulous practitioners could hope to claim success in curing the illness, for, in the words of Jacques Ferrand, "unless the physician be a person of judgment and penetration, he will be deceived."[86] *Furor uterinus* was a malady best diagnosed by a skillful and discreet physician,

81. For discussion of the social status of physicians in the early modern Netherlands, and further exploration of the various levels of medical practice, including "quackery," see ibid., chaps. 3 and 4; and Willem Frijhoff, "Non satis dignitatis . . . over de maatschappelijke status van geneeskundigen tijdens de Republiek" (1983).

82. See Baruch David Kirschenbaum, *The Religious and Historical Paintings of Jan Steen* (1977), 99.

83. Mandeville, *A treatise of the hypochondriack and hysterick passions*, 36.

84. Ibid., 33.

85. See Du Laurens, *Discourse*, 107–8; also Thomas Sydenham, *Of the Epidemick Diseases from the Year 1675 to the Year 1680*, in *The whole Works of that excellent practical physician, Dr. Thomas Sydenham* (1729), 301.

86. Ferrand, *Erotomania*, 195.

Fig. 87 "Love refuseth help," from Otto van Veen, *Amorum emblemata*. Antwerp, 1608. By permission of the Houghton Library, Harvard University.

for, as James's encyclopedia notes, "no disease is more trouble-some either to patient or physician."[87] Doctors perceived the con-dition as terribly stubborn and often incurable, as an inscription in at least two of Steen's paintings attests: "No medicine will help when it is the pain of love" (fig. 38, colorpl. 5).[88] Further compli-cating the doctor's task was the tendency of the patient to hide the cause of her affliction and reject the cure.[89] Du Laurens also recog-nized the inclination among sufferers to "resist means and reme-dies," and Burton noted poetically that "few see their malady, all love it."[90] This common perception of "lovesickness" was trans-lated into popular emblem literature, and appears in Otto van Veen's illustration of a sick cupid refusing medicine under the motto "Love refuseth help" (fig. 87).

Medical treatises suggest that, in addition to prescribing tradi-tional "physic" in cases of *furor uterinus*, doctors were expected to

87. James, *Medical Dictionary*, vol. 2, s.v. "hysteria."

88. A similar inscription on the *Doctor's Visit* in the Alte Pinakothek, Munich (no. 158), reads: "Daar haat geen medesyn want het is minnepyn," according to the *Alte Pinakothek Katalog III* (1967), no. 75. See also Bedaux, "Minnekoorts," 1; Susan Donahue Kuretsky, *The Paintings of Jacob Ochtervelt, 1634–1682* (1979), 17; Herwig Guratzsch, *Painting in the Low Countries* (1981), 233.

89. Ferrand, *Erotomania*, 195.

90. Burton, *Anatomy*, 125. See also Du Laurens, *Discourse*, 86–87; and Lemnius, *Secret Miracles*, 122.

Fig. 88 "Shewing causeth curing," from Otto van Veen, *Amorum emblemata.* Antwerp, 1608. By permission of the Houghton Library, Harvard University.

employ psychological strategies and entreaties to reason in stubborn cases. Another emblem from Veen's popular book echoes the "psychological" role of physicians in the female sickroom. The image shows two cupids, one stricken by an arrow of love through his heart and the other holding the familiar urine vial up to the light in imitation of a doctor (fig. 88). The inscription, "Shewing causeth curing," echoes instructions found in numerous medical texts that suggest attempting a cure by changing the patient's mind and persuading her to acknowledge her illness. Since victims of uterine furies would not cooperate and did not want to be cured except by consummation of their desires, doctors were advised to "conceal your inclining" and approach their patients with "mild and soft persuasion."[91] Another authority suggested that "a physician that has his tongue well hung, and is master of the art of persuading," was likely to be successful with his female patients.[92]

The term *psychology* was unknown in the seventeenth century, and doctors would have been baffled by the Freudian distinction

91. Lemnius, *Secret Miracles,* 122; and Wright, *Passions,* 90, 99, 180–83.

92. Giorgio Baglivi, *The practice of physic reduc'd to the ancient way of observation containing a just parallel between the wisdome and experience of the Ancients, and the hypothesis's of modern physicians* (1723), 160–72.

between mental and physical illness that emerged in the modern
era. Physicians, who treated the mind and body together, as-
sumed the roles of teacher, confidant, and moral adviser to their
patients. Advice in medical texts is often surprisingly blunt, indi-
cating that doctors were sanctioned by medical authority to lie in
order to achieve the desired effect. For example, Du Laurens spec-
ified that doctors should "fool the patient by fair words and cun-
ning speeches."[93] Duplicity was a remedy that had been champi-
oned as early as the Roman era by Constantinus Africanus, who
suggested starting treatment with encouraging words.[94] The suc-
cess of the ploy was especially important if the patient languished
for love of a man whom she could not marry, for the womb must
always be appeased within the lawful bounds of matrimony. It
then became the doctor's duty to draw the patient's mind away
from her erotic obsession by any means—lying about the fidelity
of the beloved, demeaning his character and appearance, or incit-
ing hatred against him. Similar cures were sanctioned by Burton,
who maintained that in such cases it was permissible to repeat lies
about the beloved.[95] Ferrand further suggested that the physician
graphically describe the pain and perils of childbearing and then
bid the patient to "prefer life and safety, before pleasure."[96] Du-
plicity on the part of the doctor was acceptable if it resulted in a
change of mind in the sufferer. Jorden, for instance, stated that the
doctor, with the aid of friends and relatives of the patient, was to
apply good counsel, persuasion, encouragement, and religious
teaching. If "gentle instruction" failed, he should feign agreement
with the patient's whims and fancies. Doctors were even autho-
rized to arrange fulfillment by uniting lovers if all else failed.[97] This
last ploy is depicted in a Steen *Doctor's Visit* (fig. 30, colorpl. 3),
which shows the woman's lover at the sickroom door. Authorities
widely recognized that much of a doctor's success depended on the
patient's confidence in him and her willingness to be cured, a sen-
timent shared by Giorgio Baglivi, who maintained that "almost
the whole of the Cure lies in the Patient's own Breast."[98] Histori-

93. Du Laurens, *Discourse*, 123.

94. See Oskar Diethelm, *Medical Dissertations of Psychiatric Interest Printed before 1750*
(1971), 22.

95. Burton, *Anatomy*, 635.

96. Ferrand, *Erotomania*, 222.

97. Jorden, *Briefe Discourse*, 123.

98. Baglivi, *The practice of physick*, 147.

ans of medicine recognize that, by attempting to cure the body by manipulating the mind, early doctors were unwittingly practicing an early form of psychotherapy.[99] Undoubtedly some doctors were better psychologists than others, and the recognition that fraud was sometimes necessary to effect a cure for *furor uterinus* probably did not improve the reputation of the medical profession in the seventeenth century. Nonetheless, the buffoons who populate some paintings of female sickrooms are outnumbered by physicians who reflect Burton's ideal of the "wise, fatherly, reverent, discreet person, a man of authority, whom the parties do respect, stand in awe of."[100]

The multiple ironies presented by a grave, potentially fatal illness that could be cured by the simple application of sexual stimulus did not escape even the most serious medical theorists. Jorden could not hide his amusement when describing "a young maiden [who] . . . fell into these fits of the Mother." Her physician, with some embarrassment, gingerly placed his hand under her clothes to examine her, whereas a surgeon-empiric, who was also present, "not contented with that manner of examination, offered to take up her clothes, and to see it bare." The modest young girl, thoroughly shocked, "tooke such indignation at it, as did put her presently out of her fit."[101] Indeed, women's illnesses were often demeaned in popular jokes and looked on as imaginary even by physicians.[102] Richard Blackmore described the popular perception of *furor uterinus* by insensitive onlookers and baffled doctors: "Accordingly, they make the complaints of such patients the subject of mirth and raillery. The person becomes an object of derision and contempt."[103] Perhaps the most eloquent and sensitive explanation for the strange confluence of ridicule and pathos apparent in the lovesick maiden paintings comes from a physician of the time. Bernard Mandeville said of the ailment (which, in deference to iatrochemical theory, he called "Vapours"), "the very name is become a joke, and the general notion that men

99. See Diethelm, *Medical Dissertations*, 125; and Arthur K. Shapiro, "Placebo Effects in Medicine, Psychotherapy, and Psychoanalysis" (1971).

100. Burton, *Anatomy*, 777–78.

101. Jorden, *Briefe Discourse*, 25.

102. Jelle Koopmans and Paul Verhuyck, *Een kijk op anekdotencollecties in de zeventiende eeuw* (1991), 198–99, 234, reproduces several seventeenth-century jokes about lovesick maidens and their doctors.

103. Blackmore, *Treatise of the Spleen*, 97.

have of them, is, that they are nothing but a malicious mood, and contriv'd sullenness of wilful, extravagant and imperious Women. . . . Physicians, because they cannot cure them, are forced to ridicule them in their own defense, and a Woman, that is really troubled with Vapours, is pitied by none, but her unhappy Fellow sufferers."[104]

104. Mandeville, *A treatise of the hypochondriack and hysterick passions*, 270.

VI

MELANCHOLIC MEN
AND HYSTERICAL WOMEN
The Sexual Politics of Illness

The symptoms associated with uterine hysteria were not limited to women. Physicians recognized that both sexes could suffer depression, mood swings, hallucinations, pallor, abdominal upsets, fainting, and so on. Although men and women experienced identical symptoms, however, the source and cause of their complaints were believed to differ according to the sex of the victim. Women were termed "hysteric," and their problems were thought to originate in the womb. Men who presented the same symptoms were considered "melancholic" or "hypochondriacal," and their discomfort was said to originate in the "hypochondries" (spleen, bowels, and liver). Not until the late seventeenth century were the words *hysteric*, *melancholic*, and *hypochondriacal* used interchangeably in recognition of the common symptoms associated with all three disorders.[1]

Melancholia, like hysteria, was a disease of ancient origin which took its name from the Greek word for "black bile." The illness was considered cold and dry in its natural form, like the element of earth to which it corresponded in humoral theory, and also like the planet Saturn which ruled it. Melancholia could, however, cause

1. See Stanley W. Jackson, *Melancholia and Depression from Hippocratic Times to Modern Times* (1986), 78–115. For a theoretical discussion of the sexual distinction inherent in the disease of melancholia, see Juliana Schiesari, *The Gendering of Melancholia: Feminism, Psychoanalysis, and the Symbolics of Loss in Renaissance Literature* (1992).

heating and drying of the body under certain circumstances. The condition could be either "natural"—inherited or visited upon the victim by heredity or horoscope—or "accidental," that is, inflicted on the body by outside forces. In the latter instance melancholia could be produced by combustion when any humor within the body was ignited by a sudden passion or strong emotion. After such a fire the remains were said to resemble black coals and dirty smoke, which, when cooled, took on the cold, dry characteristics of natural constitutional melancholia.[2] Plato and Aristotle noted that the physical and emotional symptoms produced by black bile seemed to afflict primarily intellectuals. In the thirtieth book of the *Problemata*, Aristotle asks: "Why are all outstanding men in philosophy or politics or literature or in the arts obvious melancholics, and in fact some of them to the extent that they have succumbed to the symptoms which arise from black bile?"[3] He theorized that great intellectual effort produced a combustion of humors, the "fire of inspiration," followed by the inevitable dark and smoky aftermath. As the resulting cold, dry vapors ascended from their place of origin in the abdomen to the heart and finally to the brain, they interfered with normal emotional and intellectual functions. Thus, Aristotle theorized, the "manic-depressive" personalities of creative geniuses were caused when the vigorous fire of inspiration yielded suddenly to cold, charred ashes. Marsilio Ficino revived the ancient concept of scholarly melancholy in the Renaissance, interpreting it as a disease of the social and intellectual elite.[4]

The concept of melancholia, like that of hysteria, has enjoyed a continuous tradition from ancient times to the present day. In the seventeenth century, however, the trappings of Aristotelian melancholia became absorbed into the very fabric of popular culture as a fashionable pose for wealthy young men with pretensions. Robert Burton associated the disorder with "such as are nobly de-

2. The definitive examination of the ancient origins of medical and literary melancholia is Raymond Klibansky, Erwin Panofsky, and Fritz Saxl, *Saturn and Melancholy: Studies in the History of Natural Philosophy, Religion, and Art* (1964). For discussion of melancholia in medieval chivalric and literary contexts, see Mary Frances Wack, *Lovesickness in the Middle Ages: The "Viaticum" and Its Commentaries* (1990). See also Jackson, *Melancholia*, 29–77.

3. Aristotle, Problem 30, quoted in Klibansky, Panofsky, and Saxl, *Saturn and Melancholy*, 18.

4. Marsilio Ficino, *The Book of Life* (1980), 3–36. See also D. P. Walker, *Spiritual and Demonic Magic from Ficino to Campanella* (1958); and Giancarlo Zanier, *Le medicina astrologia e la sua teoria: Marsilio Ficino e i suoi critici contemporanei* (1977).

scended, high fedde, and such as live idle and at ease."[5] Consequently, artists depicted beleaguered students and privileged dandies alike, pouting, head in hand like the muse in Dürer's *Melencholia I* (figs. 89, 90, 91).[6] The pose was augmented by an overall air of calculated carelessness achieved by an open shirt, ungartered hose and disheveled hair. This attitude of exquisite moroseness was worn like a badge of privilege by young scholars, students, and aristocrats, men who had plenty of free time to muse over their lost loves and the sorry state of a world torn by plague, war, and economic collapse. The Ficinian association of melancholia with the qualities of sensitivity, intelligence, and wealth, long a standard fixture of philosophy and medical theory, became part of the literature and popular wisdom of the seventeenth century.[7]

The cures prescribed for melancholia were similar to those suggested for *furor uterinus*. Burton noted that idle men, like privileged women, were "far more subject to melancholy than such as are conversant or employed about any office or business."[8] But physical labor was considered unseemly for men of high social station. Instead, doctors encouraged mental activity, but only if practiced in moderation so as not to aggravate the illness it was meant to cure. In addition to the potions, diets, clysters, and bleedings appropriate to the pathology of *furor uterinus*, physicians prescribed gentle intellectual diversions for their male patients such as looking at landscape paintings, studying maps, inventing emblems, or examining herbals.[9] Walking in gardens, meditating on God, listening to music, and "seeing a fair maid" were also included in the list of curative pursuits.[10] The last activity was often considered sufficient in and of itself to restore the spirits of melancholics, for the acquisition of a "merry heart" was a

5. Robert Burton, *The Anatomy of Melancholy* (1932), 1:305.

6. For examples of images of melancholia that depend on Dürer's model, see Klibansky, Panofsky, and Saxl, *Saturn and Melancholy*, figs. 109–44. Melancholia as a subject in Dutch seventeenth-century portraits is discussed in H. Perry Chapman, *Rembrandt's Self-Portraits: A Study in Seventeenth-Century Identity* (1990); Hans Joachim Raupp, *Untersuchungen zu Künstlerbildnis und Künstlerdarstellung in den Niederlanden im 17. Jahrhundert* (1984), 226–41.

7. For discussions of social conditions as instigators of fashionable melancholia reflected in seventeenth-century literature, see Bridget Gellert Lyons, *Voices of Melancholy: Studies in Literary Treatments of Melancholy in Renaissance England* (1971); and Lawrence Babb, *The Elizabethan Malady: A Study of Melancholia in English Literature from 1580 to 1642* (1951).

8. Burton, *Anatomy*, 1:241–42.

9. Ibid., 2:68.

10. Ibid., 2:120.

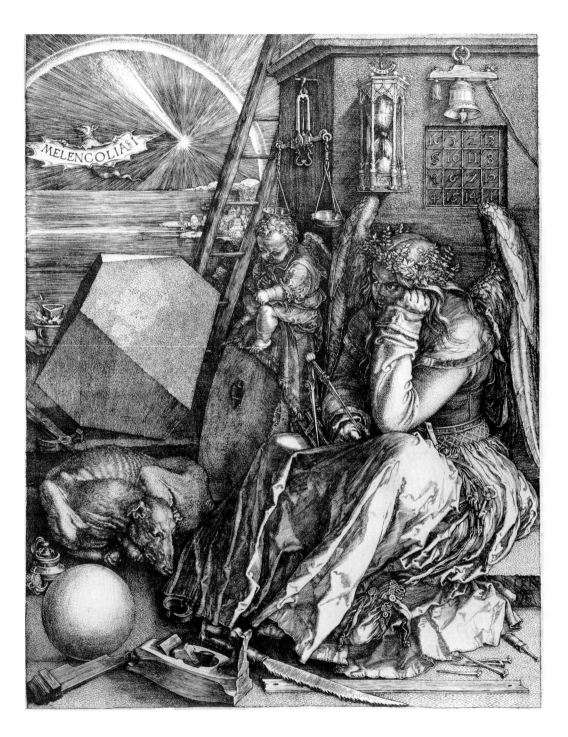

Fig. 89 Albrecht
Dürer, *Melencolia I*,
1514. Metropolitan
Museum of Art,
New York.

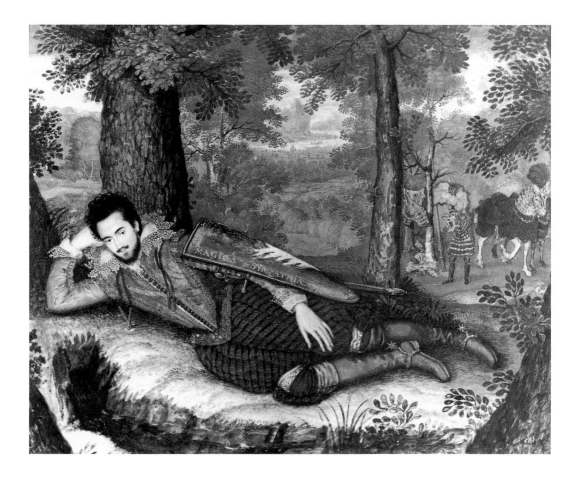

crucial element in the battle against the disease. The warm, moist passions of joy and contentment theoretically softened the cold, dry, impacted black bile of male melancholics just as they warmed the frigid bodies of female hysterics. Hence, it is not unusual to read specific clinical directions in medical texts instructing the patient to create a pleasant ambiance conducive to happiness. For melancholics the "good life," experienced in moderation, was said to act positively on the balance of bodily humors. Women, by contrast, were warned against the dangers of too much physical comfort and counseled to busy themselves with mundane domestic labor.

The distinct separation of melancholia and hysteria into diseases unique to the sexes was not always accepted without question by medical authority. The ancient Greek physician Galen recognized that both men and women who led idle lives tended to suffer "despair and sadness without reason."[11] The belief of the Renaissance

Fig. 90 Isaac Oliver, *Edward Herbert, First Baron Herbert of Cherbury,* ca. 1610–15. By permission of the Powis Castle Estate, Montgomeryshire, Wales. Photo: University of London, Courtauld Institute of Art Photographic Survey, London.

11. Galen of Pergamon, *On the Natural Faculties* (1916), 44.

Fig. 91 Pieter
Codde, *Melancholy*,
1628–30. Musée des
Beaux-Arts, Lille.
Photo: Amis des
Musées de Lille.

physician Paracelsus that the symptoms of *chorea lasciva* were caused by putrid fumes originating in the uterus resembled the traditional Aristotelian belief that smoky vapors rising from the hypochondries caused male melancholia.[12] Likewise, Ambrose Paré explained the similarity between *furor uterinus* and melancholia by citing their common origin in corrupted bodily hu-

12. See Bernard Gorceix, "La mélancolie au XVIᵉ et XVIIᵉ siècles: Paracelse et Jacob Bohme" (1979).

mors.[13] Edward Jorden further narrowed the gap by emphasizing the role of the brain in uterine disorders. Early in the seventeenth century, Burton's *Anatomy of Melancholy*, intended chiefly for male students and scholars, identified *furor uterinus* as a "particular species of melancholia" on account of the similarity of symptoms in both sexes. Burton described the physical and mental manifestations at length: heart palpitations; irregular pulse; pain in the head, chest, abdomen, belly, and sides; as well as fainting, bad dreams, fatigue, troubled sleep, perverted appetite, and a noticeable alternation of mood from laughing sociability to distracted sorrow. Burton took pains, however, to qualify his judgment, describing women's melancholy as "distinct from the rest, for it much differs from that which commonly befalls men . . . as having one only cause proper to women alone."[14] The "one cause" was, of course, the infamous uterus.

Seventeenth-century advances in the fields of anatomy and physiology revealed even more similarities between the illnesses of melancholia and hysteria. Thomas Willis's discovery that the uterus was fixed and could not move led to his redefining the ailments as two manifestations of the same disease, differing only in the sex of the victims. In order to distinguish between them, Willis referred to male melancholics as "hypochondriacs," a word coined by the Leiden physician Smollius (Gotfridus Smoll) in 1610.[15] (Willis's definition of hypochondria did not connote morbid preoccupation with one's health as it does today but referred to the abdominal organs, or "hypochondries," from whence the ailment originated.)[16] A proponent of the iatrochemical school of medicine, which depended on alchemical models, Willis suggested that hysteria and hypochondria were both caused by explosions of the vital spirits within the body.[17] The chaotic aftermath of these explosions adversely affected the brain and the other organs,

13. [Ambrose Paré], *The Workes of the Famous Chirurgion Ambrose Parey, translated out of the Latine and compared with the French by Tho. Johnson* (1649), 632–33.

14. Burton, *Anatomy*, 414.

15. Gotfridus Smoll [Smollius], *Trias maritima, proponens per introductionem trium aegrotanticum, sorcum morbosarum, domesticarum, hypochondriacae spleneticae; hypochondriacae meseraiae; hypochondriacae phantasticae; ortum et interitum* (1610).

16. The modern understanding of hypochondria as a condition in which one suffers from imaginary illness was introduced in 1822 by Jules P. Falret, *De l'hypochondrie et du suicide* (1822). See Ilza Veith, *Hysteria: The History of a Disease* (1965), 145.

17. Thomas Willis, "An Essay of the Pathology of the Brain and Nervous Stock in which Convulsive Diseases are Treated of," in *Dr. Willis's practice of physick, being the whole works of that renowned and famous physician* (1684).

causing identical symptoms in both men and women. Willis did not rule out a uterine origin for the disease in women, but he maintained that the womb was no more guilty than any other organ, and that "the same kind of Passions infest Men."[18] Likewise, Thomas Sydenham united melancholia and hysteria by recognizing a common origin in physical inactivity. He noted that, "as to females, if we except those who lead a hard and hardy life, there is rarely one who is wholly free from them [hysteric disorders]. . . . Then, again, such male subjects as lead a sedentary or studious life, and grow pale over their books and papers, are similarly afflicted; since, however much, antiquity may have laid the blame of hysteria upon the uterus, hypochondriasis (which we impute to some obstruction of the spleen or viscera) is as like it, as one egg is to another."[19]

Although progressive seventeenth-century medical theorists saw hypochondria and hysteria as two sides of the same melancholic coin, this view was hotly contested by many practitioners. Most physicians derived their definitions of women's illnesses from a vast body of scholarship spanning three thousand years, from which they selected certain "truths" and discarded others. The ancient association of *furor uterinus* with sexual abstinence remained, justifying the advisability of marriage for all women. So did belief in the independent "animal" nature of the womb, which confirmed the age-old assumption that all women were innately unstable. The fact remained, however, that the symptoms of melancholia suffered by venerated artists, heroic lovers, and geniuses were also common among humble women. Bernard Mandeville wrestled with the paradox in his *Treatise of the hypochondriack and hysterick passions*, in which the mythical physician Philopirio and his female patient Polytheia discuss the two ailments.[20] When Polytheia asks if hysteria is not merely another word for scholarly hypochondria, Philopirio replies that studying cannot be the primary cause of illness among women because they do so little of it. He justifies his case for a sexual division of the two ailments by noting that women's naturally weak spirits automatically dispose them to hysteria at the slightest provocation in the same way that

18. Ibid., 69.
19. *The Works of Thomas Sydenham* (1848), 85.
20. Bernard Mandeville, *A treatise of the hypochondriack and hysterick passions* (1976), 238–39.

the depletion of spirits in men after a bout of intense study results in melancholia.

Physicians who warned that a woman's body must not be idle did not apply the same directive to her mind. Even though the primary cause of uterine furies was prolonged celibacy, continual reading and intense study, especially on thorny mathematical and philosophical subjects, could worsen the condition or even instigate it. Overzealous mental activity, it was believed, tended to consume the natural moisture of the body and aggravate the inflamed womb.[21] Even the genteel pastimes of making maps, studying geometry, and inventing emblems prescribed for male sufferers were considered dangerous pursuits for women, whose minds, naturally weak from birth, could not stand the strain.[22] Physicians warned their female patients not to muse on the "abstract sciences," for these belonged properly to the male intellectual realm. They further maintained that "extreme thought" could cause miscarriage, and therefore discouraged intellectual activity even for healthy married women.[23] The inherent feebleness of the female mind, the result of natural coldness, was often cited as justification for barring the entire sex from serious intellectual activities.[24] It is no wonder that so few women in the seventeenth century, and before, devoted their lives to the theoretical pursuits of mathematics, musical composition, and science.

The question of education for women was hotly debated in the seventeenth century. The medical justification for limiting intellectual activity in women reinforced the general belief that they should be restricted in their scholarly endeavors. Light learning was allowed and artistic and musical talent encouraged for the amusement of lovers, husbands, and fathers, whereas mathematical and scientific accomplishments were considered inappropriate for and unattractive in the female sex. Thus, women painters such as Clara Pieters and Maria van Oosterwyck, gifted artists whose

21. Johannes Lange, *Traité des vapeurs* (1689), 182.

22. André Du Laurens [Laurentius], *A discourse on the preservation of the sight: of melancholike diseases; of rheumes, and of old age* (1599), 15; Jacques Ferrand, *Erotomania; or, A treatise discoursing of the essence, causes, symptomes, prognosticks and cure of love, or erotique melancholy* (1640), 56.

23. Andrew Boorde, *The breviarie of health, wherein doth folow remedies for all maner of sicknesses & diseases the which may be in man or woman* (1598), 8.

24. Bartolommeo della Rocca Coccles, *The Contemplation of Mankinde, contayning a singular discourse after the art of phisiognomie, on all the members and partes of man, as from the heade to the foote* (1571), iv.

works were highly valued during their lifetimes, were allowed some latitude as professionals.[25] Their talents, however, were developed and maintained within a male sphere, and their subject matter was limited to that which was considered seemly for women: still life, portraits, and light genre works rather than large-scale history painting. Since women were barred from attending university, any higher education was limited to private instruction or directed study at home.[26] Thus the success of women artists, though considerable in Holland, was usually the result of a father's or husband's encouragement. The case for female education was made in the *Apologie de la science des dames* (1662), which declared that "an accomplished woman is an adornment to her husband or father," destined by God to "charm the solitude of man by her presence."[27] The statement is but a seventeenth-century variation on Saint Paul's biblical analogy: "[Man] is the image and glory of god: but woman is the glory of man" (1 Corinthians 11:7).

The difference in treating hypochondriacal men and hysterical women, then, lay not only in the definition of how much study was "too much" but also in the choice of subject matter allowed each. The suggestion that melancholia and hysteria were closely related through common symptoms and causes made it even more necessary to deny afflicted women access to the exalted realm of the melancholic genius. This was achieved by barring them from certain areas of study, ostensibly for the sake of decorum and good health. The seventeenth-century medical establishment also adopted with renewed vigor the belief that women should marry young, remain sexually active, engage in physical labor, deny themselves the comforts of the good life, and take care not to "overburden" their minds. Hypochondria thus continued to be

25. For the lives and works of women artists, see Ann Sutherland Harris and Linda Nochlin, *Women Artists: 1550–1950* (1977); and Wendy Slatkin, *Women Artists in History: From Antiquity to the Twentieth Century* (1985). For studies of the subject matter of seventeenth-century women artists in the context of their time, see Frima Fox Hofrichter, *Judith Leyster: A Woman Painter in Holland's Golden Age* (1989); Norma Broude and Mary D. Garrard, eds., *Feminism and Art History: Questioning the Litany* (1982); and Mary D. Garrard, *Artemisia Gentileschi: The Image of the Female Hero in Italian Baroque Art* (1989).

26. See Jeanne Marie Noël, "L'école des filles et la philosophie du mariage dans les Pays-Bas de XVIᵉ et du XVIIᵉ siècles" (1982); idem, "Education morale des filles et des garçons dans les Pays-Bas au 16ᵉ siècle: deux manuels pédagogiques" (1986).

27. Quoted in Gustave Reynier, *La femme au XVIIᵉ siècle, ses ennemis et ses défenseurs* (1921), 180.

associated positively with men of creative genius and material wealth, whereas the illness of hysteria marked women's sex as a social liability.

The Threat of Illness as Social Control

The study of the imagery of the female sickroom prompts many questions. Why were physicians so concerned with the negative effects of intellectual activity on women at a time when women were accomplishing more in the realms of literature and art than ever before in history? Why did seventeenth-century physicians stubbornly persist in embracing the myth of the "wandering womb" in the face of published accounts to the contrary? What was there about the social climate of the seventeenth century that could have inspired a wide-ranging fascination with the unique medical problems of women? Why was this the century when women came under the relentless scrutiny of the male medical establishment, a scrutiny borne out by an unprecedented increase in the number of medical treatises devoted to uterine disorders and paralleled in the sudden popularity of the female sickroom as a subject for artists?

Answers to these questions emerge from a complex interweaving of economic, religious, and scientific forces, many of which were dependent on the concerns of a male-dominated culture. Men of the seventeenth century had strong motives for seeking to control women by the weight of medical authority, and physicians tended to champion causal and curative theories that justified and reinforced the social mandates of their time. As we shall see, the old ideal of the subservient, marginally literate woman was strengthened and reaffirmed in response to social directives.[28] It was a time when most women accepted without question the ancient fiction that they were doomed from birth to physical and intellectual inferiority.

Historians have shown that the confluence of capitalism and Protestantism in northern Europe during the seventeenth century

28. For discussion of the social expectations of women in the Renaissance, see Ruth Kelso, *Doctrine for the Lady of the Renaissance* (1956); and Ian Maclean, *The Renaissance Notion of Woman: A Study in the Fortunes of Scholasticism and Medical Science in European Intellectual Life* (1980).

had a dramatic effect on women.[29] During this time women faced changes in the social perception of their roles and expectations both within the family and without. After the collapse of the old land-based feudal system, women were bereft of meaningful employment, as they were no longer integral partners in family farms and businesses.[30] The roles of wife and mother were the only ones left to them, as the closing of convents in the Netherlands meant that women could no longer even choose the cloistered, consecrated lives of nuns as an alternative to marriage.[31] Although spinsterhood was a possibility, this choice often meant a life of poverty and uncertainty. Indeed, many of the "surplus" single women who might formerly have entered convents were left without shelter or vocation, and the need for charitable institutions to care for them grew more urgent.[32] As capitalism left women with fewer choices and Catholicism no longer offered an alternative to marriage, Protestantism filled the gap, emphasizing newly defined roles for women within the domestic sphere. Integral to this new definition was contempt for the old Catholic notion of virginity as the ultimate female virtue. Protestant thought sanctioned sex within the institution of marriage as a natural human function that reinforced the affectionate bond between man and wife, whereas Catholic theologians perceived women as the source of all evil and looked on marriage as an institution stained with the sin of lust.[33] Indeed, Saint Paul only begrudgingly sanctioned marriage with the proviso that "it is better to marry than to burn" (1 Corinthians 7:9). The rejection of celibacy, accompanied by the

29. See Alice Clark, *Working Life of Women in the Seventeenth Century* (1919); Maurice Herbert Dobb, *Studies in the Development of Capitalism* (1947); Roberta Hamilton, *The Liberation of Women: A Study of Patriarchy and Capitalism* (1978); Christopher Hill, *Reformation to Industrial Revolution: A Social and Economic History of Britain, 1530–1780* (1969); idem, *World Turned Upside Down: Radical Ideas during the English Revolution* (1972); Viola Klein, "Industrialization and the Changing Role of Women" (1963–64): 27–33; and Simon Schama, *The Embarrassment of Riches: An Interpretation of Dutch Culture in the Golden Age* (1987), 375–480.

30. Hamilton, *Liberation of Women*, 1–20.

31. See Isabella Henriette van Eeghen, *Vrouwenkloosters en begijnhof in Amsterdam van de 14e tot het eind der 16de eeuw* (1941); Sherrin Marshall Wyntjes, ed., *Women in Reformation and Counter-Reformation Europe: Public and Private Worlds* (1989), 130–31; Hendrik Casmirus de Wolf, *De kerk en het Maagdenhuis: Vier episoden uit de geschiedenis van katholiek Amsterdam* (1970), 52–64.

32. Klein, "Industrialization," 63.

33. See Jean Bethke Elshtain, *Public Man, Private Woman: Women in Social and Political Thought* (1981), 80–90; R. M. Frye, "The Teachings of Classical Puritanism on Conjugal Love" (1955); Charles H. George and Katherine George, *The Protestant Mind of the English Reformation, 1570–1640* (1961).

elevation of conjugal love as a necessary component of marriage, undermined the old Catholic image of woman as a necessary evil. The male authority of the Catholic priesthood was replaced by that of husbands and fathers within the home, as the Protestant idealization of the family was given substance by the capitalist division of the world into the male sphere of public life and work and the female realm of private life and domesticity.[34] Medical theory echoed the Protestant view of sex, treating celibacy as a disease that could be cured by marriage, childbirth, and housework. Artists invented a new subject, the female sickroom, in response to both theological and medical directives. Paintings of ailing women suffering from abstinence-induced illness reinforced the Protestant message against celibacy by instilling the fear of sickness and debility in female viewers. Marriage and family became the best choice not only for the common good but also for each individual woman's health and happiness.

Rebellious Women: The "New Feminism" of the Seventeenth Century

Modern women tend to perceive their relative freedom within society as the result of an unbroken historical evolution from powerlessness to emancipation. Scholars in the field of women's history, however, have shown that feminism, defined as a pro-female reaction to sexual inequality, has existed for many centuries and has waxed and waned in response to changing social trends.[35] Their reassessment of cultural history has brought to light a "new feminism" that peaked in mid-seventeenth-century Europe and involved women on an international scale. Bored and frustrated

34. Hamilton, *Liberation of Women*, 22.

35. The area of women's studies is vast and can be only briefly summarized here. For key books and their bibliographies which represent a highly selective list of works on seventeenth-century women, see Dorothy Anne Liot Backer, *Precious Women* (1974); Renate Bridenthal and Claudia Koonz, eds., *Becoming Visible: Women in European History* (1977); Vern L. Bullough, Brenda Shelton, and Sarah Slavin, *The Subordinate Sex: History of Attitudes toward Women* (1988); Ross Davies, *Women and Work* (1975); Garrard, *Artemisia Gentileschi*; Pearl Hogrefe, *Tudor Women: Commoners and Queens* (1975); Bridget Hutter and Gillian Williams, eds., *Controlling Women: The Normal and the Deviant* (1981); Carolyn C. Lougee, *Le Paradis des Femmes: Women, Salons, and Social Stratification in Seventeenth-Century France* (1976); Ian Maclean, *Woman Triumphant: Feminism in French Literature, 1610–1652* (1977); Rosalind K. Marshall, *Virgins and Viragos: A History of Women in Scotland from 1080–1980* (1983); Hilda Smith, *Reason's Disciples: Seventeenth-Century English Feminists* (1982); Linda Woodbridge, *Women and the English Renaissance: Literature and the Nature of Womankind, 1540–1620* (1986).

with lives of idleness and powerlessness and faced with the glorious possibilities offered by a new world order, women demanded more. Their arguments against the biological inferiority of the female sex were not theoretical debates but a real call for change. Female scholars such as Mary Astell in England, Lucrezia Marinelli in Italy, and Anna Maria van Schurman in Holland demanded the removal of social and intellectual restrictions that had bound women for centuries.[36]

Partial credit for the outspoken self-confidence of feminist authors in the seventeenth century must go to the example of Elizabeth I of England, whose successful reign challenged traditional beliefs about the innate incompetence of women in all but the domestic sphere. Several other female leaders also came to prominence in the late sixteenth and early seventeenth centuries, including Mary of Guise, Mary Tudor, and Catherine de' Medici. This historical coincidence inspired a torrent of misogynist diatribe, much of it aimed at curtailing the qualities of assertiveness and independence in women and demeaning the success of female monarchs as either anomalous or unnatural.[37] This animosity was expressed throughout the long reign of Elizabeth I and afterward.

There can be no doubt that the boldness and competence of seventeenth-century women aroused the ire of the conservative patriarchy. The highly emotional debate over the emancipation of women was mounted in the popular press. Misogynist books and pamphlets criticizing women for entertaining hopes of power, adopting manly roles, or seeking a formal education became ever more numerous and popular. Predictably this stance was most vocally declared by men, whose arguments centered on defining the differences between the sexes as symptomatic of women's natural inferiority. Female authors were articulate in their own defense, often taking a direct stance against a particular book or pamphlet.

36. Mary Astell, *A Serious Proposal to the Ladies for the Advancement of their true and greatest Interest* (1694); Lucrezia Marinelli, *La nobilità et l'eccellenza delle donne, co'deffetti et mancamenti de gli huomini* (1601); Anna Maria van Schurman, *Dissertatio, de ingenii muliebris ad doctrinam, & meliores litteras aptitudine* (1641).

37. See Barbara Joan Baines, ed., *Three Pamphlets on the Jacobean Antifeminist Controversy* (1978); Coryl Crandall, "The Cultural Implications of the Swetnam Antifeminist Controversy in the Seventeenth Century" (1968); Katherine U. Henderson and Barbara F. McManus, *Half Humankind: Contexts and Texts of the Controversy about Women in England, 1540–1640* (1985); Susan Moller Okin, *Women in Western Political Thought* (1979); Katherine M. Rogers, *The Troublesome Helpmate: A History of Misogyny in Literature* (1966); *Satires on Women* (1976); Francis Lee Utley, *The Crooked Rib: An Analytical Index to the Argument about Women in English and Scots Literature to the End of the Year 1568* (1944).

HIC MVLIER:
OR,
The Man-Woman:

Being a Medicine to cure the Coltifh Difeafe of
the Staggers in the *Mafculine-Feminines*
of our Times.

Expreft in a briefe Declamation.

Non omnes poſumus omnes.

Miftris, will you be trim'd or truff'd?

London printed for I. T. and are to be fold at Chrift Church gate. 1620.

Fig. 92 Hic mulier: or, the man-woman . . . , title page. London, 1620. By permission of the Houghton Library, Harvard University.

The satirical *Hic mulier: or, the man-woman . . .* (fig. 92), for example, was countered by the humorous *Haec-Vir: Or The Womanish-Man*, which attacked the fashion for precious foppery rampant at the English Stuart court.[38] A notorious exchange was capitulated by John Knox's *First Blast of the Trumpet against the Monstrous Regiment of Women* (Geneva, 1558), which was countered by Jane Aylmer in *An Harbour for Faithful and True Subjects against the Late Blown Blast Concerning the Government of Women*

38. *Haec-Vir: Or The Womanish-Man: Being an Answere to a late Booke intituled Hic-Mulier* (London, 1620), reprinted in Baines, *Three Pamphlets*.

(London, 1559).[39] Yet another famous interchange took place in France as Jacques Olivier's *Alphabet de l'imperfection et malice des femmes, dedié à la plus mauvaise du monde* (Alphabet of the Imperfection and Malice of Women, Dedicated to the Worst in the World; 1617), which attached a female vice to each letter of the alphabet, was countered by the anonymous *Défense des femmes contre l'Alphabet de leur prétendue malise et imperfection* (Women's Defense against the Alphabet of Their Supposed Malice and Imperfection). Women rose to the challenge and vigorously responded to printed slander against their sex.[40] Several enlightened men also came to their defense, though such sympathetic men became less numerous as the close of the sixteenth century merged into the beginning of the seventeenth.[41]

Despite the female call for more freedom and power, the belief that ordinary women were inordinately free and unrestrained was a fixture of seventeenth-century common wisdom. In 1617 Fynes Moryson made the famous assertion that England was "the Hell of Horses, Purgatory of Servants and the Paradise of Woemen."[42] That clever saying was adopted later in the century by the French, who described Paris similarly as "le paradis des femmes, le pourgatoire des hommes, et l'enfer des chevaux" (the paradise of women, purgatory of men, and hell of horses).[43] Civic authorities responded by legislating female behavior, even to the extent of controlling feminine fashion. Cross-dressing, which had become stylish among the upper classes, was soundly criticized throughout Europe, and women found guilty of assuming male identities were punished by law.[44] Instead of "manly short lockes" for women, "faire large haire" was prescribed. Women were required to exchange swords and daggers for needles and replace their "gyant-like behaviors" with modest, restrained gestures.[45] *Hic mulier* reserved a special vehemence for the manly "viragos" who appropriated traditional male elements in their dress. The pamphlet

39. See Hogrefe, *Tudor Women*, 5–6.

40. See Louis B. Wright, *Middle-Class Culture in Elizabethan England* (1935), 488–89.

41. See, for example, Henrich Cornelius Agrippa von Nettesheim, *On the Superiority of Woman over Man* (1873), which some historians think was written in irony; and Anthony Gibson, *A womans woorth defended against all the men in the World. Prooving them to be more perfect, excellent and absolute in all vertuous actions, than any man* (1599), which may have been written to curry favor with Queen Elizabeth I.

42. Fynes Moryson, *An Itinerary* (1971), 462.

43. *Catechisme des courtisans* (1668), quoted in Lougee, *Paradis*, 12.

44. See Marshall, "Protestant, Catholic, and Jewish Women," 120–39.

45. Stated in James I's decree of January 25, 1620, reprinted in Baines, *Three Pamphlets*, vii.

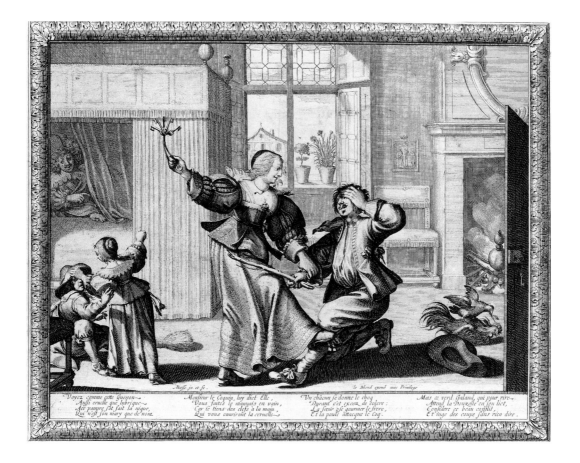

Fig. 93 Abraham Bosse, *Man Beating a Woman*, mid-17th c. From the Art Collection of the Folger Shakespeare Library, Washington, D.C.

severely criticized women for "exchanging the modest attire of the comely hood, caule, coyfe, handsome dresse or kerchief, to the cloudy ruffianly . . . broad-brimd hat, and wanton feather . . . loose, lascivious civil embracement of a French doublet, being all unbuttoned to entice, all of one shape to hide deformatie, and extreme short wasted to give a most easy way to every luxurious action."[46] An engraving by Abraham Bosse of a man beating a woman is one of many that reflect the cultural paranoia that gripped the century (fig. 93). An amusing variation on the age-old "battle for the breeches" theme, it depicts a cuckolded husband whose attempt to subdue his wife has been foiled by her superior strength.[47]

46. *Hic mulier: or, the man-woman: being a medicine to cure the coltish disease of the staggers in the masculine-feminines of our times* (1620).

47. The "battle for the breeches" was a popular theme throughout the medieval and Renaissance eras. A woman carrying a pair of men's underpants appears, for example, in a marginal drollerie from Pucelle's *Heures de Jeanne d'Evreux*, ca. 1325. For further discussion of the "power of women" theme in art, see *Helse en hemelse vrouwen: Schrikbeelden en voorbeelden van de vrouw in de christelijke cultuur* (1988); Alison G. Stewart, *Unequal Couples: A Study of Unequal Couples in Northern Art* (1977); *Tussen heks & heilige: Het vrouwbeeld op de drempel van de moderne tijd, 15de/16de eeuw* (1985); and Schama, *Embarrassment of Riches*, 430–60.

The wife, dressed in the unseemly French doublet favored by "viragos," holds the household keys in one hand while she brings her husband to his knees with the other. The scene is echoed in the play of a little boy and girl who mimic the behavior of their parents, and in the battle of a cock and hen in which the hen has gained the advantage. The engraving shows a woman out of control—a thing to be feared and avoided in the seventeenth century.

Detractors of women gained the upper hand after the death of Queen Elizabeth.[48] The Restoration in 1660 further put an end to the Commonwealth phenomenon of the English businesswoman, though Dutch women continued to be active in the business world.[49] Treatises dedicated to the great women of history (excluding the example of the recent queen of England) taught wives "to demean themselves toward their husbands in all conjugall affection," and revealed how "daughters may here be taught examples of obedience and chastity . . . widows that constancy which befits their solitude."[50] Predictably, such books dealt exclusively with chaste, honorable examples from the distant biblical and classical past who were either fruitful mothers, virtuous daughters, or pious widows. In the words of Mary Astell, women were once again forced into the role of "little useless and impertinent animals."[51]

Women in Holland: Their Health and Welfare

Since the theme of the female sickroom originated in Holland during the seventeenth century, it is worth examining the relationship of these pictures to the actual situation of women in this time and place. In general, women in the predominantly Protestant, capitalist Netherlands mirrored the circumstances of women

48. See Baines, *Three Pamphlets*, v, vi.

49. See Clark, *Working Women*, 42; Sherrin Marshall Wyntjes, *The Dutch Gentry, 1500–1650: Family, Faith, and Fortune* (1989), 53–68.

50. Thomas Heywood, *The generall history of women, contayning the lives of the most holy and profane, the most famous and infamous of all ages, exactly described not only from poeticall fictions, but from the most ancient, modern, and admired historians, to our times* (1657), A3. See also Suzanne W. Hull, *Chaste, Silent and Obedient: English Books for Women, 1475–1640* (1982). For a comprehensive discussion of moral and literary support for this image of woman and its reflection in Dutch art, see Wayne E. Franits, *Paragons of Virtue: Women and Domesticity in Seventeenth-Century Dutch Art* (1993); also Ilja M. Veldman, "Lessons for Ladies: A Selection of Sixteenth- and Seventeenth-Century Dutch Prints" (1986).

51. Astell, *Serious Proposal*, 93.

in other European countries.[52] The Puritan Pietist movement, popular in both England and the Netherlands, sought to restrain them by proclaiming domestic duties as their "calling," ordained from on high.[53] Thus, the ideal of women as mild-mannered homebodies—passive, modest, humble, sweet, simple, peaceful, kind, pious, childlike, and beautiful—was reinstated and enforced by the Protestant patriarchy.[54] Women were once again tightly restricted by the mandatory virtues of patience, charity, constancy, and obedience. Industry and self-sacrifice were praised, assertiveness and ambition criticized. Guardians of the patriarchy, like the physician Johannes van Beverwijck and the moralist Jacob Cats, lauded women for their thrift and industry in running the home rather than for their capabilities outside the domestic sphere.[55] Instead of being satisfied with their new roles as paragons of virtue on the homefront, however, some women spoke out. Anna Maria van Schurman's accomplished treatise *De ingenii muliebris* (The Learned Maid) of 1641, composed in the scholarly language of Latin thought too taxing for women, appealed for equal educational opportunities for both sexes.[56]

The historian Simon Schama has written that "any consideration of the image of women in Dutch culture is inevitably an inspection of male responses towards them."[57] The same sentiment was echoed by two physicians in this century, who observed that the diagnosis of hysteria has always been "a picture of women in the words of men," a "caricature of femininity."[58] Indeed, the na-

52. Much recent scholarship addresses the situation of Dutch women. See, for example, the historiographic essay by Rudolf Dekker, "Vrouwen in middeleeuws en vroeg-modern Nederlands" (1992).

53. See Steven Ozment, *When Fathers Ruled: Family Life in Reformation Europe* (1983), 1–25; Margo Todd, *Christian Humanism and the Puritan Social Order* (1987). For discussion of the Puritan Pietist movement's philosophy reflected in art, see Franits, *Paragons*, 66, 147.

54. See Donald Haks, *Huwelijk en gezin in Holland in de 17de en 18de eeuw* (1985); Judith Hokke, " 'Mijn alderliefste Jantielief.' Vrouw en gezin in de Republiek: Regentenvrouwen en hun relaties" (1987); Lène Dresen-Coenders and Ton Brandenbarg, *Vijf eeuwen gezinsleven: Liefde, huwelijk en opvoeding in Nederland* (1988).

55. See Johan van Beverwijck, *Van de wtnementheyt des vrouwelijken geslachts* (1639); and Jacob Cats, *Houwelijck; dat is de gansche gelegentheyt des echten staets* (1655).

56. See Joyce Irwin, "Anna Maria van Schurman: From Feminism to Pietism" (1977); Mirjam de Baar, ed., *Anna Maria van Schurman (1607–1678): Een uitzonderlijk geleerde vrouw* (1992); idem, "Van kerk naar sekte: Sara Nevius, Grietje van Dijk en Anna Maria van Schurman" (1991).

57. Simon Schama, "Wives and Wantons: Versions of Womanhood in Seventeenth-Century Dutch Art" (1980): 1.

58. Paul Chodoff and Henry Lyons, "Hysteria, the Hysterical Personality, and 'Hysterical' Conversion" (1958), 739. The same belief was stated by Howard M. Wolowitz, "Hysterical Character and Feminine Identity" (1972).

ture of the seventeenth-century Dutch social structure and econ-
omy suggests that the artistic portrayal of women as sick and
therefore powerless could have been more a form of male wish
fulfillment than a statement of fact. Indeed, there is historical evi-
dence suggesting that Dutch women were notorious for not con-
forming to the traditional requirements of feminine behavior. The
visiting Englishman Fynes Moryson recorded his amazement at
their boldness and business acumen: "While their husbands sport
idly at home, the women especially of Holland . . . manage most
part of the businesse at home, and in neighbor cities. In the shops
they sell all, they take all accompts, and it is no reproch to the men
to be never inquired after, about these affaires, who taking money
of their wives for daily expenses, gladly passe their time in idle-
nesse."[59] Likewise, William Temple, writing in 1673, found the
women of Holland "such lovers of their liberty, as not to bear the
servitude of a mistriss . . . or a master."[60]

Foreign visitors, especially those from southern European
countries, perceived the Dutch women as cold, aloof, and prag-
matic. This they attributed in part to the northern climate, which
caused a dominance of phlegmatic and melancholic humors
within the body. The humoral nature of Dutch women was
thought to be further exaggerated by the many swamps and canals
surrounding their homes.[61] They were also criticized for their leg-
endary overfondness for chocolate, tea, and coffee, substances that
were believed to increase melancholy.[62] Even the typical northern
European diet, consisting of large amounts of dairy products,
fish, bread, and root vegetables—all substances associated with
phlegm and black bile—was said to encourage coldness.[63] In addi-

59. Moryson, *Itinerary*, 97.

60. William Temple, *Observations upon the United Provinces of the Netherlands* (1673), 148.

61. See William Rowley, *A treatise on female, nervous, hysterical, hypochondriacal, bilious, convulsive diseases; appoplexy and palsy; with thoughts on madness, suicide, etc., in which the principal disorders are explained from anatomical facts, and the treatment formed on several new principles* (1788).

62. See George Cheyne, *The English malady; or, A treatise of nervous diseases of all kinds, as spleen, vapours, lowness of spirits, hypochondriacal, and hysterical distempers, etc.* (1976), 34; Pierre Pomme, *Essai sur les affections vaporeuses des deux sexes* (1760), 28; Joseph Raulin, *Traité des affections vaporeuses de sexe; avec l'exposition de leurs symptômes . . . et la méthode de les guére* (1758), 11.

63. Moryson, *Itinerary*, 97. On the importance of fish and dairy products in the Dutch diet, see Lambertus Burema, *De voeding in Nederland van de middeleeuwen tot de twintigste eeuw* (1953), 107–14; and Peter G. Rose, trans. and ed., *The Sensible Cook: Dutch Foodways in the Old and the New World* (1989).

tion, the natural physiognomy of most northern European women, who tended to be fair and plump, was thought to predispose them to uterine disturbances. In the early eighteenth century George Cheyn made a case for the prevalence of melancholia and hysteria in northern Europe, noting that "those of the fairest, clearest and brightest colored hair, are of the loosest and weakest state of fibers and nerves." His theory of racial predisposition to "nervous" diseases (based on Aristotelian physiognomy) designated blondes with "soft and yielding" flesh and "very fine and white hair" as naturally weak and tender. "White, fair, blanch'd, wax or ashen-colour'd" skin also indicated a weaker constitution than a complexion of a "ruddy brown or dark hue."[64]

Medical theorists also noted that this natural coldness of Dutch women, combined with their pressing business responsibilities outside the home, caused them to neglect the delights of the marriage bed. Nicolas Venette attributed the frigidity of northern European women to the fact that they were naturally cold and wet, whereas love was a warm passion.[65] This characteristic was noted by the Englishman William Temple, who reported that "in general, all appetites and passions seem to run lower and cooler in their tempers not airy enough for joy; nor warm enough for love."[66] Indifference to sex was believed to be hereditary and habitual among the women of Holland owing to the preponderance of earth and water in their bodies and the influence of the cold, wet northern climate. Compared to the volatile, sanguine French and Italians, the pragmatic northern women must have seemed relatively uninterested in attracting the attentions of the opposite sex. In fact, the French saying "to make love like a Dutch woman" became a sarcastic way of describing a frigid female in the seventeenth century.[67]

Strong, competent women were not always regarded negatively in the Netherlands. Indeed, the willful daughter who rejects her father's choice of a husband was a popular subject in seventeenth-century Dutch plays, and the threat of "lovesickness"

64. Cheyne, *English malady*, 69–70.

65. Nicolas Venette, *Venus minsieke gasthuis, waer in beschreven worden de bedryven der liefde in den staet des houwelijks, met de natuurlijke eygenschappen der manen en vrouwen, hare siekten, oirsaken en genesingen* (1688), 195. See also Herman Roodenburg, " 'Venus minsieke gasthuis': Over seksuele attitudes in de achttiende-eeuwse Republiek" (1985).

66. Temple, *Observations*, 147–48.

67. Paul Zumthor, *Daily Life in Rembrandt's Holland* (1963), 22.

was involved in a number of legal cases that granted daughters the right to marry without their father's consent.[68] There is also a history of Dutch women being involved in political protests and even instigating riots. Feminine displays of pluck and "manly" courage, when made on behalf of family and country, were considered noble and likened to the example of the biblical paragon Judith, who beheaded Holofernes, the enemy of her people.[69] But when such displays of independent action did not support the family or accord with the common good, female perpetrators were punished and treated as deviant. Such was the case when women attempted cross-dressing, whether to lead their lives as men or to enter an institution that would otherwise have been closed to them.[70] As in England, a tradition of misogynist literature sprang up in response to female pretensions of equality and demands for power outside the home. Works such as Jan de Mol's *Huwlijks doolhof* (Marriage Maze; 1634), Hieronymus Sweerts's *De boosardige en bedrigelikje huisvrou* (The Shrewish and Deceitful Housewife; 1682), and the infamous *Tien vermakelijkheden der houwelyks* (Ten Amusements of Marriage; 1678) satirized women who profaned the institution of marriage by reaching beyond their "natural" roles as subservient wives and mothers.[71]

Dutch artists, working within the genre tradition, joined with physicians to reinforce and reflect the mission of society to preserve economic, moral, and social stability. Physicians and painters were especially cognizant of one another in the city of Leiden, where one of the world's great medical schools was located. It is not surprising, then, that the majority of so-called lovesick maiden and doctor's visit paintings were produced by artists who either lived in Leiden or had trained there, though the subject of the female sickroom was by no means confined to that city. The concentration of these paintings in Leiden does, however, reflect a growing interest in women's illness that would eventually evolve

68. Einar Petterson, "*Amans Amanti Medicus*: Die Ikonologie des Motivs der *ärztliche Besuch*" (1987): 212–17, notes several seventeenth-century Dutch plays that address the theme of lovesickness.

69. See Rudolf Dekker, *Holland in beroering* (1982), 51–60; idem, "Women in Revolt: Collective Protest and Its Social Basis in Holland" (1987); Wayne P. te Brake, Rudolf M. Dekker, and Lotte C. van de Pol, "Women and Political Culture in the Dutch Revolutions" (1990); Marshall, "Protestant, Catholic, and Jewish Women," 121–24.

70. See Rudolf M. Dekker and L. van de Pol, *Dar was laatse een meisje loos* (1981), 135–39; Marshall, "Protestant, Catholic, and Jewish Women," 123.

71. See Schama, "Wives and Wantons," 5–13; idem, *Embarrassment of Riches*, 444–63; Peter C. Sutton et al., *Masters of Seventeenth-Century Dutch Genre Painting* (1984), lxxv–vi.

into a "specialization" of the city's medical school. In fact, the university at Leiden accounted for approximately one fourth of the 125 seventeenth-century doctoral dissertations written on the subject of women's illness dispersed among 22 European medical colleges.[72] These treatises, required for receipt of the M.D. degree, were written and published in Latin so as to ensure an international audience.

The great number of new medical works devoted to women's illnesses, in combination with the visual evidence left to us by painters, suggests that women must have suffered in larger numbers than ever before in the seventeenth century. Historians of medicine do indeed identify hysteria as one of the "new" diseases that arose during this time.[73] Medical texts of the period affirm that *furor uterinus* was considered an illness of epidemic proportions, as widespread as scurvy and rickets in the year 1661.[74] It is important to remember, however, that "hysteria" could mimic any disease, and that the uterus was considered the ultimate source of every symptom in women. It is therefore likely that this observation indicates an increase in the diagnosis of *furor uterinus* caused by the new direction that medicine was taking at the time. Although the Dutch fascination with women's illnesses led to the evolution of a new science of gynecology based on empirical observation, it is tempting to perceive such advances as inspired in part by a need to devise a scientific response to the "new feminism" of the seventeenth century.[75]

The classical medical image of woman as dominated from birth by the wayward influence of the moon and subject to the whims and appetites of the fickle uterus both reflected and reinforced the wishes of the international patriarchy in the post-Elizabethan era. Doctors saw themselves as moral and physical guardians of the welfare of women and of the social status quo. Dutch women were considered willful, forward, clever, and passionless, a characterization at odds with the meek and subservient feminine ideal of the seventeenth century. They were also perceived as predis-

72. See list of dissertations written on the subject of hysteria between 1575 and 1699 in the appendix.

73. See Lloyd G. Stevenson, " 'New Diseases' in the Seventeenth Century" (1965).

74. The increase in female illness in the seventeenth century was noted by many at that time. See, for example, John Graunt, *Natural and Political Observations upon the Bills of Mortality* (1661–62).

75. See Esther Fischer-Homberger, "Hysterie und Misogynie: Ein Aspekt der Hysteriegeschichte" (1969).

posed to sexual abstinence and illness by their race, physiognomy, and national geography. Physicians easily found justification in two thousand years of medical tradition for claiming that the attributes that made women dangerous to society also threatened their health and well-being. Behaving in an "unwomanly" manner, pursuing an education, remaining unmarried, and being idle were all guaranteed to affect the sensitive womb, resulting in extreme physical discomfort, miscarriage, even death. The time-honored, medically sanctioned cures for hysteria—marriage, housework, and childbearing—ultimately had the effect of restricting women to their homes. Cognizance of the unpredictable sensitivity of the uterus forced women to acknowledge the limitations of their sex and accept their dependence on the professional prowess of male doctors, if not their own husbands and fathers. The same goal was sought by Dutch moralists, who described an ecstatic image of female joy and tranquillity within the home as a way of making domestication attractive to women. In response, women avoided politics, science, and other traditional male intellectual spheres. Riddled with guilt, belittled by misogynist abuse, and frightened by the specter of illness, most dared not endanger themselves, their families, or their country by challenging the only authority known to them. A sick woman was also a safe woman.

VII

EPILOGUE
Exit the Wandering Womb

Classical humoral theory gradually lost ground throughout the seventeenth century and had all but become invalid by the early years of the eighteenth. The iatrochemical theories championed by Willis and Sydenham were soon displaced by proponents of the mechanistic school of medicine, though elements of iatrochemistry continued to be part of medical theory throughout the century. Influenced by Harvey's discovery of the circulation of blood and Descartes's writings, medical theorists came to view the human body as a biological machine.[1] They explained every bodily function in mechanical terms, interpreting the body as a vastly complicated hydraulic complex and the abdominal region as an intricate sewer system. Disorders in the lower body were thought to influence delicate nerves and blood vessels, much as a clog or blowout would affect a hydraulic mechanism. Friedrich Hoffmann, who combined iatrochemical and mechanical modes of thought, described the body as a machine composed of both solid and fluid particles. When the fluids turned acidic, they became sluggish, causing the low energy and

1. On the mechanistic school of medicine's explanation of hysteria and hypochondria, see Stanley W. Jackson, *Melancholia and Depression from Hippocratic Times to Modern Times* (1986), 116–21; Lester S. King, *The Philosophy of Medicine: The Early Eighteenth Century* (1978), 121–24; Robert Mauzi, "Les maladies de l'âme au XVIIIᵉ siècle" (1960); Ilza Veith, *Hysteria: The History of a Disease* (1965), 146–56.

mental depression typical of "nervous" diseases.[2] Archibald Pitcairn visualized the human system as a series of canals whose purpose was to convey fluids throughout the body. He theorized that when the blood thickened, circulation became sluggish, thereby affecting the flow of animal spirits in the nerves.[3] Hermann Boerhaave, who headed the Leiden medical school at the height of its international prestige, abandoned traditional humoral theory in favor of a circulatory physiology based on hydrodynamics.[4] Boerhaave and his distinguished protégé Gerard van Swieten described the body as a series of vessels in which circulating fluids composed of microparticles responded to mechanical forces. The vascular system was divided into four parts, one for each humor. Though Boerhaave thus used the traditional Galenic term for bodily fluids, his humors were not derived from earth, air, water, and fire but consisted of watery, fatty, oily, and glutinous particles. Loss of watery particles in the body resulted in *atrabilis*, or coagulation of formerly volatile elements. When this "melancholy juice" separated from the blood, it settled and accumulated in the abdomen, where, thick and stagnate, it clogged the organs and vessels.[5]

Over the years physicians had come to suspect what Galen and Soranus had known centuries earlier—that the womb was not capable of spontaneous movement, but was a stationary abdominal organ bound to the body by muscles, blood vessels, and skeletal structure. As early as 1666 Thomas Willis had stated that the womb was, for the most part, not implicated in women's diseases. His belief was corroborated the following year by the Leiden anatomist Jan Swammerdam, who, by filling the uterine vessels with wax, determined the actual structure of the organ.[6] The heated argument that followed Swammerdam's publication of his discoveries is one of the great debates in medical history.[7] Controversial

2. See Friedrich Hoffmann, *A System of the Practice of Medicine* (1783).

3. See Archibald Pitcairn, *The Philosophical and Mathematical Elements of Physick* (1718).

4. See Hermann Boerhaave, *Aphorismi, de cognoscendi et curandis morbis, in usum doctrinae domesticae digesti* (1709). See also Gerrit Arie Lindeboom, *Herman Boerhaave: The Man and His Work* (1968).

5. See Gerard van Swieten, *Maladies des femmes et des enfans* (1769), 1; Boerhaave, *Aphorismi*, 224–26.

6. See Jan Swammerdam, *Miraculuum naturae, sive Uteri muliebris fabrica* (1672). See also Gerrit Arie Lindeboom, "Jan Swammerdam (1637–80) and his Biblia Naturae" (1982).

7. Part of the controversy caused by Swammerdam's publication was the fact that Regnier de Graaf simultaneously claimed the same discovery. See Regnier de Graaf, *De mulierum organis generationi inservientibus tractatus novis* (1672).

at first, belief in the stationary uterus was fully accepted as a gynecological fact in the eighteenth century.

Mechanistic theorists also upheld the linkage of hysteria and hypochondria championed by proponents of the iatrochemical school. Thus, after 1700 the two diseases were commonly discussed in the same breath and treated as one.[8] Indeed, Richard Blackmore claimed that "while some separate hypochondria and hysteria—they are really the same," and Richard Browne's treatise on medicinal music called the separation of the two conditions a "ridiculous ungrounded notion . . . long since confuted."[9] Hysteria was still believed more common in the female sex, however, on the grounds that menstrual excrement was apt to cause obstructions in women, whose bodies were delicate and easily upset.[10] Menstruation, like every other bodily function, was explained mechanically, and the womb was perceived as a complex intertwined system of tubes, vessels, veins, and arteries. When the monthly flow was impeded, theorists believed, the abdomen became engorged and the system backed up like a clogged drain.[11] Even if the womb itself could not move, vapors originating from the uterus (or from the spleen in men) could rise from the abdomen and affect the nerves and circulatory system.[12] Instead of *furor uterinus* or "fits of the mother," eighteenth-century women were said to suffer from attacks of "vapors" and "nerves." Although the uterus had been ousted as the prime villain, it remained guilty by association.

Later in the century mechanistic theory was challenged by neurological explanations that emphasized the role of the nerves in women's illnesses.[13] Robert Whytt (1714–66), a student of Boerhaave's in Leiden, expanded the definition of the word *nervous*, first used in connection with women's complaints by Willis a cen-

8. See G. S. Rousseau, "'A Strange Pathology': Hysteria in the Early Modern World, 1500–1800" (1993).

9. Richard Blackmore, *A Treatise of the Spleen and Vapours, or Hypocondriacal and Hysterical Affections* (1725), 96. See also Richard Browne, *Medicina musica: or, A mechanical essay on the effects of singing, musick and dancing, on human bodies* (1729), 70.

10. See Blackmore, *Treatise of the Spleen*, 96; Pierre Pomme, *Essai sur les affections vaporeuses des deux sexes* (1760), 24, 38; John Purcell, *A treatise of vapours, or, hysterick fits* (1707), 38; Joseph Raulin, *Traité des affections vaporeuses du sexe: avec l'exposition de leurs symptômes . . . et la méthode de les guére* (1758); Robert Whytt, *Observations on the nature, causes, and cure of those disorders which have been commonly called nervous, hypochondriac, or hysteric* (1765), 105.

11. See van Swieten, *Maladies des femmes*, 28, 39, 69.

12. See Blackmore, *Treatise of the Spleen*, 100.

13. See Jackson, *Melancholia and Depression*, 124–32; and Veith, *Hysteria*, 159–68.

tury earlier.[14] Whytt described the body as in sympathy with the nerves, the "instruments of sensation," which he believed carried a fine fluid throughout the system. He emphasized the importance of emotions in the illnesses of hysteria and hypochondria, claiming that strong passions caused sudden changes in the motion of the nervous fluid, which resulted in the physical and psychological symptoms of disease. Whytt's "nervous" explanation unified the soul and the body, for "certain ideas or affections excited in the mind are always accompanied with corresponding motions or feelings in the body."[15]

Both men and women could fall prey to "nerves," but the disorder was more common in women, whose bodies were said to be weaker and more easily affected by strong passions.[16] Whytt and van Swieten combined the nervous and uterine causes in women, maintaining that symptoms, which could result from a weakness in one or more bodily organs, were more commonly associated with the uterus because there was more extensive sympathy between that organ and the rest of the body.[17] Van Swieten, unwilling to abandon a uterine cause for female hysteria, wrote: "It cannot be denied, that corrupted humours, collected in the cavity of the uterus, or lodged in the vessels dispersed through its substance, by eroding or irritating this nervous part, may produce the worst complaints."[18] Thus, the ancient notion of the capricious womb, capable of wreaking havoc throughout the entire body, remained a fixture of eighteenth-century medical theory.

Women in Eighteenth-Century Social and Medical Thought

Beginning in the eighteenth century, a change occurred in the medical characterization of women who were prone to vapors and nerves. They were now described as "delicate" instead of "slothful," their bodies "tender" instead of "feeble," their minds of an

14. See Whytt, *Observations*, 105.

15. Ibid., 60.

16. Ibid., 102.

17. Ibid., 27–28.

18. Gerard van Swieten, *Commentaries upon Boerhaave's aphorisms concerning the knowledge and cure of diseases* (1776), 1:374.

"exquisite irritability" rather than "weak."[19] Medical theorists believed that it was an essentially feminine sensitivity that responded to the most subtle stimulus of the nerves.[20] Although some men, especially young aristocrats, were inclined to nervous disorders, women in general were considered more susceptible because their bodies were more tender and delicate, their nerves more unstable and responsive. Thus, physicians viewed vapors and nerves as essentially women's illnesses. At the same time the Dutch fascination with women's diseases lessened, a phenomenon that was accompanied by a general decline in the political and economic power of the Low Countries.[21] Concurrently, the center of art and culture in eighteenth-century Europe shifted to France, where the rarefied ambience of the court was dominated by fashionable women and literary *précieuses*.[22] The image of the sturdy Dutch housewife who served as an example to her idle and forward sisters was replaced by that of a frail, dainty, aristocratic creature who could be indolent without being labeled slothful.

The liberated environment of the French court allowed women increased sexual freedom. They happily abandoned domestic duties to servants and actively practiced contraception.[23] As a result, they were free to enjoy long hours of leisure and to pass their days in the aimless pursuit of pleasure. Bourgeois Dutch women had been instructed to love and serve their husbands, who, in theory, returned the favor in kind; aristocratic French women, however, rarely considered mutual love a factor in matrimony. As a rule, both sexes tended to view marriage as a duty and extramarital affairs as a convenience by which true affection could find fulfill-

19. See Blackmore, *Treatise of the Spleen*, 97; Jean Baptiste Pressavin, *Nouveau traité des vapeurs, ou, Traité des maladies des nerfs, dans lequel on développe les vrais principes des vapeurs* (1771), 207–9; William Rowley, *A treatise on female, nervous, hysterical, hypochondriacal, bilious, convulsive diseases; appoplexy and palsy; with thoughts on madness, suicide, etc., in which the principal disorders are explained from anatomical facts, and the treatment formed on several new principles* (1788); Whytt, *Observations*, 83. See also Étienne Trillat, *Histoire de l'hystérie* (1986), 50–60.

20. See Veith, *Hysteria*, 168–69.

21. See appendix, which suggests that the number of dissertations devoted exclusively to women's illness lessened in Holland and elsewhere in the first half of the eighteenth century.

22. See Carolyn C. Lougee, *Le Paradis des Femmes: Women, Salons, and Social Stratification in Seventeenth-Century France* (1976); Rosalind K. Marshall, *Virgins and Viragos: A History of Women in Scotland from 1080–1980* (1983), 64–88.

23. See A. Chamoux and C. Dauphin, "La contraception avant la Révolution française: l'exemple de Chatillon-sur-Seine" (1969); James F. Traer, *Marriage and Family in Eighteenth-Century France* (1980).

ment. French women's literature of the early eighteenth century conspicuously lacked the adulation of motherly and wifely roles that was ubiquitous in the Netherlands. Instead, this feminist literature extolled the concept of free love and celebrated the unmarried state, especially for young women who were well educated and intelligent.[24] The ideal eighteenth-century woman was thus a lovely, delicate lady who rarely submitted to the rigors of fidelity.

At the same time, and perhaps as a result of such views, medical theorists began to suggest that too much sex rather than not enough was a prime factor in women's illness. Although virgins could succumb, young women "of a tender habit, and subject to exorbitant sallies of lawless passion," were considered the most likely victims.[25] Some theorists cited "immoderate venery" as a cause of illness and added prostitutes to the list of potential sufferers.[26] Physicians incriminated the luxurious life-style of the French upper classes, citing "immoderate coitus" as a cause of vapors in both men and women. They claimed that the habit of abruptly switching from a sedentary life of luxury to "the convulsive pleasures of love" could upset delicate nerves, causing a paroxysm.[27] In direct contrast to the dire warnings against prolonged abstinence preached by the physicians of seventeenth-century Leiden, Whytt claimed in 1740 that virgins were the only women who were free from such complaints, and the Basel dissertations of Johannes Hofer and Nicolaus Zindel argued against the ill effects of a chaste religious life.[28] Thus, the eighteenth-century medical establishment, reacting to social changes in the behavior of women, advocated the very measures that had been so vehemently denounced in the previous century.

Even as the pathology of hysteria and hypochondria evolved dramatically in the late seventeenth and eighteenth centuries, the general cures prescribed remained relatively unchanged since an-

24. See Pierre Bayle, *Dictionnaire historique et critique* (1679), 2:1839–40. For a discussion of morality in the context of French feminist thought and literature, see G. Ascoli, "L'histoire des idées féministes en France du XVIᵉ siècle à la Révolution" (1906); François Baumal, *La féminisme au temps de Molière* (192–); Lougee, *Paradis des Femmes*, 22–37; Michel de Puré, *La prétieuse: ou, le mystère des reulles* (1656–60), 1:29, 38–39, 2:237–38.

25. Robert James, *A Medical Dictionary* (1745), s.v. "hysteria."

26. See Jean Astruc, *A Treatise on the Diseases of Women* (1762), 242; Hoffmann, *Practice of Medicine*, 300.

27. See Pressavin, *Nouveau traité*, 260–63.

28. See Whytt, *Observations*, 106; Johannes Hofer, *De religiosorum morbis* (1716); Nicolaus Zindel [Zindelius], *Dissertation inauguralis medica: De morbis ex castitate nimia oriundis* (1745).

cient times. Physicians continued to recommend diet, clysters, bleeding, and music for their female patients, but were less inclined to prescribe the old remedy of marriage as a universal cure.[29] Theorists did emphasize more strongly the positive benefits of physical exercise and outdoor activity for women. George Cheyne noted the freedom from nervous diseases among physically active people, "the poor, the low . . . those destitute of the necessities, conveniences and pleasures of life, to the frugal, the industrious and the temperate," thereby reinforcing the traditional association of vapors with the leisure classes.[30] In combination with women's delicate body structure, naturally irritable nerves, and "extreme sensibility of mind," a sedentary life-style that also included frequent sexual activity, strong emotions, dieting, "high-scented perfumes," and lack of fresh air was considered most unhealthy.[31] Doctors noted that the prevalence of such behavior had caused the disease of vapors to reach epidemic proportions among the upper classes, and some even believed that the illness was contagious. Joseph Raulin described vapors as "the most common female malady whose empire is expanding day by day."[32]

Women and Vapors in Eighteenth-Century Art

If "nerves" and "vapors" claimed epidemic numbers in the eighteenth century, where are the representations of the theme in contemporary art? The subject of the female sickroom, so popular in Dutch painting of the seventeenth century, apparently disappeared. Perhaps this was so because the moral and medical imperatives in support of domesticity that were communicated by Dutch pictures of lovesick maidens could not have been less relevant to the aristocrats who were the audience for French art. Eighteenth-century French painters suggested other means of attaining and maintaining health. The elegant *fêtes galantes* which gained popularity in the rococo era were not intended as "medi-

29. See Laurinda S. Dixon, "Some Penetrating Insights: The Imagery of Enemas in Art" (1993).

30. George Cheyne, *The English malady; or, A treatise of nervous diseases of all kinds, as spleen, vapours, lowness of spirits, hypochondriacal, and hysterical distempers, etc.* (1976), 20. See also Pomme, *Essai sur les affections,* 27; van Swieten, *Maladies des femmes,* 36.

31. Rowley, *Treatise,* 56.

32. Raulin, *Traité des affections,* 3.

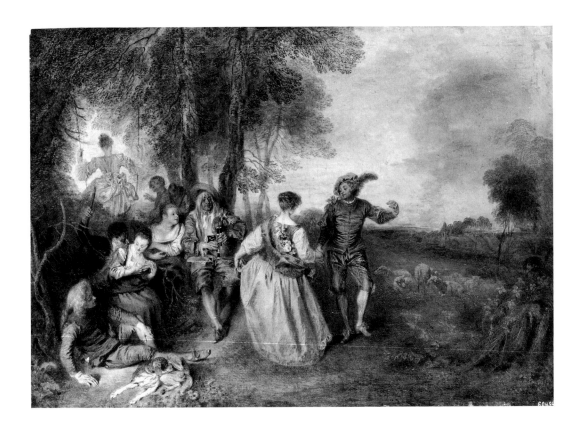

Fig. 94 Antoine
Watteau, *The
Shepherds*, ca. 1716.
Charlottenburg
Castle, Berlin.
Photo: Jörg P.
Anders, Berlin.

cal" paintings in the same sense that seventeenth-century sick-
room scenes were. Nonetheless, these works illustrate a healthful
ideal derived from medical and social contexts. Scenes of outdoor
games and dances performed among friends to the accompani-
ment of stringed instruments served to remind the delicate aris-
tocrats who viewed them of both the pleasures and dangers of a
privileged life.

The charming outdoor scenes favored by French rococo paint-
ers, especially Antoine Watteau, depict women as fragile, childlike
creatures, playing and dancing with their companions in bucolic
natural surroundings painted in the pastel colors associated with
the positive planets Venus and Jupiter. Often these ephemeral fes-
tivities involve pseudo-peasant play by participants dressed in lus-
cious silks who dance to the music of rustic bagpipes and hurdy-
gurdies (fig. 94). An element of eroticism is always present in
these paintings, which celebrate the joys of love and carefree
amusement. No matter how festive the occasion or playful the
pastime, however, such scenes often project a faint aura of melan-
choly that contrasts dramatically with the boisterous and some-
times crude revelry depicted by earlier Dutch artists. Indeed, the

elegant young men and women in the French *fêtes galantes* correspond closely to the aristocratic folk "of tender habit" who are described in Robert James's medical dictionary as being prone to attacks of vapors on account of their delicate, weak nervous systems.[33] The dainty insouciance that pervades these scenes recalls traditional medical instructions to cultivate the passion of joy as a preventative and cure for vapors. Eighteenth-century writers affirmed this prescription. John Purcell suggested that "when the patient goes hither, she by the advice of her physician, sets aside all concerns and cares, and gives her self wholly over to mirth and pastime, whereby the blood is invigorated and rendered more lively." He instructed his young female patients to "keep their minds free from all cares and concerns, to be merry, and pass their time in divertisements."[34] The painter Watteau would have been especially knowledgeable about the healthful effects of such activities, for he was a lifelong consumptive who doubtless received the same advice from his own doctors.[35]

The medically prescribed carefree atmosphere was augmented by music, which, aside from providing entertainment, was valued, as always, for its ability to regulate the pulse and rhythm of the body. Eighteenth-century mechanistic theory further maintained that musical vibrations were effective in breaking down atrabilious clogs in the body. This belief was affirmed by Pierre Pomme, who claimed in 1752 that "the sweet harmony of the violin" had reestablished the health of one nineteen-year-old patient, "Mademoiselle XXX," a girl of naturally sanguine temperament.[36] Browne's *Medicina musica* enlists the aid of music masters in maintaining the health of their female students and apologizes to his readers "since the following pages may tend not a little to the promotion of their interest."[37] Musical instruments and music making thus played an important part in establishing a healthful environment for rococo revelry.

Eighteenth-century theorists became increasingly aware of the unhealthy effects of urban living and continually praised the countryside for its soothing, regulating atmosphere. Physicians harked back to the writings of Ficino and Burton in their belief that the

33. James, *Medical Dictionary* 2, s.v. "hysteria."
34. Purcell, *A treatise of vapours*, 215–29.
35. See Donald Posner, *Antoine Watteau* (1984).
36. Pomme, *Essai sur les affections*, 76.
37. Browne, *Medicina musica*, xiii.

most healthful environment for those troubled with nerves and vapors was a cultivated outdoor park like those depicted in numerous rococo *fêtes galantes*. Gideon Harvey claimed that "clear, fresh air enlivens the blood of those used to a Town-life" and suggested that victims of vapors refresh themselves by taking a walk in the fields at least once a day. Such activity, he thought, purges the body of "all thick sooty steems . . . opens all the pores of the body, and gives vent to excrements."[38] Van Swieten's advice was more specific. He advised young girls to "walk three times among flowers of garden, barefoot, with the chest uncovered— entertained by falling caterpillars and roses and apples and oak leaves."[39] Belief in the healthful effects of nature had been a fixture of medical authority since ancient times. The idea was absorbed into eighteenth-century medical authority in recognition of the special health problems caused by city living, and was eventually reflected in the "back-to-nature" philosophy of the Enlightenment.

Doctors extolled moderate exercise as an antidote to vapors. Horseback riding was highly favored for men, as the jostling action of the horse effectively loosened impacted obstructions in the hypochondries while requiring minimal effort on the part of the rider. The same benefit of rhythmic movement imposed from without was ascribed to sailing and riding in a coach.[40] Such activities, however, were usually considered too vigorous for women, for the natural delicacy of the female body required that exercise cause neither exertion nor sweat.[41] Instead, doctors prescribed dancing, which combined the positive benefits of gentle movement with those of the rhythmic vibrations of music.[42] Browne devoted an entire chapter to the benefits of dancing, which he claimed "excels in the cure of the spleen and vapours," by regulating the pulse and stimulating circulation. He asserted that dancing causes the spirits to "flow with vigour and activity thru the whole machine" and "so attenuates and rarefies the

38. Gideon Harvey, *Morbus Anglicus: or The anatomy of consumptions* (1674), 68, 80–81, 103.

39. Van Swieten, *Maladies des femmes*, 68.

40. See Astruc, *Treatise on the Diseases of Women*, 104; Browne, *Medicina musica*, 54; Cheyne, *English malady*, 125; Pomme, *Essai sur les affections vaporeuses*, 50; Raulin, *Traité des affections*, xvii–xviii; Rowley, *Treatise*, 14; Whytt, *Observations*, 355.

41. See Browne, *Medicina musica*, 51–69.

42. See Astruc, *Treatise on the Diseases of Women*, 61; Browne, *Medicina musica*, 51–69; Raulin, *Traité des affections*, xviii; Rowley, *Treatise*, 14.

Blood, as to make it possess more space, [thus] the uterine vessels will in proportion be more distended." The momentum of surging blood was believed to conquer the resistance of stale menses and reestablish proper circulation.[43] Browne suggested that the patient commence dancing about two hours before an attack of vapors was expected and about an hour after meals. He cautioned against dancing at night, however, which tended to deplete the spirits further, and against dancing too long, which would result in loss of moisture through perspiration. This warning was directed especially toward consumptives, so called because their bodies were believed to be "consumed" by too much heat and dryness. Physicians held that by avoiding simple actions such as walking and dancing, "rich women condemn themselves to lives of illness," leading finally to fatal consumption.[44] Jean Baptiste Pressavin cautioned that such activities were not to be engaged in alone, for, "the best exercise of all is to join in gaity with cheerful friends."[45] In sum, Whytt argued that in cases of vapors "nothing has done more service than agreeable company, daily exercise . . . and a variety of amusements."[46]

Jean Honoré Fragonard's rococo masterpiece *The Swing* (ca. 1768–69), commissioned by an aristocrat to celebrate the charms of his mistress, epitomizes the era (fig. 95). The painting, almost too well known to describe, depicts a dainty young woman dressed in a delicate pink gown swinging in an idyllic open-air setting. The ropes of her swing are manipulated by an older man (her husband? a clergyman? a doctor?) who is barely visible in the shadowy background, while her young lover hides in the bushes beneath her, privy to an exclusive view of petticoats, garters, and more as the breeze whips up her skirts. Donald Posner has explained the erotic meaning of the painting, noting that the act of swinging, which became popular as a subject for artists beginning in the early eighteenth century, carried with it connotations of eroticism, sanguinity, and inconstancy.[47] His perceptive interpretation also makes it abundantly clear that rococo *fêtes galantes* were iconographically programmed and intended to convey narrative

43. See Browne, *Medicina musica*, 51–69.
44. Raulin, *Traité des affections*, xvii.
45. Pressavin, *Nouveau traité*, 292.
46. Whytt, *Observations*, 520.
47. Donald Posner, "The Swinging Women of Watteau and Fragonard" (1982). See also Mirjam Westen, "The Woman on a Swing and the Sensuous Voyeur: Passion and Voyeurism in French Rococo" (1989).

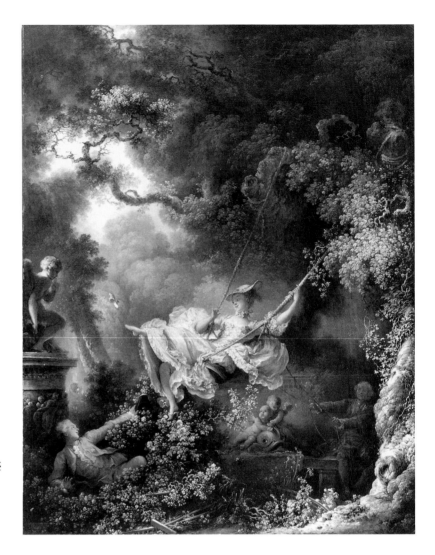

Fig. 95 Jean-Honoré Fragonard, *The Swing*, ca. 1768–69. Wallace Collection, London.

and allegorical meanings that were understood and responded to in ways that are lost to contemporary viewers.

The playful sport of swinging was not new to the eighteenth century, and neither of course was the phenomenon of inconstancy in love. Why, then, do swinging women (never men) suddenly appear in great numbers in the art of the time? In fact, the emergence of swinging women as a popular subject for artists coincides with the discovery of a new cure for vapors based on the mechanistic concept of regulated movement.[48] Plato had recommended "a surging motion, as in sailing or any other mode of conveyance which is not fatiguing" as a cure for melancholia, and

48. See Michel Foucault, *Madness and Civilization: A History of Insanity in the Age of Reason* (1965), 172–74.

the Roman Soranus advocated rocking in a hammock.[49] Indeed, images of nymphs being swung by satyrs appear frequently in ancient Greek and Roman art.[50] In accord with the ancients, eighteenth-century theorists believed that "regular oscillations" could effectively counteract irregular nerve spasms. Doctors sought a mild form of exercise for women that would incorporate natural rhythmic movement yet be strenuous enough to dislodge impacted uterine blood. Swinging was the perfect solution. The activity was practiced in the healthful outdoor air and was guaranteed to evoke exuberant high spirits, and the physical effort was applied not by the swinger but by a companion. Bernard Mandeville justified his choice of the swing as a curative instrument by citing the classics: "What I recommend is no new thing, it is without a doubt 'to fly in the air' and consequently the swing must be either the same with or else an equivalent for, the *petaurus* of the Ancients."[51] Swinging accomplished Mandeville's purpose, for "the motion which resembles a flying in the air is the exercise I require, and I could never meet with any thing so innocent, that was half so efficacious in strengthening and reviving." The swing, he wrote, "may be made after what manner your daughter fancies most; that which they call a Flying-horse, makes a very agreeable motion, a rope tied with both ends to a beam is sufficient," thus assuming that the cure would be applied to his readers' daughters and other young women. Mandeville set forth a complete regimen for the activity: "Every morning, as soon as she rises (which I would have her do before six) let her be swung for one half an hour." The procedure was to be repeated again at about three o'clock.[52] The process of swinging allowed the force of movement to reestablish the natural rhythm of the body and, in the days before women's undergarments came into use, cooled the heated uterus by exposure of the privates to the air.[53] In short, swinging became a popular remedy for aristocratic women in the eighteenth century, for the activity incorporated fresh air, sport, good times among friends, and regular movement without exertion.

49. Plato, *Timaeus* (1949), 72; Soranus of Ephesus, *"On Acute Diseases" and "On Chronic Diseases"* (1950), 547.

50. See Hans Wentzel, "Jean-Honoré Fragonards 'Schaukel': Bemerkungen zur Ikonographie der Schaukel in der bildenden Kunst" (1964).

51. Bernard Mandeville, *A treatise of the hypochondriack and hysterick passions* (1976), 305–8.

52. Ibid.

53. See Astruc, *Treatise on the Diseases of Women*, 104; William Harvey, "On Parturition," in *The Works of William Harvey, M.D.* (1847), 542.

The swinging cure gained currency as medical theorists realized its effectiveness both in maintaining good health and as a
cure for nerves and vapors. Pressavin prescribed *le volant* (the
swing) for all women, but for debilitated sufferers he recommended a "machine" consisting of an enclosed suspended carriage that would allow circulating air to surround the patient
during the swinging process.[54] James Smyth's *Account of the effects
of swinging* reported several case histories in which young
women—Mary Hartley, twenty-three years of age; Elizabeth
Beazely, twenty-three; Mary Pugh, age nineteen, and so on—
were cured of headache, weakness, and "general irritability"
by repeated swinging in the garden of a Middlesex hospital. He
lamented cynically, however, that "the simplicity of the remedy
will be a considerable objection to its being adopted."[55] This
easy and effective treatment rapidly caught on, however, culminating in the mechanized centrifugal swings that were installed
in eighteenth- and nineteenth-century asylums for the insane
(fig. 96).[56]

Although the swinging women in eighteenth-century paintings
are not markedly ill, the erotic context of such works is unmistakable, especially in Fragonard's masterpiece. It is understood that
the painting's subject lauds thwarted, illicit love, a situation guaranteed to instigate an attack of vapors. Moreover, physicians did
not reserve their recommendations for people who were already
sick but encouraged swinging and outdoor revelry as a regime of
health maintenance for all people who, by dint of their aristocratic
birthright and privileged life-style, were considered automatically
liable to attacks of nerves and vapors. By the early eighteenth century, then, women claimed vapors as a badge of privilege just as
men had done with melancholia in the Renaissance. George
Cheyne drew a parallel between the advancement of civilization
and the illness of vapors in 1701. He believed that the ready availability of riches and the abundance of creature comforts caused an
ineptitude for exercise and provided a sedentary, voluptuous
breeding ground for ill health.[57] Both sexes suffered from the effects of a style of living that was enviable by the standards of any

54. Pressavin, *Nouveau traité*, 290.

55. James Carmichael Smyth, *An account of the effects of swinging, employed as a remedy in
the pulmonary consumption and hectic fever* (1787), v–vi.

56. See Jean Starobinski, *Histoire du traitement de la mélancolie des origines à 1900* (1960),
66.

57. Cheyne, *English malady*.

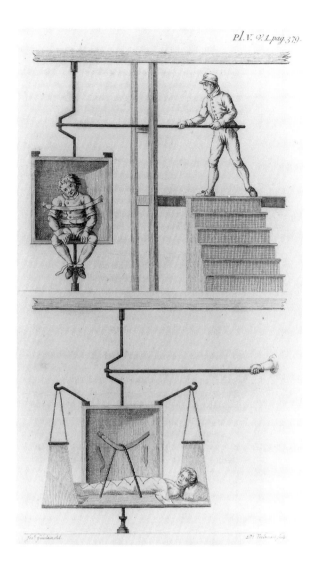

Pl. V. 92. L. pag. 379.

Fig. 96 Whirling bed and whirling chair, from J. Guislain, *Traité sur l'alienation mentale.* Amsterdam, 1826. National Library of Medicine, Bethesda, Md.

century as illness was viewed as the by-product of advanced civilization. The passions of hysteria and hypochondria were not without their privileges.

Women and Illness in the Modern Era

The social and philosophical changes of the late eighteenth and nineteenth centuries demanded a dramatic rethinking of women's susceptibility to illness based, as in the past, on their "proper" function in society and their "peculiar" anatomy. French Enlightenment philosophers demanded equality among all classes, but their concept of equality did not include women. They revived

with renewed vigor the ancient medical theories regarding the innate weakness and inferiority of the female sex, thereby supporting the argument against women's inclusion in the new social order.[58] Many women, however, insisted on attempting to do more of what physicians had always assured them they could not do. They demanded the vote, entrance into the professions, access to higher education, and economic independence. Historians of medicine have shown that medical theorists continued to use the authority of biology to justify maintaining the cultural and political differences between the sexes that were thought to be crucial to social stability. Likewise, art historians have demonstrated that the subject of the happy bourgeois mother in French painting arose anew in support of Enlightenment ideals of conventional womanhood.[59]

Nineteenth-century theorists in Europe and America reacted to the demands of an organized women's movement by pursuing with increased vehemence the concept of the female sex as constitutionally unfit and mentally weak.[60] By demanding suffrage and attempting to usurp traditional male privileges, feminists were threatening to overturn the status quo just as their predecessors had done in the seventeenth century. By resurrecting and reinforcing the old maxims about the frailty and instability of women and blaming the female reproductive system, medicine could show that the social disapproval of intellectual or professional attain-

58. See Susan G. Bell and Karen M. Offen, eds., *Women, the Family, and Freedom: The Debate in Documents* (1983), 26–142; Margaret Darrow, "French Noblewomen and the New Domesticity, 1750–1850" (1979); Barbara Haines, "The Interrelations between Social, Biological, and Medical Thought, 1750–1850: Saint-Simon and Comte" (1978); Abby R. Kleinbaum, "Women in the Age of Light" (1977); Thomas Laqueur, "Orgasm, Generation, and the Politics of Reproductive Biology" (1986); Elizabeth Racz, "The Women's Rights Movement in the French Revolution" (1952); Victor G. Wexler, "Made for Man's Delight: Rousseau as Antifeminist" (1976).

59. See Carol Duncan, "Happy Mothers and Other New Ideas in Eighteenth-Century French Art" (1973); Ella Snoep-Reitsma, "Chardin and the Bourgeois Ideals of His Time" (1973).

60. The secondary literature on nineteenth-century women's history is vast. Among the many studies that address the medical context of women's social situation, see Flavia Alaya, "Victorian Science and the 'Genius' of Women" (1977); Ellen L. Bassuk, "The Rest Cure: Repetition or Resolution of Victorian Conflicts?" (1986); Joan N. Burstyn, ed., *Victorian Education and the Ideal of Womanhood* (1984); Jill Conway, "Stereotypes of Femininity in a Theory of Sexual Evolution" (1972); Sara Delamont and Lorna Duffin, eds., *The Nineteenth-Century Woman: Her Cultural and Physical World* (1978); Elizabeth Fee, "Science and the Woman Problem: Historical Perspectives" (1974); John S. Haller, Jr., and Robin M. Haller, *The Physician and Sexuality in Victorian America* (1974); Elaine Showalter, *The Female Malady: Women, Madness, and English Culture, 1830–1980* (1985); Jeffrey Weeks, *Sex, Politics, and Society: The Regulation of Sexuality since 1800* (1981).

ment by women was based in sound physiological sense.[61] Once again the medical profession found it necessary to assure the world that there must be a relationship between the frailty of the female organism and women's roles in society.

As in the past, the physical and intellectual abilities of nineteenth-century women were inexorably linked with anatomy. Although Willis and his followers had long since pronounced the womb for the most part innocent of causing disease, nineteenth-century doctors once again claimed a uterine origin for all women's ailments. In the name of good health, women were placed under the "protection" of husbands and fathers, instructed to bear children as often as possible, and encouraged to nurse their children themselves. The phenomenon of the upper-class nursing mother, though undoubtedly healthier for the infant, had the effect of further binding woman to her biological role, and constituted a drastic rejection of the custom of wet-nursing that had been practiced for centuries.[62] Medical theorists revived the cult of domesticity that had typified seventeenth-century Holland, turning women into housebound "angels" and their homes into earthly "heavens."

Socially acceptable behavior for European and American women was strictly circumscribed by medical theory in the nineteenth century. The prestigious English medical journal *The Lancet* proclaimed: "Any woman who is logical, philosophical, scientific departs from the normal woman in her physical as well as her mental characteristics."[63] The argument was extended to include all women who attempted escape from their domestic roles, as any departure from the prescribed functions of daughter, wife, or mother would surely produce illness. Such beliefs recall the claims made three hundred years earlier by Paré and Ferrand, who, citing Galen and Hippocrates, wrote that avoidance of traditional feminine duties would not only cause the womb to run rampant but also turn women into unattractive masculine "viragines."[64] As in the past, women were discouraged from developing scholarly capabilities for fear of losing their feminine charms, and female in-

61. See Lorna Duffin, "The Conspicuous Consumptive: Woman as an Invalid" (1978).

62. See Barbara Corrado Pope, "Angels in the Devil's Workshop: Leisured and Charitable Women in Nineteenth-Century England and France" (1977).

63. *The Lancet* 2 (1868): 321, quoted in Duffin, "Conspicuous Consumptive," 48.

64. See Jacques Ferrand, *A Treatise on Lovesickness* (1990), 230, 340, 585; and [Ambrose Paré], *The Workes of the Famous Chirurgion Ambrose Parey, translated out of the Latine and Compared with the French by Tho. Johnson* (1649), 638.

tellectual accomplishments were limited to the socially pleasing, mentally tranquil pursuits of singing, drawing, writing, and conversation. Sickness among women continued to be viewed as a badge of privilege associated with the "comfortable" classes. The eighteenth-century concept of sexual desire as instigator of illness in women prevailed in the nineteenth century, as women were emotionally "de-sexed" by the prudish standards of Victorian morality and, in some cases, physically castrated by the surgical removal of the ovaries and clitoris.[65] Upper- and middle-class women, especially adolescent girls, were denied red meat and spicy foods, which were thought to arouse sexual appetites, and were often anemic as a result of their inadequate diets. Even if they had wished to be physically active, they were prevented from doing so by their weakened state and the constraints of "ladylike" behavior, not to mention bulky petticoats and restricting corsets. The archaic women's illnesses of *furor uterinus*, nerves, and vapors reappeared under new guises. Amenorrhea, melancholia, neurasthenia, epilepsy, and insanity were all linked to female physiology and shared many of the symptoms of the earlier diseases. A photograph of a woman incarcerated in the Salpêtrière, a famous Parisian hospital for poor and homeless women, shows her as a victim of "terminal state melancholia" (fig. 97).[66] If not for the nineteenth-century institutional setting, she could easily serve as a model for a seventeenth-century lovesick maiden.

The list of illnesses believed to be instigated by the female reproductive system in the nineteenth century was extended to include an entire range of so-called nervous disorders, ranging from the trivial to the serious. By the end of the century the term *hysteria* no longer referred to the ancient disease of many names but instead described a new psychogenic condition divorced from its early uterine context.[67] The illness of chlorosis, however, closely

65. Duffin, "Conspicuous Consumptive," 42–44, notes a hue and cry among nineteenth-century physicians who feared that the new invention of the treadle sewing machine would cause sexual excitement and consequent illness in women.

66. From Désiré Magloire Bourneville and Paul Regnard, *Iconographie photographique de La Salpêtrière* (1877), 1. See also Sander L. Gilman, "The Image of the Hysteric" (1993); George Rosen, *Madness in Society: Chapters in the Historical Sociology of Mental Illness* (1969), 164. The function of the Salpétrière as a prison or asylum for poor, "unattached" women is described in Jacques René Tenon, *Mémories sur les hôpitaux de Paris* (1788), 85.

67. Much has been written about the mental disorder hysteria and its nineteenth-century incarnations and origins. The literature is so vast that it cannot be summarized within the scope of this book. Some selected sources of interest include Barbara Ehrenreich and Deirdre English, *Complaints and Disorders: The Sexual Politics of Sickness* (1973); Jeffrey

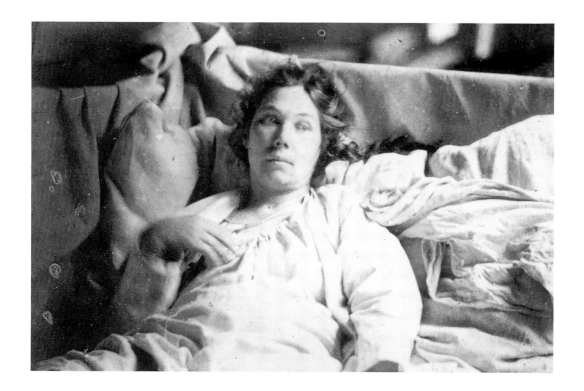

resembled the seventeenth-century ailment known as hysteria or *furor uterinus*. As we have seen, this term, meaning "green sickness," was not new to the nineteenth century; for centuries physicians had used it to refer to the greenish tinge of the flesh of women who suffered from uterine disorders.[68] Historians of medicine have noted the rapid spread of the symptoms associated with chlorosis beginning in the mid-sixteenth century and suggest, partly on the evidence of Dutch paintings, that the illness "peaked" in the seventeenth century and again in the nineteenth.[69] In both eras chlorosis was said to occur primarily in adolescent girls, and the symptoms—weakness, fainting, difficulty in breath-

Fig. 97 "Terminal State: Melancholia," from Désiré Magloire Bourneville and Paul Regnard, *Iconographie photographique de La Salpêtrière*, vol. 1. Paris, 1877. Philadelphia Museum of Art: SmithKline Beckman Corporation Fund 71-116-2a.

Moussaieff Masson, ed., *A Dark Science: Women, Sexuality, and Psychiatry in the Nineteenth Century* (1986); Elaine Showalter, "Hysteria, Feminism, and Gender" (1993); Carroll Smith-Rosenberg, "The Hysterical Woman: Sex Roles and Role Conflict in Nineteenth-Century America" (1972); Ann Douglas Wood, "The Fashionable Diseases: Women's Complaints and Their Treatment in Nineteenth-Century America" (1974). For an annotated review of major studies and their methodologies, see Mark S. Micale, "Hysteria and Its Historiography: A Review of Past and Present Writings" (1989): 246–54, 319–31.

68. See definitions of chlorosis in Robley Dunglison, *Dictionary of Medical Science* (1848), 178; and *The New Sydenham Society's Lexicon of Medicine and the Allied Sciences*, vol. 2 (1882), s.v. "chlorosis."

69. See Henry Meige, "Les peintres de la médecine: Le mal d'amour." (1899); Emile Schwarz, *Chlorosis: A Retrospective Investigation* (1951).

ing, appetite disorders, erratic pulse, pallor, and mental distur-
bances—were identical. They also affected the same kinds of
women—young, unmarried, and affluent. Lorna Duffin has sug-
gested that the medical diagnosis of chlorosis reflected the social
concern with the problematic period of female adolescence at a
time when, as in the seventeenth century, virginity was prolonged
and its effects exacerbated by delayed marriage or by the fearful
prospect of no marriage at all for upper-middle-class girls. Chlo-
rosis was a convenient medical label which rationalized and legiti-
mated women's weakness and justified their limited social role.[70]

Chlorosis enjoyed a brief respite during the years of the French
Revolution and suddenly vanished for good early in the twentieth
century, causing some historians of medicine to question whether
it actually existed and some historians of art to interpret its im-
agery in exclusively allegorical terms.[71] If we may judge, however,
from the many books and dissertations entirely devoted to the
group of symptoms labeled variously throughout the centuries as
furor uterinus, vapors, nerves, chlorosis, and the like, there can be
no doubt that the disorder once existed and was widespread
among women. Historians of medicine have suggested several
possible origins of the ailment, among them anemia, endocrine
dysfunction, and malnutrition. The most convincing explanation
ascribes the symptoms to the ill effects of wearing corsets, a con-
vention required of fashionable women at certain times through-
out history.[72] Indeed, corsets, which could reduce the size of a
woman's waist to a mere sixteen inches, were introduced in the
first half of the sixteenth century and continued to be fashionable
through the early 1960s. They were discarded in the "Empire
style" years of the French Revolution and once again, this time
more or less permanently except for a brief resurgence after the
Second World War, in the "flapper" era of the 1920s. The domi-
nance of the corset in women's fashion corresponds to the appear-
ance of the mysterious universal ailment of many names that has
afflicted women throughout history. Furthermore, the wearing of
corsets fulfills all the prerequisites for causes of the disease: the

70. See Smith-Rosenberg, "Hysterical Woman," 652–78.

71. See Schwarz, *Chlorosis*, 130–36; Mary Frances Wack, *Lovesickness in the Middle Ages:
The "Viaticum" and Its Commentaries* (1990), 175. *Black's Medical Dictionary* (1963), 189,
states that chlorosis was "very common before the First World War."

72. See Duffin, "Conspicuous Consumptive," 40; and Schwarz, *Chlorosis*, 156–59.

fashion was limited to women, starting at puberty and continuing throughout life. The negative effects of tight corseting also correspond to the symptoms associated throughout the ages with the various incarnations of hysteria and chlorosis. Compression of the thoracic skeleton decreased the capacity of the lungs, causing difficulty in breathing, heart palpitations, fatigue, and fainting. The displacement of abdominal organs resulted in digestive problems and menstrual disorders. Compression of the intestines may also have interfered with iron absorption, causing anemia and resulting in the listlessness, pallor, and perverted appetite associated with chlorosis and hysteria.[73] Not until women began a campaign for physical exercise and its accompanying dress reform did chlorosis and its historical incarnations cease to be epidemic among women.[74] It is notable that the now-extinct disease suffered by Dutch lovesick maidens and once discussed incessantly by practicing physicians coincides with periods in history when women were restrained socially by strict censure and physically by the dictates of fashion.

Changing fashion and new ideals of womanhood apparently banished the mysterious female illness depicted in seventeenth-century sickrooms in the early twentieth century. Yet physicians continued to treat women suffering from equally mysterious, exclusively "female" disorders even after the guilty corset became a thing of the past. Indeed, the image of the delicate, swooning woman being revived by the solicitous placement of smelling salts to her nostrils remained with us into the present century (fig. 98). Even in today's relatively enlightened times PMS, or premenstrual syndrome, threatens to become the new debilitating "female" disease. The findings of recent medical research on PMS sound hauntingly familiar, given the historical context of women's illnesses. Symptoms, which begin as soon as a girl attains sexual maturity, are said to affect at least 90 percent of the menstruating population, and include depression, dizziness, fatigue, food cravings, constipation, and erratic, sometimes psychotic behavior.[75] Moreover, a 1983 medical work states in the best

73. Schwarz, *Chlorosis*, 159.

74. Duffin, "Conspicuous Consumptive," 40. For the history of the perception of women's corsets as a health hazard, see Londa Schiebinger, "Skeletons in the Closet: The First Illustrations of the Female Skeleton in Eighteenth-Century Anatomy" (1986).

75. Howard J. Osofsky and Susan J. Blumenthal, eds., *Premenstrual Syndrome: Current Findings and Future Directions* (1985), xiii.

Fig. 98 Fainting woman, ca. 1920. Collection of the author.

seventeenth-century tradition that professional careers and diets rich in red meat exacerbate PMS, and that sufferers are prone to a panoply of antisocial behaviors, including alcoholism, child abuse, suicide, even murder.[76] The debate over PMS would suggest that society still feels the need for a mysterious, indefinable, uniquely female complaint, one that is innately debilitating and disparaging to its victims. Now that hysteria has joined the ranks of mental illnesses and is generally recognized as afflicting both sexes, PMS may be a modern substitute for vapors, nerves, "fits

76. Ronald V. Norris, *PMS/Premenstrual Syndrome* (1983), 157–72, 205.

of the mother"—that illusory malady of many names that is om-
nipresent in the history of medicine.

Historians recognize that medicine has been effective through-
out history in shaping the choices open to women.[77] Indeed, there
is a parallel between the Protestant effort to restrain women by
force of medical doctrine in the seventeenth century and the effort
to do the same in England and the United States at the close of the
Second World War.[78] After women relinquished the traditionally
male jobs they had held while their men were away at war, the
ideal of feminine beauty reverted once again to a curvaceous form
with an unnaturally small waist.[79] Corsets returned along with the
soldiers as Rosie the Riveter (fig. 99) metamorphosed into the
Playboy Bunny (fig. 100). At the same time, popular films of the
late 1940s emphasized the two predominant choices available to
postwar women: the joys of marriage and motherhood or the hor-
rors of independence and ruin.[80] During the 1960s doctors readily
prescribed tranquilizers for female patients suffering from "ner-
vous exhaustion." A glossy advertisement for one such medica-
tion (fig. 101) features an irritable and exhausted homemaker
who, confronted with her naked child at bath time, threatens to
crack under the strain. The caption reads: "Her kind of pressures
last all day . . . shouldn't her tranquilizer?" Compare this pathetic
creature with the calm, capable wife painted by Hendrick Sorgh in
the *Family of Eeuwout Prins* (fig. 58). Faced with the intolerable
postwar resurgence of the traditional stay-at-home wife and
mother, women in the 1960s instigated an organized feminist
movement. Tranquilizer ads such as this, by taking a sympathetic
stance, sought to impress on potential feminists that their "natu-
ral" role was not only an important but a difficult and taxing
one—too much so to be attempted without the "help" of the

77. See Mary S. Hartman and Lois Banner, eds., *Clio's Consciousness Raised: New Per-
spectives in the History of Women* (1974); Thomas S. Szasz, "Medical Care as a Form of Social
Control," in Thomas S. Szasz, ed., *The Myth of Mental Illness: Foundations of a Theory of Per-
sonal Conduct* (1961); Sander L. Gilman, *Disease and Representation: Images of Illness from
Madness to AIDS* (1988); David Ingleby, "The Social Construction of Mental Illness"
(1982).
78. See Renate Bridenthal, "Something Old, Something New: Women between the
Two World Wars" (1977); Fee, "Science and the Woman Problem," 200–220; and Carol
Smart, "Law and the Control of Women's Sexuality: The Case of the 1950s" (1981).
79. See Lois W. Banner, *American Beauty* (1983).
80. See Mary Ann Doane, "The Clinical Eye: Medical Discourses in the Woman's Film
of the 1940s" (1986).

Fig. 99 Marjory Collins, *Symington-Gould, Sand Slinger Operator at Rest. Buffalo, New York, May 1943.* Library of Congress, Washington, D.C.

medical establishment. How could a woman consider a career outside the home when housework was such a demanding job in itself?[81] Likewise, seventeenth-century women saw the threat of *furor uterinus* and the resulting complications—illness, loss of femininity, miscarriage, even death—as powerful incentives to relinquish their demands for independence which ran counter to the

81. I owe my insights regarding the depiction of women in modern drug advertisements to Richard Seidenberg, M.D., from whose collection of photographs this image comes.

Fig. 100 Playboy Bunny, 1964. Reproduced by special permission of *Playboy* magazine. Copyright © 1964 by Playboy. Photo by Pompeo Posar.

new Protestant family values. For women of both eras the threat of illness was a way for men to maintain control or, in the case of returning veterans, to reclaim it.

The study of depictions of women and illness suggests that no subject is more determined by contemporary cultural and social factors. Throughout history men have created images of women

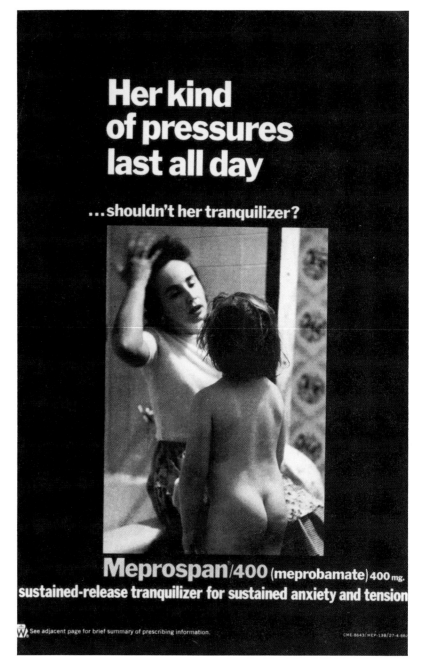

Fig. 101
Advertisement
for tranquilizers,
*American Journal
of Psychiatry*,
December 1966.
Collection of Robert
Seidenberg, M.D.,
Syracuse, N.Y.

as reflections of male interests, anxieties, and longings. They have invoked science in general and medicine in particular to justify the mandates of sex and class imposed on women by the powerful social order. Physicians have seen themselves as both moral and medical guardians of the "weaker" sex, responding to an ancient and persistent belief in the inherent instability of woman.

Seventeenth-century artists reinforced the goals of physicians as both professions used their persuasive powers to address a wide range of questions, not least in response to demands made by women for greater freedom and increased opportunities. The lovesick maiden and doctor's visit themes in seventeenth-century painting communicate a message of social control, responding to medicine as a force that shaped the options and roles available to women. Artists joined in reflecting what was at the time a universal social aim. Just as modern women are not continuously and consciously aware of the daily shaping of their own images and behavior by media portrayals, women living in earlier times may not have articulated the specific effect on their lives and activities of the paintings that hung in their homes. Yet they could not have ignored the powerful messages. If the ailing women in Dutch paintings could speak to us now, perhaps they would advise against allowing the forces of society and fashion to control our lives and shape our images.

Medical Dissertations on the Subject of Female Hysteria Written between 1575 and 1740

The medical *dissertation inauguralis* replaced the scholastic thesis as a requirement for the M.D. degree in the sixteenth century. Its organization was generally freer than the standard medieval argumentative form favored in earlier centuries, though most dissertations included a review of pertinent literature, a presentation of the student's observations, a discussion, and a conclusion. By the beginning of the seventeenth century, universities routinely printed dissertations in quarto in small editions of two or three hundred copies. These documents are often quite short, varying in length from four to twenty or so pages. Because they were loosely bound and usually without a cover, many pages have become separated and lost over time. As a result, there is no assurance that a dissertation exists in the archives of the university that produced it. The universities of Basel and Paris, however, kept records that are still intact, and there is a list of all Dutch medical dissertations at the University of Amsterdam.

The lists given here are drawn from several sources; they represent an approximate tally of medical dissertations written on the subject of female hysteria. Although the implication is that the subject gained dramatically in importance during the last half of the seventeenth century, especially in the Netherlands, the listings can give only a rough indication. There is no written evidence to support the supposition, but it is safe to assume that the number of doctors who graduated with a specialization in women's diseases was actually higher, as degree candidates were often allowed to substitute a written examination for the disserta-

tion requirement. Only dissertations dealing primarily with uterine hysteria are listed here. Not included are Italian dissertations, which were not published, and dissertations written on the subjects of melancholia, hypochondria, passions, and the humors that discuss hysteria tangentially as a related syndrome.

DISSERTATIONS WRITTEN ON THE SUBJECT OF
HYSTERIA BETWEEN 1575 AND 1699

ALTDORF
Feldner, Caspar, *De suffocatione uteri*, 1661
Lochner, Mich. Fried., *De nymphomania historiam medicam*, 1689

BASEL
Geiselbrunner, Elias, *De suffocatione*, 1622
Gugger, Joh. Jac., *Olympia iatrica de hysterica affectione*, 1607
Jencke, Friedr., *De uteri suffocatione*, 1616
Kaufmann, Herm., *De uteri suffocatione*, 1652
Kholbmann, Conrad, *De uteri strangulatu*, 1591
Schiffmann, Thom., *De hysterica affectione*, 1600
Wolfhard, Marc., *De suffocatione appellata hysterica*, 1604

DUISBURG
Elnberger, Adamus Henricus, *De passione hysterica dem Aufsteigen der Mutter*, 1695

ERFURT
Belov, Jac. Chn., *De matrona hypochondriaca*, 1685
Bercke, Johann, *Passionem hystericam*, 1672
Braun, Jeremias Jacob, *De suffocatione hysterica*, 1685
Buehren, David Friedrich, *Sistens, aegram suffocatione uterino laborantem*, 1698
Gavius, Christianus Pius, *De passione hysterica*, 1685
Gotter, Johann.-Jacobus, *De suffocatione uterina*, 1672
Helwig, Christoph, *Virginem chlorosi qua volgu dicitur. Die Jungfernkranckheit, Liebes-Farbe, Liebes-Fieber*, 1693
Nietner, Johann Gottfried, *De nymphomania*, 1694
Unsenius, Johannes, *De hysteromania*, 1671
Unknown, *Casus matronae hypochondriacae*, 1685

FRANKFURT
Huebner, Johann Henricus, *De febre virginum amatoria*, 1688
Lincke, Johann Joachim, *De suffocatione hysterica*, 1678
Unknown, *De uteri suffocatione*, n.d. (ca. 1650)

GIESEN

Bilitzer, Christophorus, *De pulso amatoria*, 1611
Gieswein, Johannes Philipp, *De suffocatione uterina*, 1665
Jungermann, Ludovicus, *De curatione vesani amoris*, 1611

GRIEFSWALD

Harmens, Petrus, *De suffocatione uteria*, 1687

HALLE

Gaetke, Joa. Petr., *De vena portae, porta malorum hypochondriaco-splenico-suffocativo-hysterico-colico-haemorrhoidariorum*, 1698

HEIDELBERG

Dolaeus, J., *Du suffocatione hypochondriaca seu hysterica*, 1673

HELMSTADT

Behrens, Conrad Barthold, *De suffocatione hysterica*, 1684
Wollinius, Johannes, *De amore insano*, 1661

JENA

Amman, G. Dhr., *De uteri suffocatione*, 1661
Backhaus, Augustinus Severus, *De amore insano*, 1686
Blumberg, Gothofredo Gulielmo, *Venus medica et morbofera*, 1685
Bremer, E. G., *De nymphomania*, 1691
Fasch, August Henricus, *De suffocatione uterina*, 1680
Glosemeyer, Jo., *De febre amatoria*, 1689
Gruebelius, Johann Georg, *De strangulatione uteri*, 1672
Gruendel, F. W., *De epilepsia hysterica*, 1676
Hedenus, Nicolaus Leonhardus, *De epilepsia hysterica*, 1676
Heim, Johann Caspar, *De hysteromania*, 1666
Lysthenius, J. F., *De suffocatione uterina*, 1661
Mueller, Joh., *De febre amatoria*, 1689
Rhoda, Frider. Wilhelm de, *De opisthotono*, 1696
Schmidius, Justus Andreas, *De suffocatione uterino*, 1681
Waxmann, Sigismund, *De suffocatione hysterica*, 1687
Unknown, *De uteri suffocatione*, 1674
Unknown, *De suffocatione uterina*, 1661

LEIDEN

Beuken, Petrus, *De chlorosi*, 1683
Bussius, Aug. Frid., *De passione hysterica*, 1692
Croeser, Jacob, *De uteri suffocatione*, 1650
Dalen, Antonius van, *De passione hysterica*, 1661
Emrich, Johannes, *De morbo virgineo*, 1663

Fischer, H., *De suffocatione uterina*, 1675
Gael, Iohannes, *De suffocatione uterina*, 1655
Gesenius, Georgius, *De suffocatione uterina*, 1654
Gilpin, Richard, *De hysterica passione*, 1676
Hamilton, David, *De passione hysterica*, 1683
Heemsterhuys, Joannes, *Historia laborantis chlorosi*, 1678
Holland, Adamus, *De hysterica passione*, 1687
Iken, H., *De furore uterino*, 1685
Jordan, Samuel, *De passione hysterica*, 1678
Leberecht, Giorgius, *De chlorosi seu morbo virgineo*, 1680
Mast, Paschasius Van der, *De suffocatione uterina*, 1651
Maton, Petrus, *De chlorosi*, 1696
Mayr, *De passione hysterica*, 1625
Moris, Petrus, *De suffocatione uterina*, 1676
Osenbruck, Georg Theodorus, *De suffocatione hypochondriaca et uterina*,
 1672
Paz, Jacob de, *De syncope*, 1658
Rurock, Johannes Christianus, *De passione hysterica*, 1679
Russius, *De passione hysterica*, 1692
Sack, Erasmus, *De minera et medela affectionis hypochondriacae . . .
 affectionis scorbuticae et hystericae dictae*, 1665
Schleich, Jo. Leonh., *De passione hysterica*, 1675
Schweitzer, Chr., *De passione hysterica*, 1684
Seeliger, Christophorus, *De suffocatione uteri*, 1662
Sternberg, Christophorus, *De suffocatione uteri*, 1652
Tombes, Johannes, *De chlorosi*, 1688
Voorde, Cornelis van de, *De syncope*, 1653
Weslingh, Joannes, *De passione hysterica*, 1694
Xylander, Carolus Christianus, *De chlorosi*, 1691

LEIPZIG
Rupitz, Valentinus, *De praefocatione hysterica*, 1623

MARBURG
Stoll, Johannes, *De suffocatione & procidentia uteri*, 1616

MONTPELLIER
Aquin, Andonius D', *An chlorosi venus?* 1647
Bonetus, Joachimus, *An uterinae suffocationi graveolentia?* 1619
Sanche, Petrus, *An electuarium diaphaeniconis hystericis affectibus conveniat?*
 1619
Weberski, Joannes-Jadobus, *An in phrenitide repellentia? An hystericis
 castoreum?* 1682

PARIS

Buvardis, Carolus, *An mulieri quam viro Venus Aptior?* 1604

Chauvel, Renatus, *An venus hystericarum medela?* 1674

Constant, Petrus, *An hystericis quibuscumque venae sectio?* 1636

Du Chemin, Petrus, *An insanienti virgini venus?* 1576

Ellain, Nicolaus, *An hystericis Venus?* 1570

Gaillard, Joannes, *An Amor ingenium mutat?* 1685

Hervee, Joan., *An Venus morbos gignat et expellat?* 1546

Hubault, Cyprianus, *An furor amatorius melancholicus affectus?* 1621

Le Letier, Simon, *An convulsio hysterica encheres?* 1618

Le Rat, Franciscus, *An opium hystericae accessioni noxium?* 1677

Lusson, Guil., *An mulieri ab utero quam a capite plures morbi?* 1574

Maurin, Raphael, *An melancholicis Venus?* 1658

Puylon, Gilbertus, *An insaniae ab amore?* 1630

Quanteal, Claude de, *Est-ne faemina viro salacior?* 1669

Renaudot, Isaac, *An insanienti amore virgini venae sectio?* 1639

REIMS

Blanchard, Jean, *An Venus salubris?* 1690

Bouchetal, Andreas, *An Venus hystericarum unica medela?* 1688

ROSTOCK

Knoevenagel, Chn., *De uterina vel hysterica suffocatione,* 1628

Schaper, Johannes Ernestus, *De malo hysterico in viris,* 1699

STRASBOURG

Neucranz, Michael, *De uteri suffocatione,* 1632

TÜBINGEN

Hellwig, Johann Friderick, *De passione hysterica,* 1677

Schreiner, Georg Eberhard, *De amore insano ejusque cura,* 1633

UTRECHT

Alen, Albertus ab, *Die chlorosi,* 1678

Amersfoort, Jacobus, *De hysterica passione,* 1694

Anderson, Josephus, *De chlorosi,* 1686

Busch, Johannes Franciscus, *De morbo virgineo,* 1667

Dooreslaer, *De chlorosi,* 1696

Heggeman, Fredericus, *De passione hysterica,* 1694

Hulst, Abrahamus van der, *De morbo virgineo,* 1685

Jongh, Johannes De, *De uteri suffocatione,* 1694

Kau, Jacobus, *De malo aphrodisi,* 1697

Kryt, Cornelius De, *De hysterica passione,* 1696

Majus, Johannes, *De passione hysterica,* 1692

Malus, *De passione hysterica*, 1693
Moll, Theodorus, *De suffocatione uterina*, 1662
Ortlob, Andreas, *De passione hysterica*, 1684
Rau, Jacob, *De malo aphrodiseo*, 1697
Rontris, Caspar, *De hysterica passione*, 1674
Schaak, Johannes Tombes, *De chlorosi*, 1686
Steenwijck, Jan, *De chlorosi*, 1690
Velius, Theodorus, *De fluxu menstruorum*, 1653
Weitz, Jacob, *De passione hysterica*, 1665

WITTENBERG
Falckner, Jacobus, *De suffocatione uterina*, 1660
Kroes, Antonius, *De matricis praefocatione*, 1614
Kunadus, Theodorus, *Erotomania seu amoris insani*, 1681

DISSERTATIONS WRITTEN ON THE SUBJECT OF HYSTERIA BETWEEN 1700 AND 1750

ALTDORF
Stegmayerus, Joh. Georgius, *De furore hysterico, vel uterino*, 1713

BASEL
Duvernoy, Jean George, *Theoria vaporum uterinorum, seu pathologia morbi hysterici*, 1710

DUISBURG
Krahe, Petrus, *De furore uterino*, 1705

ERFURT
Buechner, Andreas Elias, *De atrocissimo sequioris sexus flagello s. passione hysterica*, 1721
Clemens, Johannes Fridericus, *De melancholia hysterica*, 1727
Fick, Dieterious Christoph, *De malo hypochondriaco et hysterico incolis Saxoniae inferioris proprio*, 1725
Fuchs, David Caspar, *De furore uterino*, 1724
Gluckius, Johann Andreas, *De furore uterino*, 1720
Hesselbarth, Johann Carolus Gottlieb, *Sistens pathologiam et therapiam passionis hystericae*, 1739
Himme, Joh. Ernst, *De strangulatione uteri*, 1727
Lehmann, Joannes Matthaeus, *De furore uterino, oder Tobsucht der Weiber*, 1715
Vesti, Justus, *Aeger melancholia amatoria variisque symptomatibus gravioribus macitatus*, 1701
Zech, Johann Michael, *Casum passione hysterica laborantis ejusque curationem proponens*, 1703
Unknown, *De passione hysterica*, 1729

FRANKFURT
Scheffler, Christian Joannes, *Idolum muliebre in bulgo ita dieta passione hysterica*, 1707

GÖTTINGEN
Meier, Friedrich Gottlieb, *De malo hysterica*, 1741

GRONINGEN
Gerhard, Tiddus, *De suffocatione uterina*, 1703

HALLE
Alberti, Michael, *De hypochondriaco-hysterica malo*, 1703
Bucholtz, Theodor Gottlieb, *Sistens furorem uterinum*, 1747
Hoffmann, Fr., Jr., *De morbis hystericis vera indole, sede, origine et cura*, 1733
Wegener, Adamus, *De morbis faeminarum virilibus*, 1738

JENA
Andrea, Erdmann Friedrich, *De passione hysterica strangulatoria*, 1710
Bieler, Ambrosius Carolus, *De amore insano*, 1717
Erdmann, Fridericus Andreas, *De passione hysterica strangulatoria*, 1710
Haag, Johann Wolfgang, *De passione hysterica*, 1733
Hahn, Ludwig August, *Puerperam suffocationis hypochondriaco-hystericae periculo expositam*, 1701
Heisterbergk, Carolus Augustus, *De virgine nymphomania laborante casus*, 1748
Leisner, Jo. Gottl., *De malo hypochondriaco-hysterico*, 1749
Schomburg, Josia Sigm., *De strangulatione uteri syncoptica laborans*, 1717

LEIDEN
Daum, Caspar Conrad, *De amore insano*, 1704
Gordon, Georgius, *De spasmo hysterica*, 1734
Lambertus, Joh. Fridericus Marquard, *De febri amatoria*, 1706
Vernon, Thommas, *De passione hypochondriaca, hysterica dicta*, 1704
Witten, Alexander, *De hysterica passione*, 1722

LEIPZIG
Crellius, Johannes Fridericus, *De melancholia hysterica*, 1732

MONTPELLIER
Delestre, Ignatius-Laurentius, *An passioni hysterica martialia?* 1711

PARIS
Constant, Petrus, *An hystericis quibuscumque venae sectio?* 1636

ROSTOCK
Neuhaus, Georg Sebastian, *De affectione hysterica*, 1718
Unknown, *De affectione hysterica*, 1718

STRASBOURG
Le Motte, Henr. Jac. de, *De malo hysterica*, 1738

UTRECHT
Arnoldus, Johannes Petrus, *De suffocatione hysterica*, 1701
Hele, Henricus, *De morbis hypochondriacis et hystericis*, 1719
Keppel, Wilhelm, *De hysterica passione*, 1710
Ketell, Guielielmus, *De passione hysterica*, 1724
Plaatman, Gerardus, *De hysterica passione*, 1724
Rogers, Josephus, *De affectione hysterica. seu hypochondriaca*, 1708
Rupartus, Jacobus Thomas, *De hysterica passione*, 1724
Scholte, Johannes Franciscus, *De passione hysterica seu suffocatione hypochondriaca*, 1730
Stochius, Antonius, *De affectione hypochondriaca*, 1730

BIBLIOGRAPHY

Abricossoff, Glafira. *L'hystérie aux XVII^e et XVIII^e siècles (étude historique et bibliographique)*. Paris, 1897.

Adair, James Makittrick. *Essays on fashionable diseases, the dangerous effects of hot and cold crouded rooms, the cloathing of invalids, lady and gentlemen doctors, and on quacks and quackery*. London, 1790.

Adams, Thomas. *Diseases of the soul: A discourse divine, morall, and physicall. . . .* London, 1616.

Agrippa von Nettesheim, Heinrich Cornelius. *On the Superiority of Woman over Man*. Reprint. New York, 1873.

Alardus, Auleius. *Monitio ad ordines Frisiae de reformanda praxi medica*. Frankfurt, 1603.

Alaya, Flavia. "Victorian Science and the 'Genius' of Women." *Journal of the History of Ideas* 38 (April–June 1977): 261–80.

[Albertus Magnus.] *Women's Secrets: A Translation of Pseudo–Albertus Magnus' 'De Secretis Mulierum' with Commentaries*. Edited and translated by Helen Rodnite Lemay. Albany, N.Y., 1992.

Albutt, Thomas Clifford. *Greek Medicine in Rome*. London, 1921.

Alciati, Andrea. *Emblemata cum commentariis*. Padua, 1621.

Alexander, J. J. G., ed. *A Survey of Manuscripts Illuminated in the British Isles*. London, 1975.

Alpers, Svetlana. *The Art of Describing: Dutch Art in the Seventeenth Century*. Chicago, 1983.

Alte Pinakothek Katalog III: Hollaendische Malerei des 17 Jahrhunderts. Munich, 1967.

Amselle, Gaston. *Conception de l'hystérie; étude historique et clinique.* Paris, 1907.

Amundsen, Darrel W. "Medicine and Faith in Early Christianity." *Bulletin of the History of Medicine* 56 (1982): 326–50.

Andel, Martinus Antonie van. *Chirurgijns, vrije meesters, beunhazen en kwakzalvers; de chirurgijnsgilden en de praktijk der heelkunde, 1400–1800.* Amsterdam, 1946.

Anderson, Ruth Leila. *Elizabethan Psychology and Shakespeare's Plays.* New York, 1964.

Anglo, Sydney. "Melancholia and Witchcraft: The Debate between Wier, Bodin, and Scott." In *Folie et déraison à la Renaissance: colloque internatonal sous les auspices de la fédération internationale tenu en Novembre 1973 des institutes et sociétés pour l'étude de le Renaissance,* 209–28. Brussels, 1976.

Antidotum melancholiae vel: schola curiositatis, omnibus hypochondriacis & atrabili laborantibus sive fratribus spleneticus & melancholicus, vulgo Denen Meltzbrüdern. Frankfurt, 1620.

Applewhite, Harriet Branson, and Darline Gay Levey, eds. *Women and Politics in the Age of the Democratic Revolution.* Ann Arbor, 1990.

Arano, Luisa Cogliati. *The Medieval Health Handbook: Tacuinum Sanitatis.* New York, 1976.

Arbitman [Hellerstedt], Kahren Jones. "The Love Sick Maiden." In *Death, Love, and the Maiden.* Pittsburgh, 1975.

[Aretaeus.] *The Extant Works of Aretaeus, the Cappadocian.* Translated by Francis Adams. London, 1856.

Aristotle. *History of Animals.* Translated by R. Cresswell. London, 1862.

Arthur, Marylin B. "Early Greece: The Origins of the Western Attitude toward Women." *Arethusa* 6 (Spring 1973): 7–58.

Ascoli, G. "L'histoire des idés féministes en France du XVIe siècle à la Révolution." *Revue de synthèse historique* 13 (1906): 25–56, 161–84.

Astell, Mary. *A Serious Proposal To the Ladies For the Advancement of their true and greatest Interest.* London, 1694.

Aston, Trevor Henry, ed. *Crisis in Europe, 1560–1660: Essays from Past and Present.* New York, 1965.

Astruc, Jean. *A Treatise on the Diseases of Women. . . .* 2 vols. London, 1762.

[Avicenna.] *A Treatise on the Canon of Medicine by Avicenna.* Translated by O. Cameron Gruner. London, 1930.

Baar, Mirjam de, ed. "Van kerk naar sekte: Sara Nevius, Grietje van Dijk en Anna Maria van Schurman." *De Zenventiende Eeuw* 7 (1991): 159–71.

———. *Anna Maria van Schurman (1607–1678): Een uitzonderlijk geleerde vrouw.* Zutphen, 1992.

Babb, Lawrence. "Melancholy and the Elizabethan Man of Letters." *Hunterian Library Quarterly* 4 (1941): 247–61.

——. "Love Melancholy in the Elizabethan and Early Stuart Drama." *Bulletin of the History of Medicine* 12 (February 1943): 117–32.

——. "Hamlet, Melancholy, and the Devil." *Modern Language Notes* 59 (1944): 120–22.

——. *The Elizabethan Malady: A Study of Melancholia in English Literature from 1580 to 1642.* East Lansing, Mich., 1951.

——. *Sanity in Bedlam.* East Lansing, 1959.

Bachrach, Alfred Gustave Herbert. *Sir Constantine Huyghens and Britain, 1596–1687: A Pattern of Cultural Exchange.* London, 1962.

Backer, Dorothy Anne Liot. *Precious Women.* New York, 1974.

Bacon, Francis. *The Advancement of Learning.* Edited by W. A. Wright. Oxford, 1920.

Baer, Rhonda. "The Paintings of Gerrit Dou (1613–1675)." Ph.D. diss., New York University, 1990.

Baglivi, Giorgio. *The practice of physic reduc'd to the ancient way of observation containing a just parallel between the wisdome and experience of the Ancients, and the hypothesis's of modern physicians. . . .* London, 1723.

Baines, Barbara Joan, ed. *Three Pamphlets on the Jacobean Antifeminist Controversy.* Delmar, N.Y., 1978.

Bandmann, Günter. *Melancholie und Musik: Ikonographische Studien.* Cologne, 1960.

Banner, Lois W. *American Beauty.* Chicago, 1983.

Barasch, Moshe. *Gestures of Despair in Medieval and Early Renaissance Art.* New York, 1976.

Bardwick, Judith M., ed. *Readings on the Psychology of Women.* New York, 1972.

Barrough, Phillip. *The method of phisick, containing the causes, signes, and cures of inward diseases in mans body, from the head to the foot.* London, 1583.

Bartlett, Robert. *Trial by Fire and Water: The Medieval Judicial Ordeal.* Oxford, 1986.

Bassuk, Ellen L. "The Rest Cure: Repetition or Resolution of Victorian Conflicts?" In *The Female Body in Western Culture: Contemporary Perspectives,* edited by Susan Rubin Suleiman, 139–51. Cambridge, Mass., 1986.

Bauch, Kurt. *Der frühe Rembrandt in seine Zeit.* Berlin, 1960.

Baumal, François. *Le féminisme au temps de Molière.* Paris, 192–.

Bax, Dirk. *Hieronymus Bosch: His Picture Writing Deciphered.* Translated by M. A. Bax-Botha. Rotterdam, 1979.

Bayle, Pierre. *Dictionnaire historique et critique.* Rotterdam, 1697.

Bayon, H. P. "Trotula and the Ladies of Salerno: A Contribution to the

Knowledge of the Transition between Ancient and Mediaeval Physic." *Proceedings of the Royal Society of Medicine* 23 (1940): 471–75.

Bedaux, Jan Baptist. "Minnekoorts- zwangerschaps- en doodsver-schijnselen op zeventiende-eeuwse schilderijen." *Antiek* 10 (June–July 1975): 17–42.

Beecher, Donald A., and Massimo Ciavolella, eds. *Eros and Anteros: The Medical Traditions of Love in the Renaissance.* Ottawa, 1993.

Behn, Aphra. *Ten Pleasures of Marriage.* Amsterdam, 1682.

Bell, Rudolf M. *Holy Anorexia.* Chicago, 1985.

Bell, Susan G., and Karen M. Offen, eds. *Women, the Family, and Freedom: The Debate in Documents.* Stanford, 1983.

Bender, Thomas, ed. *The University and the City from Medieval Origins to the Present.* New York, 1988.

Benton, John F. "Trotula, Women's Problems, and the Professionaliza-tion of Medicine in the Middle Ages." *Bulletin of the History of Medicine* 59 (1985): 30–53.

Bergmans, Simone. "Un fragment peint du pèlerinage des épileptiques à Molenbeek-Saint-Jean, oeuvre perdue de Pierre Bruegel L'Ancien." *Revue belge d'archéologie et d'histoire de l'art* (1972): 41–57.

Berriot-Salvadore, Evelyne. "De vrouw in geneeskunde en naturrwe-tenschap." In *Geschiedenis van de vrouw*, edited by Georges Duby and Michelle Perrot, 279–313. Amsterdam, 1992.

Beverwijck, Johan van. *Schat der gesontheyt.* Dordrecht, 1638.

——. *Van de wtnementheyt des vrouwelijken geslachts.* Dordrecht, 1639.

——. *Schat der ongesontheyt.* Amsterdam, 1642.

——. *Alle de wercken.* Amsterdam, 1660.

Birns, Beverly, ed. *Women and Mental Illness: International Journal of Mental Health* 11 (Spring–Summer, 1982).

Bjerye, Poul Cart. *The History and Practice of Psychoanalysis.* Translated by Elizabeth N. Barrow. Boston, 1920.

Blackmore, Richard. *A Treatise of the Spleen and Vapours, or Hypocondria-cal and Hysterical Affections.* London, 1725.

Black's Medical Dictionary. Edited by W. A. R. Thomson. London, 1963.

Blankert, Albert, et al. *The Impact of a Genius: Rembrandt, His Pupils and Followers in the Seventeenth Century.* Amsterdam, 1983.

Bloch, R. Howard. "Medieval Misogyny." *Representations* 20 (1987): 1–24.

Bocchi, Achille. *Symbolicarum quaestionum de universa genere.* Bonn, 1555.

Boehm, B. "Heilende Musik im greichischen Altertum." *Zeitschrift für Psychotherapie und Medizinische Psychologie* 7 (1957): 132–51.

Boerhaave, Hermann. *Aphorismi, de cognoscendi et curandis morbis, in usum doctrinae domesticae digesti.* Louvain, 1709.

——. *Aphorisms: Concerning the Knowledge and Cure of Diseases.* London, 1735.

Bonet, Juan Pablo. *Reduction de las letras y arte para enseñar a ablar los mudos.* Madrid, 1620.

——. *Simplification of the Letters of the Alphabet and Method of Teaching Deaf-Mutes to Speak.* Translated by H. N. Dixon. Harrogate, 1890.

Bonifacio, Giovanni. *L'arte de' cenni, con la quale formandosi favella visibile, si tratta della muta eloquenza, che non e' altro che un facone silentio.* Vicenza, 1616.

Boorde, Andrew. *The breviarie of health, wherein doth folow remedies for all maner of sicknesses & diseases the which may be in man or woman.* London, 1598.

Bos, H. J. M., ed. *Studies on Christian Huygens.* Lisse, 1980.

Boss, Jeffrey M. N. "The Seventeenth-Century Transformation of the Hysteric Affection and Sydenham's Baconian Medicine." *Psychological Medicine* 9 (1979): 221–34.

Bourneville, Désiré Magloire, and Paul Regnard. *Iconographie photographique de La Salpêtrière.* Vol. 1. Paris, 1877.

Boxer, Charles Ralph. *The Dutch Seaborne Empire, 1600–1800.* Harmondsworth, 1973.

Brain, Peter. *Galen on Bloodletting: A Study of the Origins, Development, and Validity of His Opinions, with a Translation of the Three Works.* Cambridge, 1986.

Brake, Wayne P. te, Rudolph M. Dekker, and Lotte C. van de Pol. "Women and Political Culture in the Dutch Revolutions." In *Women and Politics in the Age of the Democratic Revolution*, edited by Harriet Branson Applewhite and Darlene Gay Levey, 109–47. Ann Arbor, 1990.

Brant, Sebastian. *The Ship of Fools.* Translated by Edwin Zeydel. New York, 1944.

Brathwaite, Richard. *A solemne joviall disputation, theoreticke and practike; briefly shadowing the law of drinking. . . .* London, 1617.

Bremmer, Jan, ed. *From Sappho to De Sade: Moments in the History of Sexuality.* London, 1989.

Bremmer, Jan, and Herman Roodenburg, eds. *Gestures in History: A Cultural History of Gestures from Antiquity to the Present.* Ithaca, 1992.

Breuer, Josef. *Studies in Hysteria.* Boston, 1950.

Bridenthal, Renate. "Something Old, Something New: Women between the Two World Wars." In *Becoming Visible: Women in European History*, edited by Renate Bridenthal and Claudia Koonz, 422–44. Boston, 1977.

Bridenthal, Renate, and Claudia Koonz, eds. *Becoming Visible: Women in European History.* Boston, 1977.

Bright, Timothie. *A Treatise of melancholie*. London, 1586.

Brock, Arthur John, ed. and trans. *Greek Medicine: Being Abstracts Illustrative of Medical Writers from Hippocrates to Galen*. London, 1929.

Brocklesby, Richard. *Reflections on ancient and modern music, with the Application to the Cure of Diseases*. London, 1749.

Bromley, John Selwyn, ed., *Britain and the Netherlands*. Groningen, 1974.

Broude, Norma, and Mary D. Garrard, eds. *Feminism and Art History: Questioning the Litany*. New York, 1982.

Brown, Christopher. *Art in the Seventeenth Century*. London, 1976.

Browne, Richard. *Medicina musica: or, A mechanical essay on the effects of singing, musick and dancing, on human bodies*. London, 1729.

Brundage, James A. "The Merry Widow's Serious Sister: Remarriage in Classical Canon Law." In *Matrons and Marginal Women in Medieval Society*, edited by Robert R. Edwards and Vickie Ziegler. Woodbridge, Suffolk, 1995.

Bruyn, J., et al., eds. *Album amicorum J. G. van Gelder*. The Hague, 1973.

Bullough, Vern L. *The Development of Medicine as a Profession: The Contribution of the Medieval Universities to Modern Medicine*. New York, 1966.

——. "Medieval Medical and Scientific Views of Women." *Viator* 5 (1973): 485–501.

Bullough, Vern L., and James Brundage. *Sexual Practices and the Medieval Church*. Buffalo, 1982.

Bullough, Vern L., Brenda Shelton, and Sarah Slavin. *The Subordinated Sex: A History of Attitudes toward Women*. Athens, Ga., 1988.

Bulwer, John. *Chirologia: Or the Natural Language of the Hand and Chironomia: Or the Art of Manual Rhetoric*, 1644. Reprint. Edited by J. W. Cleary. Carbondale, Ill., 1974.

Burema, Lambertus. *De voeding in Nederland van de middeleeuwen tot de twintigste eeuw*. Assen, 1953.

Burstyn, Joan N., ed. *Victorian Education and the Ideal of Womanhood*. New Brunswick, N.J., 1984.

Burton, Robert. *The Anatomy of Melancholy, What It Is. With All The Kindes, Causes, Symptomes, Prognostickes, And Several Cures Of It*. 3 vols. London, 1621.

——. *The Anatomy of Melancholy. . . .* 3 vols. New York, 1865.

——. *The Anatomy of Melancholy. . . .* Edited by H. Jackson. New York, 1932.

——. *The Anatomy of Melancholy. . . .* New York, 1977.

Butler, Charles. *The principles of musik in singing and setting, with the twofold use thereof (ecclesiasticall and civil)*. London, 1636.

Bylebyl, Jerome J. "Galen on the Nonnatural Causes of Variation in the Pulse." *Bulletin of the History of Medicine* 45 (1971): 482–85.

Camillus, Leonardus. *Mirror of Stones*. London, 1750.

Carapetyan, Armen. "Music and Medicine in the Renaissance and in the Seventeenth and Eighteenth Centuries." In *Music and Medicine*, edited by Dorothy M. Schullian and Max Schoen, 117–57. New York, 1948.

Carpenter, Nan Cooke. *Rabelais and Music*. Chapel Hill, 1954.

——. *Music in Medieval and Renaissance Universities*. New York, 1972.

Carroy-Thirard, Jacqueline. "Figures de femmes hystériques dans la psychiatrie française au 19ᵉ siècle." *Psychanalyse à l'université* 4 (1974): 313–23.

Castro, Rodricus à. *Medicus-politicus*. Hamburg, 1662.

Cats, Jacob. *Spiegel vanden ouden ende nieuwen tijdt*. The Hague, 1632.

——. *Houwelijck; dat is de gansche gelegentheyt des echten staets*. Amsterdam, 1655.

——. *Alle de wercken*. Amsterdam, 1665.

Céard, Jean, ed. *La folie et le corps: études réunies*. . . . Paris, 1985.

——. "The Devil and Lovesickness: Views of Sixteenth-Century Physicians and Demonologists." In *Eros and Anteros: The Medical Traditions of Love in the Renaissance*, edited by Donald A. Beecher and Massimo Ciavolella, 33–48. Ottawa, 1993.

[Celsus.] *Aul. Cor. Celsus on Medicine in Eight Books*. Edited by L. Targa and translated by Alex Lee. London, 1831.

——. *De medicina*. Translated by W. G. Spencer. Cambridge, Mass., 1953–61.

Cesbron, Henri. *Histoire critique de l'hystérie*. Paris, 1909.

Chamoux, A., and C. Dauphin. "La contraception avant la Révolution française: l'exemple de Chatillon-sur-Sein." *Annales: économies, sociétés, civilisations* (May–June 1969): 662–84.

Chapman, H. Perry. *Rembrandt's Self-Portraits: A Study in Seventeenth-Century Identity*. Princeton, 1990.

Chauvel, Renatus. "An venus hystericarum medela?" Diss., University of Paris, 1674.

Cheyne, George. *The English malady; or, A treatise of nervous diseases of all kinds, as spleen, vapours, lowness of spirits, hypochondriacal, and hysterical distempers, etc.* 1733. Reprint. New York, 1976.

Children of Mercury: The Education of Artists in the Sixteenth and Seventeenth Centuries. Providence, R.I., 1984.

Chodoff, Paul, and Henry Lyons. "Hysteria, the Hysterical Personality, and 'Hysterical' Conversion." *American Journal of Psychiatry* 114 (1958): 734–40.

Chrohns, Hjalmar. "Zur Geschichte der Liebe als 'Krankheit.'" *Archiv für Kulturgeschichte* 3 (1905): 66–86.

Chudleigh, Mary. *The female preacher*. London, 1699.

Ciavolella, Massimo. "Métamorphoses sexuelles et sexualité féminine durant la Renaissance." *Renaissance and Reformation* 12 (1988): 13–20.

Cicero, Marcus Tullius. *Tusculan Disputations*. Translated by J. E. King. London, 1927.

Clagett, Marshall, ed. *Critical Problems in the History of Science: Proceedings of the Institute for the History of Science at the University of Wisconsin, September 1–11, 1957*. Madison, 1959.

Clark, Alice. *Working Life of Women in the Seventeenth Century*. London, 1919.

Clark, Stuart. "The Rational Witchfinder: Conscience, Demonological Naturalism, and Popular Superstitions." In *Science, Culture, and Popular Belief in Renaissance Europe*, edited by Stephen Pumfrey, Paolo L. Rossi, and Maurice Slawinski, 222–48. Manchester, 1991.

Coccles, Bartolommeo della Rocca. *The Contemplation of Mankinde, contayning a singular discourse after the art of phisiognomie, on all the members and partes of man, as from the heade to the foote*. . . . Translated by Thomas Hill. London, 1571.

Coeffeteau, F. Nicolas. *Tableau des passions humaines: de leurs causes et de leurs effects*. Paris, 1620.

——. *A Table of Humane Passions*. Translated by E. Grimeston. London, 1621.

Cogan, Thomas. *The haven of health, chiefly made for the comfort of students and consequently for all those that have a care of their health*. . . . London, 1612.

Constantinus Africanus. *L'arte universale della medicina*. Translated by M. T. Malato and U. de Martini. Rome, 1961.

——. "The De Genecia Attributed to Constantinus Africanus." Edited by Monica H. Green. *Speculum* 62 (1987): 299–323.

Conway, Jill. "Stereotypes of Femininity in a Theory of Sexual Evolution." In *Suffer and Be Still: Women in the Victorian Age*, edited by Martha Vicinus, 140–54. Bloomington, Ind. 1972.

Corrozet, Gilles. *Hecatomgraphie*. Paris, 1543.

Cosman, Madeleine Pelner, and Bruce Chandler, eds. *Machaut's World: Science and Art in the Fourteenth Century: Annals of the New York Academy of Sciences* 314 (1978).

Crandall, Coryl. "The Cultural Implications of the Swetnam Antifeminist Controversy in the Seventeenth Century." *Journal of Popular Culture* 2 (Summer 1968): 136–48.

Crellin, J. K. *A Catalogue of the English and Dutch Collections in the Museum of the Wellcome Institute of the History of Medicine*. London, 1969.

Crombie, Alistair Cameron. "Mathematics, Music, and Medical Science." *Organon* 6 (1969): 21–36.

Crombie, Alistair Cameron, and Nancy Siraisi, eds. *The Rational Arts of*

Living. Smith College Studies in History, no. 50. Northampton, Mass., 1987.

Cuffe, Henry. *The Differences of the ages of mans life: together with the originall causes, progresse, and end thereof*. London, 1607.

D'Alverny, Marie-Thérèse. "Comment les théologiens et les philosophes voient la femme." *Cahiers de civilization médiévale* 20 (1977): 105–29.

Dariot, Claude. *A briefe and most easy introduction to the astrological judgment of the starres*. London, 1557.

Darrow, Margaret. "French Noblewomen and the New Domesticity, 1750–1850." *Feminist Studies* 5 (1979): 41–65.

Davies, David William. *Dutch Influences in English Culture, 1558–1625*. Ithaca, 1964.

Davies, Ross. *Women and Work*. London, 1975.

Davis, Audrey B., and Toby Appel. *Bloodletting Instruments in the National Museum of History and Technology*. Washington, D.C., 1977.

Davis, Natalie Zemon. *Society and Culture in Early Modern France*. Stanford, 1975.

Debus, Allen, ed., *Science, Medicine, and Society in the Renaissance*. 2 vols. New York, 1972.

Deconinck, Cécile. "Le luth dans les arts figurés des Pays-Bas au XVIᵉ siècle: étude iconologique." *Revue belge d'archéologie et d'histoire de l'art* 48 (1979): 3–43.

De Jongh, Eddy. *Zinne- en minnebeelden in de schilderkunst van de zeventiende eeuw*. Amsterdam, 1967.

———. "Erotica in vogelperspectief; de dubbelzinnigheid van een reeks 17de eeuwse genrevoorstellingen." *Simiolus* 3 (1968–69): 22–74.

———. "Realism et schijnrealism in de Hollandse schilderkunst van de zeventiende eeuw," in *Rembrandt en zijn tijd*. Brussels, 1971.

———. Review of Peter Sutton, *Pieter de Hooch. Simiolus* 11 (1980): 181–85.

———. *Portretten van echt en trouw: Huwelijk en gezin in de Nederlandse kunst van de zeventiende eeuw*. Zwolle, 1986.

De Jongh, Eddy, et al. *Tot lering en vermaak: Betekenissen van Hollandse genrevoorstellingen vit de zeventiende eeuw*. Amsterdam, 1976.

Dekker, Rudolf M. *Holland in beroering*. Baarn, 1982.

———. "Women in Revolt: Collective Protest and Its Social Basis in Holland." *Theory and Society* 16 (1987): 337–62.

———. "Vrouwen in middeleeuws en vroeg-modern Nederlands." In *Geschiedenis van de vrouw*, edited by Georges Duby and M. Perrot, 415–45. Amsterdam, 1992.

Dekker, Rudolf M., and L. van de Pol. *Dar was laatse een meisje loos*. Baarn, 1981.

Delamont, Sara, and Lorna Duffin, eds. *The Nineteenth-Century Woman: Her Cultural and Physical World*. London, 1978.

Delva, Anna. *Vrouwengeneeskunde in Vlaanderen tijdens de late middeleeuwen.* Bruges, 1983.

Diepgen, Paul. *Frau und Frauenheilkunde in der Kultur des Mittelalters.* Stuttgart, 1963.

Diethelm, Oskar. *Medical Dissertations of Psychiatric Interest Printed before 1750.* Basel, 1971.

Diik, C. van. *De suffocatione hypochondriaca.* Leiden, 1665.

Dixon, Laurinda S. "Music, Medicine, and Morals: The Iconography of an Early Musical Instrument." *Studies in Iconography* 7–8 (1981–82): 147–56.

——. "Bosch's *St. Anthony* Triptych: An Apothecary's Apotheosis." *Art Journal* 44 (1984): 119–32.

——. "Some Penetrating Insights: The Imagery of Enemas in Art." *Art Journal* 53 (Fall 1993): 28–35.

Doane, Mary Ann. "The Clinical Eye: Medical Discourses in the Woman's Film of the 1940s." In *The Female Body in Western Culture: Contemporary Perspectives,* edited by Susan Rubin Suleiman, 152–74. Cambridge, Mass., 1986.

Dobb, Maurice Herbert. *Studies in the Development of Capitalism.* New York, 1947.

Domandle, Sepp, ed. *Paracelsus: Werk und Wirkung.* Salzburger Beiträge zur Paracelsusforschung 13 (1975).

Dotterer, Ronald, and Susan Bowers, eds. *Politics, Gender, and the Arts: Women, the Arts and Society.* Selinsgrove, Pa., 1992.

Draper, John W. *The Humors and Shakespeare's Characters.* New York, 1970.

Dresen-Coenders, Lène, and Ton Brandenbarg. *Vijf eeuwen gezinsleven: Liefde, huwelijk en opvoeding in Nederland.* Nijmegen, 1988.

Dubois, E. Frédéric. *Histoire philosophique de l'hypochondrie et de l'hystérie.* Paris, 1837.

Duby, Georges, and Michelle Perrot, eds. *Geschiedenis van de vrouw.* Vol. 3 of *Van Renaissance tot de moderne tijd.* Edited by Arlette Farge and Natalie Zemon Davis. Amsterdam, 1992.

Duffin, Lorna. "The Conspicuous Consumptive: Woman as an Invalid." In *Nineteenth-Century Woman: Her Cultural and Physical World,* edited by Sara Delamont and Lorna Duffin, 26–56. London, 1978.

Du Laurens, André [Laurentius]. *A discourse on the preservation of the sight: of melancholike diseases; of rheumes, and of old age.* London, 1599.

Duminil, Marie-Paule. "La mélancolie amoureuse dans l'antiquité." In *La folie et le corps,* edited by Jean Céard, 91–109. Paris, 1985.

Duncan, Carol. "Happy Mothers and Other New Ideas in Eighteenth-Century French Art." *Art Bulletin* 55 (1973): 570–83.

Dunglison, Robley. *A Dictionary of Medical Science.* Philadelphia, 1848.

Dunstan, Gordon Reginald, ed. *The Human Embryo: Aristotle and the Arabic and European Traditions*. Exeter, 1990.

Duval, Jacques. *Des hermaphrodits, accouchemens des femmes, et traitement qui est requis pour les releuer en santé*. Rouen, 1612.

Ebbell, Bendix, trans. *The Papyrus Ebers, the Greatest Egyptian Medical Document*. Copenhagen, 1937.

Eccles, Audrey. *Obstetrics and Gynaecology in Tudor and Stuart England*. Kent, Ohio, 1982.

Edelstein, Ludwig. "Greek Medicine in Its Relation to Religion and Magic." *Bulletin of the History of Medicine* 5 (1937): 201–46.

Eeghen, Isabella Henriette van. *Vrouwenkloosters en begijnohof in Amsterdam van de 14e tot het eind der 16de eeuw*. Amsterdam, 1941.

Ehrenreich, Barbara, and Deirdre English. *Complaints and Disorders: The Sexual Politics of Sickness*. Old Westbury, N.Y., 1973.

Eisler, Colin. *Paintings from the Samuel H. Kress Collection*. Oxford, 1977.

Elshtain, Jean Bethke. *Public Man, Private Woman: Women in Social and Political Thought*. Princeton, 1981.

Elyot, Thomas. *The Castel of Health*. London, 1610.

Emmens, Jan. "De kwakzalver." *Kunsthistorische Opstellen* 2 (1981): 163–67.

L'enseignement et l'éducation dans les Pays-Bas au dix-huitième siècle. Amsterdam, 1982.

Estienne, Charles. *Siben Bücher von dem Feldbau*. Translated by Melchiore Sebizio. Strassburg, 1579.

Evans, Bergen. *The Psychiatry of Robert Burton*. New York, 1972.

Falret, Jules P. *De l'hypochondrie et du suicide*. Paris, 1822.

Farrington, Benjamin. *Greek Science*. London, 1961.

Fee, Elizabeth. "Science and the Woman Problem: Historical Perspectives." In *Sex Differences: Social and Biological Perspectives*, edited by Michael S. Teitelbaum, 175–223. Garden City, N.Y., 1974.

Ferrand, Jacques. *Erotomania; or, A treatise discoursing of the essence, causes, symptomes, prognosticks, and cure of love, or erotique melancholy*. Translated by Edmund Chilmead. Oxford, 1640.

——. *A Treatise on Lovesickness*. Edited and translated by Donald A. Beecher and Massimo Ciavolella. Syracuse, N.Y., 1990.

Ficino, Marsilio. *Contro alla peste*. Florence, 1576.

——. *Les trois livres de la vie*. Translated by Guy Le Fevre de la Boderie. Paris, 1582.

——. *Commentarium in convivium Platonis de amore*. Edited and translated by Sears Reynolds Jane. Columbia, Mo., 1944.

——. *The Book of Life*. Translated by Charles Boer. Irving, Tex., 1980.

Fink, Z. S. "Jacques and the Malcontent Type." *Philological Quarterly* 14 (1935): 237–62.

Finlay, Ian F. "Musical Instruments in Seventeenth-Century Dutch Painting." *Galpin Society Journal* 6 (1953): 52–69.

Finney, Gretchen Ludke. "Music, Mirth, and the Galenic Tradition in England." In *Reason and Imagination: Studies in the History of Ideas, 1600–1800*, edited by Joseph Antony Mazzeo, 143–54. New York, 1962.

———. "Vocal Exercise in the Sixteenth Century Related to Theories of Physiology and Disease." *Bulletin of the History of Medicine* 42 (1968): 422–49.

Fischer, Peter. *Music in Paintings of the Low Countries in the Sixteenth and Seventeenth Centuries*. Amsterdam, 1975.

Fischer-Homberger, Esther. "Hysterie und Misogynie: Ein Aspekt der Hysteriegeschichte." *Gesnerus* 26 (1969): 117–27.

———. "Hypochondriasis of the Eighteenth Century: Neurosis of the Present Century." *Bulletin of the History of Medicine* 46 (1972): 391–401.

Flack, Isaac Harvey. *Eternal Eve: The History of Gynaecology And Obstetrics by Harvey Graham (Pseud.)*. Garden City, N.Y., 1951.

Flashar, Hellmut. *Melancholie und Melancholiker in den medizinischen Theorien der Antike*. Berlin, 1966.

Floyer, John. *The physician's pulse-watch; or, An essay to explain the old art of feeling the pulse, and to improve it by the help of a pulse-watch. . . .* 2 vols. London, 1707–10.

Fludd, Robert. *Pulsus. Seu, Nova et arcana pulsuum historia. . . .* Frankfurt, 1629.

Folie et déraison à la Renaissance: colloque international sous les auspices de la fédération internationale tenu en Novembre 1973 des institutes et sociétés pour l'étude de la Renaissance. Brussels, 1976.

Forbes, Thomas Rogers. *The Midwife and the Witch*. New Haven, 1966.

Ford, John. *The Lovers Melancholy*. London, 1629.

Forest, Pieter van [Forestus]. *Het onzeker ende bedrieghlick oordeel der wateren*. Leiden, 1626.

Foucault, Michel. *Madness and Civilization: A History of Insanity in the Age of Reason*. New York, 1965.

Francheville, Robert. "Une thérapeutique musicale dans la vieille médecine." *Pro Medico* 4 (1927): 243–48.

Franits, Wayne E. "The Virtues Which Ought to Be in a Compleate Woman: Domesticity in Seventeenth-Century Dutch Art." Ph.D. diss., New York University, 1987.

———. "Housewives and Their Maids in Dutch Seventeenth-Century Art." In *Politics, Gender and the Arts: Women, the Arts, and Society*, edited by Ronald Dotterer and Susan Bowers, 112–29. London, 1992.

———. *Paragons of Virtue: Women and Domesticity in Seventeenth-Century Dutch Art*. Cambridge, 1993.

Fresia, Carol Jean. "Quacksalvers and Barber-Surgeons: Images of Medical Practitioners in Seventeenth-Century Dutch Genre Painting." Ph.D. diss., Yale University, 1991.

Friedenwald, Julius, and Samuel Morrison. "The History of the Enema with Some Notes on Related Procedures." *Bulletin of the History of Medicine* 8 (1940): 68–114, 239–76.

Friedreich, Johannes Baptista. *Historisch-kritische Darstellung der Theorien über des Wesen und den Sitz der psychischen Krankheiten*. Leipzig, 1836.

Frijhoff, Willem. "Non satis dignitatis . . . over de maatschappelijke status van geneeskundigen tijdens de Republiek." *Tijdschrift voor geschiedenis* 96 (1983): 379–406.

Fritz, Paul, and Richard Morton, eds. *Woman in the Eighteenth Century and Other Essays*. Toronto, 1976.

Frye, R. M. "The Teachings of Classical Puritanism on Conjugal Love." *Studies in the Renaissance* 2 (1955): 148–59.

Gaddesen, John of. *Rosa anglica practica medicinae*. Pavia, 1492.

Galen of Pergamon. *Art of Physick*. Translated by Nicolas Culpeper. London, 1652.

——. *Claudii Galeni opera omnia*. 20 vols. Edited by Karl Gottlob Kuhn. Leipzig, 1821–22.

——. *On the Natural Faculties*. Translated by Arthur John Brock. New York, 1916.

——. *On the Usefulness of the Parts of the Body*. 2 vols. Edited and translated by Margaret May. Ithaca, 1968.

Garfield, Sol L., and Allen E. Bergin, eds. *Handbook of Psychotherapy and Behavior Change*. New York, 1971.

Garrard, Mary D. *Artemisia Gentileschi: The Image of the Female Hero in Italian Baroque Art*. Princeton, 1989.

Gaskell, Ivan. "Gerrit Dou, His Patrons, and the Art of Painting." *Oxford Art Journal* 5 (1982): 15–23.

George, Charles H., and Katherine George. *The Protestant Mind of the English Reformation, 1570–1640*. Princeton, 1961.

Gerard, John. *The herball, or General historie of plantes*. London, 1636.

Gibson, Anthony. *A womans woorth, defended against all the men in the world. Prooving them to be more perfect, excellent and absolute in all vertuous actions, than any man*. London, 1599.

Gilbert, Sandra M., and Susan Gubar. *The Madwoman in the Attic: The Woman Writer and the Nineteenth-Century Literary Imagination*. New Haven, 1980.

Gillespie, Robert Dick. *Hypochondria*. London, 1929.

Gilman, Sander L. *Seeing the Insane: A Cultural History of Psychiatric Illustration*. New York, 1982.

——. *Difference and Pathology: Stereotypes of Sex, Race, and Madness*. Ithaca, 1985.

——. *Disease and Representation: Images of Illness from Madness to AIDS.* Ithaca, 1988.

——. "The Image of the Hysteric." In Sander L. Gilman et al., *Hysteria beyond Freud*, 345–452. Berkeley, 1993.

Gilman, Sander L., et al. *Hysteria beyond Freud.* Berkeley, 1993.

Gils, J. B. F. van. *De dokter in de oude Nederlandsche tooneelliteratuur.* Haarlem, 1917.

——. "Een detail op de doktersschilderijen van Jan Steen." *Oud Holland* 38 (1920): 200–201.

——. "Een detail op doktersschilderijen van Jan Steen." *Nederlandish Tijdschrift voor Geneeskunde* 65 (1921): 2561–63.

Glanvilla, Bartholemeus Anglicus de. *De proprietatibus rerum.* Translated by John of Treves. London, 1535.

Glaser, Gilbert H. "Epilepsy, Hysteria, and 'Possession': A Historical Essay." *Journal of Nervous and Mental Disease* 166 (April 1978): 268–74.

Glass, David Victor, and D. E. C. Eversley, eds. *Population in History: Essays in Historical Demography.* London, 1965.

Gorceix, Bernard. "La mélancolie au XVIᵉ et XVIIᵉ siècles: Paracelse et Jacob Bohme." *Recherches germaniques* 9 (1979): 18–29.

Gordon, Benjamin Lee. *Medieval and Renaissance Medicine.* New York, 1959.

Gorham, Deborah. *The Victorian Girl and the Feminine Ideal.* Bloomington, Ind., 1982.

Gottlieb, Carla. "The Brussels Version of the Mérode Annunciation." *Art Bulletin* 39 (1957): 53–60.

Gowing, Lawrence. *Vermeer.* London, 1952.

Graaf, Regnier de. *De mulierum organis generationi inservientibus tractatus novis. 1672.* Translated as "A New Treatise Concerning the Generative Organs of Women" by H. D. Jocelyn and B. P. Setchell. *Journal of Reproduction and Fertility* suppl. 17 (1972): 77–222.

Grafton, Anthony. "Civic Humanism and Scientific Scholarship at Leiden." In *The University and the City from Medieval Origins to the Present*, edited by Thomas Bender, 59–77. New York, 1988.

Graham, Thomas Francis. *Medieval Minds: Mental Health in the Middle Ages.* London, 1967.

Grange, Kathleen M. "The Ship Symbol as a Key to Former Theories of the Emotions." *Bulletin of the History of Medicine* 36 (1962): 512–23.

Grant, Edward, ed. *A Source Book in Medieval Science.* Cambridge, Mass., 1974.

Graunt, John. *Natural and Political Observations upon the Bills of Mortality.* London, 1661–62.

Green, Monica H. "The Transmission of Ancient Theories of Female Physiology and Disease through the Early Middle Ages." Ph.D. diss., Princeton University, 1985.

——. "Constantinus Africanus and the Conflict between Religion and Science." In *The Human Embryo: Aristotle and the Arabic and European Traditions*, edited by Gordon Reginald Dunstan, 47–69. Exeter, 1990.

——. "Obstetrical and Gynecological Texts in Middle English." *Studies in the Age of Chaucer* 14 (1992): 53–88.

Greene, John C. "Biology and Social Theory in the Nineteenth Century: Auguste Comte and Herbert Spencer." In *Critical Problems in the History of Science: Proceedings of the Institute for the History of Science at the University of Wisconsin, September 1–11, 1957*, edited by Marshall Clagett, 419–46. Madison, 1959.

Groot, Cornelius Hofstede de. *Beschreibendes und kritisches Verzeichnis der Werke der hervorragendsten Hollaendischen Maler des XVII Jahrhunderts.* 10 vols. Essilingen, 1908–27.

Groot, Cornelius Wilhelmus de. *Jan Steen; beeld en woord.* Utrecht, 1952.

Grosjean, Ardis. "Toward an Interpretation of Pieter Aertsen's Profane Iconography." *Konsthistorisk Tidskrift* 43 (December 1974): 122–43.

Gudlaugsson, Sturla J. *The Comedians in the Work of Jan Steen and Contemporaries.* Translated by James Brocknay and Patricia Wardle. Soest, 1975.

Guratzsch, Herwig. *Dutch and Flemish Painting.* New York, 1981.

——. *Painting in the Low Countries.* London, 1981.

Gutmann, Harry B. "The Medieval Content of Raphael's *School of Athens.*" *Journal of the History of Ideas* 2 (1941): 420–29.

Hadrianus Junius. *Hadriani Iunii, medici emblemata.* Antwerp, 1575.

Hafenreffer, Samuel. *Monochordon symbolico-biomanticum.* Ulm, 1650.

Haines, Barbara. "The Interrelations between Social, Biological, and Medical Thought, 1750–1850: Saint-Simon and Comte." *British Journal for the History of Science* 11 (March 1978): 19–35.

Haks, Donald. *Huwelijk en gezin in Holland in de 17de en 18de eeuw.* Utrecht, 1985.

Haley, Kenneth Harold Dobson. *The Dutch in the Seventeenth Century.* London, 1972.

Hall, A. Rupert. *The Revolution in Science, 1500–1750.* London, 1983.

Hallaert, M.-R., ed. *The "Sekenesse of wymmen": A Middle English Treatise on Diseases of Women.* Brussels, 1982.

Haller, John S., Jr., and Robin M. Haller. *The Physician and Sexuality in Victorian America.* Urbana, Ill., 1974.

Hamilton, Roberta. *The Liberation of Women: A Study of Patriarchy and Capitalism.* London, 1978.

Hannema, Frans. *Gerard Terborch*. Amsterdam, 1943.

Hanson, Ann Ellis. "Hippocrates: 'Diseases of Women' I." *Signs: Journal of Women and Culture in Society* 1 (1975): 567–82.

Hargreaves-Mawdsley, W. N. *A History of Academical Dress in Europe until the End of the Eighteenth Century*. Oxford, 1963.

Harris, Ann Sutherland, and Linda Nochlin. *Women Artists: 1550–1950*. New York, 1977.

Hart, James. *Klinike, Or the Diet of the Diseased. . . .* London, 1633.

Hartman, Mary S., and Lois Banner, eds. *Clio's Consciousness Raised: New Perspectives in the History of Women*. New York, 1974.

Harvey, Gideon. *Morbus Anglicus: or The anatomy of consumptions*. Cornhill, 1674.

——. *The disease of London: or a New discovery of the scorvey*. London, 1675.

Harvey, William. *Exercitationes de generatione animalium*. London, 1651.

——. *The Works of William Harvey, M.D.* Translated by R. Willis. London, 1847.

Harward, Simon. *Phlebotomy: or, A treatise of letting of bloud. . . .* 1601. Reprint. New York, 1973.

Havers, George, and J. Davies, trans. *Another collection of philosophical conferences of the French virtuosi, upon questions of all sorts. . . .* London, 1665.

Hecker, J. F. C. *The Dancing Mania of the Middle Ages*. Translated by B. G. Babington. New York, 1970.

Heinsius, Daniel. *Het ambach van Cupido. . . .* Leiden, 1615.

Hellinga, W. G. "De bewogenheid der staalmeesters; enkele beschouwingen over wegen en grenzen der interpretatie." *Nederlands kunsthistorisch jaarboek* 8 (1957): 151–84.

Helse en hemelse vrouwen: Schrikbeelden en voorbeelden van de vrouw in de christelijke cultuur. Utrecht, 1988.

Henderson, Katherine U., and Barbara F. McManus. *Half Humankind: Contexts and Texts of the Controversy about Women in England, 1540–1640*. Urbana, Ill., 1985.

Henry, John. "Doctors and Healers: Popular culture and the Medical Profession." In *Science, Culture, and Popular Belief in Renaissance Europe*, edited by Stephen Pumfrey, Paolo L. Rossi, and Maurice Slawinski, 191–221. Manchester, 1991.

Herrlinger, Robert. *A History of Medical Illustration from Antiquity to A.D. 1600*. New York, 1970.

Heywood, Thomas. *The generall history of women, contayning the lives of the most holy and profane, the most famous and infamous of all ages, exactly described not only from poeticall fictions, but from the most ancient, modern, and admired historians, to our times*. London, 1657.

Hic mulier: or, the man-woman: being a medicine to cure the coltish disease of the staggers in the masculine-feminines of our times. London, 1620.

Hill, Christopher. *Reformation to Industrial Revolution: A Social and Economic History of Britain, 1530–1780.* Harmondsworth, 1969.

———. *World Turned Upside Down: Radical Ideas during the English Revolution.* London, 1972.

[Hippocrates.] *Oeuvres complètes d'Hippocrate.* Translated by Émile Littré. Paris, 1839–61.

———. *Works of Hippocrates.* Translated and edited by W. H. S. Jones and E. T. Withington. 4 vols. Cambridge, Mass., 1923–31.

———. *Hippocratic Writings.* Edited by G. E. R. Lloyd and translated by J. Chadwick and W. N. Mann. Harmondsworth, 1978.

Hofer, Johannes. *De religiosorum morbis.* Basel, 1716.

Hoffmann, Friedrich. *A System of the Practice of Medicine.* 2 vols. Translated by William Lewis and Andrew Duncan. London, 1783.

Hoffmann, Paul. *La femme dans la pensée des lumières.* Paris, 1977.

Hofrichter, Frima Fox. *Judith Leyster: A Woman Painter in Holland's Golden Age.* Doornspijk, 1989.

Hogrefe, Pearl. *Tudor Women: Commoners and Queens.* Ames, Iowa, 1975.

Hokke, Judith. " 'Mijn alderliefste Jantielief.' Vrouw en gezin in de Republiek: Regentenvrouwen en hun relaties." *Jaarboek voor Vrouwengeschiedenis* 8 (1987): 45–74.

Holländer, Eugen. *Die Medizin in der klassischen Malerei.* Stuttgart, 1950.

Horine, Emmet Field. "An Epitome of Ancient Pulse Lore." *Bulletin of the History of Medicine* 10 (1941): 209–49.

Huizinga, Jakob Herman. *Dutch Civilization in the Seventeenth Century.* Translated by A. J. Pomerans. London, 1968.

Hull, Suzanne W. *Chaste, Silent, and Obedient: English Books for Women, 1475–1640.* San Marino, Calif., 1982.

Hunnewell, Richard Whittier. "Gerrit Dou's Self-Portraits and Depictions of the Artist." 2 vols. Ph.D. diss., Boston University, 1983.

Hutter, Bridget, and Gillian Williams, eds. *Controlling Women: The Normal and the Deviant.* London, 1981.

Ingleby, David. "The Social Construction of Mental Illness." In *The Problem of Medical Knowledge: Examining the Social Construction of Medicine,* edited by Peter Wright and Andrew Treacher, 123–43. Edinburgh, 1982.

Innes Smith, R. W. *English-Speaking Students of Medicine at the University of Leyden.* London, 1932.

Irwin, Joyce. "Anna Maria van Schurman: From Feminism to Pietism." *Church History* 46 (March 1977): 48–62.

Jackson, Stanley W. "Galen: On Mental Disorders." *Journal of the History of Behavioral Sciences* (1965): 365–84.

——. *Melancholia and Depression from Hippocratic Times to Modern Times.* New Haven, 1986.

Jacobs, Eva, ed. *Woman and Society in Eighteenth-Century France: Essays in Honor of John Stephenson Spinck.* London, 1979.

Jacquart, Danielle, and Claude Thomasset. *Sexuality and Medicine in the Middle Ages.* Princeton, 1988.

James, Robert. *A Medical Dictionary.* 3 vols. Oxford, 1745.

Janiçon, François-Michel. *État présent de la république des Provinces-unies, et des pais qui en dépendent.* The Hague, 1730.

Jobe, T. H. "Medical Theories of Melancholia in the Seventeenth and Early Eighteenth Centuries." *Clio medica* 11 (1976): 217–31.

Jones, Peter Murray. *Medieval Medical Miniatures.* London, 1984.

Jordan-Smith, Paul. *Bibliographia Burtoniana: A Study of Robert Burton's "The Anatomy of Melancholy," with a Bibliography of Burton's Writings.* Stanford, 1931.

Jorden, Edward. *A Briefe Discourse of a Disease Called the Suffocation of the Mother. . . .* London, 1603.

Joseph, Bertram Leon. *Elizabethan Acting.* London, 1951.

Kelly, Joan. "Early Feminist Theory and the *Querelle des Femmes,* 1400–1789." *Signs: Journal of Women and Culture in Society* 8 (Autumn 1982): 4–28.

Kelly-Gadol, Joan. "Did Women Have a Renaissance?" In *Becoming Visible: Women in European History,* edited by Renate Bridenthal and Claudia Koonz, 137–64. Boston, 1977.

Kelso, Ruth. *Doctrine for the Lady of the Renaissance.* Urbana, Ill., 1956.

Kemp, William. *A briefe treatise of the nature, causes, signes, preservation from, and cure of the pestilence.* London, 1665.

Kessel, Elisja Schulte van, ed. *Women and Men in Spiritual Culture, XIV–XVII Centuries: A Meeting of South and North.* The Hague, 1986.

Kettering, Alison McNeil. *The Dutch Arcadia: Pastoral Art and Its Audience in the Golden Age.* Montclair, N.J., 1983.

Kibre, Pearl. "The Faculty of Medicine at Paris: Charlatanism and Unlicensed Medical Practice in the Later Middle Ages." *Bulletin of the History of Medicine* 27 (1953): 1–20.

King, Helen. "Once Upon a Text: Hysteria from Hippocrates." In Sander Gilman et al., *Hysteria beyond Freud,* 3–90. Berkeley, 1993.

King, Lester S. *The Growth of Medical Thought.* Chicago, 1963.

——. "Attitudes toward 'Scientific' Medicine around 1700." *Journal of the History of Medicine* 39 (1965): 124–33.

——. *The Road to Medical Enlightenment.* New York, 1970.

——. *The Philosophy of Medicine: The Early Eighteenth Century.* Cambridge, Mass., 1978.

Kinsman, Robert S., ed. *The Darker Vision of the Renaissance: Beyond Fields of Reason.* Berkeley, 1974.

Kircher, Athanasius. *Musurgia universalis.* . . . Rome, 1650.

Kirschenbaum, Baruch David. *The Religious and Historical Paintings of Jan Steen.* New York, 1977.

Kittelson, James M., and Pamela J. Transue, eds. *Rebirth, Reform, and Resilience: Universities in Transition, 1300–1700.* Columbus, Ohio, 1984.

Klein, H. Arthur. *Graphic Worlds of Pieter Bruegel the Elder: Reproducing Sixty-Four Engravings and a Woodcut after Designs by Peter Bruegel, the Elder.* New York, 1963.

Klein, Viola. "Industrialization and the Changing Role of Women." *Current Sociology* 12 (1963–64): 24–34.

Kleinbaum, Abby R. "Women in the Age of Light." In *Becoming Visible: Women in European History,* edited by Renate Bridenthal and Claudia Koonz, 217–35. Boston, 1977.

Klibansky, Raymond, Erwin Panofsky, and Fritz Saxl. *Saturn and Melancholy: Studies in the History of Natural Philosophy, Religion, and Art.* New York, 1964.

Knights, Lionel Charles. *Drama and Society in the Age of Jonson.* London, 1957.

Knowlson, James R. "The Idea of Gesture as a Universal Language in the Seventeenth and Eighteenth Centuries." *Journal of the History of Ideas* 26 (1965): 495–508.

Koopmans, Jelle, and Paul Verhuyck. *Een kijk op anekdotencollecties in de zeventiende eeuw.* Amsterdam, 1991.

Koorn, Florence. "Illegitimiteit en eergevoel: Ongehuwde moeders in Twente in de achttiende eeuw." *Jaarboek voor vrouwengeschiedenis* 8 (1987): 74–98.

Kramer, Heinrich, and James Sprenger. *Malleus maleficarum.* Translated and edited by Montague Summers. 1486. Reprint. New York, 1971.

Krell, D. F. "Female Parts in *Timaeus.*" *Arion* 2 (1975): 400–421.

Kristeller, Paul Oskar. "Music and Learning in the Early Italian Renaissance." *Journal of Renaissance and Baroque Music* (1947): 269–72.

Kroon, Just Emile. *Bijdragen tot de geschiedenis van het geneeskundig onderwijs aan de Leidsche universiteit, 1575–1625.* . . . Leiden, 1911.

Kuhn, Thomas S. *The Structure of Scientific Revolutions.* Chicago, 1962.

Kümmel, Werner F. *Musik und Medizin: Ihre Wechselbeziehungen in Theorie und Praxis von 800 bis 1800.* Freiburg, 1977.

Kuretsky, Susan Donahue. *The Paintings of Jacob Ochtervelt, 1634–1682.* Montclair, N.J., 1979.

Kurz, Otto. "The Medieval Illustrations of the Wellcome MS." *Journal of the Warburg and Courtauld Institutes* 5 (1942): 137–42.

Kuznetsov, Jury, and Irene Linnik. *Dutch Painting in Soviet Museums.* New York, 1982.

Lange, Johannes. *Traité des vapeurs.* Paris, 1689.

Laqueur, Thomas. "Orgasm, Generation, and the Politics of Reproductive Biology." *Representations* 14 (Spring 1986): 1–41.

Laslett, Peter, ed. *Household and Family in Past Time.* Cambridge, Mass., 1972.

LeGates, Marlene. "The Cult of Womanhood in Eighteenth-Century Thought." *Eighteenth-Century Studies* 10 (1976): 21–39.

Leibbrand, Annemarie, and Werner Leibbrand. "Die 'Kopernikanische Wendung' des Hyteriebegriffes bei Paracelsus." In *Paracelsus: Werk und Wirking. Salzburger Beitrage zur Paracelsusforschung,* edited by Sepp Domandle, 124–32. Vienna, 1975.

Lemay, Helen Rodnite. "Some Thirteenth- and Fourteenth-Century Lectures on Female Sexuality." *International Journal of Women's Studies* 1 (1978): 391–400.

Lemnius, Levinus. *The Secret Miracles of Nature.* London, 1650.

——. *The Touchstone of Complexions.* Translated by Thomas Newton. London, 1576.

Levin, Kenneth. "Freud's Paper on 'Male Hysteria' and the Conflict between Anatomical and Physiological Models." *Bulletin of the History of Medicine* 48 (1974): 377–97.

Liébault, Jean. *Trois livres appartenans auz infirmitez et maladies des femmes. Pris du Latin de M. Jean Liébaut.* Paris, 1598.

Lieberman, William. "The Enema." *Revue of Gastroenterology* 13 (May–June 1946): 215–29.

Lilly, William. *Christian astrology modestly treated of in three books.* London, 1647.

Lindeboom, Gerrit Arie. *Herman Boerhaave: The Man and His Work.* London, 1968.

——. *Boerhaave and Great Britain: Three Lectures on Boerhaave with Particular Reference to his Relations with Great Britain.* Leiden, 1974.

——. "Jan Swammerdam (1637–80) and His Biblia Naturae." *Clio Medica* 17 (December 1982): 113–31.

——. *Dutch Medical Biography.* Amsterdam, 1984.

Lochner, Michel Friedrich. *De nymphomania.* Altdorf, 1684.

Logan, Anne-Marie, ed. *Essays in Northern European Art Presented to Egbert Haverkamp Begemann on His Sixtieth Birthday.* Doornspijk, 1983.

Lorenzoni, Piero. *La giuliva siringa: Storia universale del clistere.* Milan, 1969.

Lougee, Carolyn C. *Le Paradis des Femmes: Women, Salons, and Social Stratification in Seventeenth-Century France.* Princeton, 1976.

Lunsingh Scheurleer, Theodoor Herman, and G. H. M. Posthumus Meyjes, eds. *Leiden University in the Seventeenth Century: An Exchange of Learning.* Leiden, 1975.

Lyons, Albert S., and R. Joseph Petrucelli. *Medicine, An Illustrated History*. New York, 1978.

Lyons, Bridget Gellert. *Voices of Melancholy: Studies in Literary Treatments of Melancholy in Renaissance England*. London, 1971.

MacDonald, Michael. *Mystical Bedlam: Anxiety, Madness, and Healing in Seventeenth-Century England*. Cambridge, 1981.

MacKinney, Loren. *Medical Illustrations in Medieval Manuscripts*. Berkeley, 1965.

MacKinney, Loren, and Harry Bober. "A Thirteenth-Century Medical Case History in Miniatures." *Speculum* 35 (April 1960): 251–59.

——. "La prima autopsia." *Kos* 2 (1984): 51–60.

Maclean, Ian. *Woman Triumphant: Feminism in French Literature, 1610–1652*. Oxford, 1977.

——. *The Renaissance Notion of Woman: A Study in the Fortunes of Scholasticism and Medical Science in European Intellectual Life*. Cambridge, 1980.

Maeterlinck, Louis. *Le genre satirique, fantastique et licencieux dans la sculpture flamande et wallonne; les miséricordes de stalles (art et folklore)*. Paris, 1910.

Maines, Rachel. "Socially Camouflaged Technologies: The Case of the Electromechanical Vibrator." *IEEE Technology and Society Magazine* (June 1989): 3–23.

Mandeville, Bernard. *The virgin unmask'd; or, Female dialogues betwixt an elderly maiden lady, and her niece, . . . on several diverting discourses, on love, marriage, memoirs, and morals, etc. of the times*. London, 1709.

——. *A treatise of the hypochondriack and hysterick passions*. 1711. Reprint. New York, 1976.

Mandrou, Robert. "Le baroque europien: mentalité pathetique et révolution sociale." *Annales* 15 (1960): 898–914.

Marbodeus. *Lapidarium*. [1539.] Translated by S. Roparty. N.p., 1873.

Marcuse, Sibyl. *A Survey of Musical Instruments*. New York, 1975.

Marinelli, Lucrezia. *La nobilità et l'eccellenza delle donne, co' deffetti et mancamenti de gli huomini*. Venice, 1601.

Marquet, François-Nicolas. *Nouvelle méthode facile et curieuse, pour connoitre le pouls par les notes de la musique. . . .* Paris, 1769.

Marshall, Rosalind K. *Virgins and Viragos: A History of Women in Scotland from 1080–1980*. Chicago, 1983.

Martin, Wilhelm. *Gerard Dou, sa vie et son oeuvre*. Translated by Louis Dimier. Paris, 1911.

——. *Dutch Painting of the Great Period, 1650–1697*. Translated by D. Harning. London, 1951.

Masson, Jeffrey Moussaieff, ed. *A Dark Science: Women, Sexuality, and Psychiatry in the Nineteenth Century*. New York, 1986.

Mattioli, Pietro Andrea. *Senensis Medici*. Venice, 1619.

Mauriceau, François. *Traité des maladies des femmes grosses, et de celles qui sont nouvellement accouchées*. Paris, 1668.

——. *Tractat van de siektens der swangere vrouwen, en der gene die eerst gebaert hebben*. Amsterdam, 1683.

——. *The diseases of women with child, and in child-bed*. . . . London, 1710.

Mauzi, Robert. "Les maladies de l'âme au XVIIIᵉ siècle." *Revue des sciences humaines* 100 (October–December 1960): 459–93.

Mayor, A. Hyatt. "Artists as Anatomists." *Metropolitan Museum of Art Bulletin* 22 (1963–64): 201–9.

Mazzeo, Joseph Anthony, ed. *Reason and Imagination: Studies in the History of Ideas, 1600–1800*. New York, 1961.

Meige, Henry. "Les peintres de la médecine: Le mal d'amour." *Nouvelle iconographie de La Salpétrière* 12 (1899): 57–68, 227–60, 340–52, 420–32.

——. "Les médecins de Jan Steen." *Janus* 5 (1900): 187–90.

Merchant, Carolyn. *The Death of Nature: Women, Ecology, and the Scientific Revolution*. San Francisco, 1980.

Mersenne, Marin. *Questions harmoniques*. Paris, 1634.

——. *Harmonie universelle*. Paris, 1636.

Mesnardière, Hippolyte-Jules de la. *Traité de la mélancolie*. Paris, 1636.

Mesulam, Marek-Marsel, and Jon Perry. "The Diagnosis of Love-Sickness: Experimental Psychophysiology without the Polygraph." *Psychophysiology* 9 (1972): 546–51.

Micale, Mark S. "Hysteria and Its Historiography: A Review of Past and Present Writings." *History of Science* 27 (1989): 223–61; 319–31.

——. "Hysteria and Its Historiography: The Future Perspective." *History of Psychiatry* 1 (March 1990): 33–124.

Midelfort, E. C. Erik. *Witch-Hunting in Southwestern Germany, 1562–1684: The Social and Intellectual Foundations*. Stanford, 1972.

Miles, Margaret. "The Virgin's One Bare Breast: Female Nudity and Religious Meaning in Tuscan Early Renaissance Culture." In *The Female Body in Western Culture: Contemporary Perspectives*, edited by Susan Rubin Suleiman, 193–207. Cambridge, Mass., 1986.

Millar, Oliver. *The Age of Charles I: Painting in England, 1620–1649*. London, 1972.

Mirimonde, Albert P. de. "La musique dans les oeuvres hollandaises du Louvre." *Revue du Louvre* 12 (1962): 123–38, 175–84.

——. "La musique dans les allegories de l'amour. I. Venus." *Gazette des Beaux-Arts* 68 (1966): 265–90.

——. "La musique dans les allegories de l'amour. II. Eros." *Gazette des Beaux-Arts* 69 (1967): 319–46.

——. "Musique et symbolisme chez Jan-Davidszoon de Heem,

Cornelis-Jansoon et Jan II Janszoon de Heem." *Jaarboek van het Koninklijk Museum voor Schone Kunsten Antwerpen* (1970): 241–96.

——. "Les sujets musicaux chez Vermeer van Delft." *Gazette des Beaux-Arts* 57 (1961): 29–52.

——. *Astrologie et musique*. Geneva, 1977.

Mitchinson, Wendy. "Hysteria and Insanity in Women: A Nineteenth-Century Canadian Perspective." *Journal of Canadian Studies* 21 (Fall 1986): 87–105.

Montague, J. F. "History and Appraisal of the Enema." *Medical Record* 139 (1934): 91–93, 243–47, 297–99, 458–60.

Montias, John Michael. *Artists and Artisans in Delft*. Princeton, 1982.

Morewedge, Rosemarie Thee, ed. *The Role of Women in the Middle Ages: Papers from the Sixth Annual Conference of the Center for Medieval and Early Renaissance Studies, State University of New York at Binghamton, 6–7 May 1972*. Albany, N.Y., 1975.

Morse, Harriet Klamroth. *Elizabethan Pageantry: A Pictorial Survey of Costume and Its Commentators from c. 1560–1620*. 1934. Reprint. New York, 1969.

Moryson, Fynes. *An Itinerary*. 1617. Reprint. Amsterdam, 1971.

——. *Shakespeare's Europe: Unpublished Chapters of Fynes Moryson's Itinerary. Being a Survey of the Condition of Europe at the End of the Sixteenth Century*. Introduction by Charles Hughes. London, 1903.

Mousnier, Roland. "Les XVIᵉ et XVIIᵉ siècles. Les progrès de la civilization européenne et le déclin de l'Orient." In vol. 4 of *Histoire générale des civilizations*. Paris, 1954.

Mueller, William Randolf. *The Anatomy of Robert Burton's England*. Berkeley, 1952.

Mullett, Charles F. "Thomas Walkington and His 'Optick Glasse.'" *Isis* 36 (January 1946): 96–105.

Murray, John J. "The Cultural Impact of the Flemish Low Countries on Sixteenth- and Seventeenth-Century England." *American Historical Review* 62 (April 1957): 837–54.

Murris, Roelof. *La Hollande et les hollandais au XVIIᵉ et au XVIIIᵉ siècles vus par les français*. Paris, 1925.

Naumann, Otto. *Frans van Mieris the Elder (1635–1681)*. 2 vols. Doornspijk, 1981.

Neville, H. *Newes from the New Exchange: or The Commonwealth of Ladies, drawn to the life, in their severall characters and concernments*. London, 1650.

The New Grove Dictionary of Music and Musicians. Edited by Stanley Sadie. London, 1980.

New Sydenham Society. *The New Sydenham Society's Lexicon of Medicine and the Allied Sciences*. Edited by Henry Power and Leonard W. Sedgwick. London, 1879–99.

Nochlin, Linda. *Women, Art, and Power and Other Essays.* New York, 1988.

Noël, Jeanne Marie. "L'école des filles et la philosophie du mariage dans les Pays-Bas du XVIᵉ et du XVIIᵉ siècles." In *L'enseignement et l'éducation dans les Pays-Bas au dix-huitième siècle,* 137–54. Amsterdam, 1983.

———. "Education morale des filles et des garçons dans les Pays-Bas au 16ᵉ siècle: deux manuels pédagogiques." In *Women and Men in Spiritual Culture, XIV–XVII Centuries: A Meeting of South and North,* edited by Elisja Schulte van Kessel, 93–109. The Hague, 1986.

Norman, H. J. "John Bulwer, the Chirosopher." *Proceedings of the Royal Society of Medicine* (May 1943): 589–602.

Norris, Ronald V. *PMS/Premenstrual Syndrome.* New York, 1983.

Nourse, Timothy. *A discourse upon the nature and faculties of Man, in several essays. . . .* London, 1697.

The Nun's Rule, Being the Ancren Rewle, Modernized by James Morton. London, 1926.

Nutton, Vivian. "Montanus, Vesalius, and the Haemorrhoidal Veins." *Clio medica* (1983): 33–42.

Okin, Susan Moller. *Women in Western Political Thought.* Princeton, 1979.

O'Malley, Charles D. *History of Medical Education.* Berkeley, 1970.

Onderwijs en opvodeing in de achttiende eeuw. Amsterdam, 1983.

Osofsky, Howard J., and Susan J. Blumenthal, eds. *Premenstrual Syndrome: Current Findings and Future Directions.* Washington, D.C., 1985.

Owen, Alan Robert George. *Hysteria, Hypnosis, and Healing: The Work of J.-M. Charcot.* London, 1971.

Ozment, Steven. *When Fathers Ruled: Family Life in Reformation Europe.* Cambridge, 1983.

Pächt, Otto, and J. J. G. Alexander. *Illuminated Manuscripts in the Bodleian Library: Oxford III, British School.* Oxford, 1972.

[Paracelsus.] *Four Treatises of Theophrastus von Hohenheim Called Paracelsus, translated from the original German, with introductory essays, by Lilian Temkin, George Rosen, Gregory Zilboorg, and Henry E. Sigerist.* Baltimore, 1941.

[Paré, Ambrose.] *The Workes of the Famous Chirurgion Ambrose Parey, translated out of the Latine and compared with the French by Tho. Johnson.* London, 1649.

Paster, Gail Kern. *The Body Embarrassed: Drama and the Disciplines of Shame in Early Modern England.* Ithaca, 1993.

Peacham, Henry. *Minerva Britanna, or A garden of heroical devises, furnished, and adorned with emblems and impresas of sundry natures, newly devised, moralized, and published.* London, 1612.

Petterson, Einar. "*Amans Amanti Medicus*: Die Ikonologie des Motivs *Der ärztliche Besuch*." *Holländische Genremalerei im 17. Jahrhundert Symposium, Berlin, 1984. Jahrbuch Preussischer Kulturbesitz* 4 (1987): 193–224.

Pigeaud, Jackie. *La maladie de l'âme: Étude sur la relation de l'âme et du corps dans la tradition médico-philosophique antique*. Paris, 1981.

Pinto, Lucille B. "The Folk Practice of Gynecology and Obstetrics in the Middle Ages." *Bulletin of the History of Medicine* 47 (1973): 513–23.

Pitcairn, Archibald. *The Philosophical and Mathematical Elements of Physick*. London, 1718.

Plato. *Timaeus*. Translated by Benjamin Jowett. New York, 1949.

Pliny the Elder. *Historie of the World*. Translated by Philimon Holland. London, 1601.

Pomme, Pierre. *Essai sur les affections vaporeuses des deux sexes*. Paris, 1760.

Pope, Barbara Corrado. "Angels in the Devil's Workshop: Leisured and Charitable Women in Nineteenth-Century England and France." In *Becoming Visible: Women in European History*, edited by Renate Bridenthal and Claudia Koonz, 296–324. Boston, 1977.

Porter, Roy. "The Body and the Mind, the Doctor and the Patient: Negotiating Hysteria." In Sander L. Gilman et al., *Hysteria beyond Freud*, 225–85. Berkeley, 1993.

Posner, Donald. "The Swinging Women of Watteau and Fragonard." *Art Bulletin* 66 (1982): 75–89.

——. *Antoine Watteau*. Ithaca, 1984.

Posthumus Meyjes, Guillaume Henri Marie. *Geschiedenis van het Waalse college te Leiden, 1606–1669: Tevens een bijdrage tot de vroegste geschiedenis van het fonds Hallet*. Leiden, 1975.

Praz, Mario. *Studies in Seventeenth-Century Imagery*. Rome, 1964.

Pressavin, Jean Baptiste. *Nouveau traité des vapeurs, ou, Traité des maladies des nerfs, dans lequel on développe les vrais principes des vapeurs. . . .* Paris, 1771.

Primaudaye, Pierre de la. *The French academie, wherin is discoursed the institution of maners, and whatsoever els concerneth the good and happie life of all estates and callings, by precepts of doctrine, and examples of the lives of ancient sages and famous men*. London, 1589.

Primrose, James [Primerosius]. *Popular errours. Or the errours of people in physick*. Translated by Robert Wittie. London, 1651.

——. *Traité de Primerose sur les erreurs vulgaires de la médecine, avec des additions tres-curieuses par M. de Rostagny*. Lyon, 1689.

Prior, Mary, ed. *Women in English Society, 1500–1800*. London, 1985.

Pumfrey, Stephen, Paolo L. Rossi, and Maurice Slawinski, eds. *Science, Culture, and Popular Belief in Renaissance Europe*. Manchester, 1991.

Purcell, John. *A treatise of vapours, or, hysterick fits*. London, 1707.

Puré, Michel de. *La prétieuse: ou, le mystère des reulles.* . . . Paris, 1656–60.

Rabelais, François. *Pantagruel.* In *Portable Rabelais.* Translated and edited by Samuel Putnam. New York, 1946.

Racz, Elizabeth. "The Women's Rights Movement in the French Revolution." *Science and Society* 16 (Spring 1952): 151–74.

Raulin, Joseph. *Traité des affections vaporeuses du sexe; avec l'exposition de leurs symptômes . . . et la méthode de les guére.* Paris, 1758.

Raupp, Hans Joachim. "Musik im Atelier." *Oud Holland* 92 (1978): 106–29.

———. *Untersuchungen zu Künstlerbildnis und Künstlerdarstellung in den Niederlanden im 17. Jahrhundert.* Hildesheim, 1984.

Raynaud, Maurice. *Les médecins au temps de Molière.* Paris, 1863.

Rembrandt en zijn tijd. Brussels, 1971.

Reynier, Gustave. *La femme au XVIIᵉ siècle, ses ennemis et ses défenseurs.* . . . Paris, 1921.

Ricci, James V. *The Genealogy of Gynaecology: History of the Development of Gynaecology throughout the Ages, 2000 B.C.–1800 A.D.* Philadelphia, 1950.

———. *The Development of Gynaecological Surgery and Instruments: A Comprehensive Review of the Evolution of Surgery and Surgical Instruments for the Treatment of Female Diseases from the Hippocratic Age to the Antiseptic Period.* San Francisco, 1990.

Riewald, J. G. "New Light on English Actors in the Netherlands, c. 1590–c. 1660." *English Studies* 41 (1960): 65–92.

Riggs, Timothy A. *Hieronymus Cock, Printmaker and Publisher.* New York, 1977.

Rivière, Lazare. *Praxis medica.* Lyons, 1660.

Robinson, Franklin W. *Gabriel Metsu (1629–1667): A Study of His Place in Dutch Genre Painting of the Golden Age.* New York, 1974.

Robinson, Nicholas. *A New System of the Spleen, Vapours, and Hypochondriack Melancholy.* London, 1729.

Roesslin, Eucharius. *Der Swangern Frawen uud heb ammē roszgartē.* Hagenau, 1513.

———. *Den Rosegaert vanden beuruchten vrouwen.* Leyden, 1555. Reprint. Delft, 1608.

Rogers, Katherine M. *The Troublesome Helpmate: A History of Misogyny in Literature.* Seattle, 1966.

———. *Feminism in Eighteenth-Century England.* Urbana, Ill., 1982.

Rogers, Timothy. *A Discourse on Trouble of Mind.* 1691. Reprint. London, 1808.

Rolenhagen, Gabriel. *Selectorum emblematum.* Arnheim, 1613.

Roodenburg, Herman. "'Venus minsieke gasthuis': Over seksuele attitudes in de achttiende-eeuwse Republiek." *Documentatieblad werkgroep achttiende eeuw* 17 (1985): 119–43.

Rose, Peter G., ed. and trans. *The Sensible Cook: Dutch Foodways in the Old and the New World.* Syracuse, N.Y., 1989.

Rosen, George. *Madness in Society: Chapters in the Historical Sociology of Mental Illness.* New York, 1969.

Rosenberg, Jakob, Seymour Slive, and E. H. ter Kuile. *Dutch Art and Architecture, 1600–1800.* Baltimore, 1966.

Rousseau, G. S. " 'A Strange Pathology': Hysteria in the Early Modern World, 1500–1800." In Sander L. Gilman et al., *Hysteria beyond Freud,* 91–221. Berkeley, 1993.

Rousseau, G. S., and Roy Porter. *The Ferment of Knowledge.* Cambridge, 1980.

Rousselle, Aline. *Porneia: De la maîtrise du corps à la privation sensorielle, IIᵉ–IVᵉ siècles de l'ère chrétienne.* Paris, 1983.

Rowlands, Samuel. *Democritus, or Doctor Merry-man his medicines, against melancholy humours.* London, 1607.

Rowley, William. *A treatise on female, nervous, hysterical, hypochondriacal, bilious, convulsive diseases; appoplexy and palsy; with thoughts on madness, suicide, etc., in which the principal disorders are explained from anatomical facts, and the treatment formed on several new principles.* London, 1788.

Ruestow, Edward Grant. *Physics at Seventeenth- and Eighteenth-Century Leiden: Philosophy and the New Science in the University.* The Hague, 1973.

Russell, Andrew W., ed. *The Town and State Physician in Europe from the Middle Ages to the Enlightenment.* Wolfenbüttel, 1981.

Russell, Jeffrey Burton. *Witchcraft in the Middle Ages.* Ithaca, 1972.

Sabbah, Guy, ed. *Le Latin médical: la constitution d'un langage scientifique. Réalités et langage de la médecine dans le monde romain. Actes du IIIᵉ Colloque international "Textes médicaux latins antiques" (Saint-Étienne, 11–13 Septembre 1989).* Saint-Étienne, 1991.

Sadler, John. *The sicke womans private lookingglass wherein methodically are handled all uterine affects, or diseases arising from the wombe. . . .* London, 1636.

Salisbury, Joyce E. "Fruitful in Singleness." *Journal of Medieval History* 8 (June 1982): 97–106.

Salter, Frank Reyner, ed. *Some Early Tracts on Poor Relief.* London, 1926.

Sandler, Lucy Freeman. *Gothic Manuscripts, 1285–1385.* Vol. 5 of *A Survey of Manuscripts Illuminated in the British Isles.* Edited by J. J. G. Alexander. London, 1986.

Satires on Women. Introduction by Felicity A. Nussbaum. Augustan Reprint Society, vol. 180. Los Angeles, 1976.

Sauvages de la Croix, François Boissier de. *Nosologia methodica sistens morborum classes, genera et species, juxta Sydenhamie mentem & Botanicorum ordinem. . . .* Amsterdam, 1763.

Scarborough, John. "Botany, Pharmacy, and the Culinary Arts." In *The Rational Arts of Living: Ruth and Clarence Kennedy Conference in the Renaissance, 1982. Smith College Studies in History*, edited by Alistair Cameron Crombie and Nancy Siraisi, 161–204. Northampton, Mass., 1987.

Schadewaldt, Hans. "Der 'Morbus Amatorius' aus medizinhistorischer Sicht." In *Das Ritterbild in Mittelalter und Renaissance*. Vol. 1 of *Studia humaniora: Dusseldorfer Studien zu Mittelalter und Renaissance*, 87–104. Dusseldorf, 1985.

Schama, Simon. "Wives and Wantons: Versions of Womanhood in Seventeenth-Century Dutch Art." *Oxford Art Journal* 3 (April 1980): 5–13.

———. *The Embarrassment of Riches: An Interpretation of Dutch Culture in the Golden Age*. New York, 1987.

Schatborn, Peter. *Dutch Genre Drawings of the Seventeenth Century*. New York, 1972.

Schiebinger, Londa. "Skeletons in the Closet: The First Illustrations of the Female Skeleton in Eighteenth-Century Anatomy." *Representations* 14 (Spring 1986): 42–82.

Schiesari, Juliana. *The Gendering of Melancholia: Feminism, Psychoanalysis, and the Symbolics of Loss in Renaissance Literature*. Ithaca, 1992.

Schmidt-Degener, Frederick W. *Jan Steen*. London, 1927.

The School of Salernum. Translated by John Harington. New York, 1920.

Schullian, Dorothy M., and Max Schoen, eds. *Music and Medicine*. New York, 1948.

Schurman, Anna Maria van. *Dissertatio, de ingenii muliebris ad doctrinam, & meliores litteras aptitudine*. Leyden, 1641.

———. *The learned maid, or, Whether a maid may be a scholar?* London, 1659.

Schwarz, Emile. *Chlorosis: A Retrospective Investigation*. Brussels, 1951.

Seneca, Lucius Anaeus. *Moral Essays*. Translated by J. Basore. London, 1928.

Shahar, Shulamith. *The Fourth Estate: A History of Women in the Middle Ages*. London, 1983.

Shapiro, Arthur K. "Placebo Effects in Medicine, Psychotherapy, and Psychoanalysis." In *Handbook of Psychotherapy and Behavior Change: An Empirical Analysis*, edited by Sol. L. Garfield and Allen E. Bergin, 439–73. New York, 1971.

Shepherd, Simon, ed. *The Women's Sharp Revenge: Five Women's Pamphlets from the Renaissance, 1580–1640*. London, 1985.

Showalter, Elaine. *The Female Malady: Women, Madness, and English Culture, 1830–1980*. New York, 1985.

———. "Hysteria, Feminism, and Gender." In Sander L. Gilman et al., *Hysteria beyond Freud*, 286–344. Berkeley, 1993.

Siegel, Rudolph E. *Galen's System of Medicine and Physiology, an Analysis of his Doctrines on Bloodflow, Respiration, Humours, and Internal Diseases*. Basel, 1968.

———. "Melancholy and Black Bile in Galen and Later Writers." *Bulletin of the Cleveland Medical Library* 18 (1971): 10–12.

Sigerist, Henry Ernest. *Civilization and Disease*. Ithaca, New York, 1943.

———. "Bedside Manners in the Middle Ages: The Treatise 'De Cautelis Medicorium' Attributed to Arnauld of Villanova." *Quarterly Bulletin of the Northwestern University Medical School* 28 (1946): 136–43.

———. *Primitive and Archaic Medicine*. Vol. 1 of *A History of Medicine*. New York, 1951.

Singer, Charles. "Thirteenth-Century Miniatures Illustrating Medical Practice." *Proceedings of the Royal Society of Medicine* 9, pt. 2, History Section (1915–16): 29–41.

———. "The Figures of the Bristol Guy de Chauliac MS (circa 1430)." *Proceedings of the Royal Society of Medicine, Section on the History of Medicine* 10 (1917): 71–90.

Siraisi, Nancy G. *Medieval and Early Renaissance Medicine*. Chicago, 1990.

Slatkes, Leonard. *Vermeer and His Contemporaries*. New York, 1981.

Slatkin, Wendy. *Woman Artists in History: From Antiquity to the Twentieth Century*. New York, 1985.

Slive, Seymour. "Realism and Symbolism in Seventeenth-Century Dutch Painting." *Daedalus* 91 (1962): 469–500.

Smart, Carol. "Law and the Control of Women's Sexuality: The Case of the 1950s." In *Controlling Women: The Normal and the Deviant*, edited by Bridget Hutter and Gillian Williams, 40–60. London, 1981.

Smith, David R. *Masks of Wedlock: Seventeenth-Century Dutch Marriage Portraiture*. Ann Arbor, 1982.

Smith, Hilda. *Reason's Disciples: Seventeenth-Century English Feminists*. Chicago, 1982.

Smith, Paul Jordan. *Bibliographica Burtania: A Study of Robert Burton's "The Anatomy of Melancholy," with a Bibliography of Burton's Writings. . . .* Stanford, 1931.

Smith-Rosenberg, Carroll. "The Hysterical Woman: Sex Roles and Conflict in Nineteenth-Century America." *Social Research* 39 (1972): 652–78.

———. "The Female Animal: Medical and Biological Views of Women in Nineteenth-Century America." *Journal of American History* 60 (1973): 332–56.

Smoll, Gotfridus [Smollius]. *Trias maritima, proponens per introductionem trium aegrotanticum, sorcum morbosarum, domesticarum, hypochondriacae spleneticae; hypochondriacae meseraiae; hypochondriacae phantasticae; ortum et interitum*. Leiden, 1610.

Smyth, James Carmichael. *An account of the effects of swinging, employed as a remedy in the pulmonary consumption and hectic fever. . . .* London, 1787.

Snoep-Reitsma, Ella. "Chardin and the Bourgeois Ideals of His Time." *Nederlands Kunsthistorisch Jaarboek* 24 (1973): 147–243.

———. "De waterzuchtige vrouw van Gerard Dou en de betekenis van de lampetkan." In J. Bruyn et al., *Album amicorum J. G. van Gelder*, 285–92. The Hague, 1973.

Socio-Medical Inquiries: Recollections, Reflections, and Reconsiderations. Philadelphia, 1983.

Soranus of Ephesus. *"On Acute Diseases" and "On Chronic Diseases."* Edited and translated by Miriam F. Drabkin. Chicago, 1950.

———. *Soranus' "Gynecology."* Translated by Owsei Temkin. Baltimore, 1956.

Spanos, Nicholas P., and Jack Gottlieb. "Demonic Possession, Mesmerism, and Hysteria: A Social-Psychological Perspective on Their Historical Interrelations." *Journal of Abnormal Psychology* 88 (October 1979): 527–46.

Speert, Harold. *Iconographica Gyniatrica: A Pictorial History of Gynecology and Obstetrics.* Philadelphia, 1973.

Spender, Dale. *Women of Ideas and What Men Have Done to Them: From Aphra Behn to Adrienne Rich.* London, 1982.

Spink, John Stephenson. *Woman and Society in Eighteenth-Century France.* London, 1979.

Staden, Heinrich von. "'Apud nos foedior verba': Celsus' Reluctant Construction of the Female Body." In *Le Latin médical: la constitution d'un langage scientifique. Réalités et langage de la médecine dans le monde romain. Actes du III^e Colloque international "Textes médicaux latins antiques" (Saint-Étienne, 11–13 Septembre 1989),* edited by Guy Sabbah, 271–96. Saint-Étienne, 1991.

Starobinski, Jean. "Histoire du traitement de la mélancolie des origines à 1900." *Acta psychosomatica 4.* Basel, 1960.

———. *A History of Medicine.* New York, 1964.

Stechow, Wolfgang. *Dutch and Flemish Paintings.* Amsterdam, 1938.

———. "The Love of Antiochus with Faire Stratonica in Art." *Art Bulletin* (1945): 221–37.

———. *Sources and Documents in the History of Art: Northern Renaissance Art, 1400–1600.* Englewood Cliffs, N.J., 1966.

Stevenson, Lloyd G. "'New Diseases' in the Seventeenth Century." *Bulletin of the History of Medicine* 39 (January–February 1965): 1–21.

Stewart, Alison G. *Unequal Couples: A Study of Unequal Couples in Northern Art.* New York, 1977.

Stone-Ferrier, Linda. *Dutch Prints of Daily Life: Mirrors of Life or Masks of Morals?* Kansas City, 1983.

Storer, Horatio Robinson. *The Causation, Course and Treatment of Reflex Insanity in Women.* 1871. Reprint. New York, 1972.

Strong, Roy. "The Elizabethan Malady: Melancholy in Elizabethan and Jacobean Portraiture." *Apollo* 49 (1964): 264–69.

——. *The English Icon: Elizabethan and Jacobean Portraits.* London, 1969.

——. *Tudor and Jacobean Portraits.* 2 vols. London, 1969.

——. *The Elizabethan Images.* New York, 1970.

Strümpell, Adolf von. *A Text-Book of Medicine for Students and Practitioners.* New York, 1895.

Struthius, Josephus. *Sphygmicae artis jam mille ducentos annos perditae & desideratae libri V. . . .* Basel, 1555.

Stuard, Mosher. "Dame Trot." *Signs: Journal of Women in Culture and Society* 1 (1975): 537–42.

Sudhoff, Karl. "Weitere Beitrage zur Geschichte der Anatomie im Mittelalter, 2." *Sudhoff's Archiv für Geschichte der Medizin* 7 (1914): 372–74.

——. "Salerno, Montpellier und Paris um 1200." *Archiv für Geschichte der Medizin* 20 (1928): 51–62.

Suleiman, Susan Rubin, ed. *The Female Body in Western Culture: Contemporary Perspectives.* Cambridge, Mass., 1986.

Sullivan, Margaret. "Bruegel's Proverbs: Art and Audience in the Northern Renaissance." *Art Bulletin* 73 (September 1991): 431–66.

Sutton, Peter C. *Jan Steen: Comedy and Admonition. Bulletin of the Philadelphia Museum of Art* 78 (Winter 1982–83).

——. *Pieter de Hooch.* Ithaca, 1980.

Sutton, Peter C., et al. *Masters of Seventeenth-Century Dutch Genre Painting.* Philadelphia, 1984.

Swammerdam, Jan. *Miraculuum naturae, sive Uteri muliebris fabrica. . . .* Leiden, 1672.

Swetnam, Joseph. *The arraignment of lewd, idle, froward, and unconstant women: or, The vanitie of them. . . .* London, 1622.

——. *Recht-banck het eerste deel. Tegen de ydele, korzelighe ende wispeltuyrighe vrouwen.* Amsterdam, 1662.

Swieten, Gerard van. *Maladies des femmes et des enfans.* Paris, 1769.

——. *Commentaries upon Boerhaave's aphorisms concerning the knowledge and cure of diseases.* 18 vols. Edinburgh, 1776.

[Sydenham, Thomas.] *The whole Works of that excellent practical physician, Dr. Thomas Sydenham.* London, 1729.

——. *The entire works of Dr. Thomas Sydenham, newly made English from the originals . . . by John Swan, M.D.* London, 1742.

——. *The Works of Thomas Sydenham, M.D.* Translated by R. G. Latham. London, 1848.

Sylvius, Jacobus. *Opera medica.* Geneva, 1630.

Szasz, Thomas S. *The Myth of Mental Illness: Foundations of a Theory of Personal Conduct.* New York, 1961.

Talbot, Charles H. *Medicine in Medieval England.* London, 1967.

Taylor, Frederick Kraüpl. *The Concepts of Illness, Diseases, and Morbus.* Cambridge, 1979.

Teitelbaum, Michael S., ed. *Sex Differences: Social and Biological Perspectives.* Garden City, N.Y., 1974.

Tellenbach, Hubertus. *Melancholie.* Berlin, 1961.

———. *Melancholy: History of the Problem, Endogeneity, Rypology, Pathogenesis, Clinical Considerations.* Translated by Erling Eng. Pittsburgh, 1980.

Temkin, Owsei. *Galenism: The Rise and Decline of a Medical Philosophy.* Ithaca, 1973.

Temkin, Owsei, and C. L. Temkin, eds. *Ancient Medicine.* Baltimore, 1967.

Temple, William. *Observations upon the United Provinces of the Netherlands.* London, 1673.

Tenon, Jacques René. *Mémoires sur les hôpitaux de Paris.* Paris, 1788.

Theopold, Wilhelm. *Mirakel, Heilung zwischen Wissenschaft und Glauben.* Munich, 1983.

Thiel, P. J. J. van. "Frans Hals' portret van de Leidse rederijkersnar Pieter Cornelisz van der Morsch, alias Piero (1543–1628)." *Oud Holland* 76 (1961): 152–72.

Thorndike, Lynn. *History of Magic and Experimental Science.* 8 vols. New York, 1923–58.

Todd, Margo. *Christian Humanism and the Puritan Social Order.* Cambridge, 1987.

Traer, James F. *Marriage and Family in Eighteenth-Century France.* Ithaca, 1980.

Trevor-Roper, Hugh R. *The Gentry, 1540–1640: Economic History Review Supplements.* Vol. 1. Ann Arbor, 1953.

Trillat, Étienne. *Histoire de l'hystérie.* Paris, 1986.

Trotula of Salerno. *Passionibus mulierum curandorum.* Translation of *The Diseases of Women* by Elizabeth Mason-Hohl. Los Angeles, 1940.

———. *Medieval Woman's Guide to Health: The First English Gynecological Handbook.* Edited and translated by Beryl Rowland. Kent, Ohio, 1981.

Turner, Robert. *De morbis foemineis.* London, 1686.

Tussen heks & heilige: Het vrouwbeeld op de drempel van de moderne tijd, 15de/16de eeuw. Nijmegen, 1985.

Underwood, E. Ashworth. "Apollo and Terpsichore: Music and the Healing Art." *Bulletin of the History of Medicine* 21 (1947): 639–73.

Utley, Francis Lee. *The Crooked Rib: An Analytical Index to the Argument about Women in English and Scots Literature to the End of the Year 1568.* Columbus, Ohio, 1944.

Vann, Richard T. *The Social Development of English Quakerism, 1655–1755*. Cambridge, Mass., 1969.

———. "Toward a New Lifestyle: Women in Preindustrial Capitalism." In *Becoming Visible: Women in European History*, edited by Renate Bridenthal and Claudia Koonz, 192–216. Boston, 1977.

Vaughan, William. *Directions for health, both natural and artificiall: Approved and derived from the best Physitians. . . .* London, 1626.

Veen, Otto van [Vaenius]. *Amorum emblemata*. Antwerp, 1608.

Veith, Ilza. "On Hysterical and Hypochondriacal Afflictions." *Bulletin of the History of Medicine* 30 (May–June 1956): 233–40.

———. *Hysteria: The History of a Disease*. Chicago, 1965.

Veldman, Ilja M. "De macht van de planeten over het mensdom in prenten naar Maarten de Vos." *Bulletin van het Rijksmuseum* 31 (1983): 21–53.

———. "Lessons for Ladies: A Selection of Sixteenth- and Seventeenth-Century Dutch Prints." *Simiolus* 16 (1986): 113–27.

Venette, Nicolas. *Tableau de l'amour conjugal, considéré dans l'estat du mariage*. Amsterdam, 1687.

———. *Venus minsieke gasthuis, waer in beschreven worden de bedryven der liefde in den staet des houwelijks, met de natuurlijke eygenschappen der manen en vrouwen, hare siekten, oirsaken en genesingen*. Amsterdam, 1688.

Vicary, Thomas. *The English-mans treasure. With the true anatomie of mans body. . . .* London, 1633.

Vicinus, Martha, ed. *Suffer and Be Still: Women in the Victorian Age*. Bloomington, Ind., 1972.

Vinken, P. J. "Some Observations on the Symbolism of the Broken Pot in Art and Literature." *American Imago* 15 (1958): 149–74.

Vives, Juan Luis. *The Instruction of a Christen Woman*. Translated by R. Hyrde. London, 1547.

———. *An introduction to wysedome*. Translated by R. Morysine. London, 1540.

Wack, Mary Frances. *Lovesickness in the Middle Ages: The "Viaticum" and Its Commentaries*. Philadelphia, 1990.

———. "From Mental Faculties to Magical Philters: The Entry of Magic into Academic Medical Writing on Lovesickness, Thirteenth–Seventeenth Centuries." In Donald A. Beecher and Massimo Ciavolella, *Eros & Anteros: The Medical Traditions of Love in the Renaissance*, 9–31. Ottowa, 1993.

Wajeman, Gérard. *Le maître et l'hystérique*. Paris, 1982.

Walker, D. P. *Spiritual and Demonic Magic from Ficino to Campanella*. London, 1958.

Walker, Obadiah. *Some instructions concerning the art of oratory*. London, 1659.

Walkington, Thomas. *The optick glasse of humors; or, The touchstone of a golden temperature*. London, 1607, 1631.

Walter, George. " 'Peri Gynaikeion A' of the Corpus Hippocraticum in a Mediaeval Translation." *Bulletin of the Institute of the History of Medicine* 3 (1935): 599–606.

Wansink, H. *Politieke wetenschappen aan de Leidse universiteit, 1575–1650*. Utrecht, 1981.

Watson, Andrew G. *Catalogue of Dated and Datable Manuscripts c. 435–1600 in Oxford Libraries*. 2 vols. Oxford, 1984.

Wear, Andrew, and R. French, eds. *The Medical Renaissance of the Sixteenth Century*. Cambridge, 1985.

Webster, Charles. *The Great Instauration: Science, Medicine, and Reform, 1626–1660*. London, 1975.

Weedon, F. R., and A. P. Heusner. "A Clinical-Pathological Conference from the Middle Ages." *Bulletin of the School of Medicine of the University of North Carolina* 8 (1960): 14–20.

Weeks, Jeffrey. *Sex, Politics, and Society: The Regulation of Sexuality since 1800*. London, 1981.

Wellesz, Egon. "Music in the Treatises of Greek Gnostics and Alchemists." *Ambix* 4 (February 1951): 145–57.

Welter, Barbara. "The Cult of True Womanhood: 1820–1860." *American Quarterly* 18 (1966): 151–74.

Wentzel, Hans. "Jean-Honoré Fragonards 'Schaukel': Bemerkungen zur Ikonographie der Schaukel in der bildenden Kunst." *Wallraf-Richartz-Jahrbuch; Westdeutches Jahrbuch für Kunst-geschichte* 26 (1964): 187–218.

Werner, Eric, and Isaiah Sonne. "The Philosophy and Theory of Music in Judaeo-Arabic Literature." *Hebrew Union College Annual* 16 (1941): 251–319; 17 (1942–43): 511–72.

Wesley, George Randolf. *A History of Hysteria*. Washington, D.C., 1979.

Westen, Mirjam. "The Woman on a Swing and the Sensuous Voyeur: Passion and Voyeurism in French Rococo." In *From Sappho to de Sade: Moments in the History of Sexuality*, edited by Jan Bremmer, 69–83. London, 1989.

Westfall, Richard S. *Science and Religion in Seventeenth-Century England*. Ann Arbor, 1973.

Wexler, Victor G. "Made for Man's Delight: Rousseau as Antifeminist." *American Historical Review* 81 (1976): 266–91.

Weyer [Wier], Johann. *De praestigiis daemonum. . . .* Basel, 1568.

Whytt, Robert. *Observations on the nature, causes, and cure of those disorders which have been commonly called nervous, hypochondriac, or hysteric*. Edinburgh, 1765.

Willis, Thomas. *Affectionum quae dicuntur hystericae et hypochondriacae pathologica spasmodica.* Leiden, 1671.

———. *D'algemeeine en bysondere . . . wercking der genees-middelen.* Translated by A. de Heide. Middleburgh, 1677.

———. *Dissertation sur les urines.* Paris, 1683.

———. *Dr. Willis's practice of physick, being the whole works of that renowned and famous physician.* Translated by S. Pordage. London, 1684.

Wilson, C. H. *England and Holland.* London, 1946.

———. *The Dutch Republic and the Civilization of the Seventeenth Century.* New York, 1977.

Wilson, Katharina M. "Marginalized Women in Literary and Historical Perspective." Paper read at "Matrons and Marginal Women in the Middle Ages" conference, Pennsylvania State University, 1991.

Winchester, H. C. *All about Enemas.* Washington, D.C., 1966.

Winternitz, Emanuel. *Musical Instruments and Their Symbolism in Western Art.* London, 1967.

———. *Musical Instruments in the Western World.* New York, 1967.

Wolf, Abraham. *A History of Science, Technology, and Philosophy in the Sixteenth and Seventeenth Centuries.* 2 vols. Gloucester, Mass., 1968.

Wolf, Hendrik Casmirus de. *De kerk en het Maagdenhuis: Vier episoden uit de geschiedenis van katholiek Amsterdam.* Utrecht, 1970.

Wolowitz, Howard M. "Hysterical Character and Feminine Identity." In *Readings on the Psychology of Women,* edited by Judith M. Bardwick, 307–14. New York, 1972.

Wood, Ann Douglas. "The Fashionable Diseases: Women's Complaints and Their Treatment in Nineteenth-Century America." In *Clio's Consciousness Raised: New Perspectives on the History of Women,* edited by Mary S. Hartman and Lois W. Banner, 1–22. New York, 1974.

Woodbridge, Linda. *Women and the English Renaissance: Literature and the Nature of Womankind, 1540–1620.* Urbana, Ill., 1986.

Woolley, Hannah. *The Accomplisht-Ladys Delight. In Preserving, Physick, Beautifying and Cookery.* London, 1675, 1677.

Woude, A. M. van der. "Variations in the Size and Structure of the Household in the United Provinces of the Netherlands in the Seventeenth and Eighteenth Centuries." In *Household and Family in Past Time,* edited by Peter Laslett, 299–318. Cambridge, Mass., 1972.

Wright, Christopher. *The Dutch Painters: One Hundred Seventeenth-Century Masters.* New York, 1978.

Wright, John P. "Hysteria and Mechanical Man." *Journal of the History of Ideas* 41 (January–March 1980): 233–47.

Wright, Louis B. *Middle-Class Culture in Elizabethan England.* Chapel Hill, 1935.

Wright, Peter, and Andrew Treacher, eds. *The Problem of Medical*

Knowledge: Examining the Social Construction of Medicine. Edinburgh, 1982.

Wright, Thomas. *The Passions of the Minde in Generall*. London, 1604.

Wyntjes, Sherrin Marshall. "Women in the Reformation Era." In *Becoming Visible: Women in European History*, edited by Renate Bridenthal and Claudia Koonz, 165–91. Boston, 1977.

——. *The Dutch Gentry, 1500–1650: Family, Faith, and Fortune*. New York, 1989.

——, ed. *Women in Reformation and Counter-Reformation Europe: Public and Private Worlds*. Bloomington, Ind., 1989.

Yearsley, Macleod. "Music as Treatment in Elizabethan Medicine." *Lancet* 228 (1935): 415–16.

Zanier, Giancarlo. *Le medicina astrologia e la sua teoria: Marsilio Ficino e i suoi critici contemporanei*. Rome, 1977.

Zarlino, Gioseffe. *Istitutioni armoniche*. Venice, 1558.

Zilboorg, Gregory. *A History of Medical Psychology*. New York, 1941.

——. *The Medical Man and the Witch During the Renaissance*. New York, 1969.

Zindel, Nicolaus [Zindelius]. *Dissertation inauguralis medica: De morbis ex castitate nimia oriundis*. Basel, 1745.

Zumthor, Paul. *Daily Life in Rembrandt's Holland*. Translated by S. W. Taylor. New York, 1963.

INDEX